THE ART OF BORDERLANDS 3

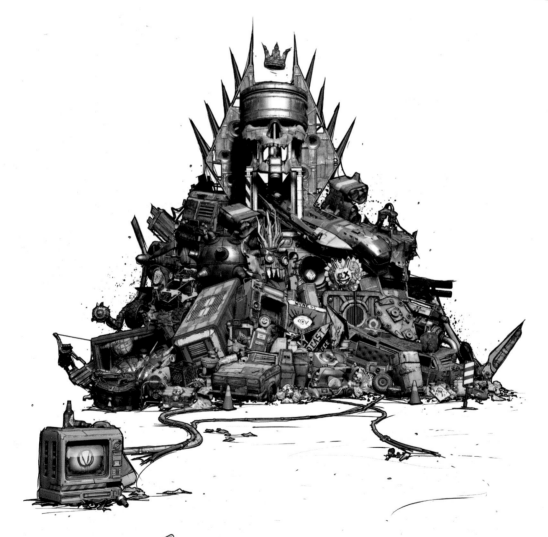

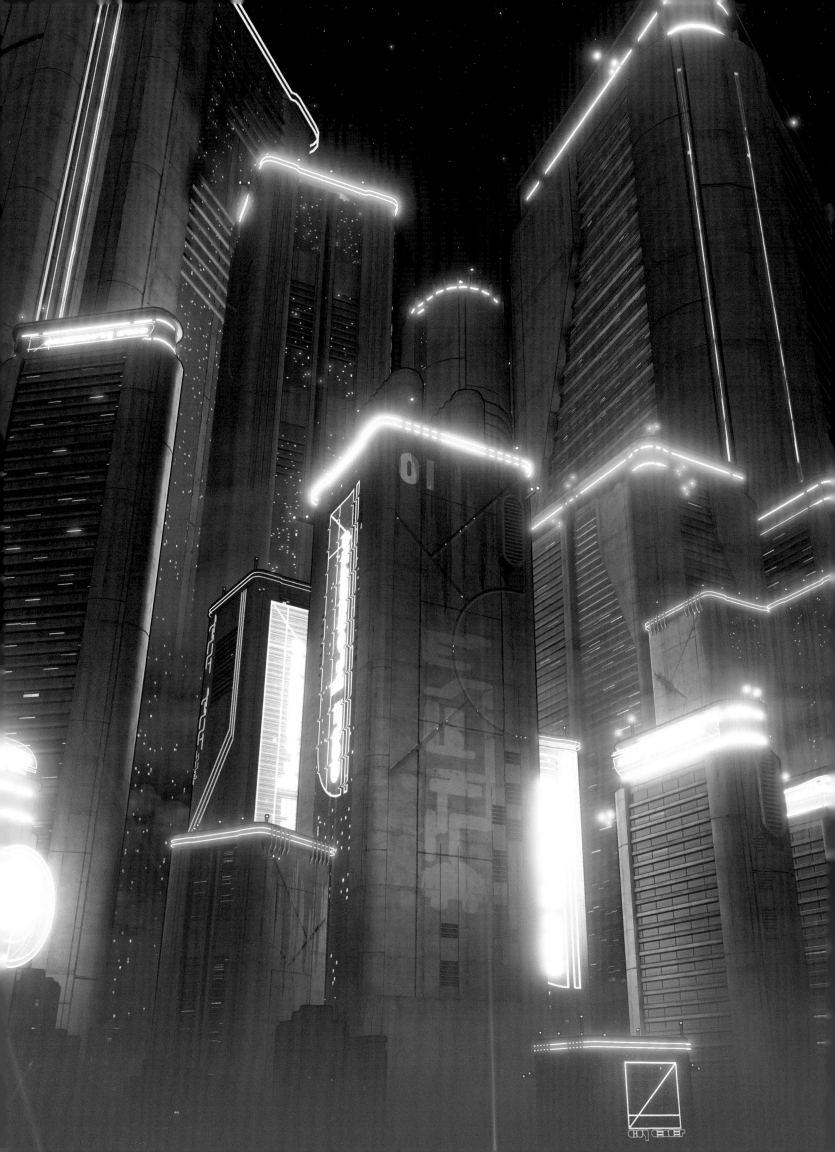

THE ART OF BORDERLANDS 3

INTRODUCTION BY SCOTT KESTER
WRITTEN BY CHRIS ALLCOCK

INSIGHT EDITIONS
San Rafael, California

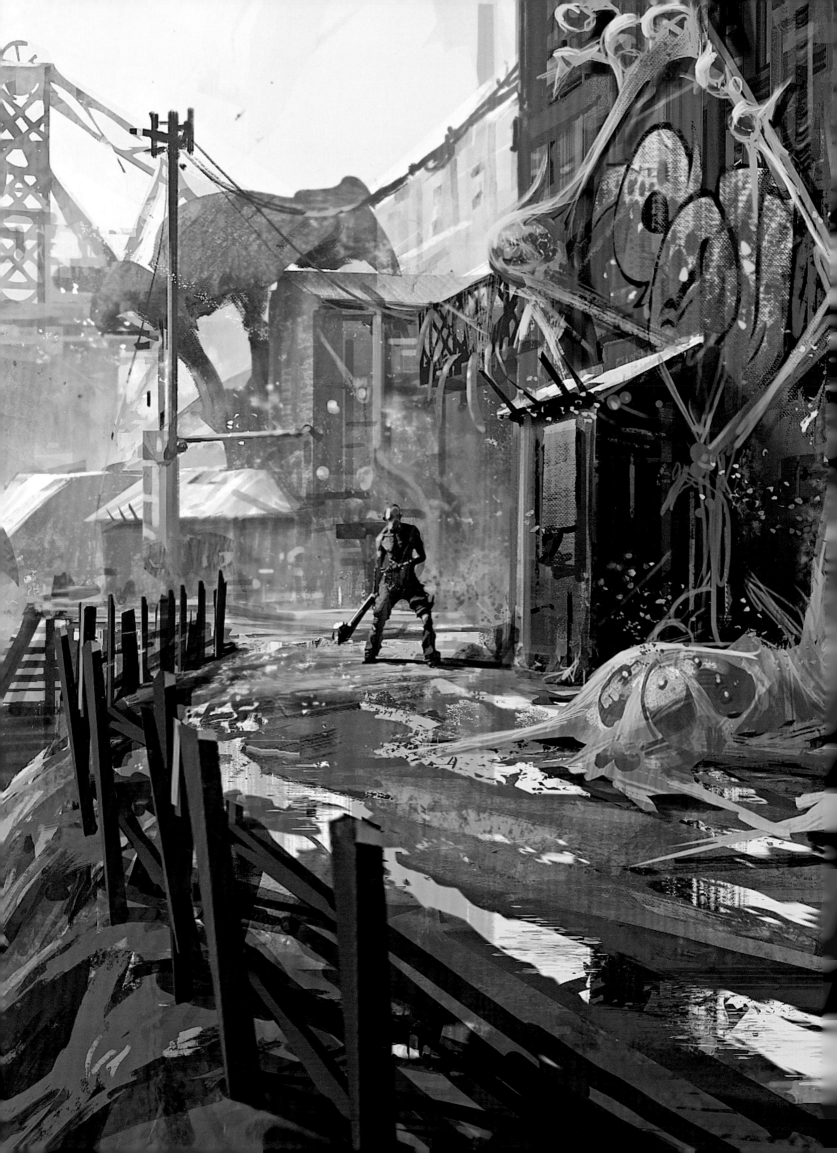

CONTENTS

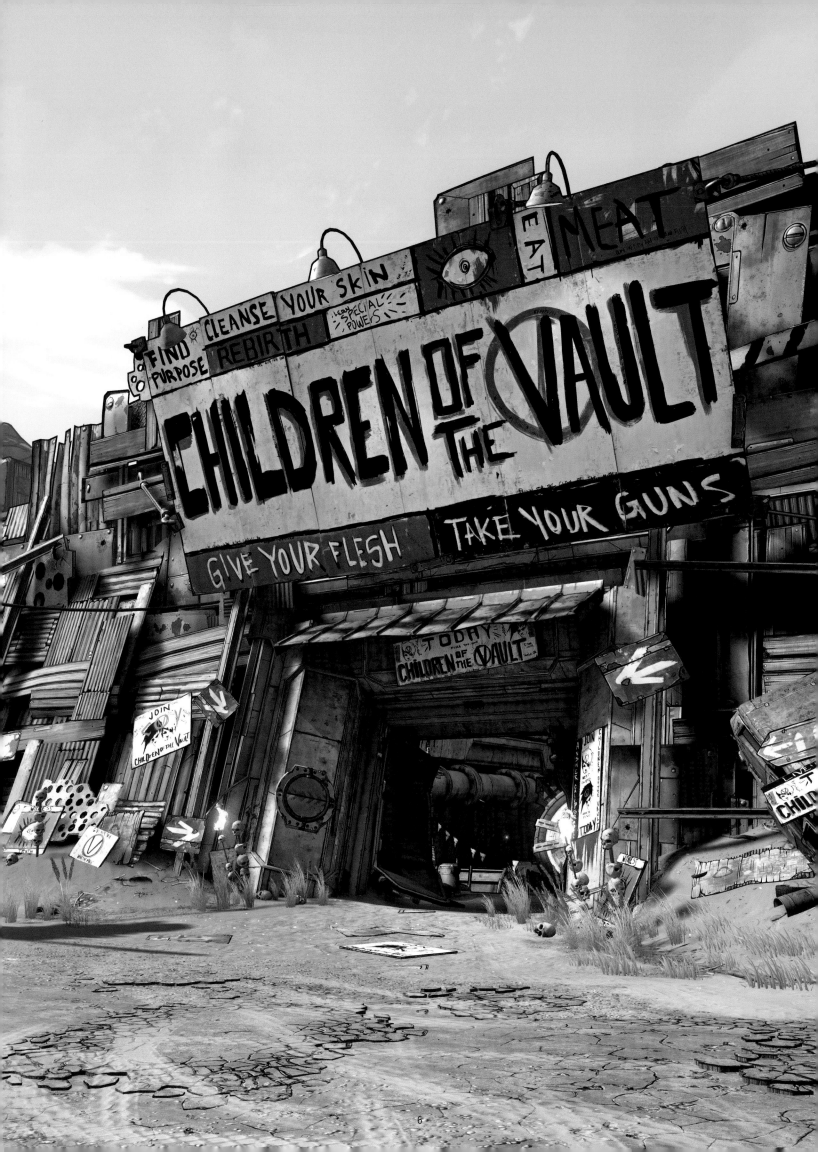

INTRODUCTION

By Scott Kester

Art Director, *Borderlands 3*

Why do I play video games? For me, it's all about the journey, more than short gameplay loops. I want to experience how my character grows and changes over time and to feel that I'm a different person at the end of that journey than where I was when it began. If I were to read a story where the first and the last sentence left me basically in the same place with no new perspective, if nothing had changed, I wouldn't be interested.

That's why, when I finished up on *Battleborn* and joined the *Borderlands 3* team during those first weeks of development, I started asking myself: What would be next for *Borderlands* on its journey? More specifically, I wondered what the epitome of *Borderlands* would look like. What was the absolute best the game could be? What had we never attempted, and where could we find new inspiration?

After all, a lot had happened since I worked as a concept artist on the first *Borderlands* back in 2009. There had been a ton of DLC, *Borderlands 2* in 2012, two full seasons of expansion content, *Borderlands: The Pre-Sequel*, and *Tales from the Borderlands* in 2014. That's not to mention *The Handsome Collection* that brought the games to current consoles. Whatever we did next, it was obvious that it couldn't just be "more *Borderlands*."

Everything needed to evolve, to be pushed further, bending the rules in ways that were going to surprise players. That's one of the best things about the *Borderlands* universe: We make the rules. If I want to make a game about where I grew up in 1990s Kansas, I can't just place a medieval castle down in the background. But in *Borderlands*, who's to say we can't have a castle in this strange, fictional alien world? Well . . . us, most of the time. We're always aiming to keep everything believable, even when it's strange. We're pretty human-focused—we don't really have blue alien people wandering around—but that's why those surprising, rule-bending moments work.

At the same time, making the leap from our specialized version of Unreal Engine 3 over to Unreal Engine 4 meant that we couldn't simply reuse anything that had come before. Characters, environments, and weapons all had to be rebuilt, and sometimes redesigned from scratch, to take advantage of larger polygon counts, greater fidelity, and higher resolutions. A detail that might have been a simple squiggle in *Borderlands* now had to be properly defined. It might even need to animate or act as a light source, and that would tie it into a whole bunch of other in-game systems.

The ambitious scope of *Borderlands 3*, taking the players to different planets and exposing them to entirely different ecosystems, all while trying to constantly keep them surprised, ultimately meant that a much bigger art team would need to be assembled. This team would see *Borderlands* veterans working side by side with the next generation of developers, some of whom were inspired to join Gearbox because of their love for the older games in the *Borderlands* series.

The concept pieces, renders, and 3D models showcased in this art book represent just a tiny fraction of the piles of notebooks, reams of paper, and countless brilliant ideas that different team members brought to the table. The first section focuses on the human (well, mostly human) characters, highlighting how old friends and enemies have changed this time around, and how they stack up against an all-new cast of Vault Hunters and non-player characters.

Other sections dive into the different worlds players will visit, the enemies and creatures who populate them, and the vehicles they'll be using to traverse that alien terrain. And, of course, no book on *Borderlands* would be complete without lovingly inspecting the many, many guns that the players will be gathering along the way.

While this book focuses primarily on the artistic work necessary to create and ship *Borderlands 3*, art is just one aspect of what it takes to make a video game, which is why it's important to recognize and applaud the herculean efforts of the software engineers, designers, musicians and audio engineers, creative leads, riggers and animators, visual effects artists, producers and project managers, quality assurance staff, voice and performance actors, and the many, many other super-talented men and women who make up the *Borderlands* team—not to mention the people who support them. Without their hard work, their passion, and their determination to realize the epitome of *Borderlands*, all these sketches would still just be sketches, and nothing more.

Lastly, a huge thank-you to you, the players, for caring enough about the universe we've created to want to peek behind the curtain with a book like this. Without further ado, allow us to bring you along on *our* journey: the journey of *Borderlands 3*. It certainly brought us all some new perspective, and hopefully, you'll feel the same.

PAGE 2: Promethea at night.

PAGES 4–5: A psycho on Eden-6.

OPPOSITE: The entrance to the Children of the Vault's stronghold.

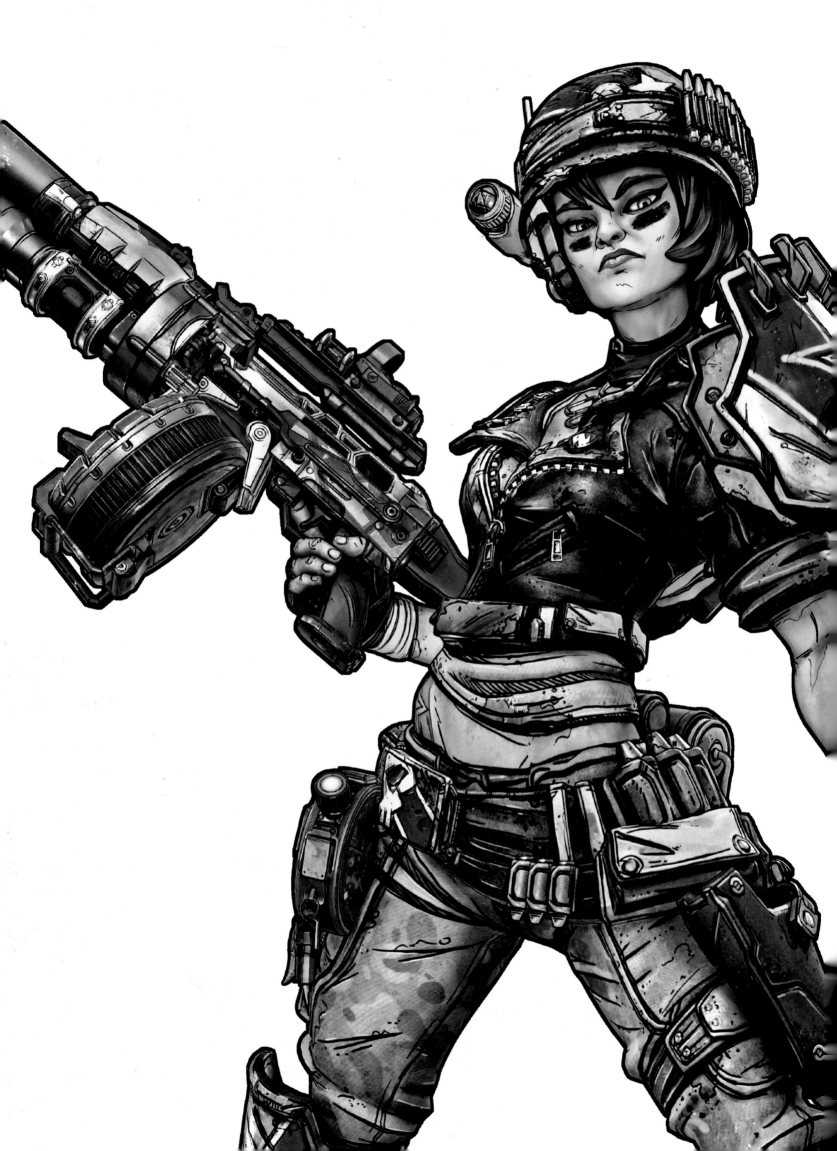

1

CHARACTERS

Characters are the heart and soul of every visit to the *Borderlands* universe, and vital to developing an even more thrilling and surprising story than the tales that unfolded in previous games. Every installment gets a fresh start thanks to a team of four new Vault Hunters that look, feel, and play differently than their predecessors, in addition to being visually distinctive and uniquely appealing even when they're together as a group.

With a story set to move beyond Pandora and introduce new societies, species, and villains, the team knew that they'd have the opportunity to push the sheer variety of the character roster even further this time. This made it more important than ever that the game's universe be coherent, requiring its designers to adhere to a unified, consistent art style.

When earlier *Borderlands* games were in development, it was common for a particular concept artist to take ownership of a character, carrying them from inception to their final incarnation with only limited input from a handful of other people. This time around, Art Director Scott Kester was eager to try a more collaborative approach:

"Back in the day, people decided to go make a character, and it just went forward. Now, I'm actually stepping back as a director and saying, 'Hey, this drawing isn't quite working out. Let's see what this other artist can do with this same character.' Everybody's going to look at it a little differently, right? I'm not a director that goes, here's seven hundred pieces of reference to create one character. I like to point to a handful of things and see people's interpretation of it."

Lead Character Artist Kevin Penrod agrees: "Our concept process is a lot more refined just because, I think, we know what we're doing now and we have more time to dedicate to doing concepts. As far as the modeling and sculpting side, it's fairly similar to what other games would do. We just have

a kind of chunkier style, focusing on the silhouette of the characters. That texturing style is what probably confuses most people. They think it's some kind of material trickery that we're doing, where actually an artist is painfully just inking a character for maybe a week, and then we'll move into doing the actual color work."

Only once it's complete will software techniques be used to augment the character with the game's distinctive outline, a process that Penrod is keen to stress is very different from the process known as traditional "cel-shading." Many of the character sketches in this chapter are the result of multiple artists from different disciplines working in tandem, iterating and spinning off one another's ideas.

Looking beyond the Vault Hunters, every NPC (non-player character) needed to be revisited and refined to take advantage of the powerful hardware and, in many cases, 4K displays in new-model consoles. Kester notes that one huge advantage of the added visual fidelity is that characters can enjoy a finer level of detail, from the trinkets around their necks to the way they fidget and move after being animated. These granular changes, along with the ways that *Borderlands*' art style allows for some freedom of shape and proportions, all help players get an instant read on a character's personality, even when they're just loafing around.

All told, *Borderlands 3* features a huge, diverse cast of over one hundred characters spread across multiple worlds. Many are new, but as is *Borderlands* tradition, some beloved favorites are making a return and will continue their personal journeys. Beginning with the Vault Hunters, this chapter will take a closer look at the genesis of all-new characters, the evolution of familiar faces, and the design process that helped bring these many friends and foes to life.

OPPOSITE: Moze, the Gunner.

AMARA
(SIREN)

With the legacies of Lilith and Maya scorched across the surface of Pandora after the events of *Borderlands 2*, any bandits unlucky enough to cross paths with a Siren might well dive into combat anticipating bouts of invisibility, explosions of fiery energy, and other superhuman trickery. What they probably wouldn't be expecting is a savage pummeling from a flurry of phased fists—but then, Amara's no ordinary Siren.

From the earliest days of development, Concept Artist Amanda Christensen had a strong vision for a very different kind of Vault Hunter to succeed the petite, range-focused Sirens that had come before. Originally nicknamed "Beef Siren" and later called the "Phasezerker," Amara was intended as a character who would play far more physically and carry a real sense of impact with her special abilities. She would also inherit the intricate web of tattoos common to all Sirens, though the team worked carefully to ensure that her relatively revealing outfit came across as practical rather than sexualized and was clothing that worked to enhance her personality rather than distract from it.

"Basically," Christensen explains, "I was like, what if we had a Super Saiyan, with that kind of energy and confidence? That [physicality] carries all the way into her attacks, with things like Amara's Phaseslam move and punches with multiple fists." It was equally important, though, that this new Siren maintain a sense of elegance and grace rather than being a rough-and-tumble brawler like *Borderlands*' Brick.

To strike this balance, the team looked toward Eastern martial arts influences to help craft an aura that can be considered "Zen destruction." The magical effects that accompany a Siren's assault likewise add to Amara's formidable appearance. While Lilith's energy manifests as a pair of wings, Amara surrounds herself with a plethora of ghostly appendages reminiscent of the Hindu goddess Kali, which help embody her attitude even when they're not being used to knock enemy heads together.

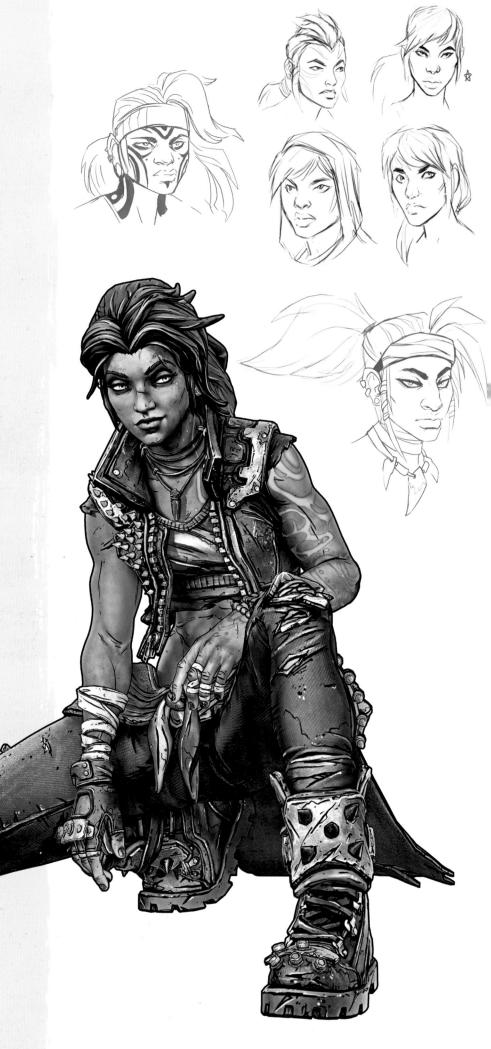

TOP: The first facial designs for Amara were highly symmetrical, with *Borderlands*' class mods suggested as a way to add in asymmetrical detail.

RIGHT: A final render of Amara.

OPPOSITE: Early explorations of Amara's physique and different fighting styles, including bladed weapons and siren energy blasts.

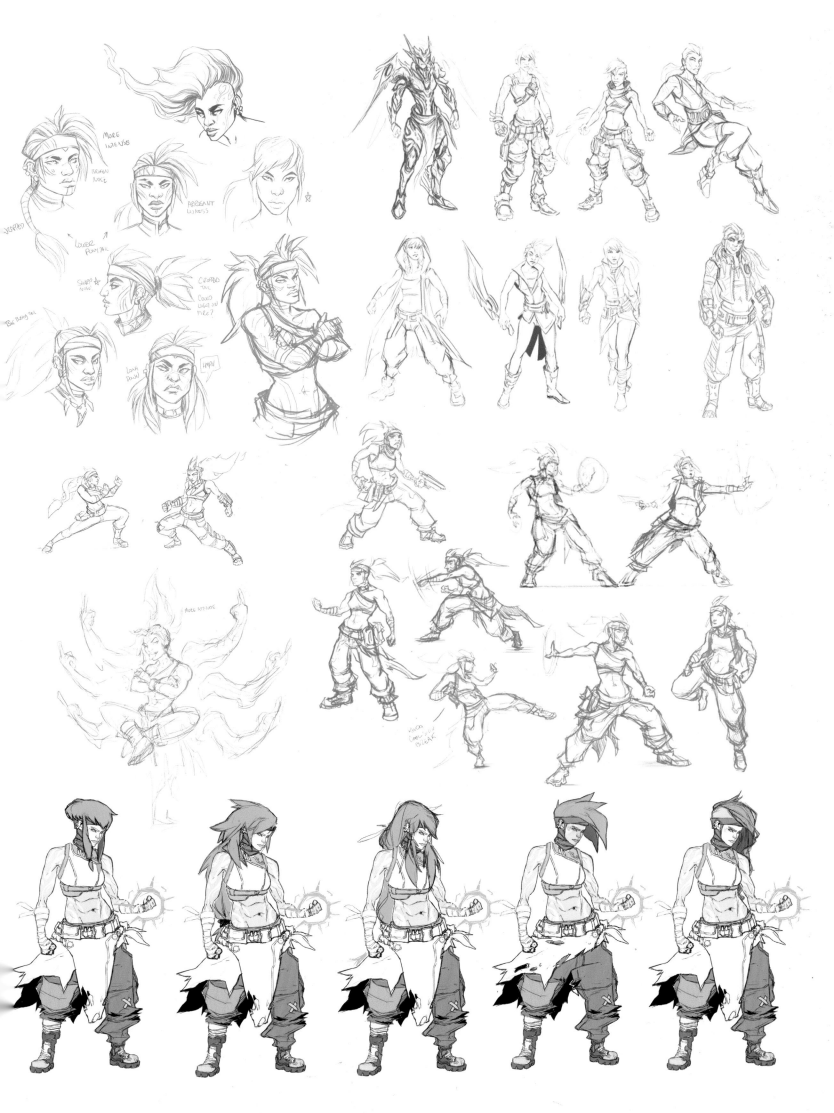

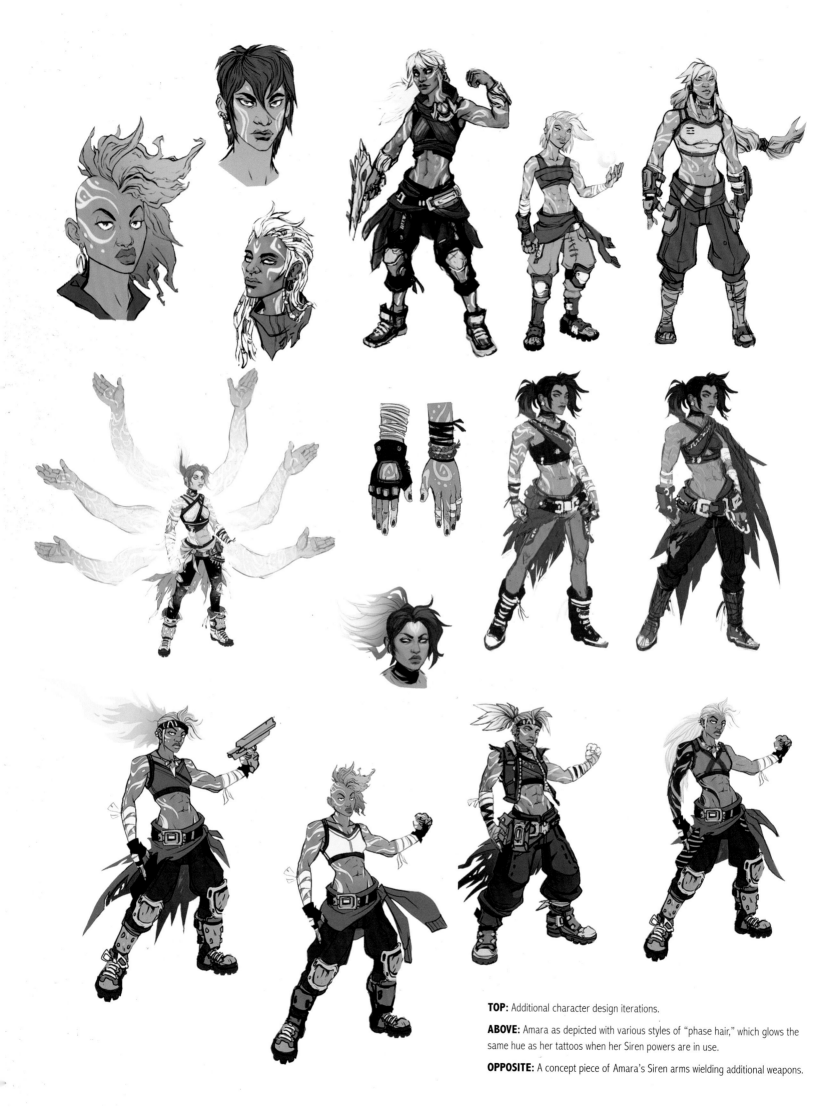

TOP: Additional character design iterations.

ABOVE: Amara as depicted with various styles of "phase hair," which glows the same hue as her tattoos when her Siren powers are in use.

OPPOSITE: A concept piece of Amara's Siren arms wielding additional weapons.

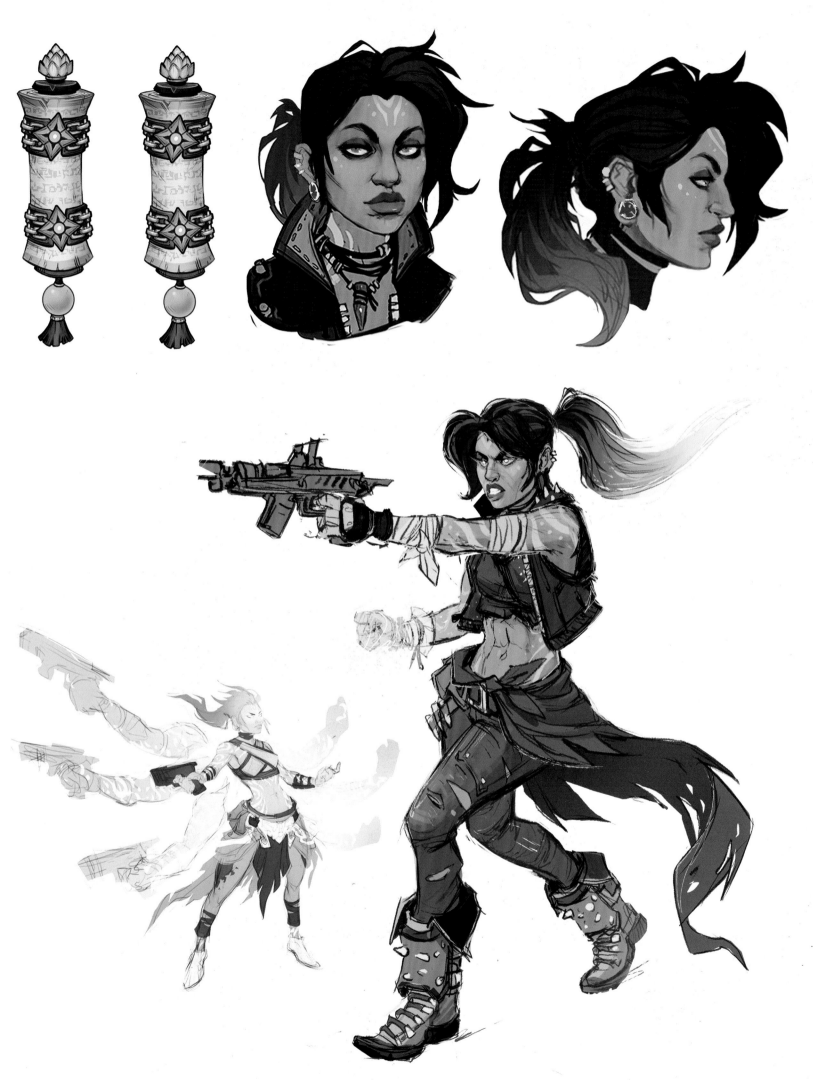

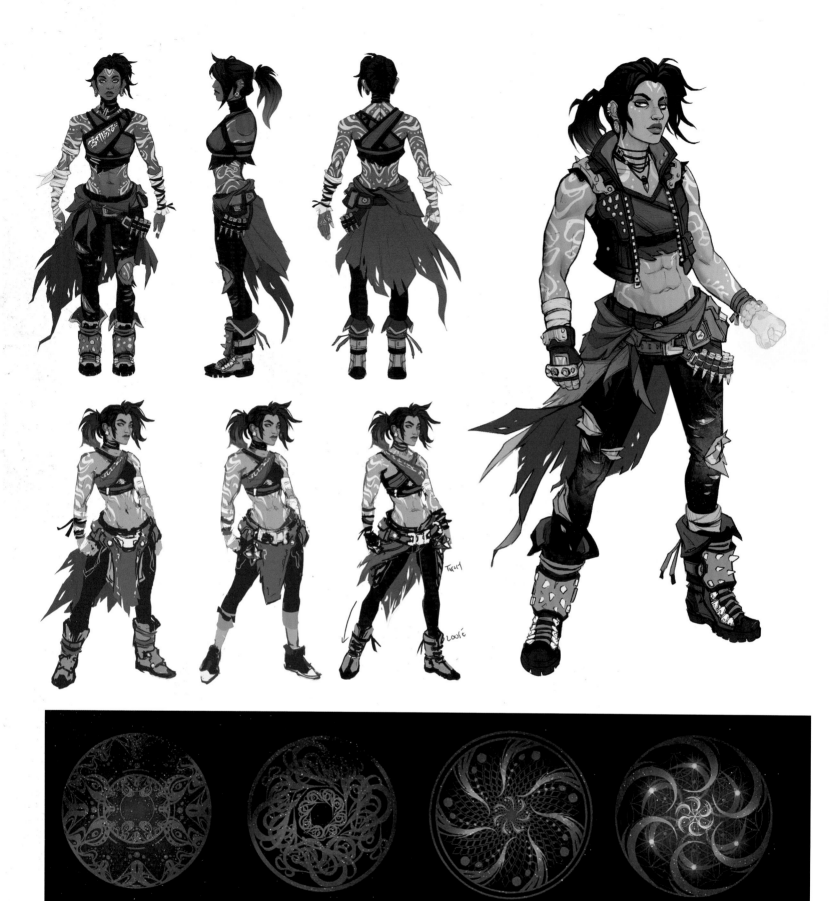

TOP: Variations on Amara's outfit saw the addition of her sturdy jacket, more wear added to the wrap around her waist, and several different shoe designs.

ABOVE: A selection of potential visual effect patterns for the vortex that appears behind Amara when she's employing her Siren abilities.

OPPOSITE: Amara's final design incorporates elements from many different iterations. Her pendant was imagined as a vial of water from her home world.

14

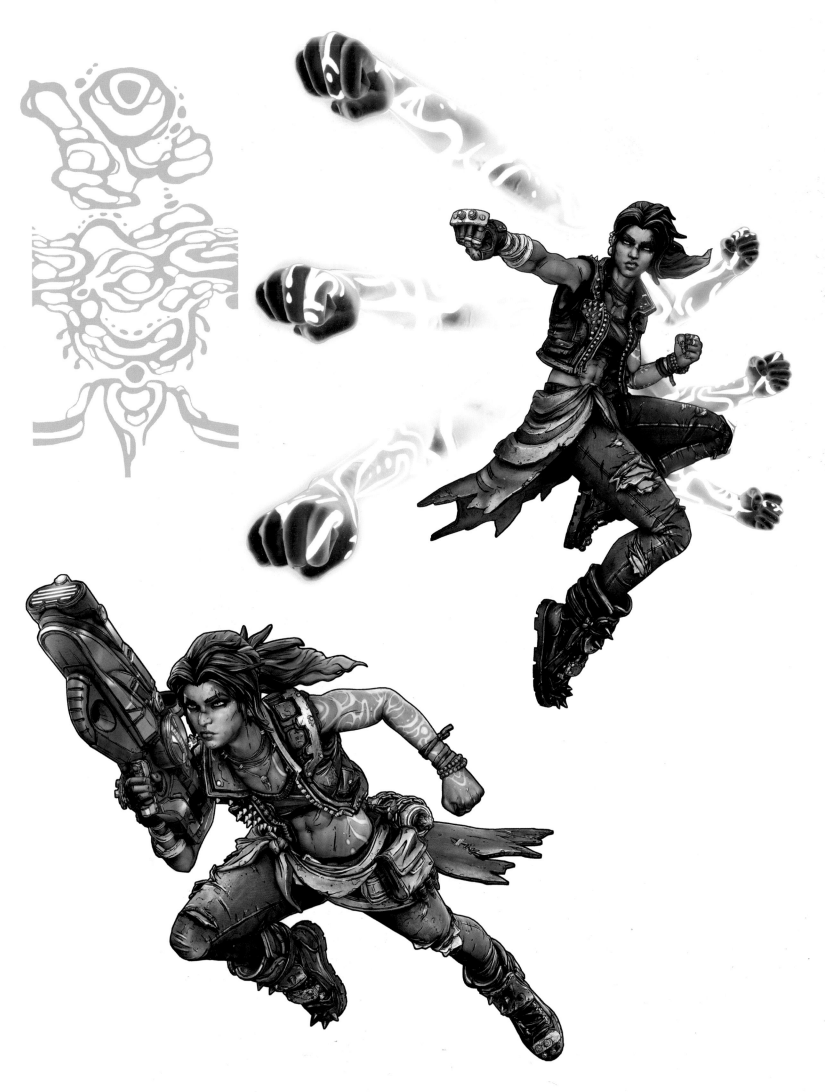

FL4K
(BEASTMASTER)

FL4K, an enigmatic Vault Hunter with a deep affinity for nature, has a history that's as strange and surprising as the augmented animals who fight at the player's side. As these early images show, a robotic Beastmaster was only one of many possible designs that the team explored during development.

Several early variants depicted the character as almost a woodland native: a cowled figure, lithe and mysterious like a high-tech Robin Hood. This path of exploration led to a series of images in which the Beastmaster not only tamed the animals, but also absorbed elements of their genetic makeup, becoming more mutated and bestial as the design underwent further iterations. Ultimately, this incarnation was considered to have too much of a fantasy aesthetic and was put aside.

Throughout the exploration phase, Art Director Scott Kester remained adamant that a robot would resonate with players: "Some people weren't fans of the character, but to me the Beastmaster was my oddity. I say I'm always allowed an oddity. Brick was sort of the oddity in the first game, but more [because the] scale of his body was so ridiculous and huge—he was still a human.

"For *Borderlands 2*, I fought really hard for Zer0 because as a child of the '80s, growing up with Storm Shadow and Snake Eyes [from *G. I. Joe*], I said, 'I have to have a character like that.' Zer0's character was met with some opposition and almost didn't exist. [FL4K's concept] might be 'Anime 101,' but I thought a robot that loves animals is way stickier of a thing than a human that loves animals, you know?"

Once FL4K's artificial nature had been settled upon, more work was done to find a suitable costume for a character who doesn't *really* need to wear clothes at all. In their final form, a tough, bulky outfit ideal for the wilderness helps disguise the Beastmaster's appearance and keeps FL4K's true identity suitably ambiguous.

RIGHT: A final render of FL4K.

TOP AND OPPOSITE TOP: Concept sketches for an elf-like Beastmaster. While these designs are drastically different from FL4K's final form, the hood shown here persisted to the finished design.

OPPOSITE BOTTOM: FL4K is depicted with a digital display—complete with emoticons—instead of a physical face, much like the enigmatic assassin Zer0.

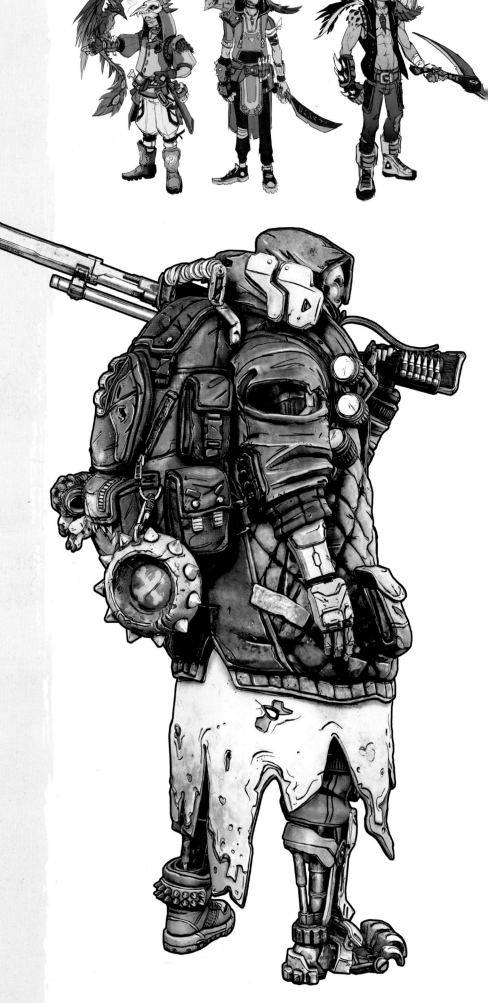

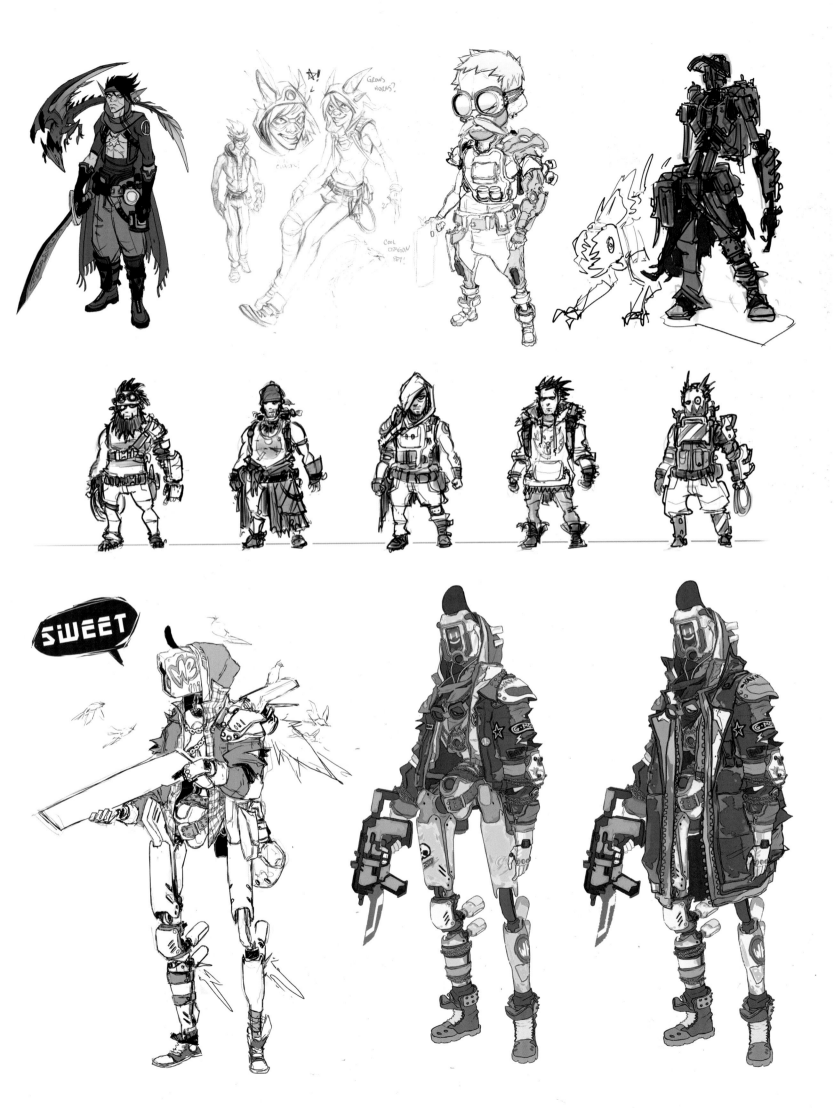

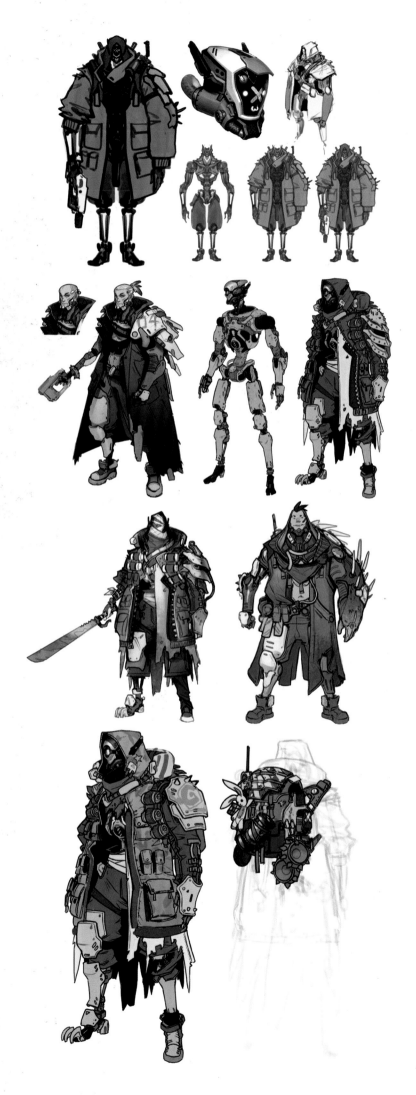
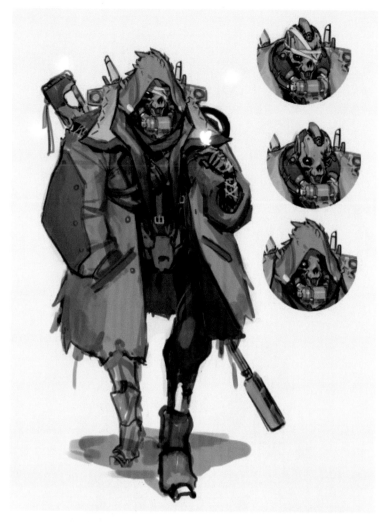
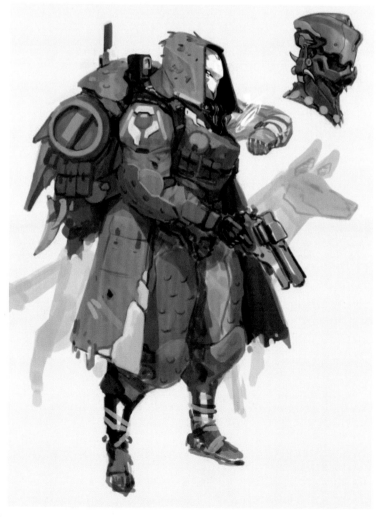

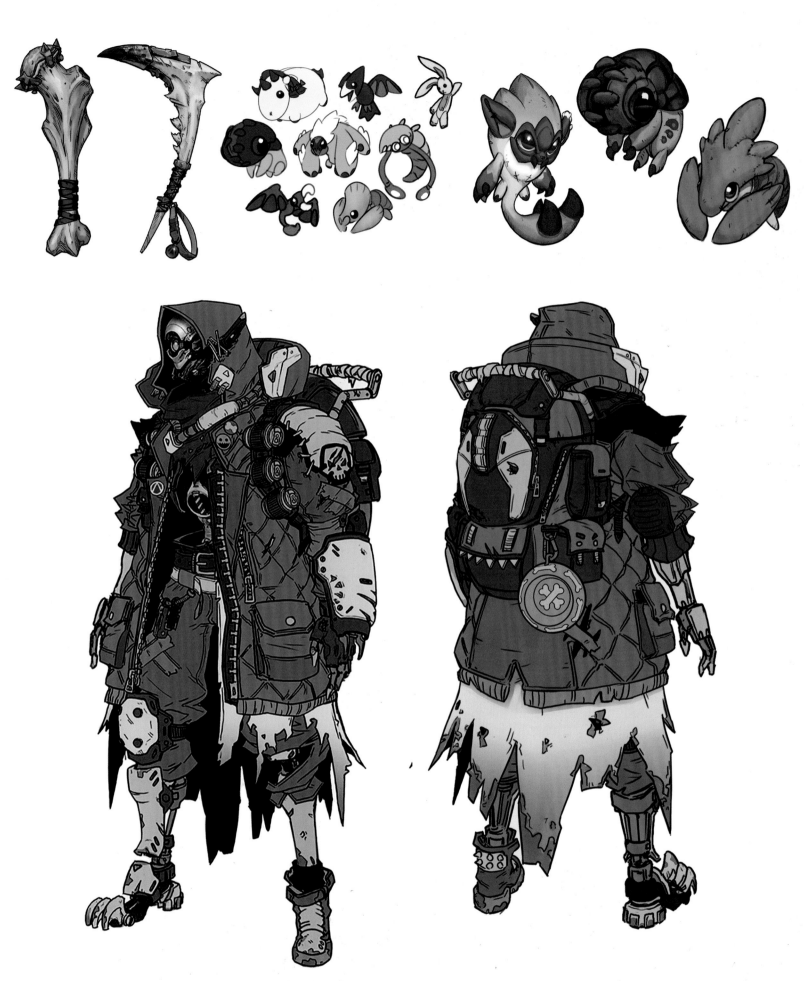

OPPOSITE LEFT: Different body types for the Beastmaster, ranging from brawny humanoid figures to slender robotic forms. The oversized coat provides heft and presence as well as ambiguity.

OPPOSITE RIGHT: A version of FL4K with an intimidating skull-like head.

TOP: A collection of cute stuffed animal designs intended to adorn FL4K's backpack. Murderous alien predators have never looked so huggable.

ABOVE: The final Beastmaster design.

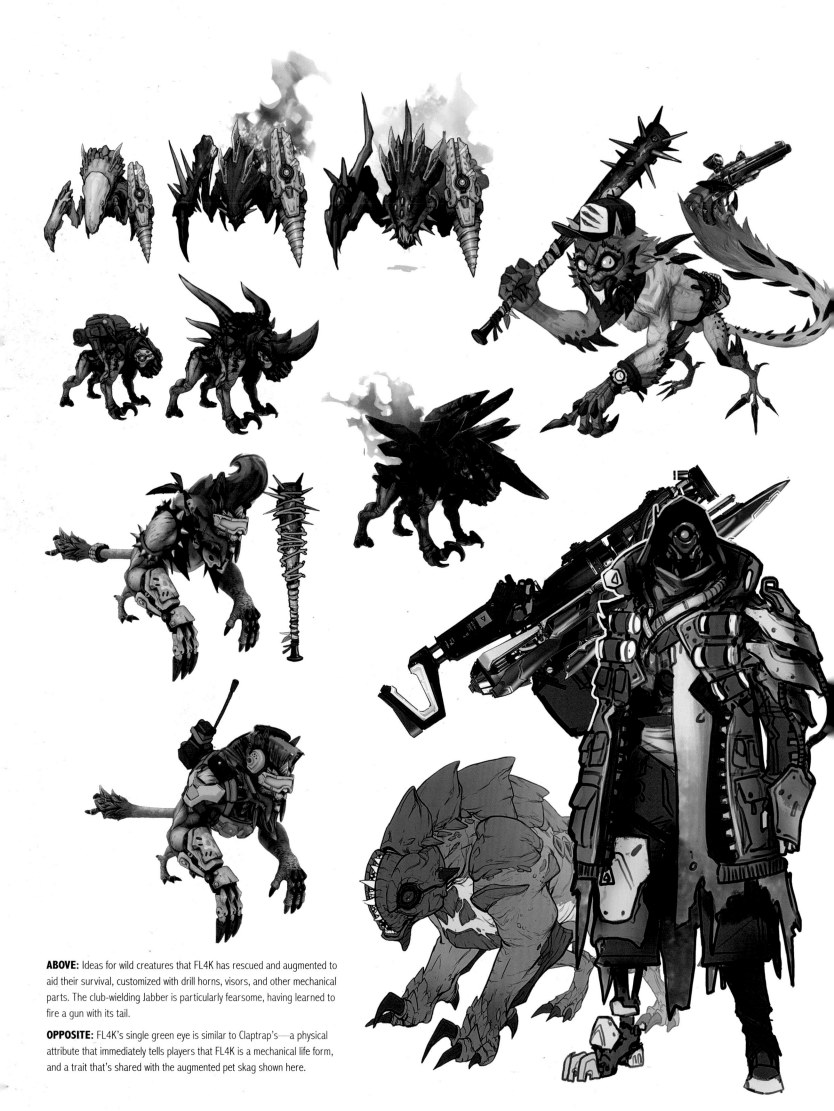

ABOVE: Ideas for wild creatures that FL4K has rescued and augmented to aid their survival, customized with drill horns, visors, and other mechanical parts. The club-wielding Jabber is particularly fearsome, having learned to fire a gun with its tail.

OPPOSITE: FL4K's single green eye is similar to Claptrap's—a physical attribute that immediately tells players that FL4K is a mechanical life form, and a trait that's shared with the augmented pet skag shown here.

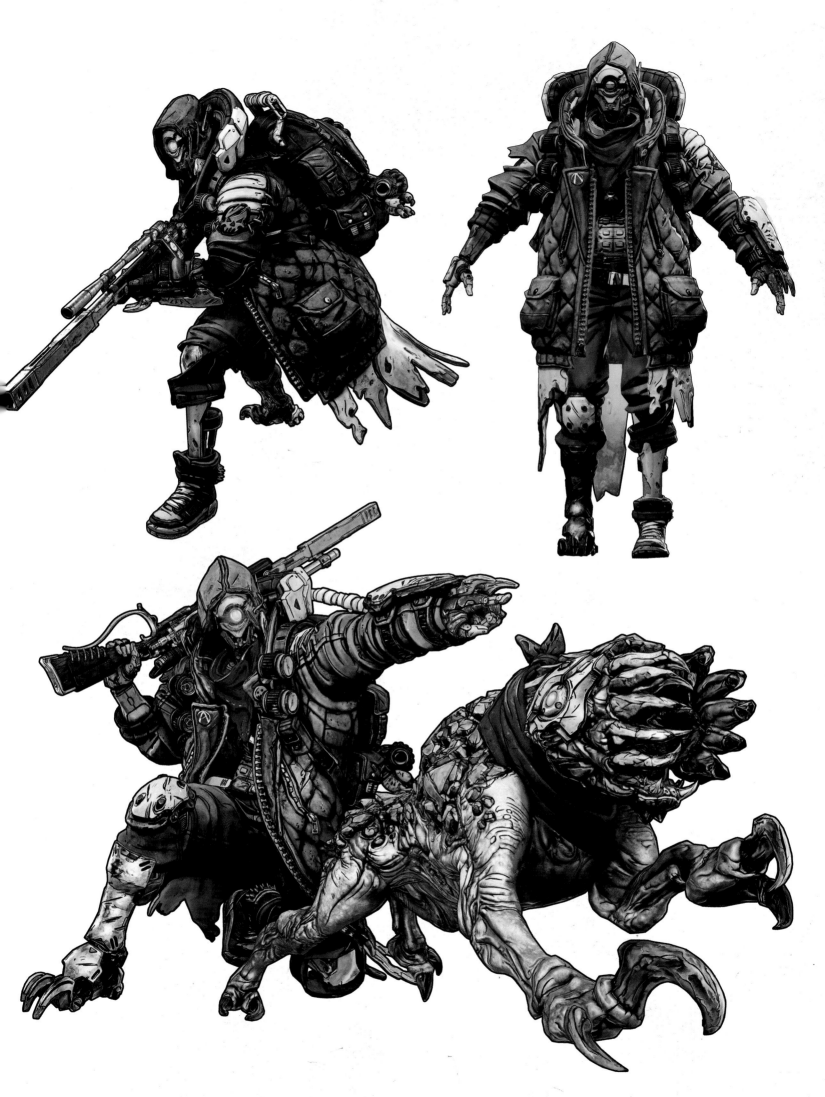

MOZE
(GUNNER)

As you'd expect in a world where corporations offer firearms via handy vending machines, weapons are a key part of life in the *Borderlands* universe, so it's no surprise that the character artists turned their attentions to their new Gunner early on. Moze may look physically unassuming compared to her fellow Vault Hunters, but she's a practiced sharpshooter with an extensive arsenal at her disposal—and most of it's attached to her best mechanical buddy, Iron Bear.

Making the call to give Moze her own personal mech had a significant impact on how the rest of the game evolved. The decision helped the team to understand how best to push the limits of how unusual and diverse the core characters of *Borderlands 3* could be, in turn encouraging bold choices to ensure that players would be surprised by the latest group of Vault Hunters and their abilities.

Elsewhere, Iron Bear's introduction meant that other issues had to be anticipated and planned for. Each and every doorway, for example, needed to be large enough to readily accommodate its hulking frame, which worked out to be almost twice the size of Moze herself. Because the intention was that Iron Bear would continue to wield whatever weapon Moze had been using, the team grappled with how to handle the switch. Lead Weapons Artist Jimmy Barnett explains:

"Early on you had to still be able to use your player gun inside Iron Bear. Somehow you had to either have your arms sticking out of it still holding your gun, or the robot had to hold the gun once you were in it. You'd throw your player on up, and then Iron Bear would have your gun outside the cockpit and its bigger arms would have what you spec into in your talent tree. So obviously, you can see how it would quickly become overcomplicated. That went through quite a lot of design. Iron Bear actually still has that pair of tiny arms that fold up, and are now forever folded away."

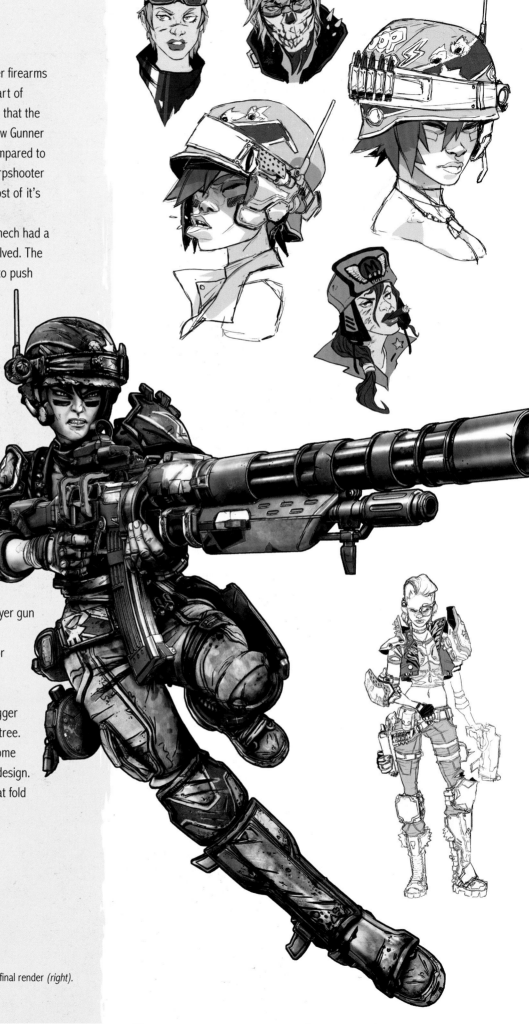

THESE PAGES: Early concept sketches for Moze, as well as a final render *(right)*.

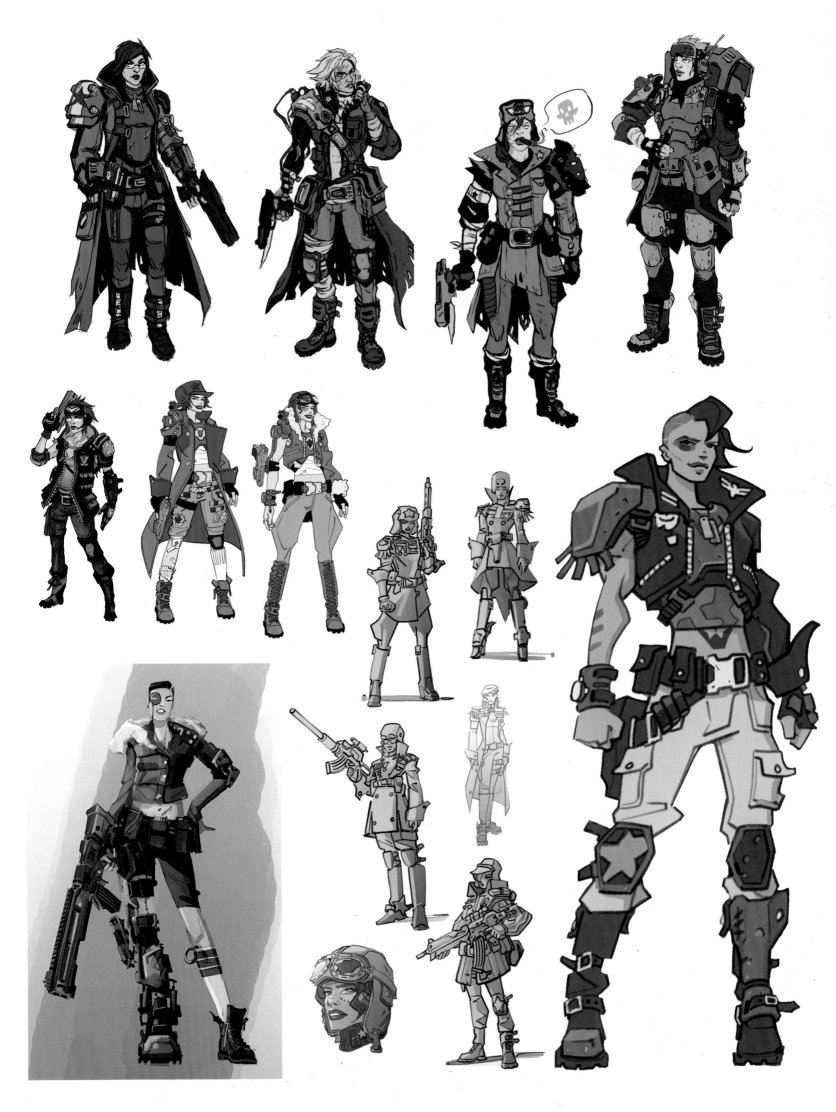

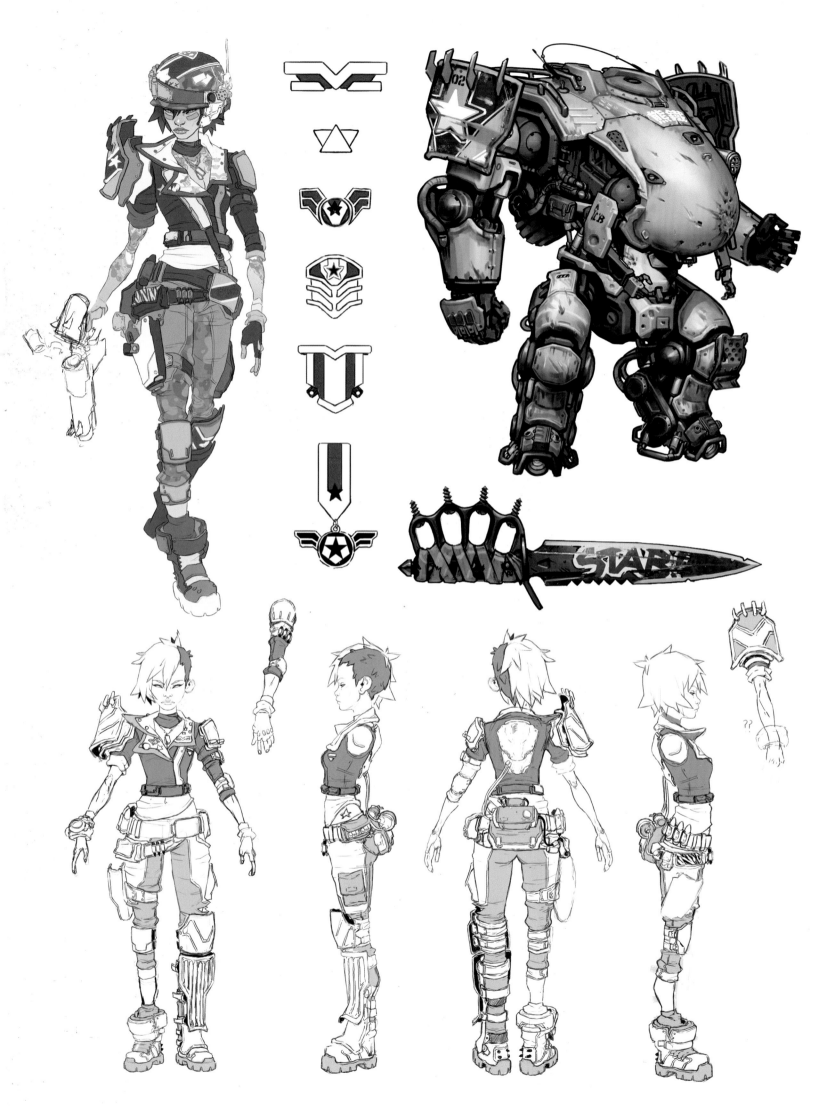

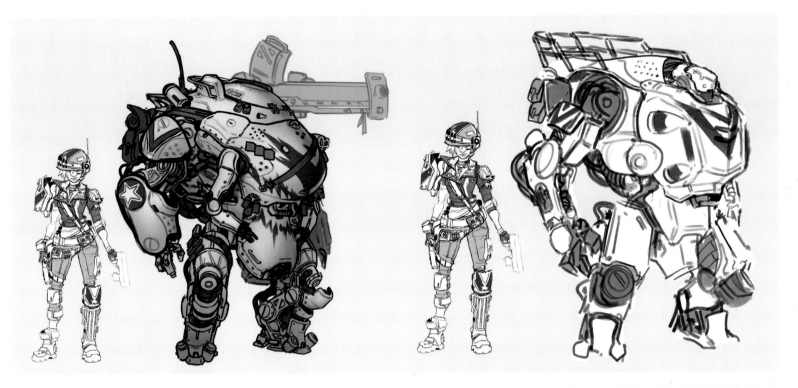

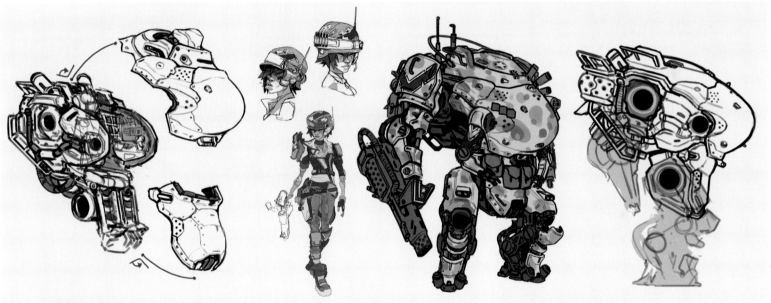

OPPOSITE TOP: Explorations of different insignia that would be shared by Moze and Iron Bear. The five-pointed star used in their final designs appears in several of the sketches. Also shown is a customized combat knife that carries its own instructions.

OPPOSITE BOTTOM: In-progress sketches of Moze offer a glimpse of the hairstyle normally hidden by her helmet. Even at this stage, many of Moze's signature elements, such as her asymmetrical shoulder pads, are in place.

ABOVE: Early sketches of a slightly smaller Iron Bear as compared to Moze, with a single color used as a highlight. A shoulder-mounted cannon is also visible.

RIGHT: Several names for Iron Bear were proposed by the team during development, including BORIS— Battle Operations Robot Integrated System.

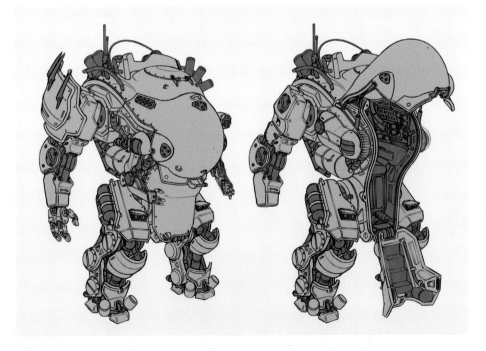

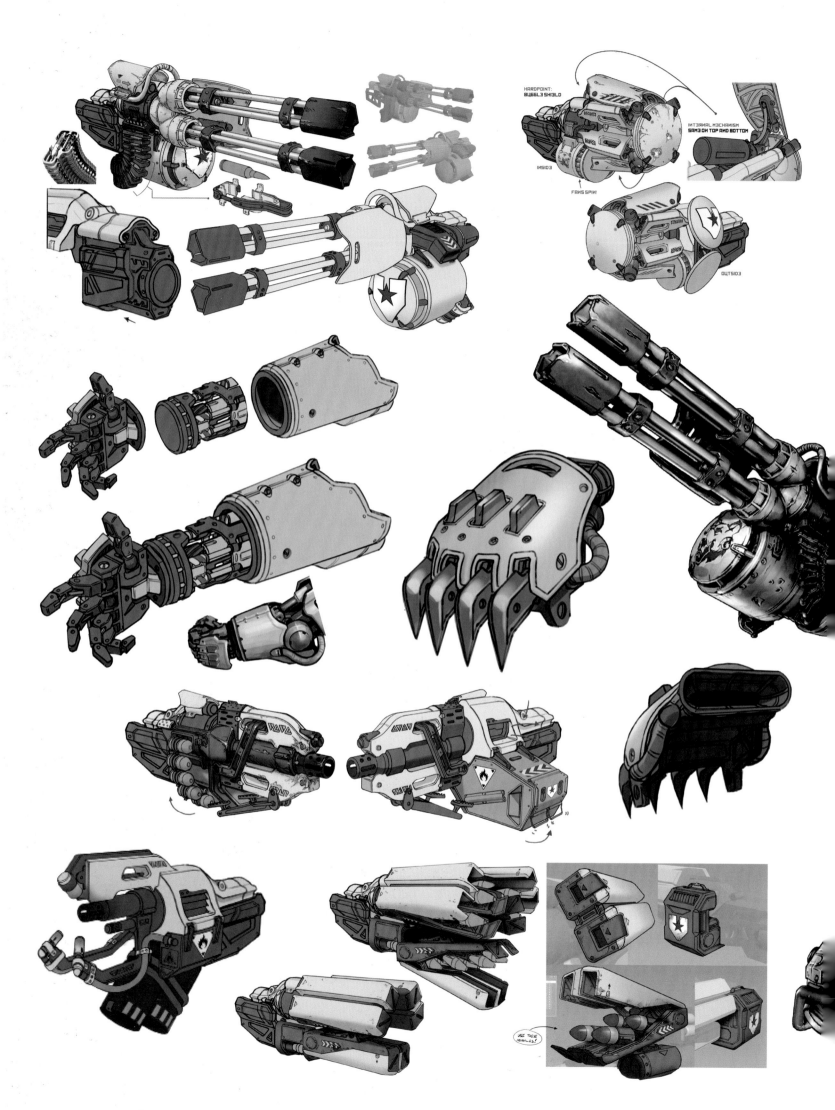

OPPOSITE: Iron Bear was designed to be extremely modular and upgradable, wielding different weapons depending on how skill points are spent. These pieces offer a detailed look at those weapons, which include a minigun and grenade launcher as well as fists and claws.

BELOW: Moze perched atop Iron Bear, both sporting their final designs.

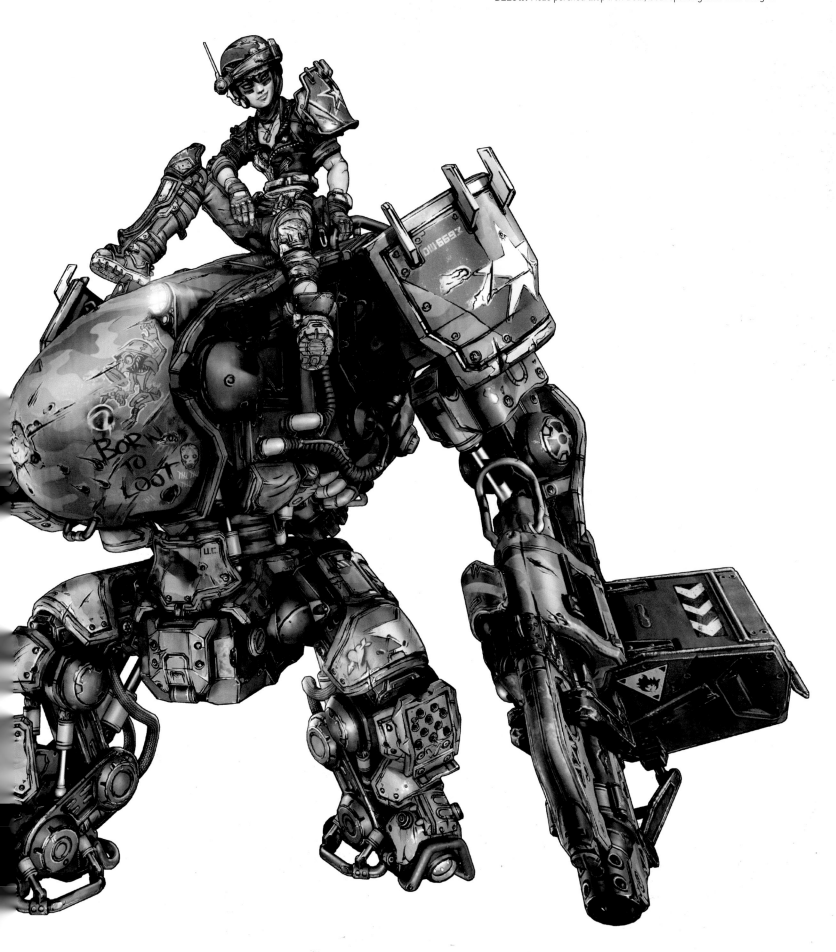

ZANE
(OPERATIVE)

Each character's journey during the early stages of development is unique, and there's no set path to success. Sometimes finding the perfect look and feel for a character involves several rounds of re-creation and refinement before lightning finally strikes.

Such was the case with Zane, the game's Operative. He was first conceived as more of a duelist: a suave, dapper sharpshooter in a fancy suit who channeled the sophistication and style of an outer-space secret agent or hit man, though Art Director Scott Kester recalls that this early idea soon evolved into more of a Wild West gunslinger.

"They wanted a James Bond character. I love John Wick, but John Wick doesn't really fit in our universe," Kester says. "And to really sell the promise of a John Wick character, it almost needs to be a third-person game, in my opinion. So we tried tactical things like trench coats, and at the time he was a Jakobs sort of dude. So I thought, 'Let's do gadgets, like a James Bond cowboy, right? Extra robotic arms, holding extra guns, all that kind of stuff.'"

Many different versions of the classic cowboy were explored, including details like ponchos and eye patches, before the concept team moved toward a cybernetic look for Zane. Zane's abilities were increasingly focused on the use of technology to aid him during combat, and his appearance needed to reflect how he would play.

With the Operative relying more heavily on his gadgets and gizmos, the cowboy look was stripped away in favor of an older, more flamboyant character with a striking palette—one whose advanced technology was integrated seamlessly into his outfit. The team worked to incorporate design flourishes inspired by the rogues and renegades they most admired in other media, too. Zane's brown holster, for instance, is inspired by a certain smuggler known for his stellar Kessel Run performance.

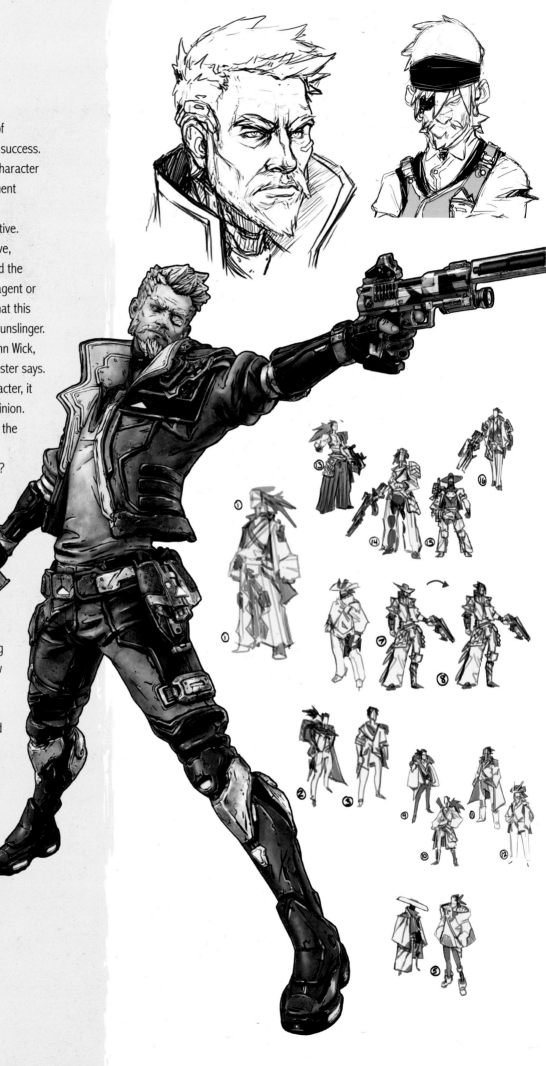

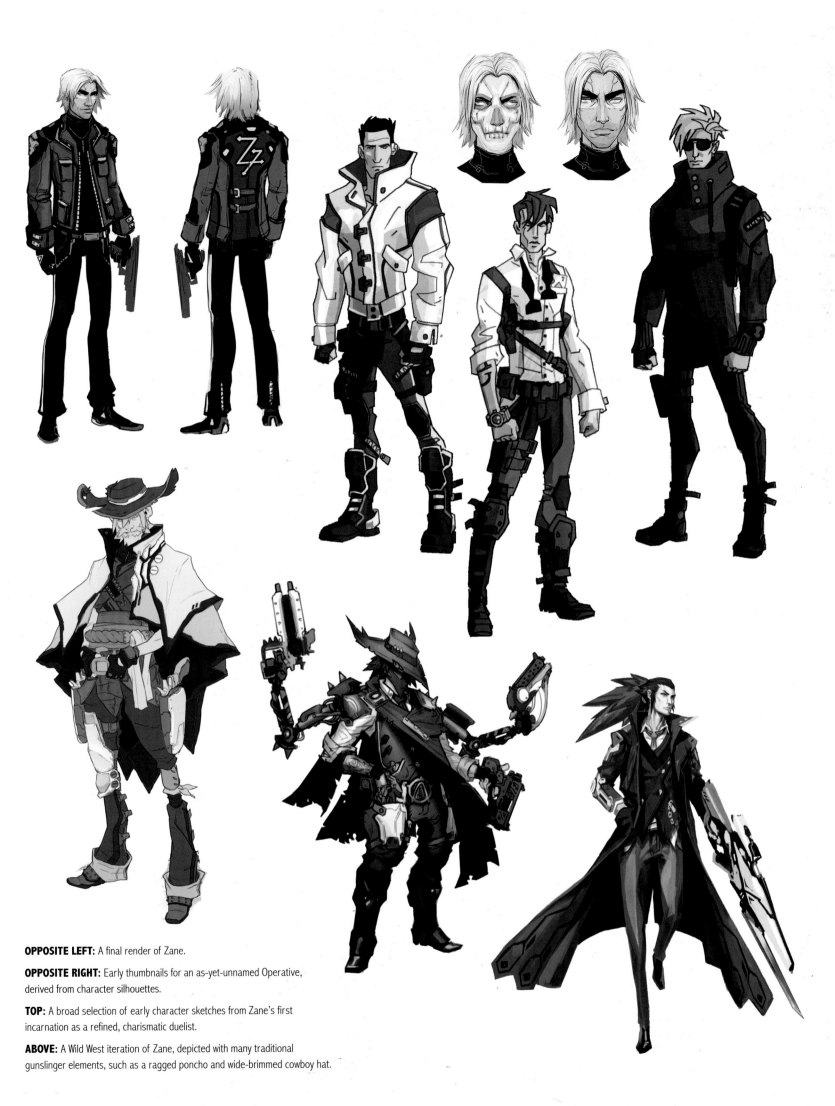

OPPOSITE LEFT: A final render of Zane.

OPPOSITE RIGHT: Early thumbnails for an as-yet-unnamed Operative, derived from character silhouettes.

TOP: A broad selection of early character sketches from Zane's first incarnation as a refined, charismatic duelist.

ABOVE: A Wild West iteration of Zane, depicted with many traditional gunslinger elements, such as a ragged poncho and wide-brimmed cowboy hat.

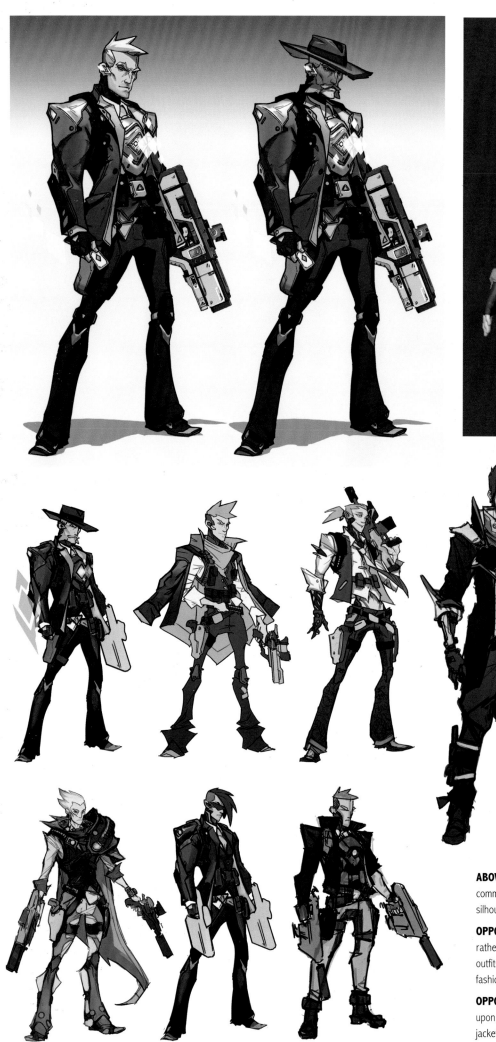

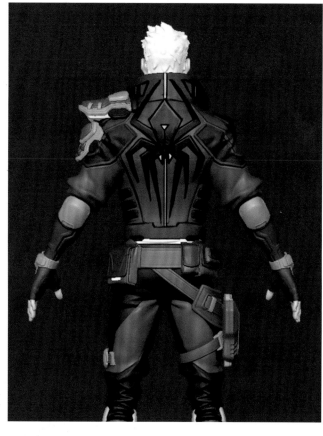

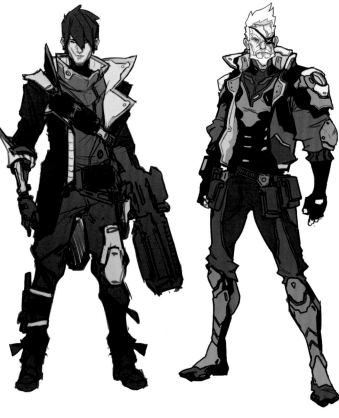

ABOVE: Although these Operative sketches have some elements in common, they explore a wide variety of personalities expressed through silhouette and style.

OPPOSITE TOP: Zane's pants are inspired by baggy samurai trousers rather than anything that would be worn while riding a horse. Earlier outfits pulled more heavily from East Asian influences, including a poncho fashioned from a kimono jacket.

OPPOSITE BOTTOM: With Zane's age and overall appearance decided upon, the next step was to move on to finer detailing, like the cut of his jacket collar and the sophistication of his eyepatch.

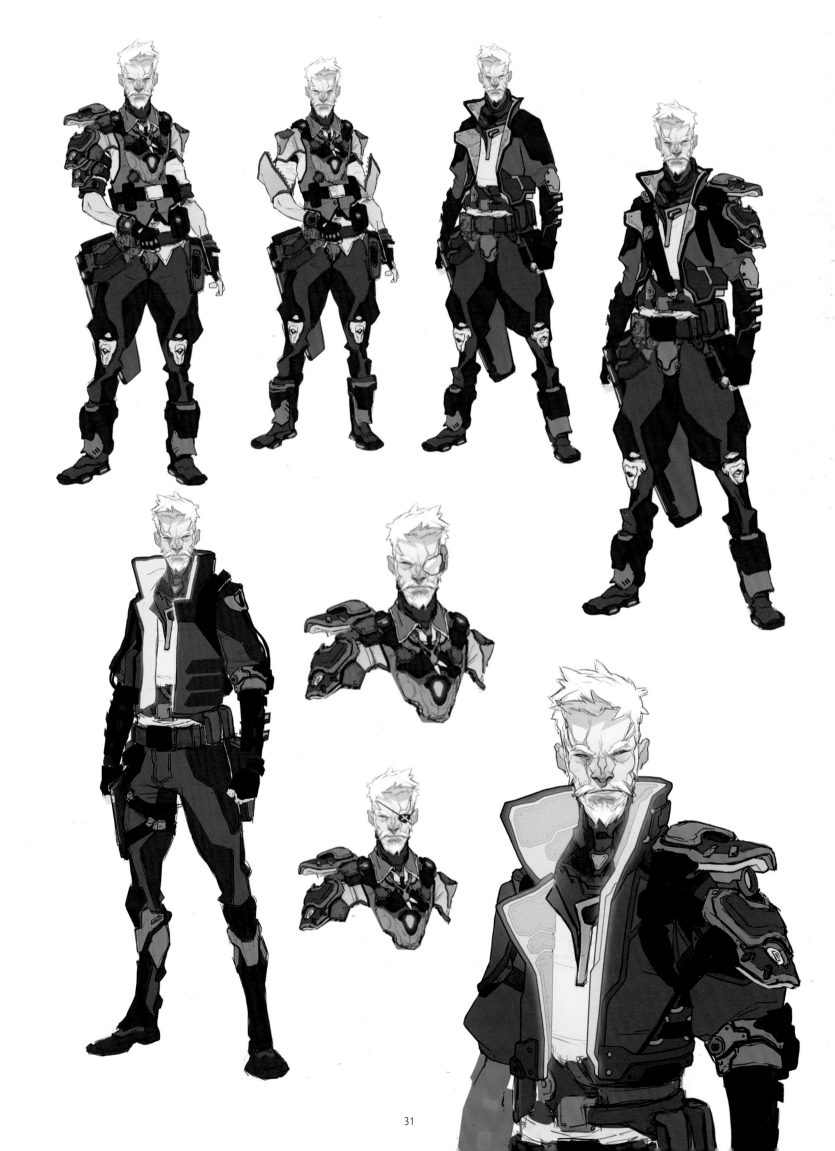

OPERATIVE DRONE

TOP

BOTTOM

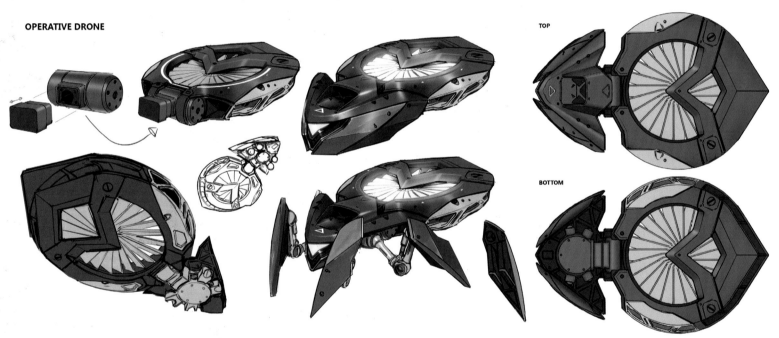

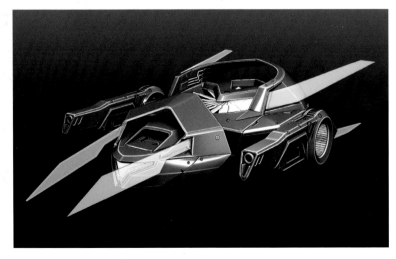

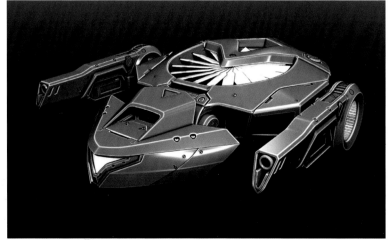

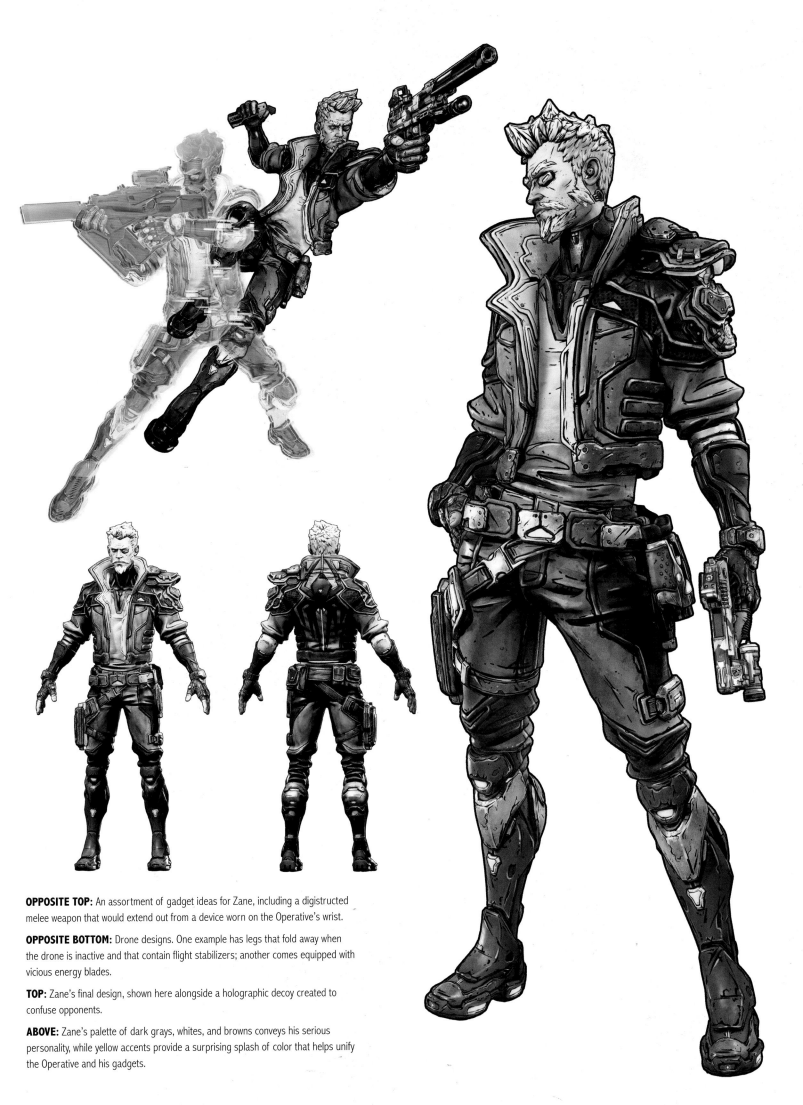

OPPOSITE TOP: An assortment of gadget ideas for Zane, including a digistructed melee weapon that would extend out from a device worn on the Operative's wrist.

OPPOSITE BOTTOM: Drone designs. One example has legs that fold away when the drone is inactive and that contain flight stabilizers; another comes equipped with vicious energy blades.

TOP: Zane's final design, shown here alongside a holographic decoy created to confuse opponents.

ABOVE: Zane's palette of dark grays, whites, and browns conveys his serious personality, while yellow accents provide a surprising splash of color that helps unify the Operative and his gadgets.

MARCUS

Marcus Kincaid has worn a lot of hats in his highly eventful life, having worked as a welcome guide, bus driver, arms merchant, part-time deity, and general fixer for the people of Pandora—at least that's the way he tells it in his campfire stories. He's the closest thing to a narrator that *Borderlands* has, and it's probably easiest just to take his word for it.

Though he may be as greedy as a house cat and as moral as a tree stump, Marcus does seem to have thrown his lot in alongside Lilith and the Crimson Raider ever since the demise of Handsome Jack in *Borderlands 2*. As such, he's on hand to greet Zane, Moze, Amara, and FL4K shortly after they're introduced and guide them toward their first mission—once the dust from the latest Children of the Vault (CoV) assault has settled, that is.

Marcus's design retains many of the elements from his previous appearances, allowing him to serve as a familiar touchstone for returning players. It's always nice to see a friendly face and to know that Marcus is firmly on your side, as long as you're the biggest spender in the room.

TOP: A handful of sketches suggest that Marcus may have lost an eye at some point after *Tales from the Borderlands*.

RIGHT: A noticeably stouter Marcus, with a large coat and fuller beard, was considered, but these designs were ultimately determined to be too much of a departure for the character. The final design shown here *(bottom right)* more closely resembles the Marcus players know and love.

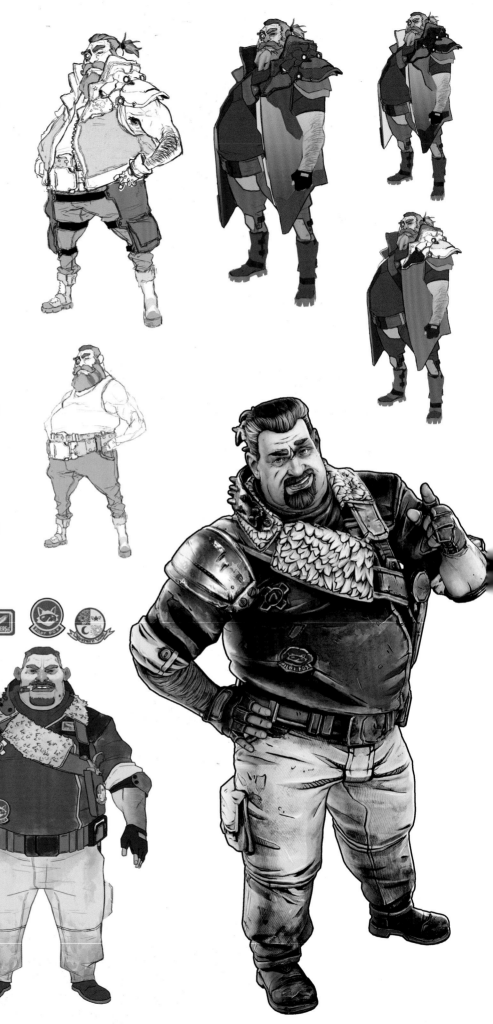

CLAPTRAP

Originally created by Hyperion as one of a number of general-purpose robot servants, Claptrap's irritating personality and eccentric behavior are the result of defective programming, years of damage and abuse, and involvement in some of the most significant incidents to take place in Pandora's eventful history.

While CL4P-TP model robots were once fairly commonplace, a remote upgrade designed to destroy Lilith's team of Vault Hunters caused this particular Claptrap to break its programming and incite a robotic revolution. Declaring himself to be an "Interplanetary Ninja Assassin Claptrap," the robotic rebel successfully revived a number of the Vault Hunters' deceased adversaries using salvaged parts from his broken buddies before taking command of a gigantic fighting machine built in his own battered image.

With Claptrap's plans for world domination foiled and his regime in ruins, things go from bad to worse when Handsome Jack exterminates the entire product line, leaving Claptrap the last of his kind. Having since been (mostly) reformed and with a stint as a Vault Hunter under his fan belt, Claptrap acts as a general lackey aboard the Vault Hunters' ship, *Sanctuary III*. One look at his tread-bare wheel and duct-taped antenna may suggest that this robot's better days are squarely behind him, but Claptrap remains as peppy and obnoxious as ever and is always ready to jump back into the fray. Just so long as it doesn't involve going up any stairs.

RIGHT: Claptrap's final design.

BOTTOM LEFT AND BOTTOM RIGHT: Early ideas for "Claptrap 3.0," showing various ways Claptrap might have upgraded himself prior to *Borderlands 3*. One example shows Claptrap's single tire replaced by tank treads; another imbues him with a larger, more human hand to replace his traditional pincers.

BOTTOM MIDDLE: An earlier design of Claptrap featured a prominent bullet hole.

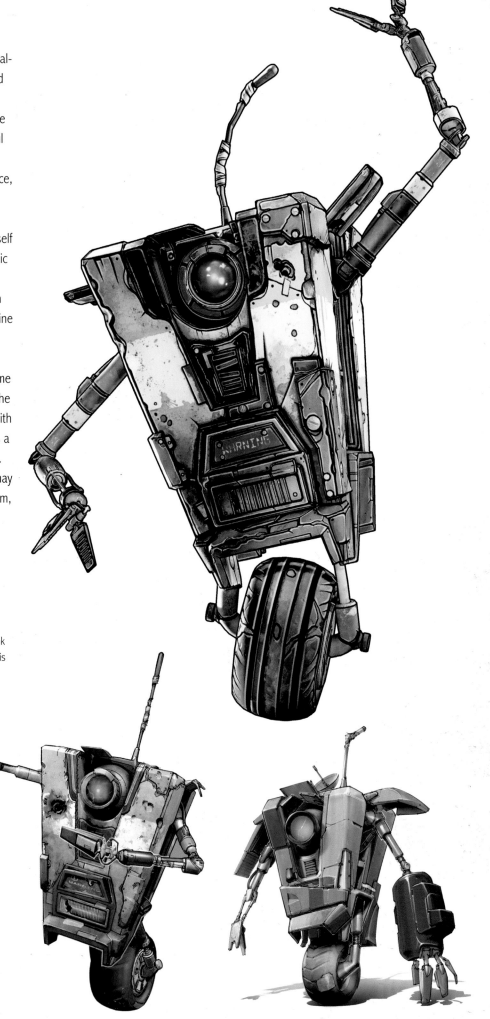

LILITH

A powerful Siren with an affinity for phasewalking among her foes unseen, Lilith was one of four Vault Hunters who arrived on Pandora seeking alien technology and became swept up in a corporate struggle that threatened to crack the planet wide open. Having helped defeat the Destroyer and avert a universal apocalypse, Lilith found her powers growing stronger with every passing day.

When she was briefly captured by Handsome Jack during the events of *Borderlands 2*, Lilith discovered she was now strong enough to rapidly charge a Vault Key, as well as teleport her friends to safety. Even with these newfound abilities at her disposal, Lilith elected to remain on Pandora after Roland's death and assume leadership of the Crimson Raiders in his name.

Unfortunately, Lilith's next visit to an Eridian Vault ends in tragedy. Left reeling from her fateful first encounter with Tyreen, one half of the Calypso Twins, Lilith finds herself adrift after her Siren abilities are stripped away. Managing Producer of Narrative Randy Varnell elaborates on the decision to bring Lilith crashing back down to earth:

"Lilith is a very central character, and she's faced with this conflict at the very beginning of the game. She's always been the massive Siren—she moved Sanctuary in *Borderlands 2*, she saved us all, and she's kept the gang together. Now we've created this arc [in *Borderlands 3* where] she's going to have to contend with and answer the question 'Am I a good leader because I was a superhero, or a good leader because I have the necessary character and leadership qualities?'"

While her appearance remains familiar to any *Borderlands* player, Lilith has reinforced her original casual clothing with a number of straps, pads, and pouches that help keep her combat-ready, no matter what the Calypso Twins might send her way. As shown in these concept sketches, the team also took the opportunity to revisit Lilith and explore other ways her outfit might be redesigned to suit an older, wiser Siren.

RIGHT: Lilith's power and confidence has increased since her arrival on Pandora back in the first *Borderlands*, and recent events have seen her become a respected leader.

TOP AND OPPOSITE TOP: A very different take on Lilith with a punky aesthetic, but the proportions of these concepts were determined to be too different from the original tall, willowy Siren of past titles.

OPPOSITE BOTTOM: Lilith's *Borderlands 3* outfit includes many familiar elements—visible tattoos, a short jacket, and heavy shin guards—but each individual part has been reconsidered and refined.

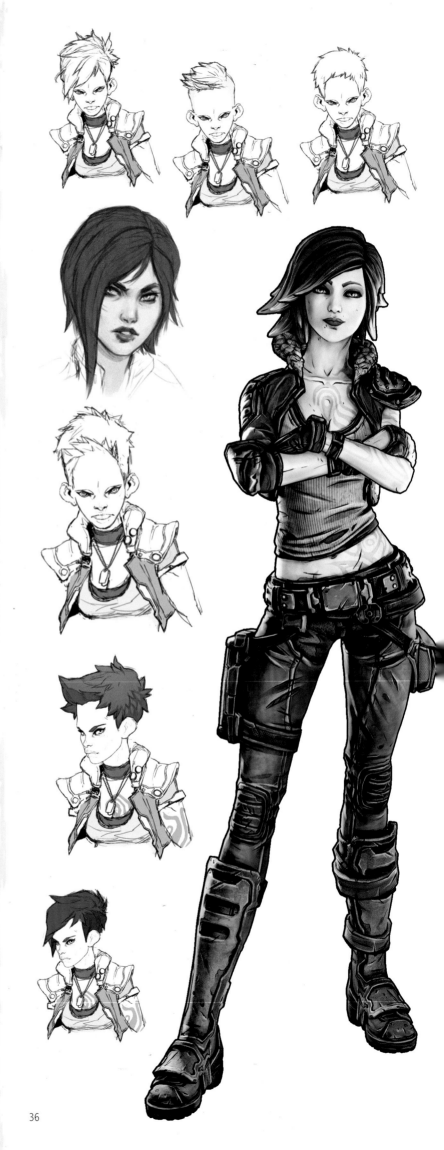

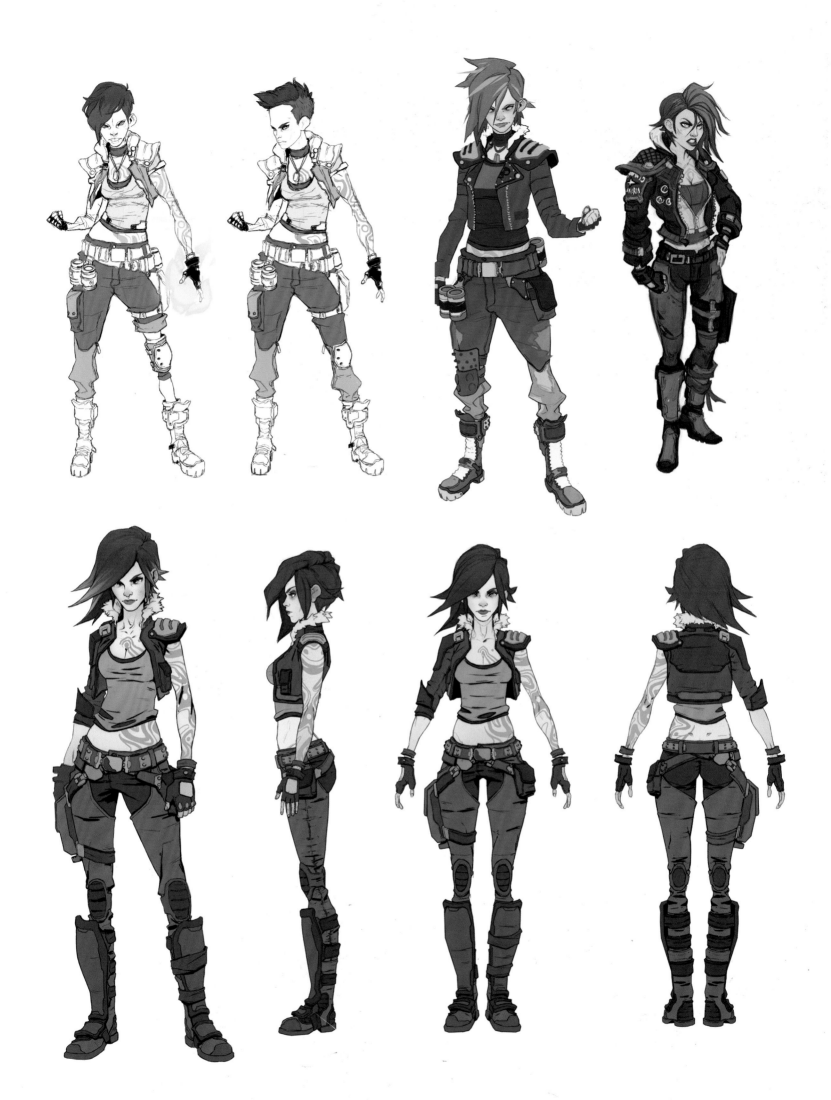

ZERO

One of four Vault Hunters introduced during *Borderlands 2* (and the personal favorite of *Borderlands 3*'s Art Director, Scott Kester), Zer0 is a formidable assassin whose portrayal pays homage to other masked, mysterious loners like *G. I. Joe*'s Snake Eyes and *Metal Gear*'s Gray Fox. Zer0's true identity remains a closely guarded secret, though observant fans will note that he possesses just four digits on each hand.

To make up for his lack of facial expressions, Zer0 seems content to make his feelings known by projecting old-school emoji and "txt msg" speak onto his faceplate, along with the occasional kanji character. This, coupled with the assassin's katana-like blade and his tendency to communicate his thoughts in haiku form, might suggest some kind of distant connection to Earth's East Asian region—then again, it could be that Zer0 just likes haiku and smiley faces.

Zer0's newfound ties to the Atlas Corporation will become clear to the Vault Hunters as they seek retribution against the Calypso Twins, but as these images show, he's clearly spent some time in consultation with his tailor. Zer0's upgraded costume augments the monochromatic leather of his outfit with a number of armored sections, additional pockets, and a large numeral zero on his chest, just in case you were having trouble picking him out of a crowd. The humanoid figures shown alongside his redesign are purely for comparison, rather than tacit confirmation of Zer0's true identity . . . we think.

RIGHT: As a stylish sci-fi assassin, Zer0 is deliberately clean and tidy compared to other characters in the series, with little evidence of wear and tear. But the team remained conscious of the need to keep the materials that make up Zer0's suit "grounded" within the *Borderlands* universe.

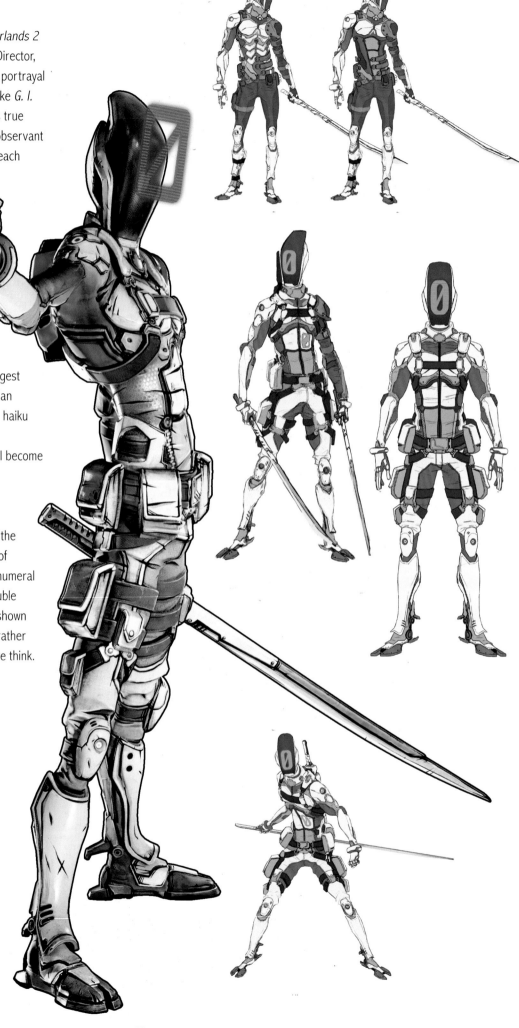

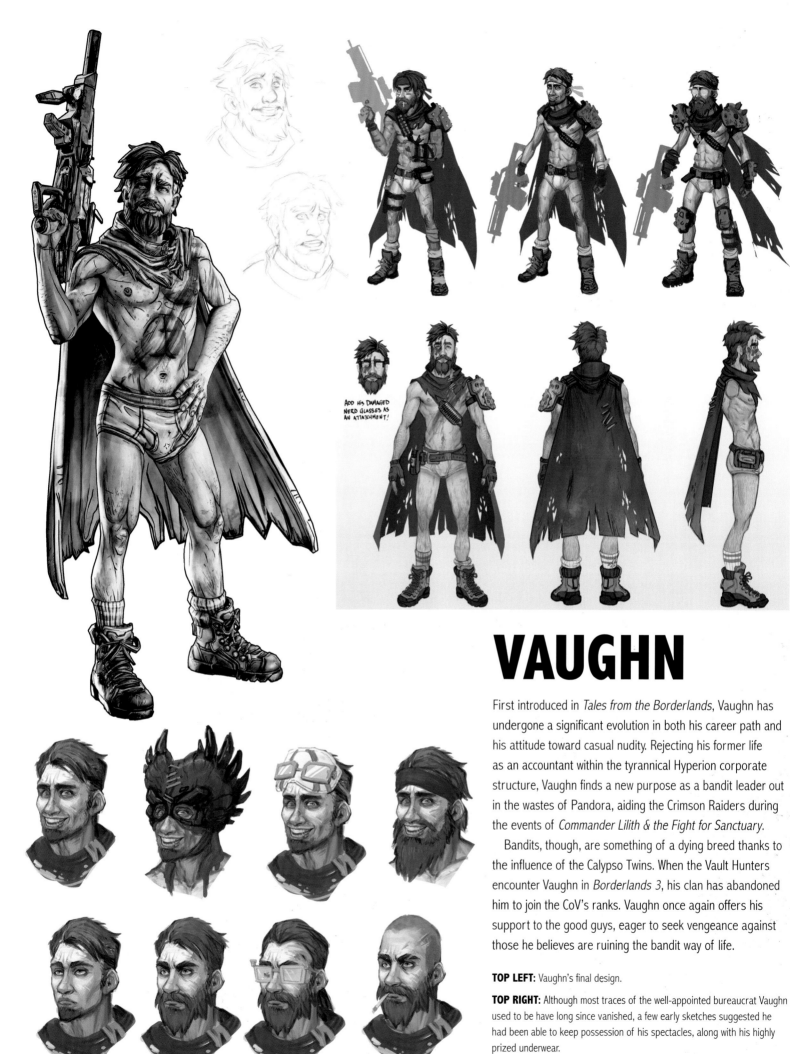

VAUGHN

First introduced in *Tales from the Borderlands*, Vaughn has undergone a significant evolution in both his career path and his attitude toward casual nudity. Rejecting his former life as an accountant within the tyrannical Hyperion corporate structure, Vaughn finds a new purpose as a bandit leader out in the wastes of Pandora, aiding the Crimson Raiders during the events of *Commander Lilith & the Fight for Sanctuary*.

Bandits, though, are something of a dying breed thanks to the influence of the Calypso Twins. When the Vault Hunters encounter Vaughn in *Borderlands 3*, his clan has abandoned him to join the CoV's ranks. Vaughn once again offers his support to the good guys, eager to seek vengeance against those he believes are ruining the bandit way of life.

TOP LEFT: Vaughn's final design.

TOP RIGHT: Although most traces of the well-appointed bureaucrat Vaughn used to be have long since vanished, a few early sketches suggested he had been able to keep possession of his spectacles, along with his highly prized underwear.

BOTTOM LEFT: Various iterations of Vaughn's facial design.

ADD HIS DAMAGED NERD GLASSES AS AN ATTACHMENT!

MAYA

It's not every day you choose to give up being revered as a religious icon, but that's precisely the decision Maya made when she left her home world of Athenas and, with it, the monastic order that worships her Siren abilities. The chance to explore Pandora's history and potentially learn more about her heritage may simply have been too tempting to pass up, although Handsome Jack's intervention at the beginning of *Borderlands 2* turned Maya's trip into much more of a firefight than a field trip.

By the time *Borderlands 3* begins, however, Maya has returned to Athenas. Having reconciled with the monks who once used her power for their own nefarious ends, she has now cultivated a bond with her apprentice, a young woman named Ava, though the arrival of a Maliwan blockade soon interferes with their pursuit of knowledge.

In *Borderlands 2*, Maya was designed in opposition to Lilith's more casual appearance; she wore a sleek combat suit and proudly displayed the Siren tattoos on her exposed left arm. Similarly, a book at her hip in place of a pistol hinted at a rather studious upbringing. Many elements of that outfit still remain, but the most striking addition to her ensemble is a large, ornate cloak lined in her trademark yellow. Her longer hair adds to her flowing, graceful appearance, though a few scuffs and tears about her person suggest that Maya hasn't given up her adventurous ways just yet.

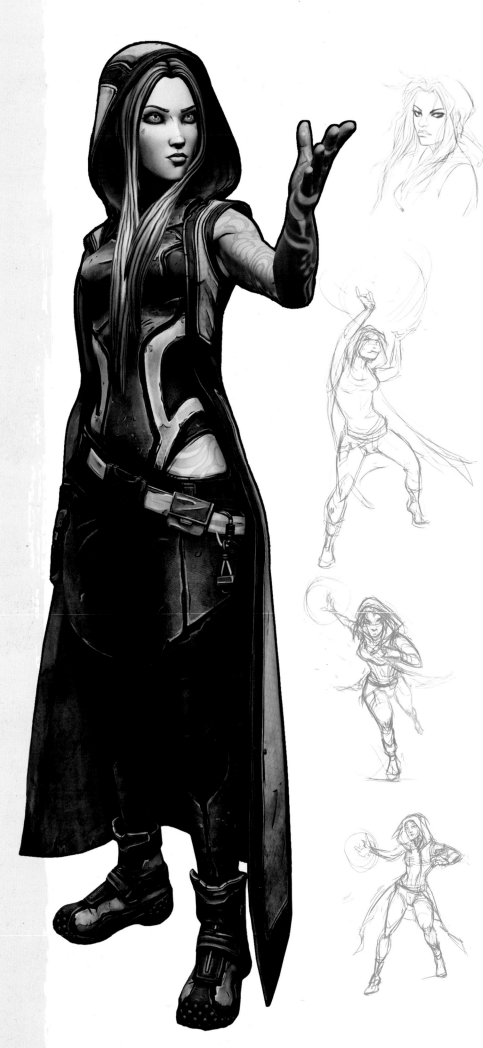

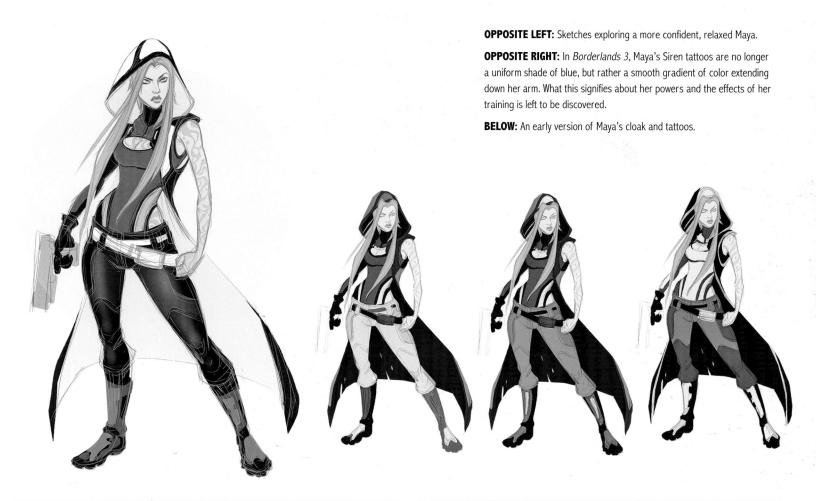

OPPOSITE LEFT: Sketches exploring a more confident, relaxed Maya.

OPPOSITE RIGHT: In *Borderlands 3*, Maya's Siren tattoos are no longer a uniform shade of blue, but rather a smooth gradient of color extending down her arm. What this signifies about her powers and the effects of her training is left to be discovered.

BELOW: An early version of Maya's cloak and tattoos.

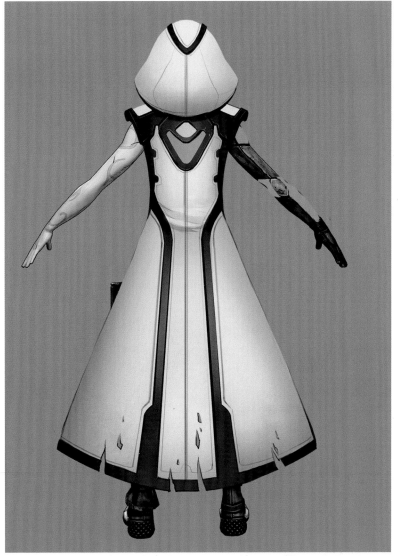

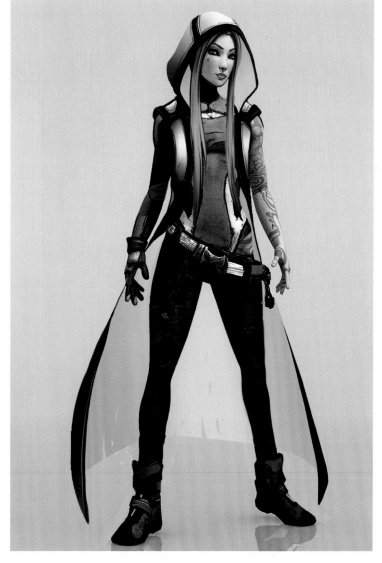

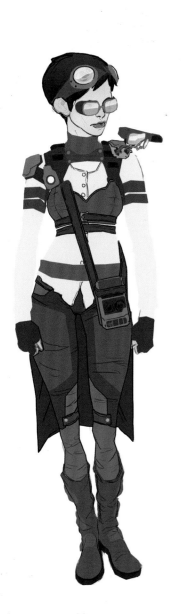
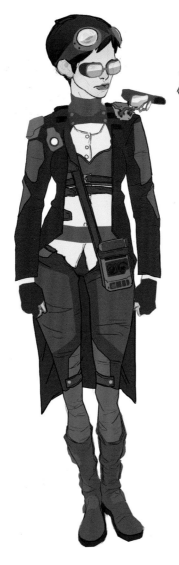

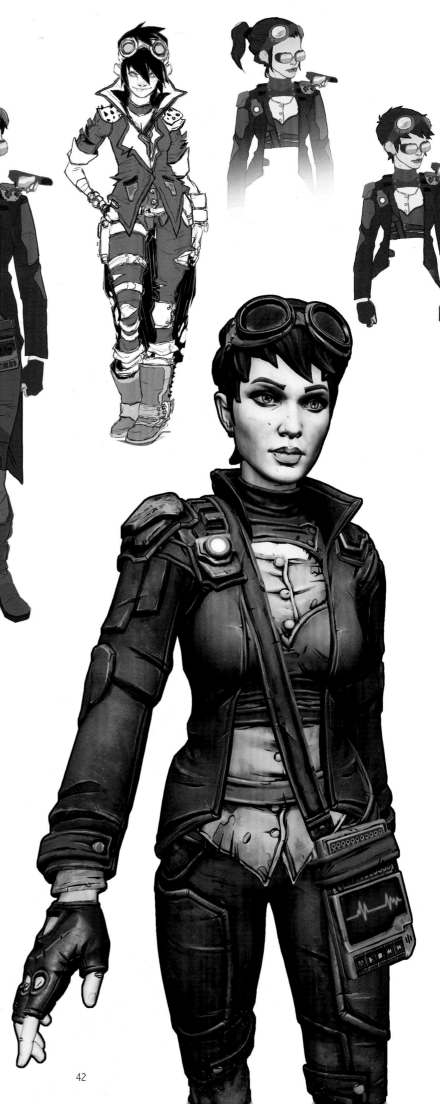

TANNIS

Though she used to be considered one of the most reclusive, condescending, and certifiably insane xenoarchaeologists ever to visit Pandora, Patricia Tannis has mellowed—slightly—and become somewhat more comfortable around other people now that she's teamed up with the Crimson Raiders. Though she can be difficult to work with, her research has proven vital to the successful discovery of many Vaults over the years—a legacy that may put her in harm's way sooner rather than later.

TOP: Early sketches of Tannis that underline her eccentricity by giving her a pair of glasses—despite the fact that she's also wearing her customary goggles.

RIGHT: A more aggressive and battle-damaged costume for Tannis that retains her distinctive red-and-brown palette.

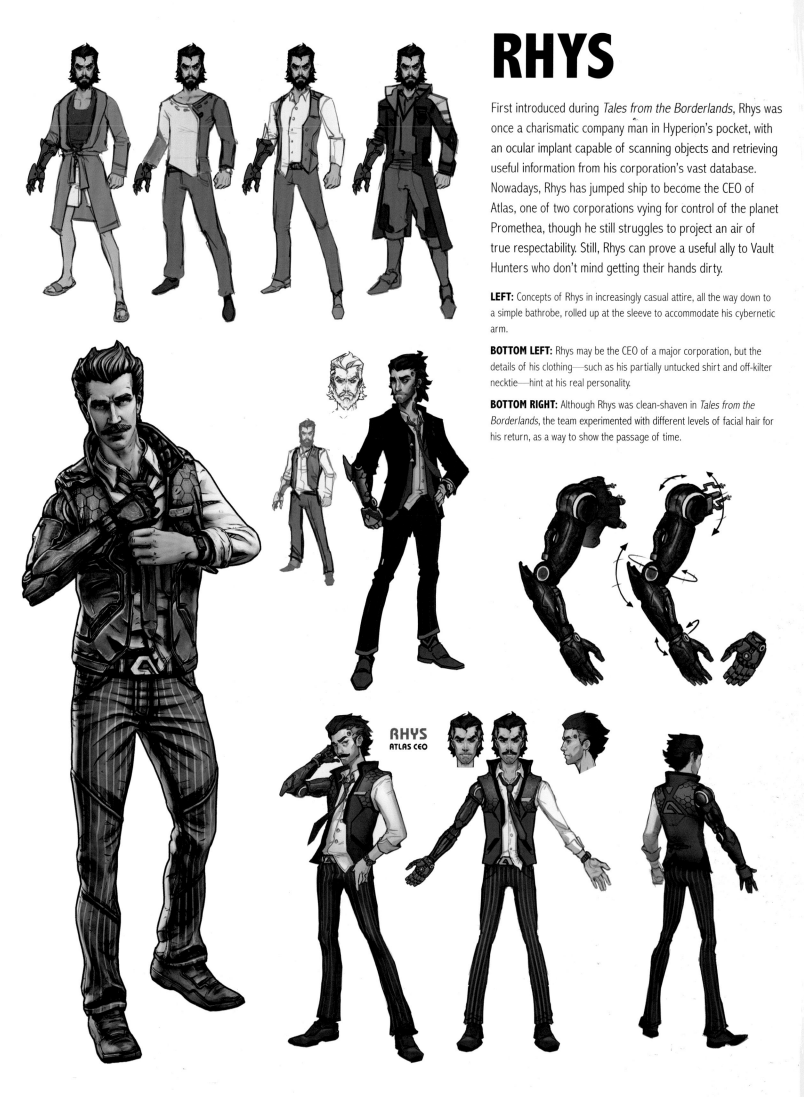

RHYS

First introduced during *Tales from the Borderlands*, Rhys was once a charismatic company man in Hyperion's pocket, with an ocular implant capable of scanning objects and retrieving useful information from his corporation's vast database. Nowadays, Rhys has jumped ship to become the CEO of Atlas, one of two corporations vying for control of the planet Promethea, though he still struggles to project an air of true respectability. Still, Rhys can prove a useful ally to Vault Hunters who don't mind getting their hands dirty.

LEFT: Concepts of Rhys in increasingly casual attire, all the way down to a simple bathrobe, rolled up at the sleeve to accommodate his cybernetic arm.

BOTTOM LEFT: Rhys may be the CEO of a major corporation, but the details of his clothing—such as his partially untucked shirt and off-kilter necktie—hint at his real personality.

BOTTOM RIGHT: Although Rhys was clean-shaven in *Tales from the Borderlands*, the team experimented with different levels of facial hair for his return, as a way to show the passage of time.

RHYS
ATLAS CEO

ATLAS FORCES

BELOW: Character sketches for Atlas forces, all sharing the same color palette. Each of the designs focuses the technological details into a single area of the body, such as the soldiers' belts or arms, creating a theme of ordered chaos.

BOTTOM: Final renders of a nameless Atlas soldier, conceived as part of an elite group named the Crimson Shield (*opposite*).

OPPOSITE BOTTOM: A Crimson Shield member and her oversized canine companion. Or should we say cannon companion?

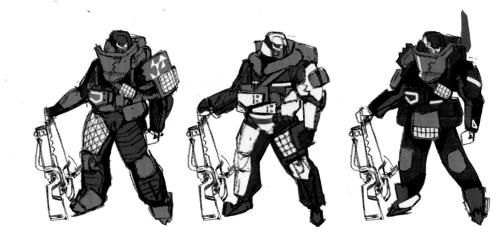

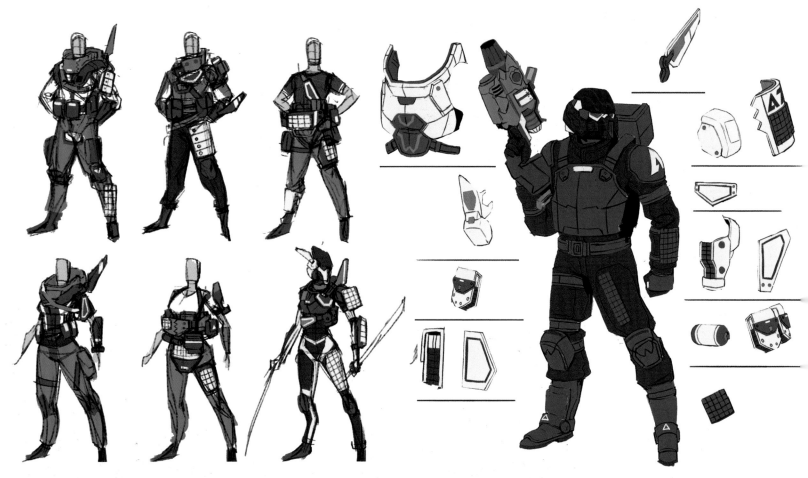

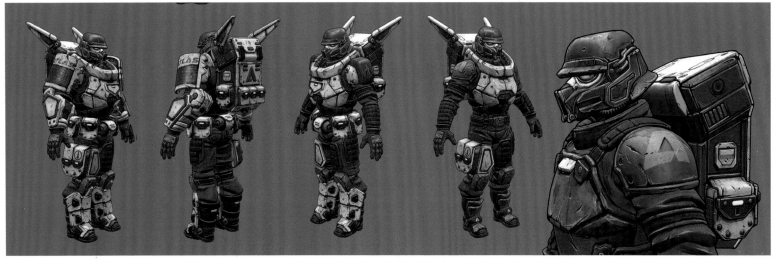

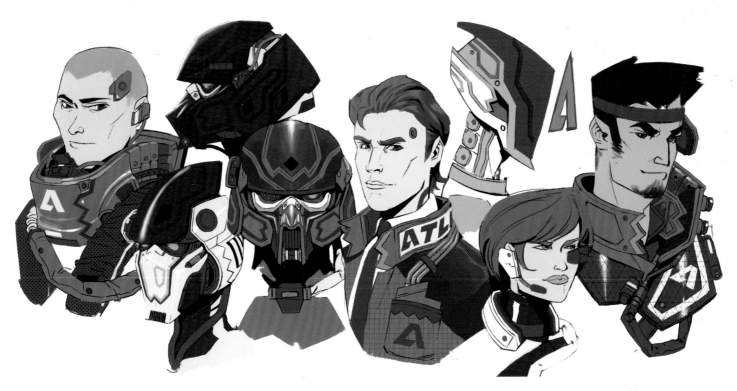

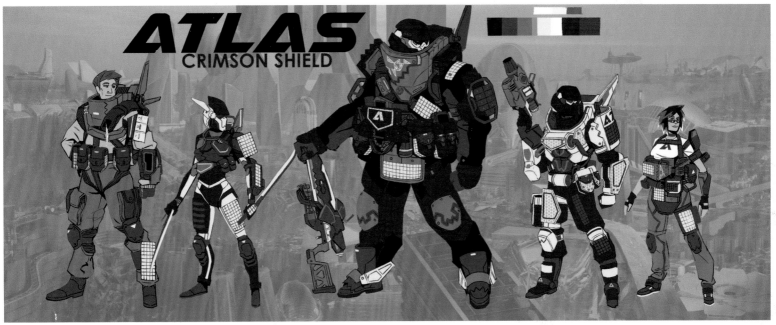

ATLAS
CRIMSON SHIELD

BEEP BOOP BOP...

ELLIE

Once a vehicle mechanic in Pandora's Dust region, Ellie is one of the first friendly faces the Vault Hunters meet when they arrive at her scrapyard. The tattoo on her arm commemorates Ellie's deceased brother, Scooter, who gave his life in a noble sacrifice during *Tales from the Borderlands*. The heart on her chest, meanwhile, symbolizes Ellie's past association with the Hodunk clan, a group obsessed with building fast cars and brewing strong moonshine—a dangerous combination of hobbies even by bandit standards.

TOP: Rather than being a cybernetic augmentation like Rhys's arm, the device Ellie wears on her right hand is a removable tool with many different configurations.

BOTTOM: Ellie's heavy welding mask sits atop her head and can drop into place when she's working.

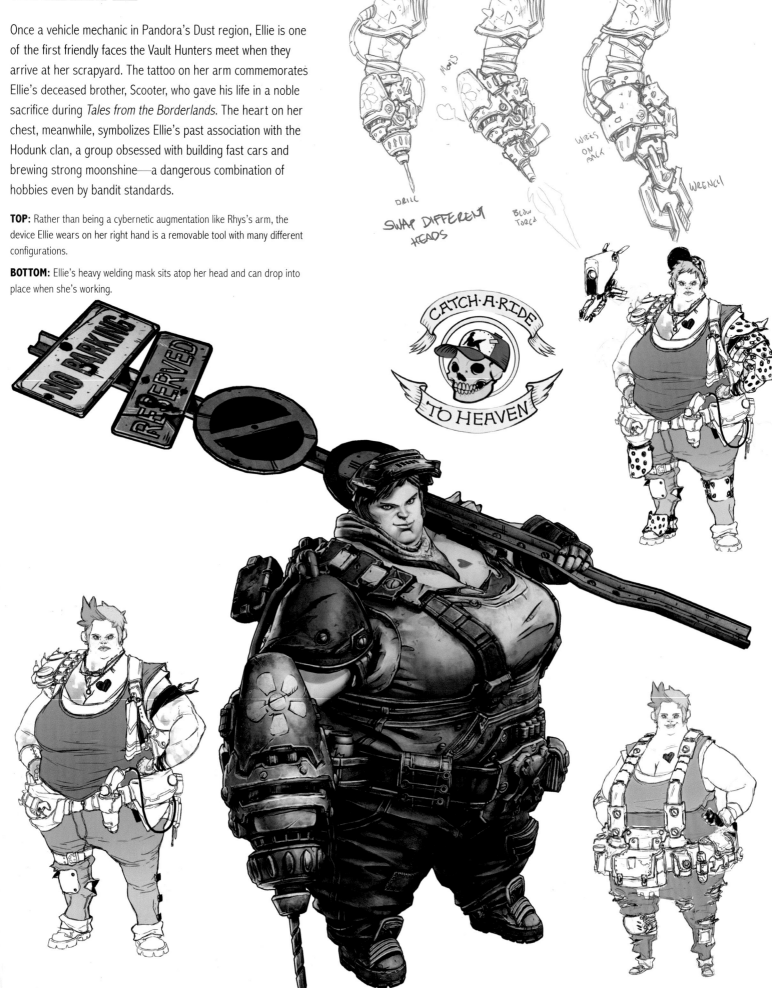

SIR HAMMERLOCK

Don't let the cybernetics fool you; Sir Alistair Hammerlock is an old-school hunter with a worldview so old-fashioned, he's more interested in mounting the heads of Pandora's creatures on his wall than exploring the planet to search for Eridian technology. Despite his antiquated attitudes, though, he's a friendly enough sort who's gotten himself into what he'd probably describe as "a spot of bother" on Eden-6, even though his older sister Aurelia now governs the planet. He'll happily repay any Vault Hunter's assistance because, after all, locking a chap up simply isn't cricket.

BELOW: In *Borderlands 2*, Hammerlock is exiled to a frozen wasteland on Pandora, but he has somehow managed to wind up in even more trouble since moving off-world.

RIGHT: Though one of the lenses in Hammerlock's glasses is broken, he can still see, courtesy of his cybernetically enhanced eye.

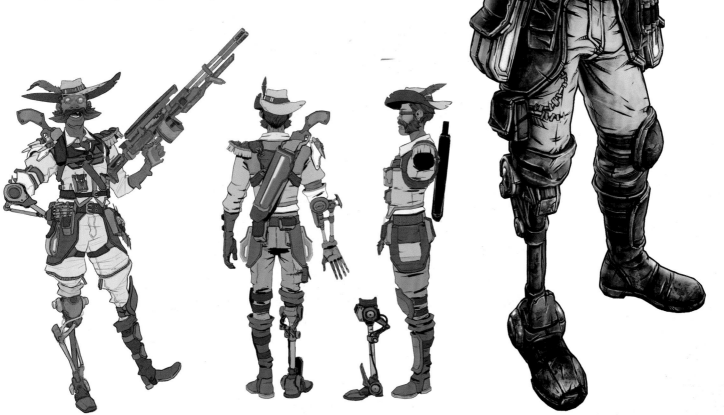

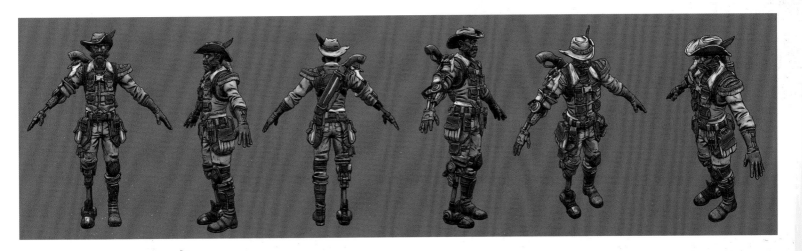

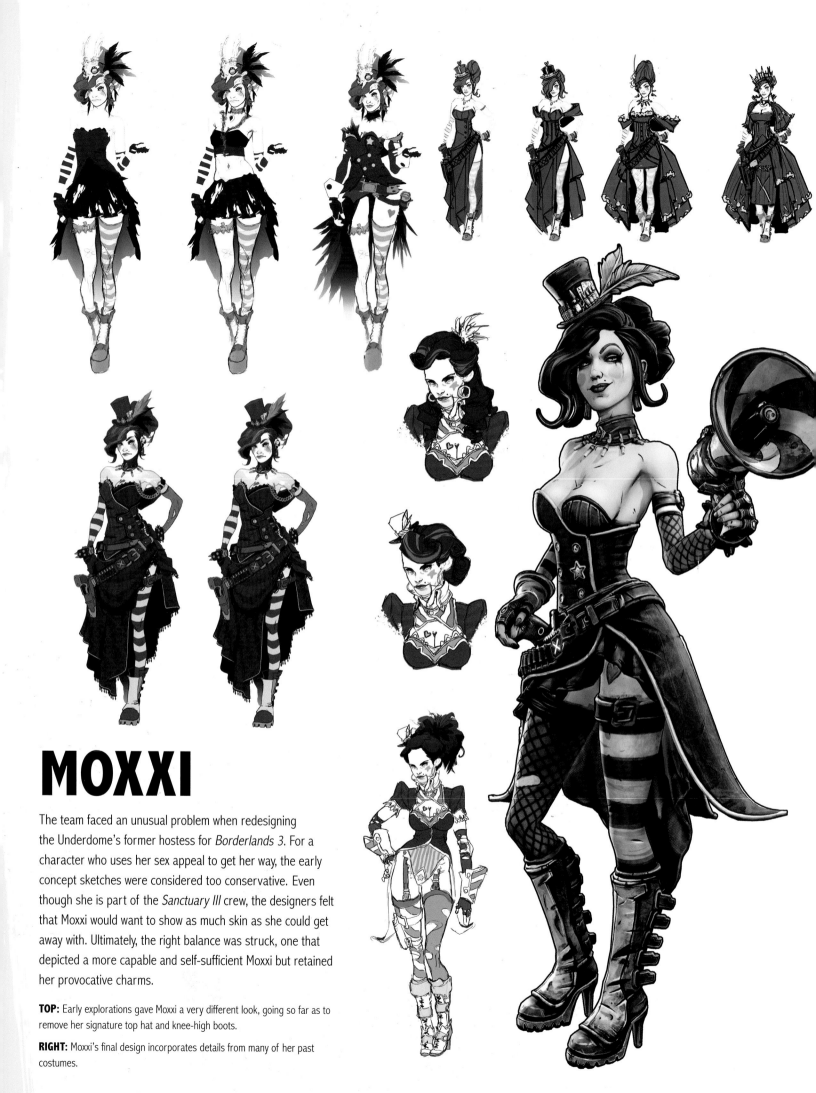

MOXXI

The team faced an unusual problem when redesigning the Underdome's former hostess for *Borderlands 3*. For a character who uses her sex appeal to get her way, the early concept sketches were considered too conservative. Even though she is part of the *Sanctuary III* crew, the designers felt that Moxxi would want to show as much skin as she could get away with. Ultimately, the right balance was struck, one that depicted a more capable and self-sufficient Moxxi but retained her provocative charms.

TOP: Early explorations gave Moxxi a very different look, going so far as to remove her signature top hat and knee-high boots.

RIGHT: Moxxi's final design incorporates details from many of her past costumes.

MORDECAI

Mordecai, along with his pet bloodwing Talon, is a Hunter and the third member of the B-Team alongside his old ally Brick and new recruit Tina. Together, the three of them travel to Eden-6 to form part of a rescue squad. Though they may have been thrown together by very different circumstances, Brick and Mordecai have crossed paths with Tina and still aren't dead, which makes them the closest thing to a dysfunctional family she's had since the loss of her parents.

BELOW: A rare glimpse at what Mordecai might look like with his face uncovered. Feathers are woven into his hair.

BOTTOM RIGHT: Mordecai's clothing is darker and more streamlined than before, hinting at the kind of covert operation that the B-Team is planning on Eden-6.

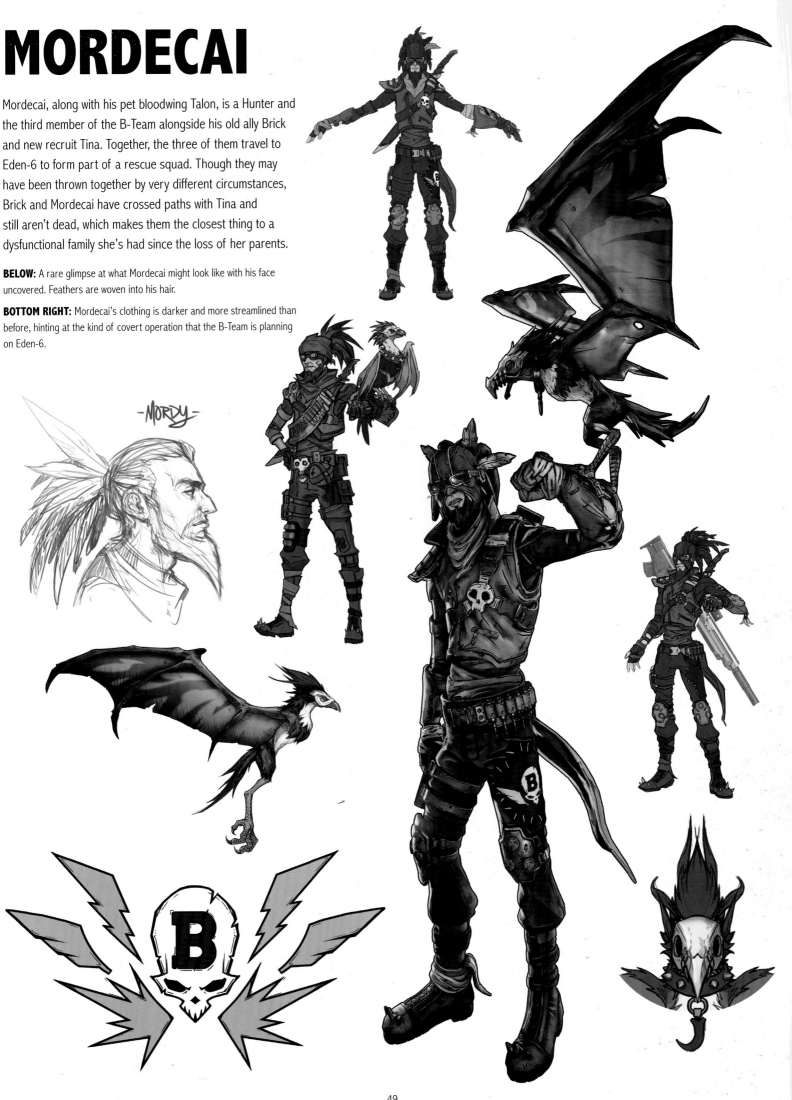

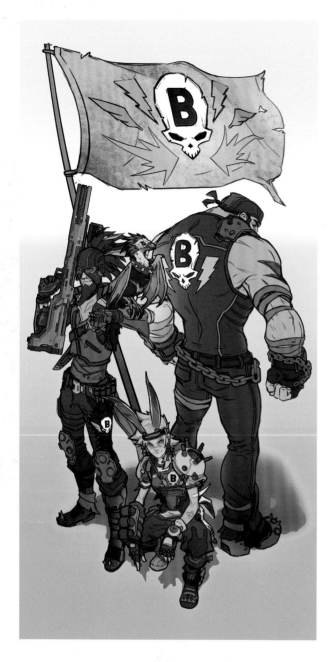

BRICK

Brick, a Berserker and one of the four Vault Hunters who defeated the Destroyer in *Borderlands*, has had many different alliances since his arrival on Pandora. Having rallied a number of bandits to fight against Hyperion as "The Slab King," Brick later rejoined his old friend Mordecai and, together with Tina, they began a new life as the B-Team. Working as mercenaries for hire, the B-Team have most recently been spotted leaving Pandora in search of fun, profit, and the Vaults that Brick is eager to explore. He *did* call dibs, after all.

TOP LEFT: Brick and the B-Team. Mordecai and Tina wear masks to conceal their identities, but disguising Brick's gargantuan frame is a trickier proposition.

TOP RIGHT: An early outfit for Brick, minus his B-Team jacket and accessories.

BOTTOM RIGHT: Brick's final design.

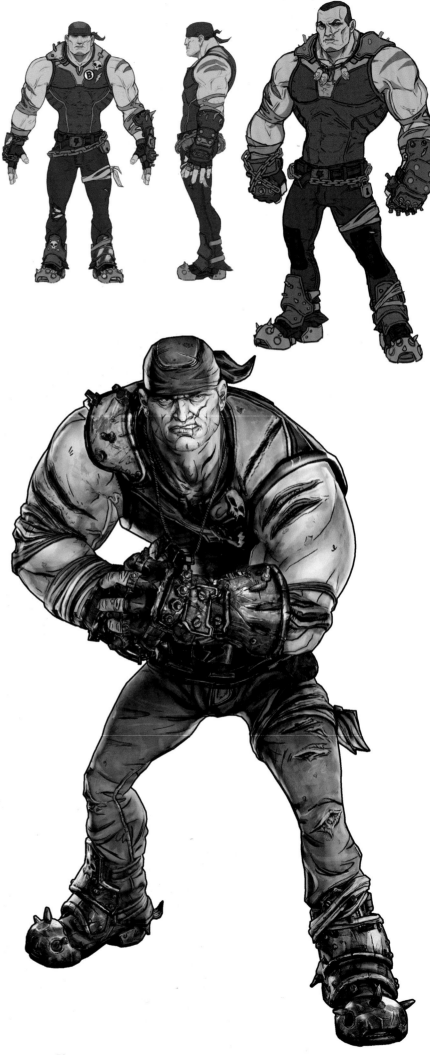

TINA

Tina is no longer quite so tiny this time around. In the years that have passed since *Borderlands 2*, she has matured from a dangerous, unstable teenager into a dangerous, unstable young adult. The team took particular care when aging up this fan-favorite character, working with voice actor Ashly Burch to consider how Tina's life might have unfolded. Her outfit may have changed, but Tina's love of fuzzy, squishy bunnies remains as strong as ever—almost on a par with her love of high-yield explosives.

BELOW: Tina's earliest designs worked to find a balance between a battle-ready outfit and a look that retained her vivacious personality. Ideas included bunny-patterned combat fatigues and armor decorated with a *T* by Tina herself.

BOTTOM RIGHT: A final render of Tina.

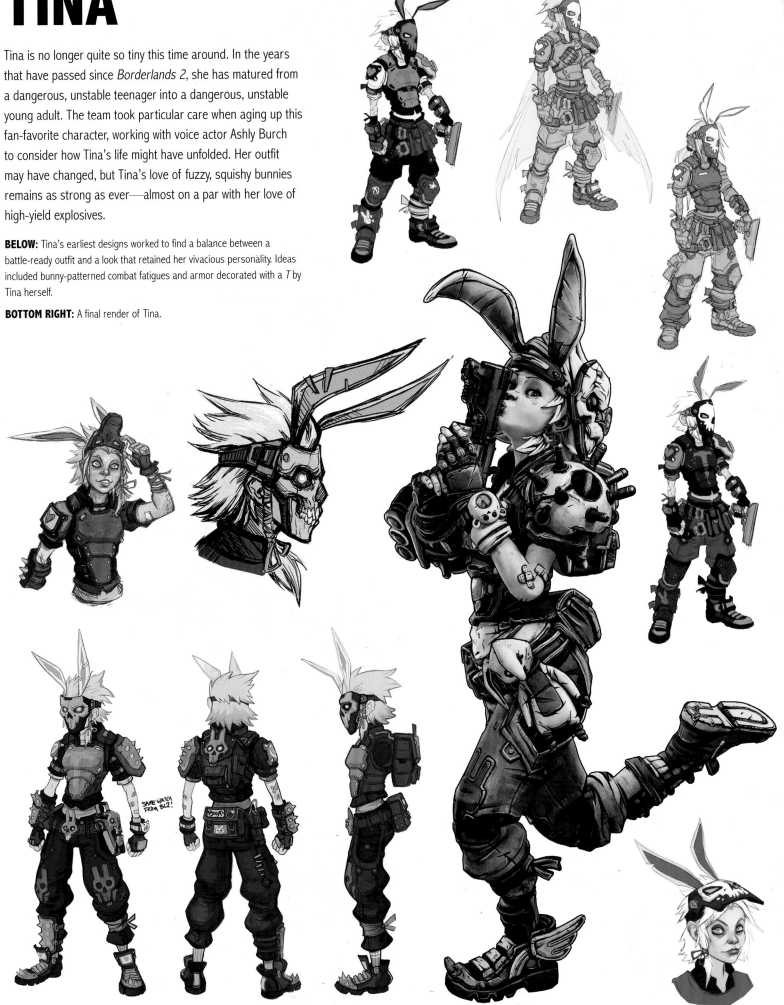

AVA

At first glance, Ava—along with her faithful pet Hermes—couldn't look more different from the willowy, flowing Maya, but she's considered a potential Siren nonetheless. Whatever may lie in Ava's future, closer examination reveals that much of her distinctive outfit has been inspired by the tight-fitting combat armor worn by Maya during *Borderlands 2*. Perhaps they're not so different after all.

THIS PAGE: Creating new characters means starting with a blank slate. The personality and tone of these early sketches vary wildly, though there are a few elements in common, such as the vibrant red hair.

OPPOSITE TOP: As these sketches of Ava's companion Hermes show, he may look cute, but he's got a nasty bite.

RIGHT AND OPPOSITE BOTTOM: Ava's final model shares traits with her mentor, Maya, such as her hood and dark blue hair color.

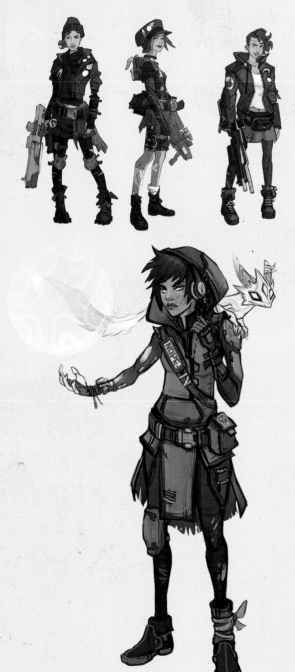

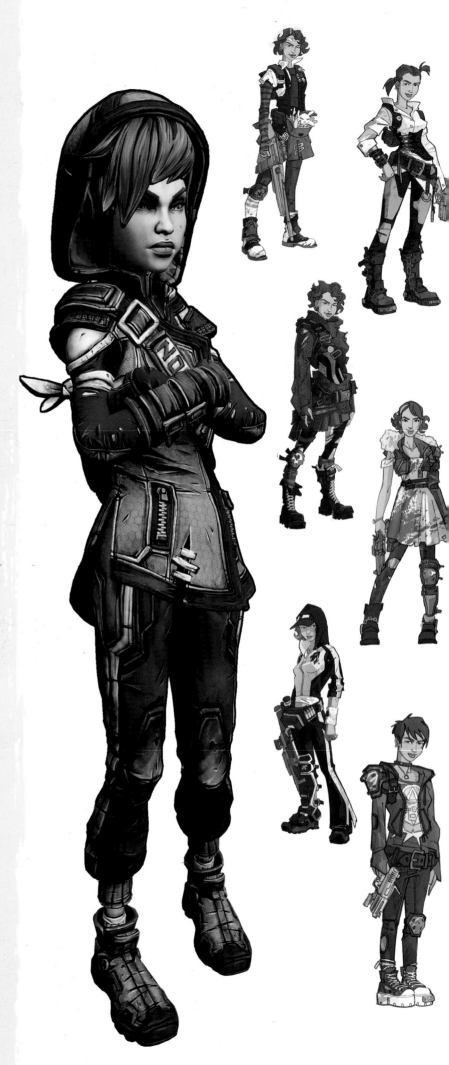

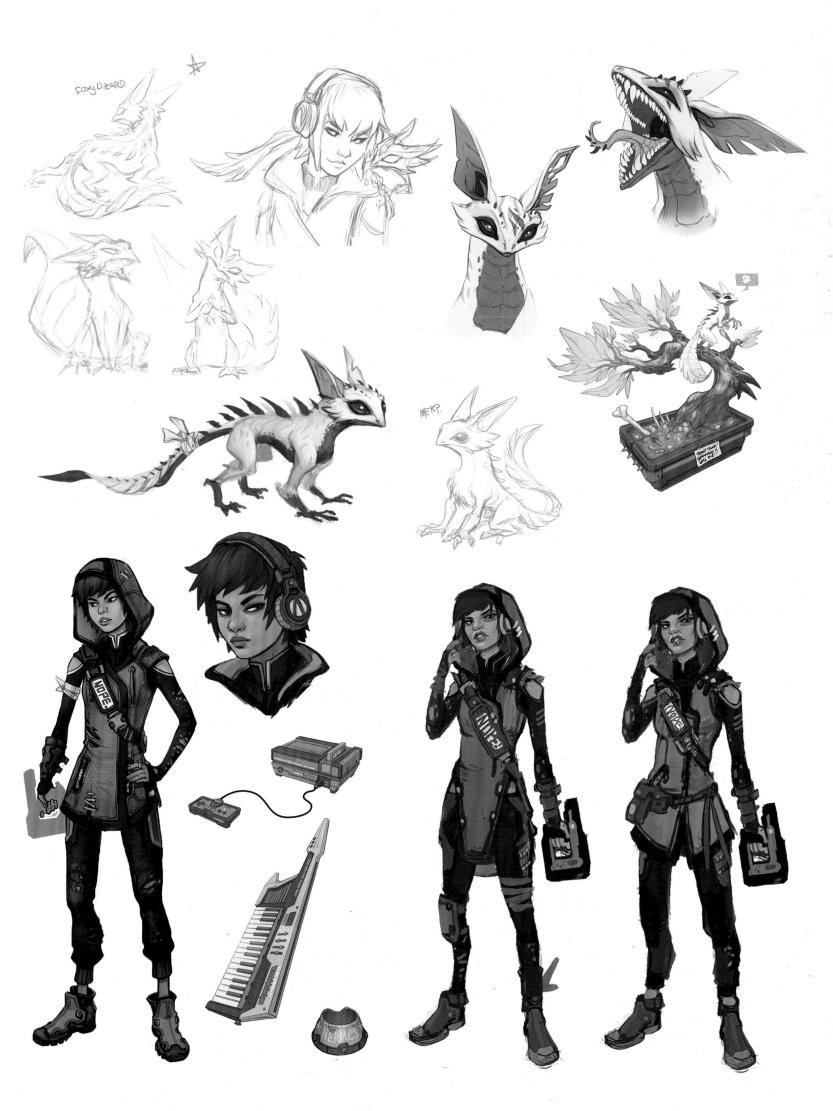

WAINWRIGHT

Wainwright Jakobs is a very rich man with very little to show for it, courtesy of the newest addition to his family: his scheming stepmother, Aurelia Hammerlock. Because he's the onetime heir to the Jakobs estate, many of that company's visual motifs, including wood tones and old Western designs, also apply to Wainwright himself, along with a rather rumpled appearance that helps suggest that he's fallen into hard times.

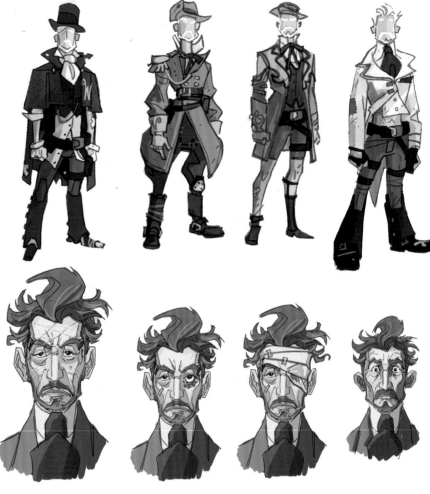

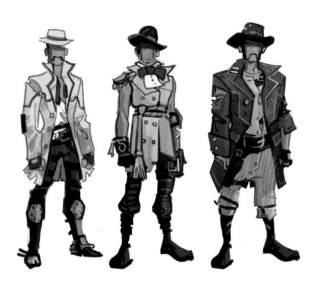

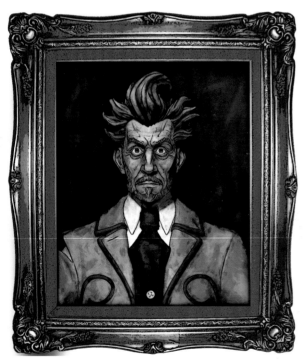

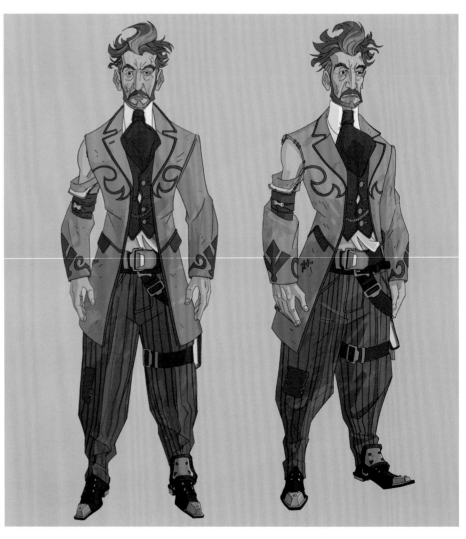

TOP: When designing Wainwright, the team considered different styles of Old West attire, from society gentleman to colonial officer. Once the form of Wainwright's attire was narrowed down, a number of alternative sketches were created. The two leftmost designs were selected as a base.

CENTER: Different facial characteristics for Wainwright, including "bug-eyed" and "stink-eyed" expressions as well as various types of injuries.

ABOVE: A portrait of Wainwright, apparently painted during more prosperous times.

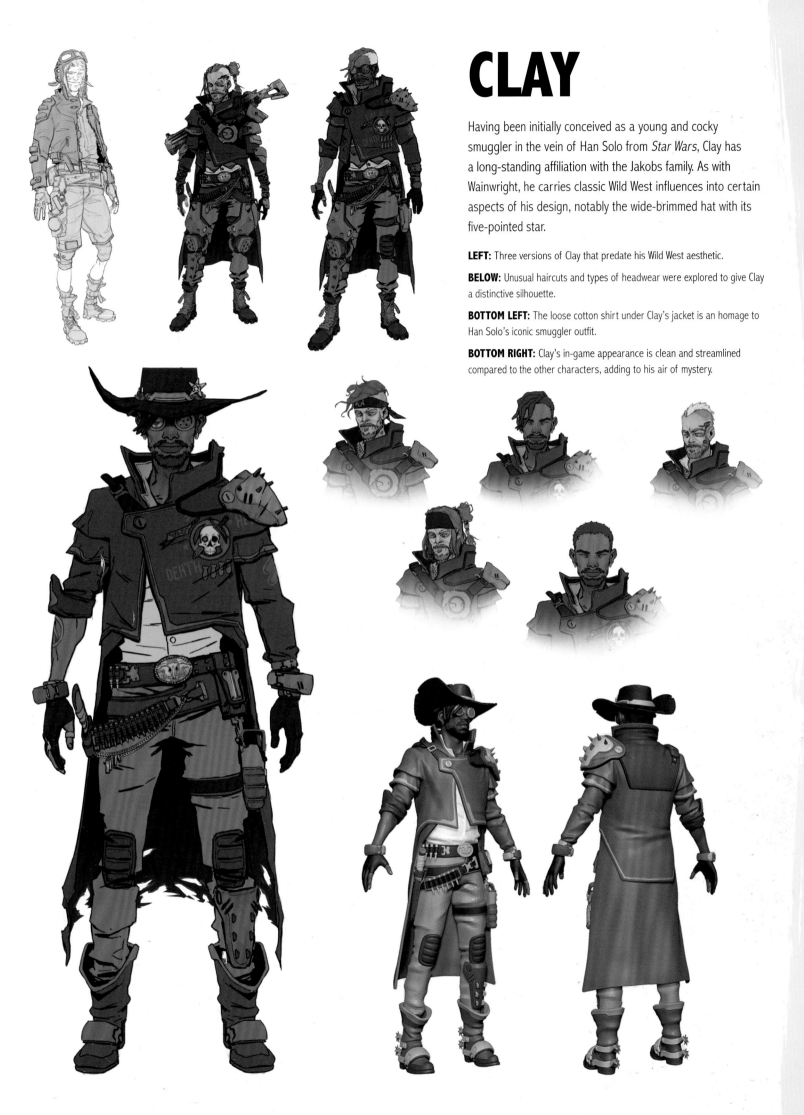

CLAY

Having been initially conceived as a young and cocky smuggler in the vein of Han Solo from *Star Wars*, Clay has a long-standing affiliation with the Jakobs family. As with Wainwright, he carries classic Wild West influences into certain aspects of his design, notably the wide-brimmed hat with its five-pointed star.

LEFT: Three versions of Clay that predate his Wild West aesthetic.

BELOW: Unusual haircuts and types of headwear were explored to give Clay a distinctive silhouette.

BOTTOM LEFT: The loose cotton shirt under Clay's jacket is an homage to Han Solo's iconic smuggler outfit.

BOTTOM RIGHT: Clay's in-game appearance is clean and streamlined compared to the other characters, adding to his air of mystery.

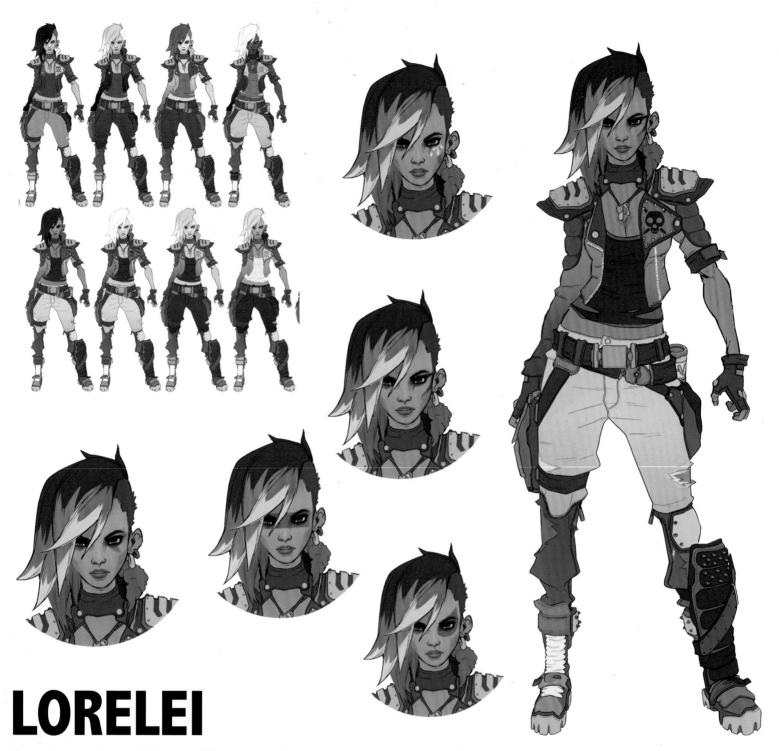

LORELEI

When war erupted between Maliwan and Atlas, many of the local population were forced to flee the creature comforts of downtown, soon finding themselves lost and afraid as they huddled in the shadows of a nearby slum. Enter Lorelei: a Promethean resident turned guerrilla fighter who's shouldered the responsibility of keeping her people safe. Having learned to trust the Vault Hunters as they work to loosen Maliwan's grip on the metropolis, Lorelei soon becomes a valuable ally, though she remains distrustful of Atlas and the chaos it has unleashed upon her city.

TOP LEFT: Concept art exploring different color palettes for Lorelei's hair, skin, and clothing.

TOP RIGHT AND CENTER: A number of facial markings were considered.

BOTTOM RIGHT: Lorelei's outfit tells the story of a trendy suburbanite transformed by circumstance into a capable freedom fighter.

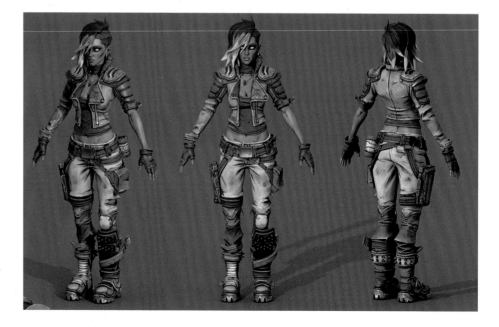

TYPHON DeLEON

However bandits and brigands might imagine the first-ever Vault Hunter, it's safe to say that Typhon DeLeon wouldn't fit their description. And yet, even though he's undoubtedly worse for wear, having been trapped on Nekrotafeyo for several decades, he and his wife, Leda, are the real deal, having discovered and dug up more Eridian history than most scholars have forgotten. His connection to Troy and Tyreen Calypso, however, runs deeper still.

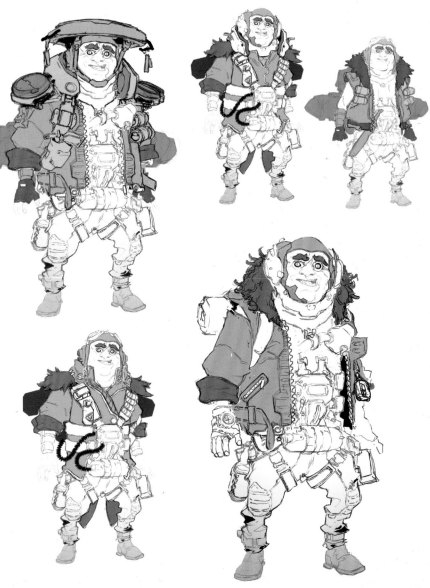

RIGHT: Later sketches of Typhon imagined the saucer on his head as being an improvised "tinfoil hat" to protect his mind from harmful energies.

BELOW: The layer underneath Typhon's jacket is a type of hazmat suit, which he continues to wear despite the suit's protective helmet having broken long ago. An explorer heading out into the unknown, Typhon was designed to be ready for anything, with all kinds of gear hanging from his waist and back.

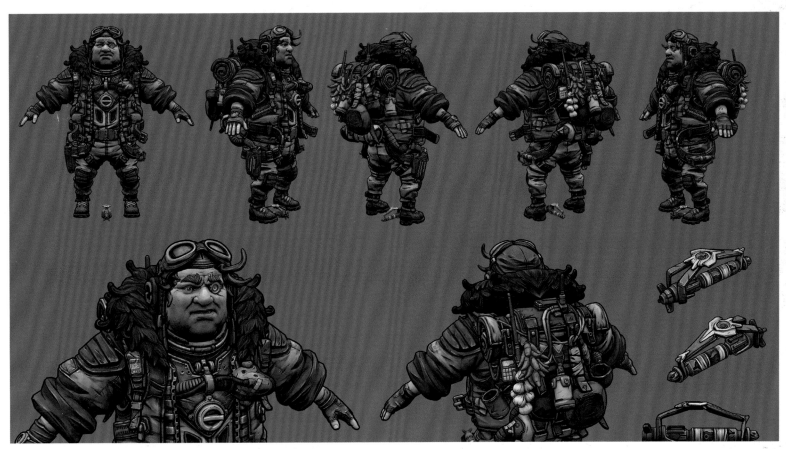

AURELIA

Aurelia—or Lady Hammerlock, as she'd doubtless prefer to be called—may seem a surprising choice to join *Borderlands 3*'s motley crew of antagonists. There are plenty of morally ambiguous characters across Pandora and beyond, of course, but players who enjoyed spending time in Aurelia's shoes during *Borderlands: The Pre-Sequel* may be surprised to learn she's teamed up so readily with the bad guys.

Concept Artist Amanda Christensen, who worked on Aurelia's design for *Borderlands: The Pre-Sequel*, suggests that Aurelia's true nature was hidden in plain sight all along: "I was thinking about the fact that all the characters besides Athena and Claptrap in the *Pre-Sequel* are villains. So I wasn't necessarily thinking of this character as being a normal hero Vault Hunter, so to say, but I thought, 'Okay, this is a villain, let's just own this' and push this over-the-top, huntress, diva, sniper-lady angle and just let her be really ridiculous.

"It's pretty weird to have a player character like that, which is why as soon as the question 'What characters are going to be back?' came for *Borderlands 3*, I [knew we needed] to bring back Aurelia but let her be her true evil villainess self, because that's really the role where she should shine."

And shine Aurelia does, as she's inherited the Jakobs family fortune, seized control of Eden-6 with a veritable army of loyal Jakobs "sheriffs" at her disposal, and imprisoned her brother, Alistair, by the time the Vault Hunters arrive—although she initially claims to be helpless in the face of aggression from Children of the Vault.

This time around, Aurelia has ditched her practical Vault Hunter attire and leaned heavily into a look that befits an aspiring tyrant. The ice-blue color of her *Pre-Sequel* outfit remains, but her costume is now far more ostentatious and imposing, with a military-style greatcoat and silver epaulets hinting at her true dictatorial ambitions.

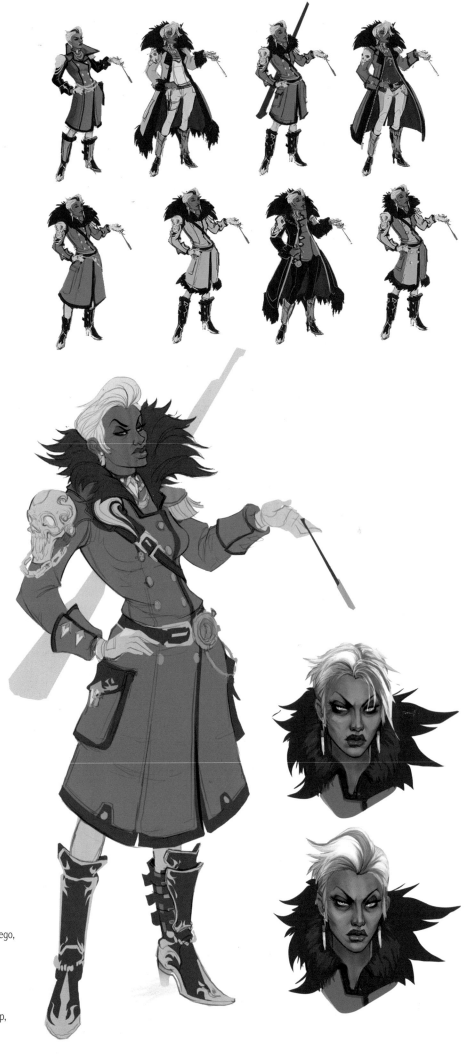

ABOVE: Monochrome sketches depicting potential new outfits for Aurelia: an ornate coat, a sombrero cordobés and shoulder pads similar to Carmen Sandiego, a complex "Ice Queen" costume, and a long gown with a complementary boa.

TOP: Concept art exploring different clothing and color combinations.

RIGHT: Aurelia's final design, with her coat buttoned.

FAR RIGHT: Two versions of Aurelia. The first has impeccable hair and makeup, while the second is more disheveled, as if a fight has just taken place.

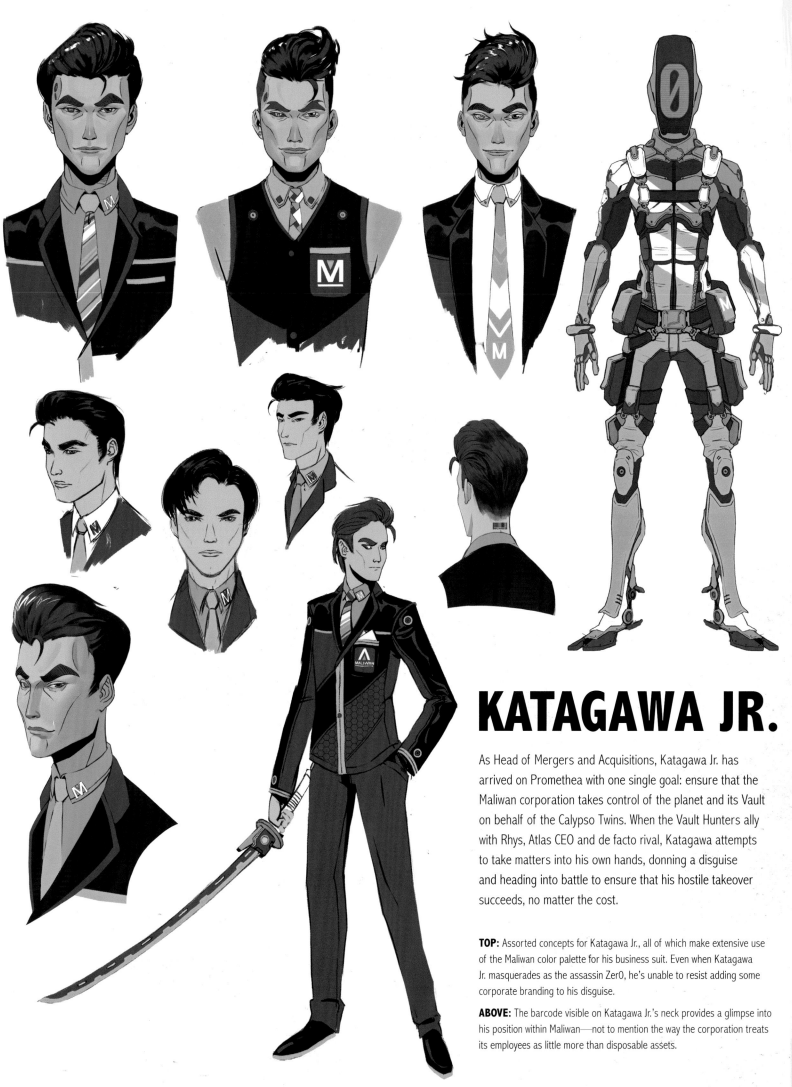

KATAGAWA JR.

As Head of Mergers and Acquisitions, Katagawa Jr. has arrived on Promethea with one single goal: ensure that the Maliwan corporation takes control of the planet and its Vault on behalf of the Calypso Twins. When the Vault Hunters ally with Rhys, Atlas CEO and de facto rival, Katagawa attempts to take matters into his own hands, donning a disguise and heading into battle to ensure that his hostile takeover succeeds, no matter the cost.

TOP: Assorted concepts for Katagawa Jr., all of which make extensive use of the Maliwan color palette for his business suit. Even when Katagawa Jr. masquerades as the assassin Zer0, he's unable to resist adding some corporate branding to his disguise.

ABOVE: The barcode visible on Katagawa Jr.'s neck provides a glimpse into his position within Maliwan—not to mention the way the corporation treats its employees as little more than disposable assets.

TROY

He may be dead and gone, but Handsome Jack has left some very large shoes to fill. With Hyperion's head honcho having appeared in three *Borderlands* titles, the narrative team felt the time was right for a new group of antagonists to clash with the next generation of Vault Hunters.

"It's such a hard thing to make a meaningful villain and also have a meaningful story," says Chris Faylor, who worked as Community Manager during *Borderlands 2*'s release and got to experience the fans' reactions firsthand. "The villain is the one that you love to hate. The antagonist is the one that keeps you going, but if they overstay their welcome, then the stakes don't exist. But if things never change . . ."

Managing Producer of Narrative Randy Varnell agrees: "There's actually a fan video that came out, and it was one of those, like, 'Seven Things We Don't Want to See in *Borderlands 3*' and Handsome Jack was one of those [things]. We brought that up in a meeting—that actually we have some fairly anecdotal evidence now that the some of the fans are fatigued."

Families are a recurring theme throughout *Borderlands 3*, so it's perhaps no surprise that the antagonists chosen this time around would be a brother-sister pairing: Troy and Tyreen Calypso, accompanied by their army of loyal followers. Tyreen is a powerful Siren capable of leaching the life and the abilities from anyone she touches, as Lilith learns the hard way during their first encounter. With the Calypso Twins' plan already in motion, the Vault Hunters must then pursue them to settle the score— not to mention save the universe.

RIGHT: Troy Calypso as he appears in the game.

TOP: Different types of hairstyles for Troy. This exploration depicts a sterner version of Troy wearing something that more closely resembles a uniform, with military boots and pants below a "space pirate" jacket.

OPPOSITE: When creating Troy, the team tried adding many unusual, exotic details that would make it hard to get a read on his character, making him scarier as a result. These included virtual reality goggles and a visor used to obscure his face.

60

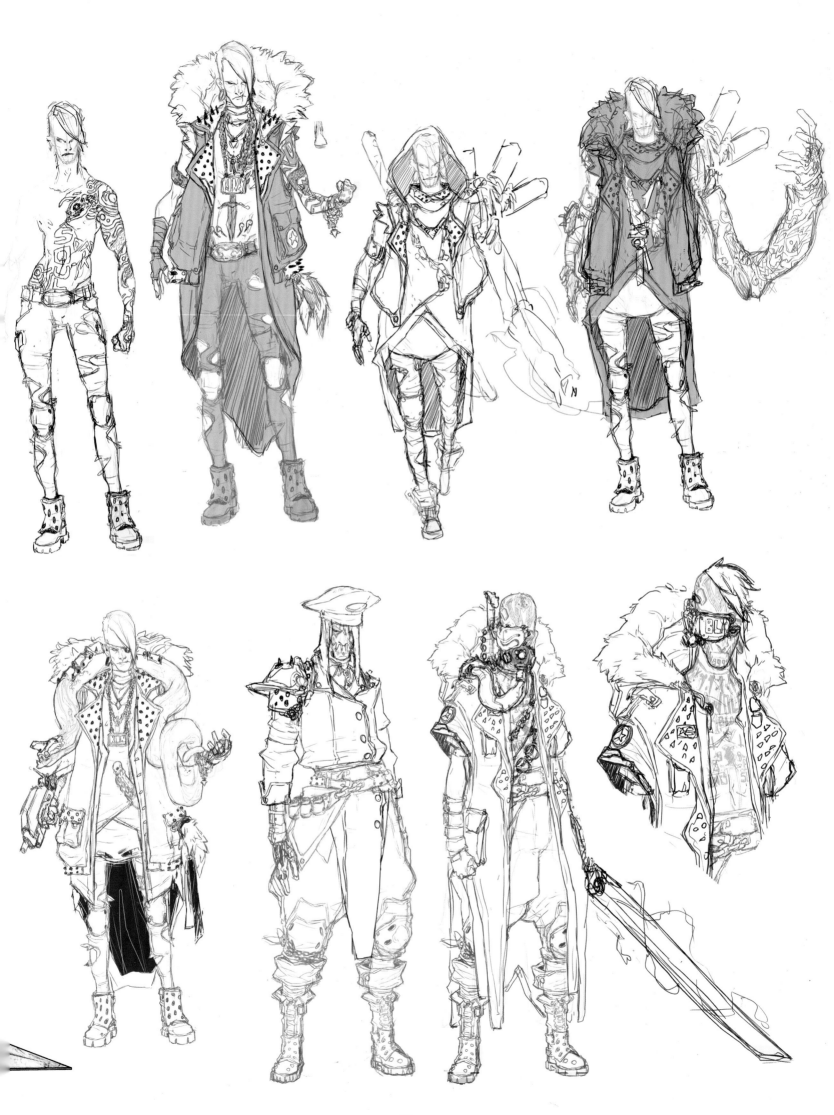

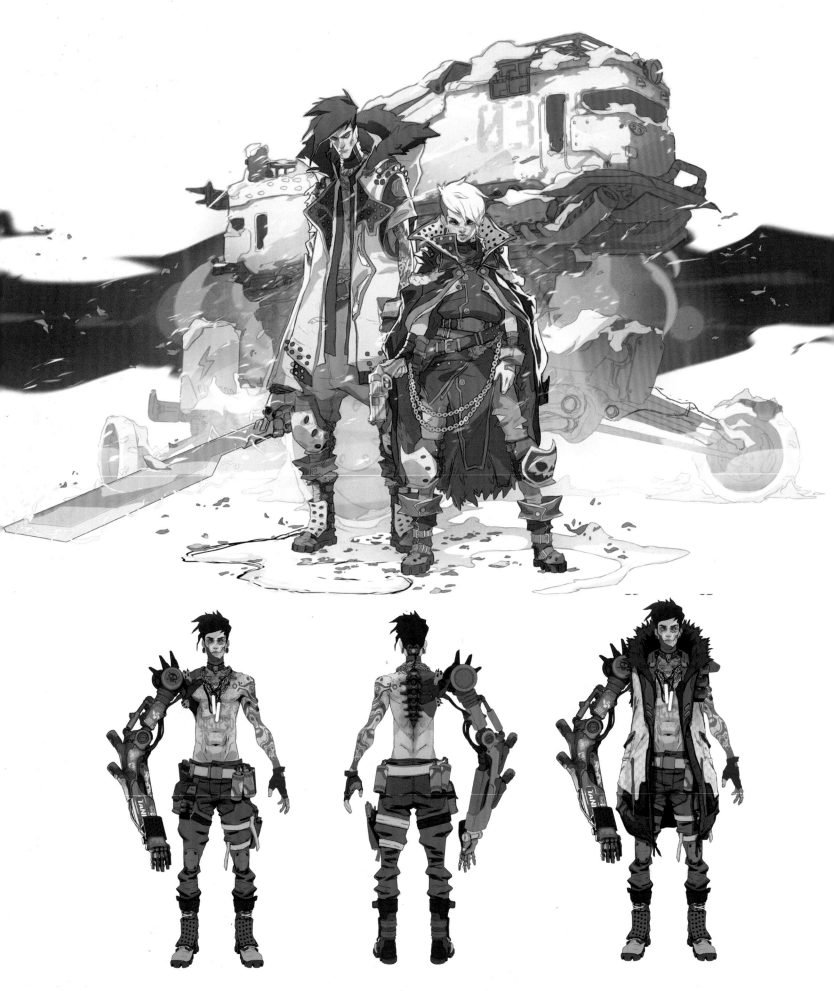

TOP: Artwork depicting Troy and Tyreen standing together. Although Troy's cybernetic arm is largely hidden from sight, the enormous blade he wields hints at his enhanced strength.

ABOVE: Troy receives his augmented arm, shown both with and without his coat to reveal that his spinal cord has also been enhanced.

OPPOSITE: A number of shapes were explored for Troy's siren energy wings: angelic curves, bat wings, and a feathered, demonic look, as well as the striking asymmetrical approach shown here. The crackling lightning from an unused concept was added into the final design.

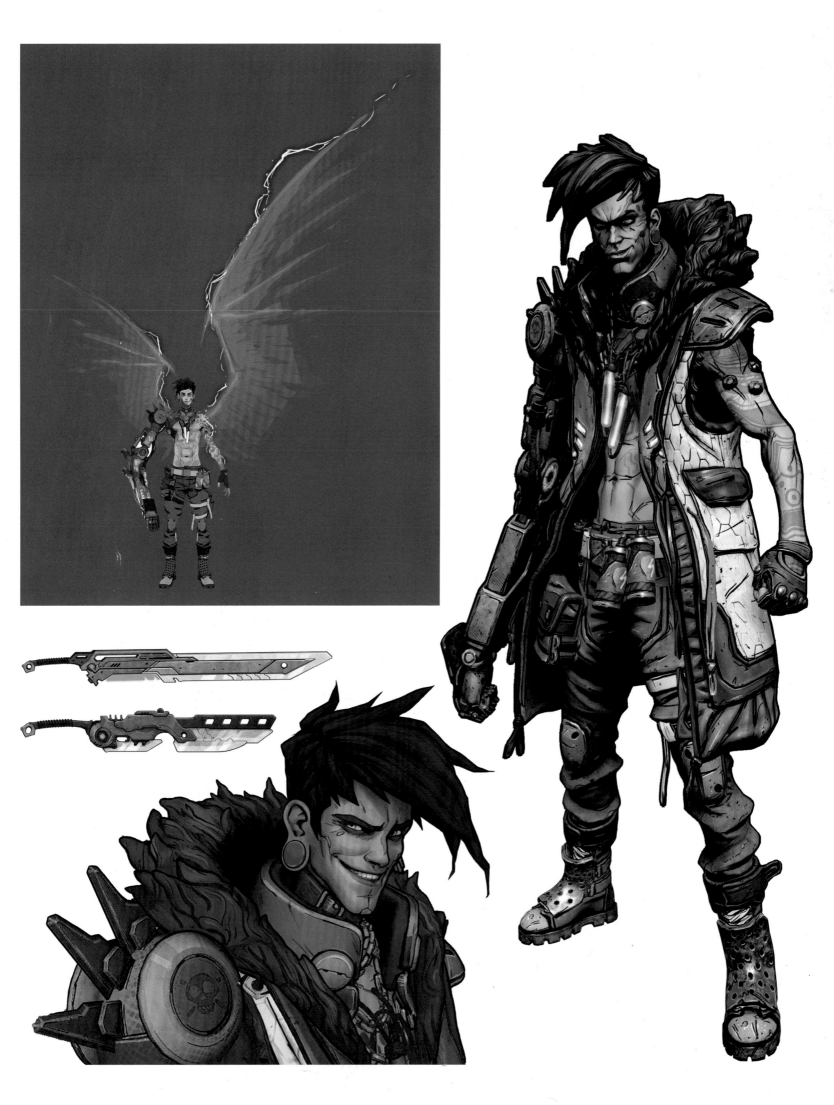

TYREEN

As the main antagonists of *Borderlands 3*, Troy and Tyreen went through an extensive iteration process and were among the first characters transformed from 2D sketches into walking, talking in-game models. As Lead Character Artist Kevin Penrod explains: "We started out with the two main villains of the game, basically taking those characters and getting the sculpting style approved by the Art Director. That would start with maybe twenty to fifty rounds of concepts that we went through. Sergi Brosa, from Barcelona, was one of the main character artists, so it was working back and forth with him, starting to sculpt and sketch the concepts in 3D to nail down the style."

By this time, a wealth of explorative sketches had already been created for both Troy and Tyreen, though some elements and details were carried throughout the process. Troy's lean, athletic physique persists through many of his designs, as does his distinctive coat with its large, imposing collar. Tyreen's self-assuredness and cocky expression can also be seen from the earliest stages of her creation, and so can her deliberately baggy and formless outfit—Tyreen wants people to follow her because of who she is, and not what she looks like.

Since both siblings were being created simultaneously, the opportunity to mix and match attributes also presented itself. Early in Troy's development, the team considered giving him a cybernetic arm, but they later switched the appendage to Tyreen, daubing it with paint that simulated her natural Siren tattoos. Eventually, the turbo-charged limb was returned to Troy, this time for good.

RIGHT: A final render of Tyreen.

FAR RIGHT: When a "space pirate" look was being considered for Troy, the team applied the same look to Tyreen as an experiment, though it was not considered intimidating enough. Later, the strong outlines of a poncho were added to further strengthen her body shape.

OPPOSITE TOP: Two variations of the same sketch, one with a thinner, longer jacket and one that more closely resembles the large cloak-like coat in Tyreen's final design.

OPPOSITE BOTTOM: Two very different takes on Tyreen, one bearing the augmented arm that would later be returned to Troy, with unique color palettes and styles.

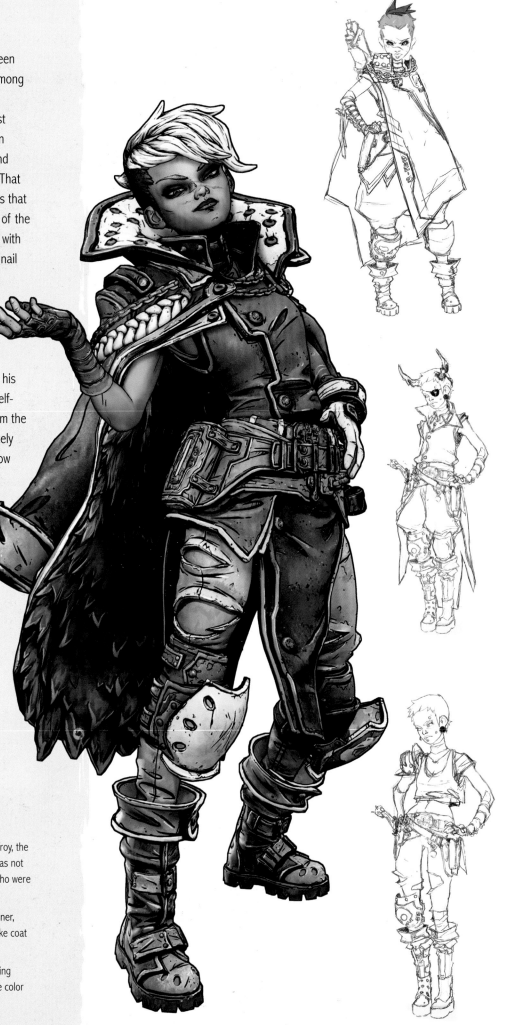

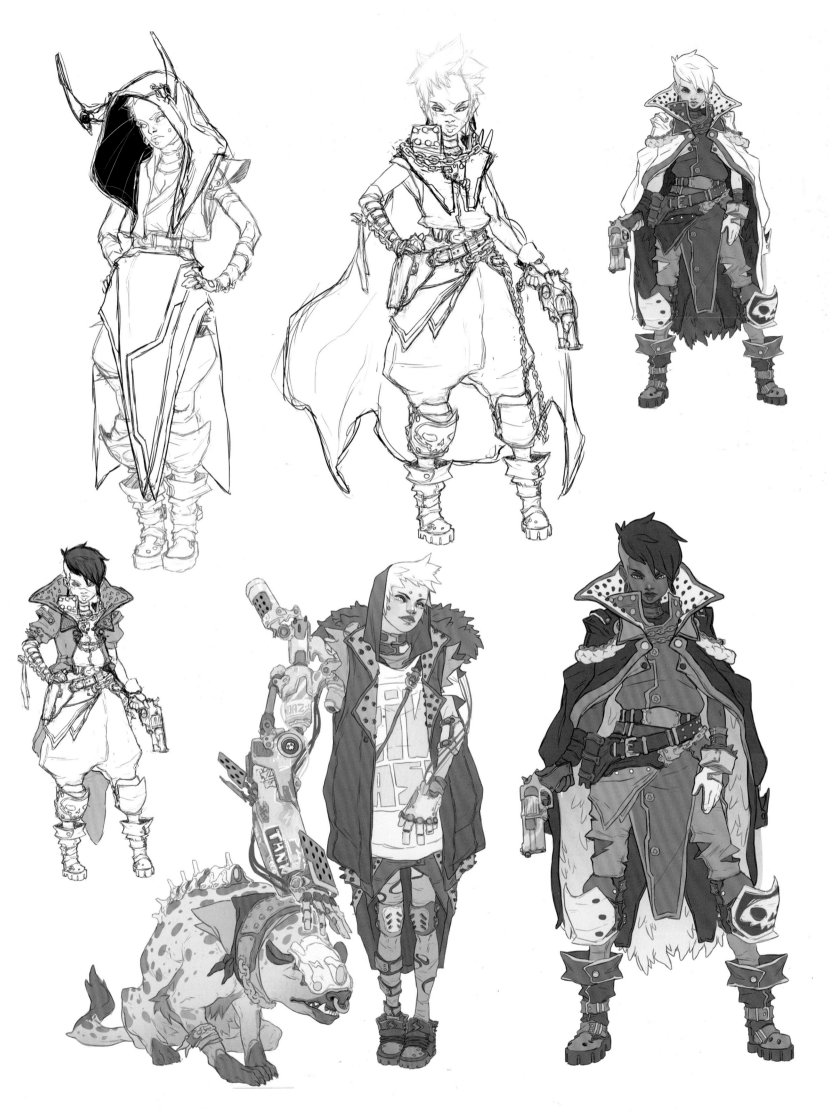

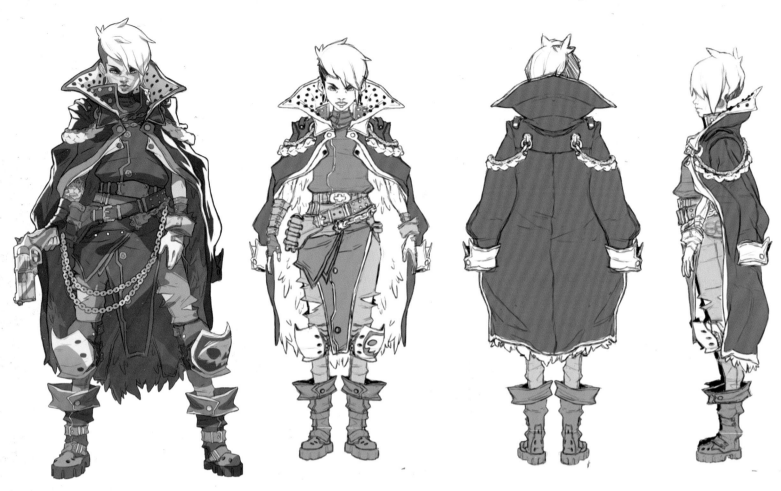

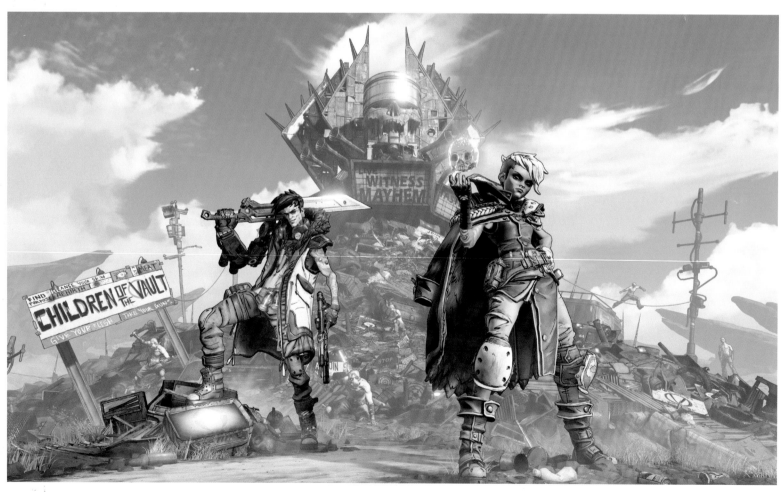

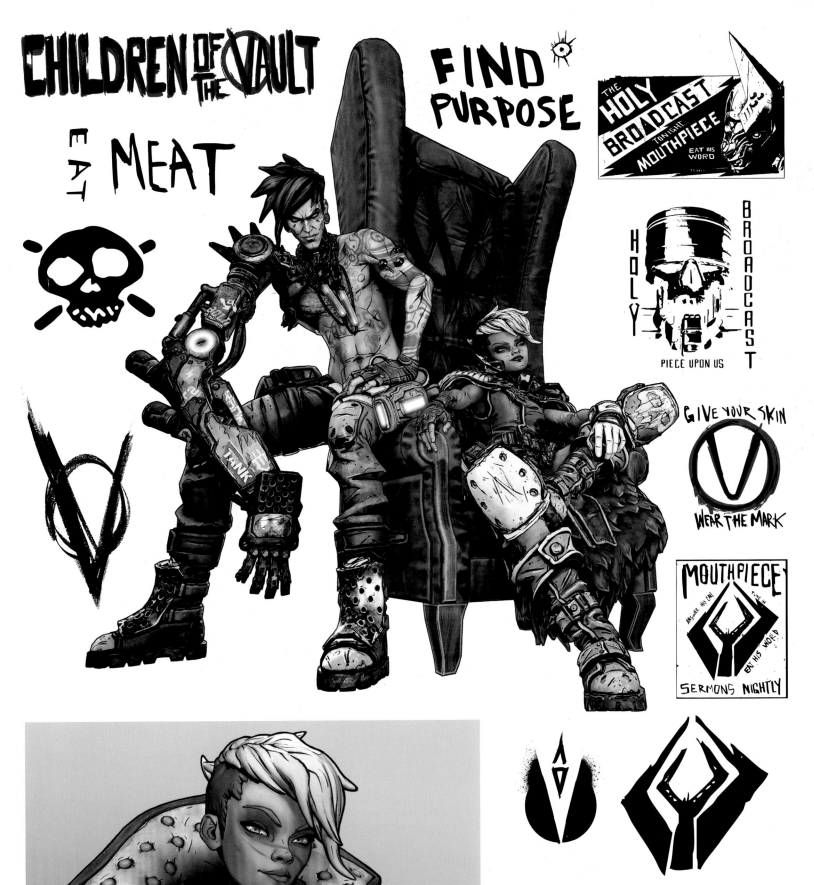

CHILDREN OF THE VAULT

EAT MEAT

FIND PURPOSE

THE HOLY BROADCAST TONIGHT... MOUTHPIECE
EAT HIS WORD

HOLY BROADCAST
PIECE UPON US

GIVE YOUR SKIN
WEAR THE MARK

MOUTHPIECE
ANSWER HIS CALL TUNE IN
EAT HIS WORD
SERMONS NIGHTLY

OPPOSITE TOP: Additional concept designs for Tyreen.

OPPOSITE BOTTOM AND THIS PAGE: Troy and Tyreen have distinctive appearances, but they share certain elements in common. Both of their coats are lined with the same blood-red hue, their faces are framed by high collars, and their Siren tattoos are exposed. Other details, such as their hair color and the outer color of their coats, sit in opposition to each other.

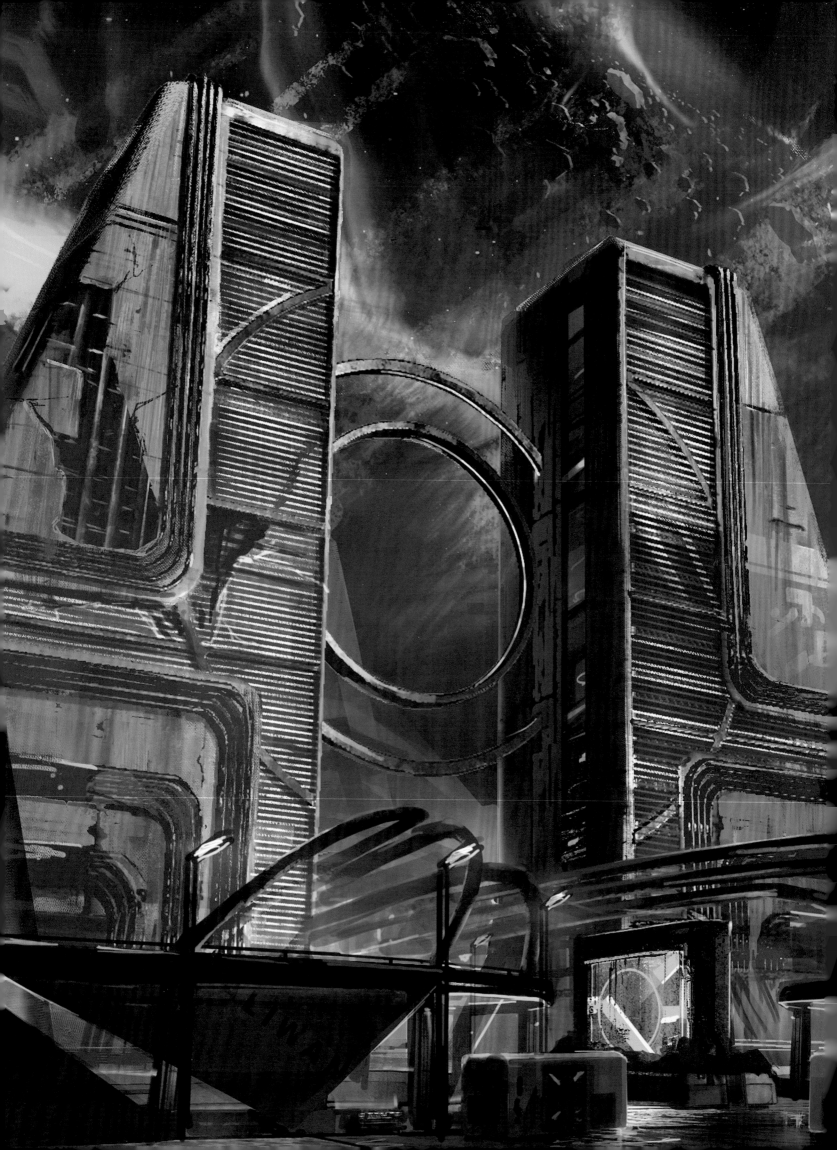

2
ENVIRONMENTS

Each new installment of *Borderlands* may feature a unique group of player characters with wildly different histories and abilities, but there has always been a unifying element connecting all entries in the series: the planet Pandora and its moon, Elpis. Pandora is a rugged world, mostly barren and often hostile, and might well have remained untouched by human hands if not for the rush to find the Eridian technology believed to be lurking under its sunbaked surface.

Thanks to the planet's rich history, Vault Hunters have been able to visit many varied and memorable locations across the length and breadth of Pandora, journeying from the spooky forests of Jakobs Cove to the grassy peaks of the Highlands and beyond. Now, thanks to Lilith's discovery of an Eridian Vault Map pointing to several other worlds, players will get to explore entirely new environments, encounter new creatures and cultures, and, naturally, get to blow them up.

For the team, the decision to take *Borderlands* off-world was both an exciting opportunity and a significant production challenge, because the game's scope would balloon with its need for many new game maps, the props to dress them, and visual effects to bring them to life. Art Director Scott Kester recalls how the team began to tackle this monumental effort:

"So the first thing I knew, or what we thought we knew, was we were going to twelve planets. I was like, 'Holy cow, that's a lot of variety.' But pretty quickly we realized we were going to four key ones and then a bunch of what we call galactic locations—asteroids or moons, things like that. All in all, there's fifty maps in the game, twice the amount for *Borderlands 2*, which is absurd.

"The first thing I really did was, I grabbed a bunch of reference material for each kind of thing, and I did this big quad division—I think it's actually still hanging on the wall. It's out of date now, but it's still eerily accurate. At the very center is the spaceship, because we knew we had a ship. And we had reference for Pandora, which we already knew, but I was very

adamant I wanted classic core Pandora-like desert this time around, leaving the grass and the snow kind of out of it.

"Then it was getting the reference for Promethea, going for more of a sci-fi city, and we had a concept of Eden-6, but the name came before we really knew what it was. So really, I took reference and things I thought were cool and I plastered them all up, and put little color swatches that represented what the key colors of the planet were—the primaries and the secondaries and the tertiaries, and that's where we started. So with that split quad, at a glance, you can get the breadth of the entire game."

With the tone and theme of each planet established, work could begin on fleshing out these high concepts into functioning, believable worlds. Everything from the broadest strokes to the tiny details needed to be considered so that players would be able to examine their surroundings, spot visual clues, and gain an understanding of the history and purpose of the alien terrain on which they were now standing. As with the character designs, consistency was just as important as diversity: Each planet provided a blank canvas, but the final results all needed to be recognizably *Borderlands* in their look and feel.

This chapter takes an in-depth look at the creation of the many environments that grew out of that initial reference map, along with several of the smaller locations players will explore during *Borderlands 3*. A closer look at the more significant landmarks and memorable locations in each environment provides insight into how multiple ecosystems have been brought to life this time around. Every planet is also showcased with key pieces of art that help define the ambience and atmosphere of Promethea, Nekrotafeyo, and the many worlds beyond.

LEFT: Promethea.

SANCTUARY III

Traveling to different planets on the hunt for alien vaults may get all the glamour and attention, but without a way to cross the interstellar void, players might as well be stuck on Pandora flapping their arms. Enter the *Sanctuary III*: a Crimson Raiders vessel with a bold, punchy design and a crew of friendly and, occasionally, familiar faces. *Sanctuary* serves as more than just an overworld hub and begins to feel more like a home—this time around players will have their own crew quarters, for example.

Even the team is excited about voyaging to other worlds. "I'm really looking forward to the *Sanctuary* ship, just because it'll be cool to see space travel for the first time," enthuses Christofer Strasz, *Borderlands 3*'s Lead UX Designer. "Plus the cast feels like they'd work well as a crew."

The development team was inspired by the prospect of visiting so many different alien locations. Adding planets made the scope of each team's work much broader, as new planets meant new art sets, creatures, enemies, gameplay mechanics, and more would have to be designed and implemented. *Borderlands 3* is clearly the largest game to date that Gearbox Software has made—not just in the *Borderlands* franchise.

The Vault Hunters will get a taste of the rough side of this larger universe early in their adventure, after their trip to Pandora turns out to be just the first leg of a voyage that spirals out across the stars. In addition to traveling aboard the *Sanctuary III*, players will encounter dangerous orbital platforms and foreboding shipwrecks, all of which help define the vast and varied cosmos in which *Borderlands 3* takes place.

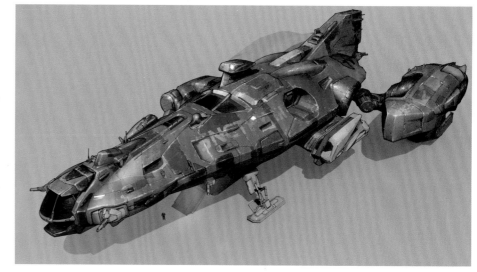

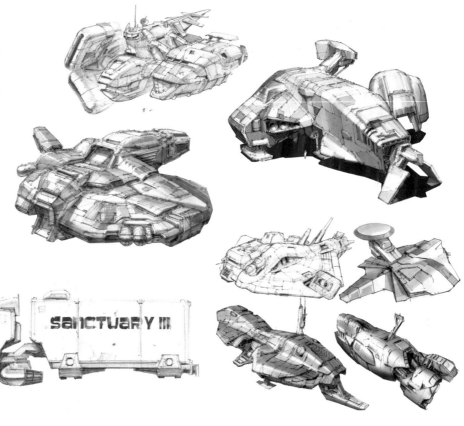

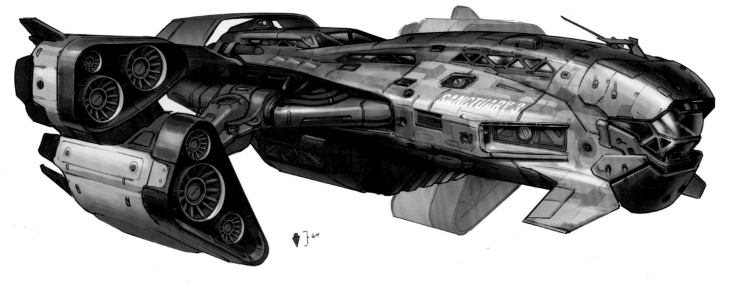

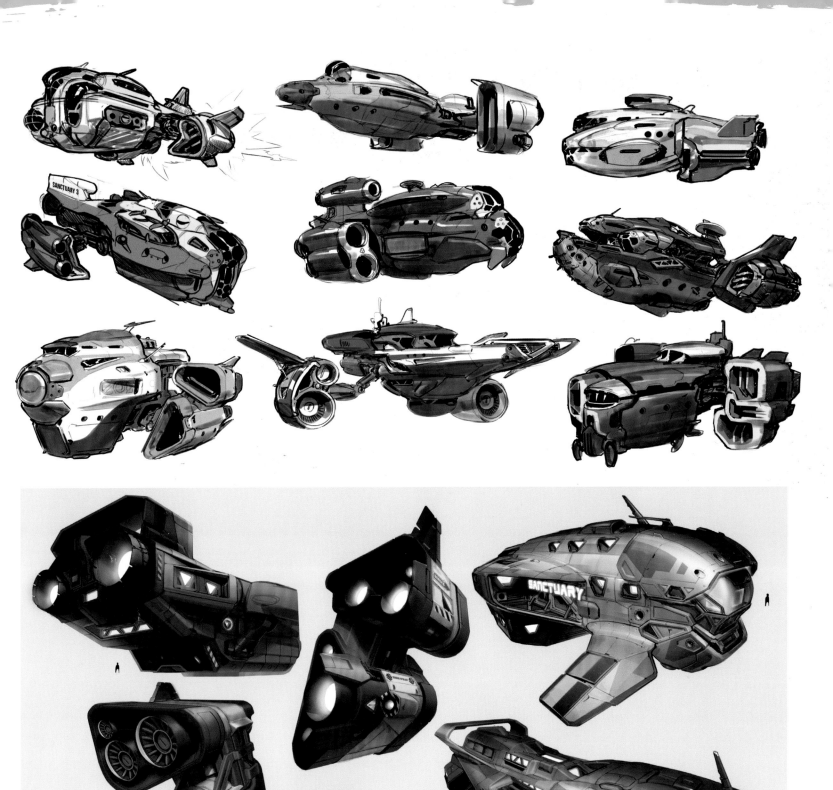

OPPOSITE TOP: The initial batch of concepts for *Sanctuary III* explored all sorts of shapes and sizes of ships, including a literal "space truck" and asymmetrical designs, along with more traditional sci-fi spacecraft.

OPPOSITE BOTTOM: *Sanctuary III*'s final design and color scheme. The ship's thrusters can be angled for atmospheric flight. Cargo can be taken aboard via either the large ramp visible under the ship or through the airlock on its side.

TOP: Potential paint jobs for *Sanctuary III*.

ABOVE: Alternate thruster designs.

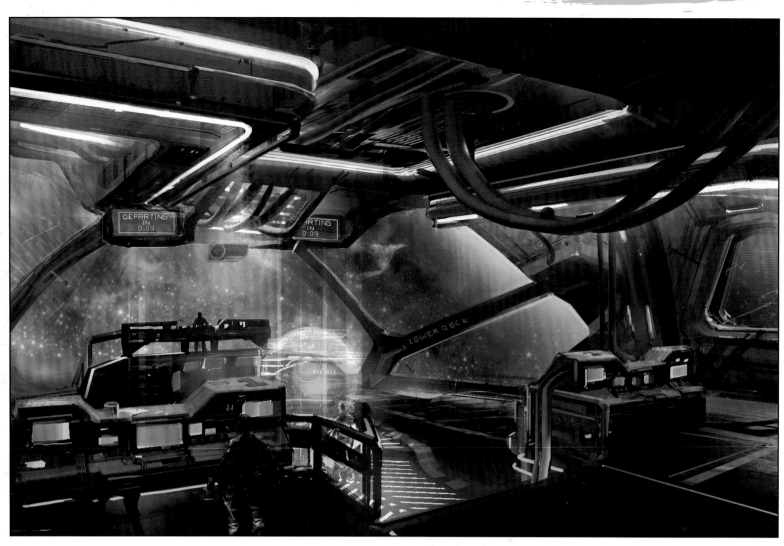

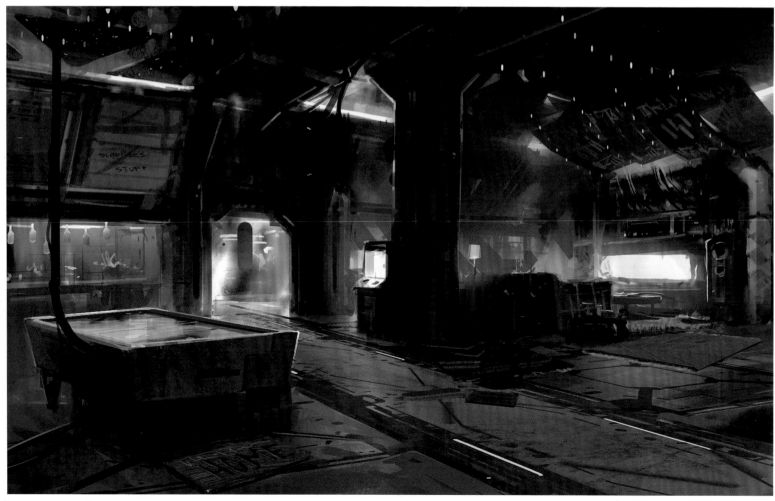

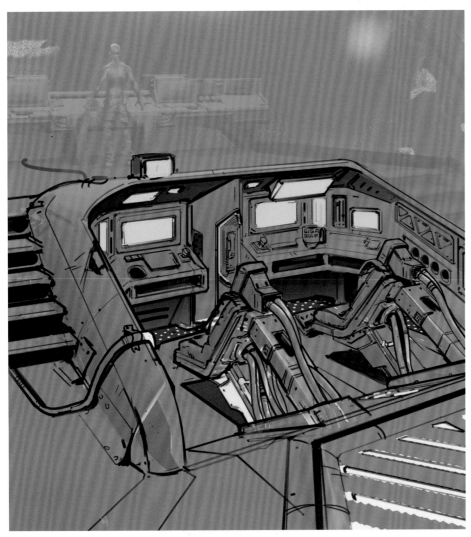

OPPOSITE: Until its unfortunate destruction, the original Sanctuary on Pandora was a refuge built atop Dahl's mining ship, the *Sanctuary*. This time around, there's no disguising the interstellar origins of the good guys' safe haven.

THIS PAGE: Paint-overs and concept pieces of control consoles for use aboard the *Sanctuary III*.

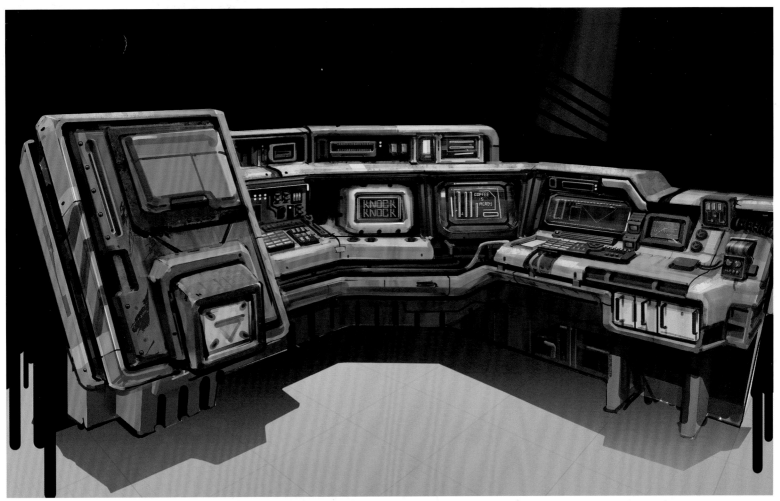

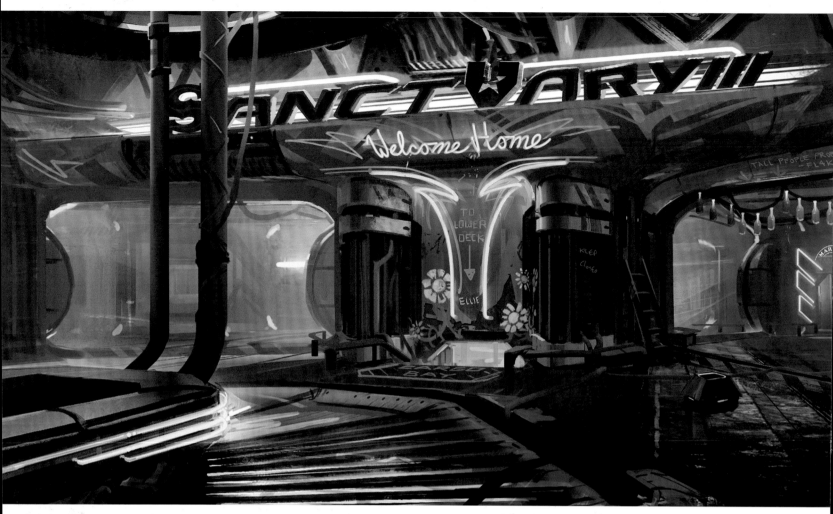

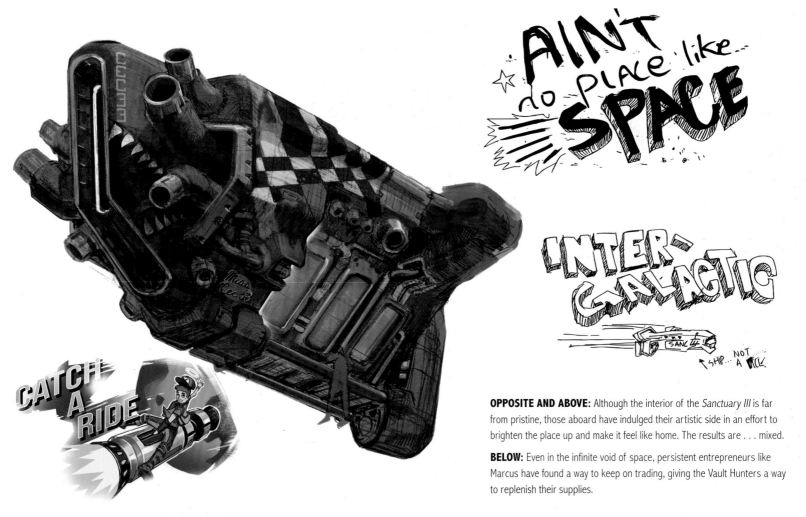

AIN'T no place like SPACE

'INTER-GALACTIC'

↑ SHIP... NOT A DICK

CATCH A RIDE

OPPOSITE AND ABOVE: Although the interior of the *Sanctuary III* is far from pristine, those aboard have indulged their artistic side in an effort to brighten the place up and make it feel like home. The results are . . . mixed.

BELOW: Even in the infinite void of space, persistent entrepreneurs like Marcus have found a way to keep on trading, giving the Vault Hunters a way to replenish their supplies.

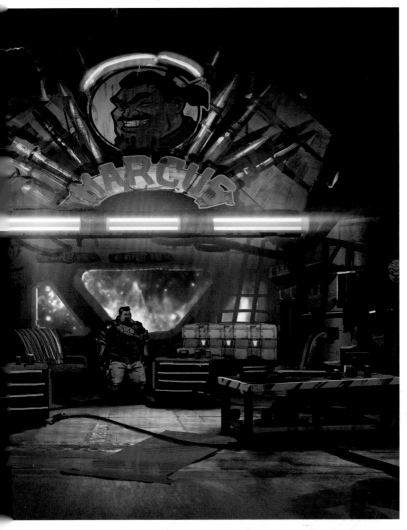

SPACE

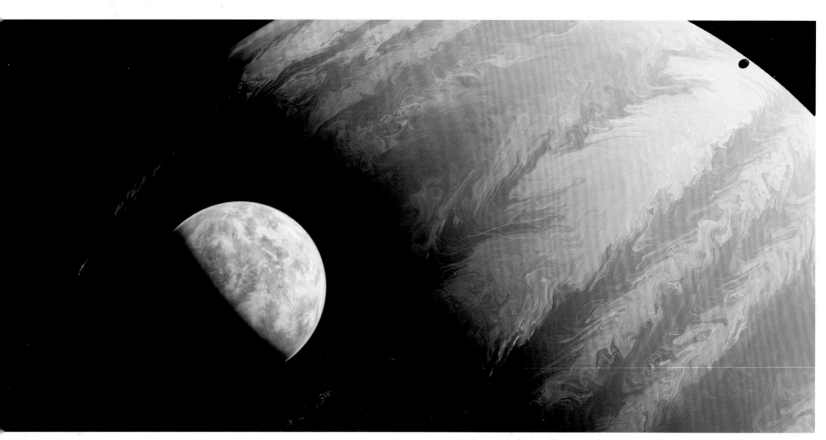

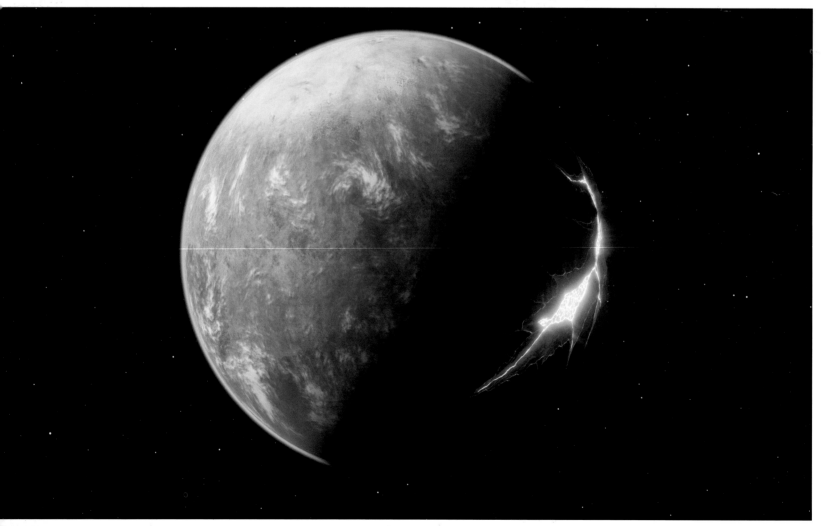

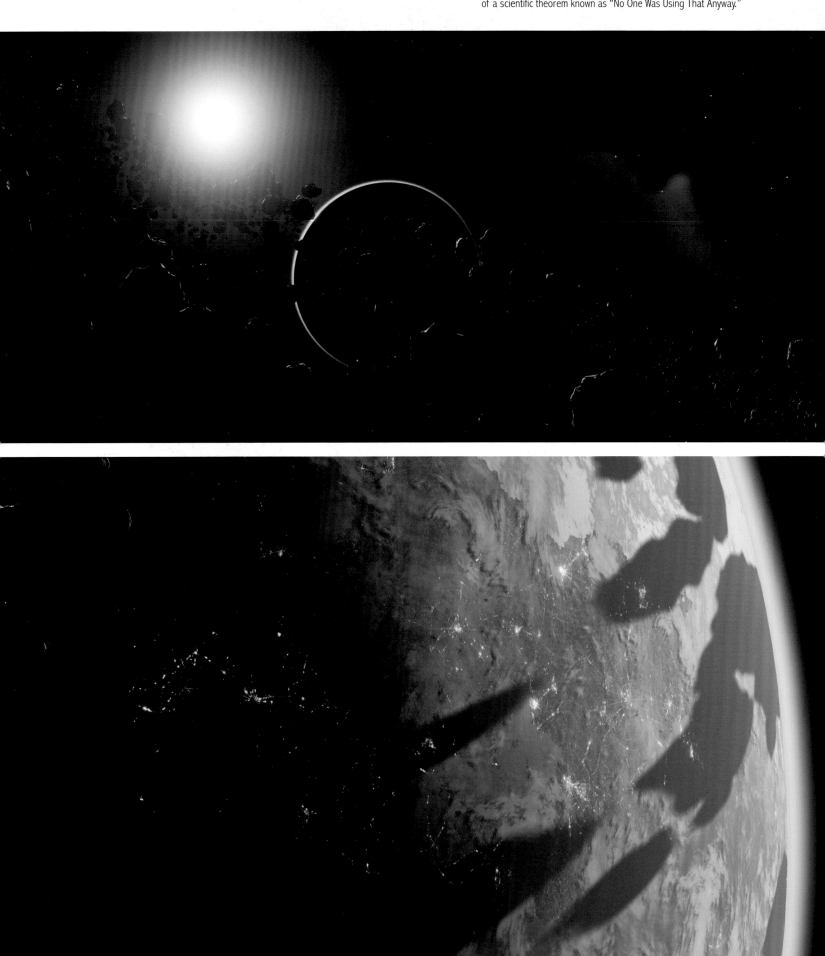

BELOW: Space travel in *Borderlands* utilizes implosion drive, a technology that calculates a path between the vehicle and its destination, then collapses all the empty space-time within. This is made possible by practical application of a scientific theorem known as "No One Was Using That Anyway."

PANDORA

Veteran players get a chance to reacquaint themselves with Pandora's familiar contours at the beginning of *Borderlands 3*, but it isn't until late in the game that the Vault Hunters, returning to her dust-coated deserts, experience something of a homecoming. Unfortunately, it's hardly a happy reunion, as players must immediately take the fight to the Calypso Twins and their forces, who are active in a number of previously unexplored locations across the planet.

The Crimson Raiders have maintained their foothold on Pandora even in the face of increasing hostility and are busy defending Roland's Rest from the Children of the Vault and other threats. Early in development, an expansive launch base owned by the Dahl Corporation was also in the cards, and several sketches of its various areas and components were created.

Whether the Vault Hunters are visiting old stomping grounds like Pandora or working their way through brand-new environments elsewhere in the galaxy, they'd have a much tougher time finding their way around were it not for the in-game map. Previous entries in the *Borderlands* series had relied on a simple top-down representation of each area, but the team needed to rethink how players would navigate this time around.

"More locations means a bigger map, that out of necessity needs more functionality than just telling you where you are with a 3D image," comments Keegan Chua. His fellow UI Designer Trisha DeSalvo adds: "*Borderlands 2* had a regular flat map that changed depending on the zone, but we knew that wasn't going to cut it anymore. Being able to view on the galaxy scale all the way down to regional size was really important so that the player could really get a sense of the scale of the universe. It was a huge challenge."

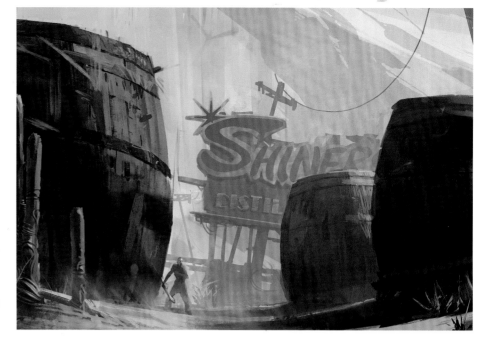

TOP: Distilleries are considered important locations by the denizens of Pandora, as they provide the alcohol that makes day-to-day bandit life, if not bearable, then at least easier to forget.

CENTER AND RIGHT: The defeat of Handsome Jack has done little to make Pandora's desert wastes less threatening.

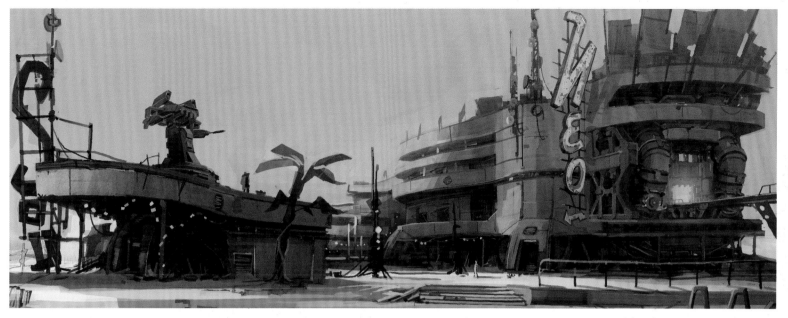

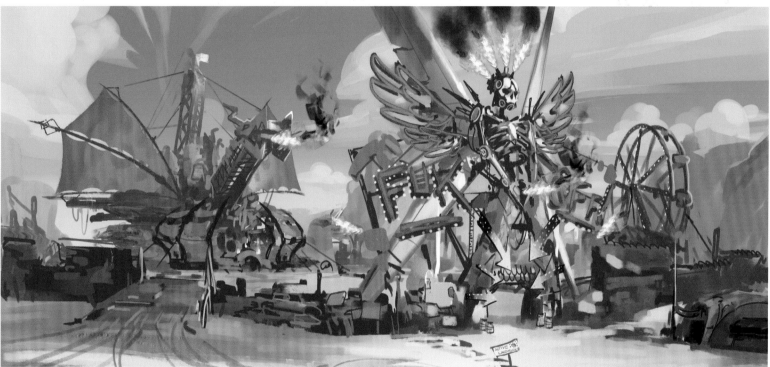

TOP AND CENTER: From the outside, Carnivora—as its name suggests—resembles a gruesome, violent carnival designed to attract Pandora's population to its grisly displays.

ABOVE AND LEFT: The propaganda and graffiti that now litters Pandora leaves little doubt as to who thinks they're in charge nowadays.

PANDORA
CARNIVORA

One particularly memorable location is the site of the festival Carnivora: a massive compound that not only resembles a bandit vehicle but actually is one, and is able to roam across the deserts of Pandora with its crew of thugs and killers defending its vast interior workings.

BELOW: The chaos and carnage of the festival pictured is what attracts many of its visitors.

OPPOSITE TOP: At the heart of Carnivora's grungy corridors lies an enormous multilevel hangar. This hive of activity is filled with enormous piles of scrap metal, garages containing bandit vehicles, huge cranes, and a veritable army of unfriendly faces.

OPPOSITE BOTTOM: The vehicle's immense wheels are large enough to pulverize any ride the Vault Hunters might encounter.

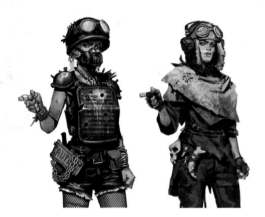

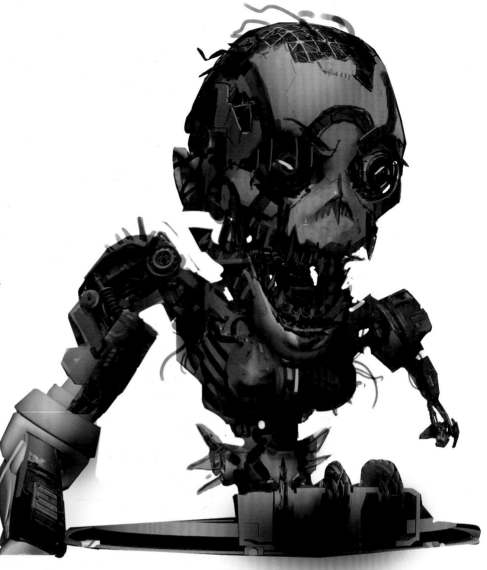

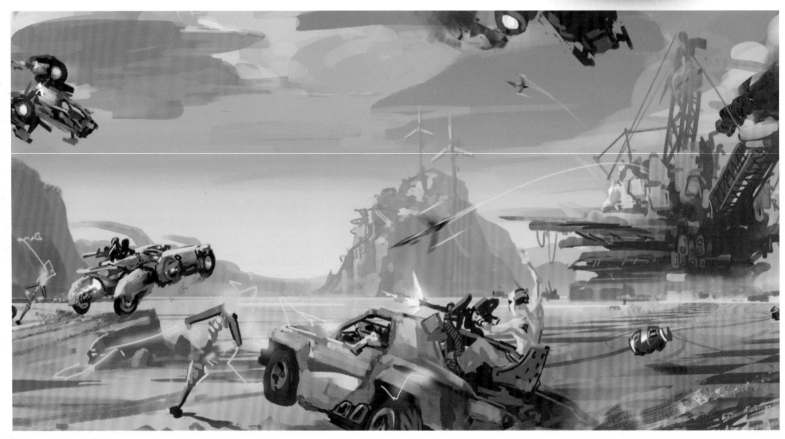

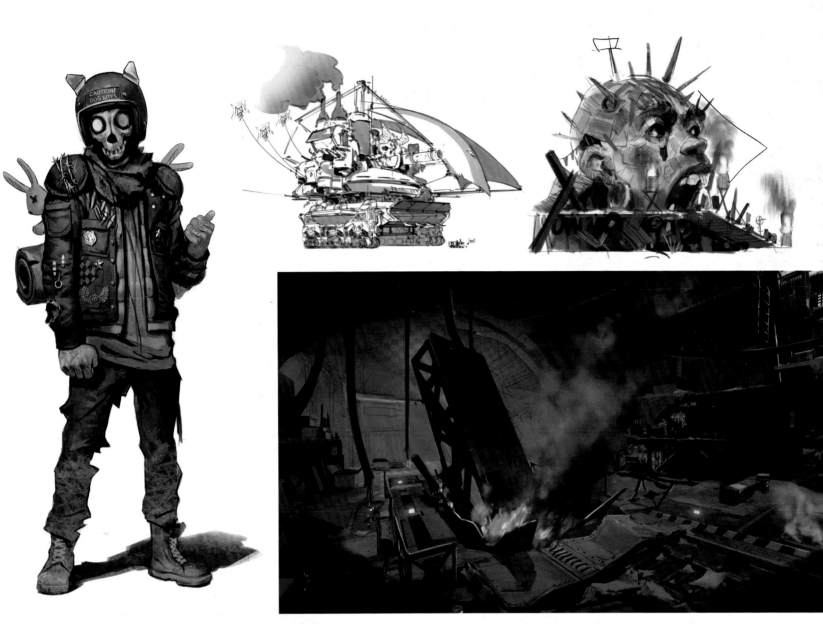

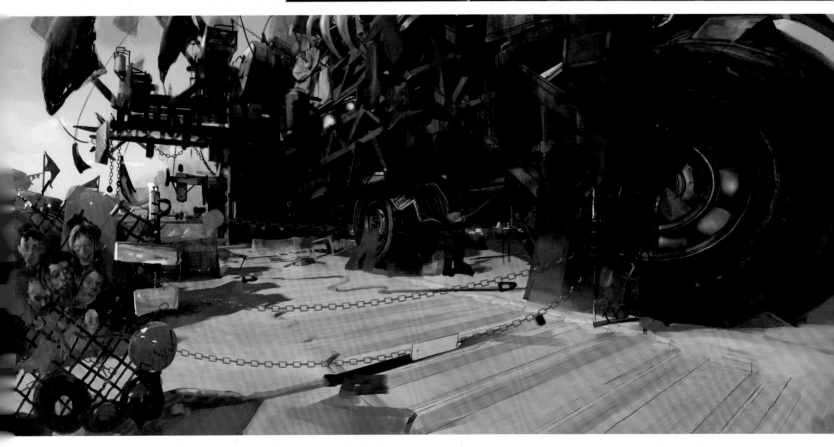

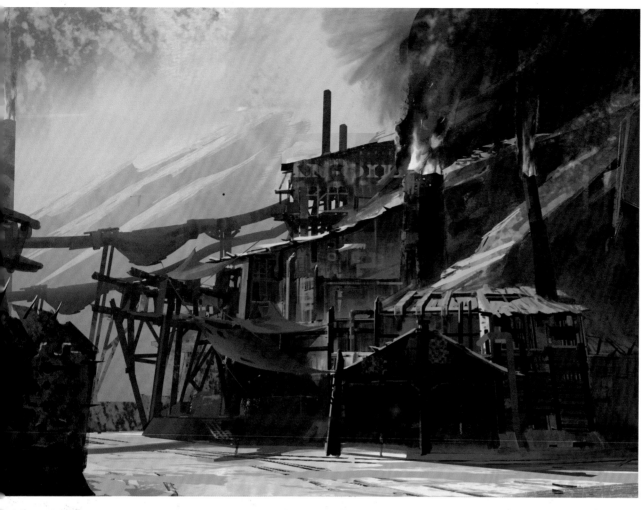

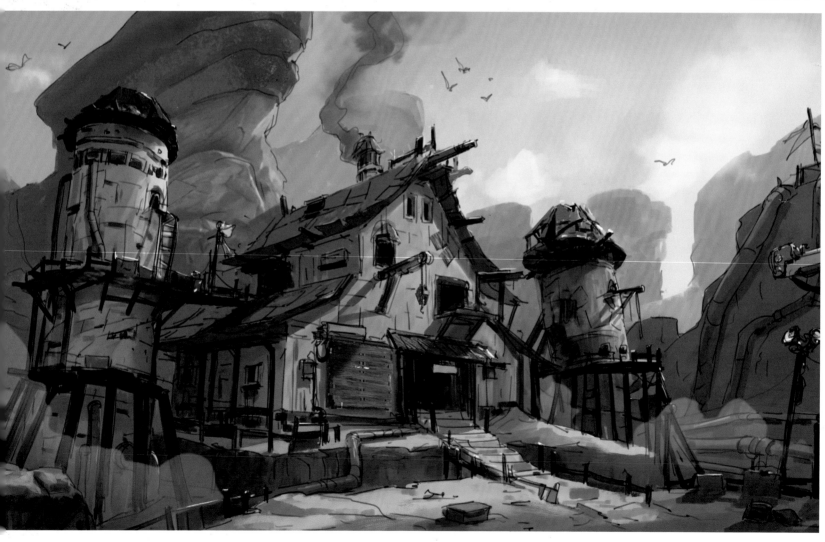

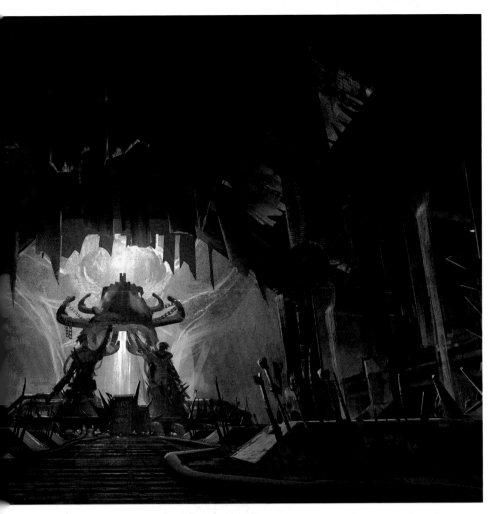

OPPOSITE: The run-down shacks and shantytowns dotted across Pandora provide little relief from the approaching menace of the Calypso Twins.

THIS PAGE: The skyline of Pandora is utterly transformed as Troy and Tyreen put the final phases of their plan into action. The Vault Hunters must lead a final assault on the Cathedral of the Twins.

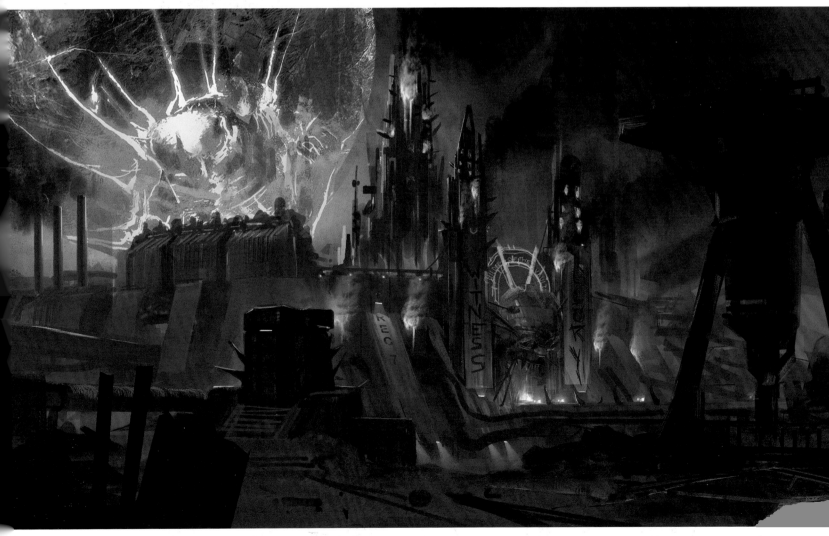

PANDORA
HOLY BROADCAST CENTER

RIGHT AND BELOW: Stained glass windows installed at the Holy Broadcast Center by the Children of the Vault, treating Troy and Tyreen as the deities they aim to become.

OPPOSITE: The Holy Broadcast Center was originally constructed as a control tower for a nearby Dahl spaceport. Now, its powerful ECHO arrays are used to beam out constant livestreams of murder and worship.

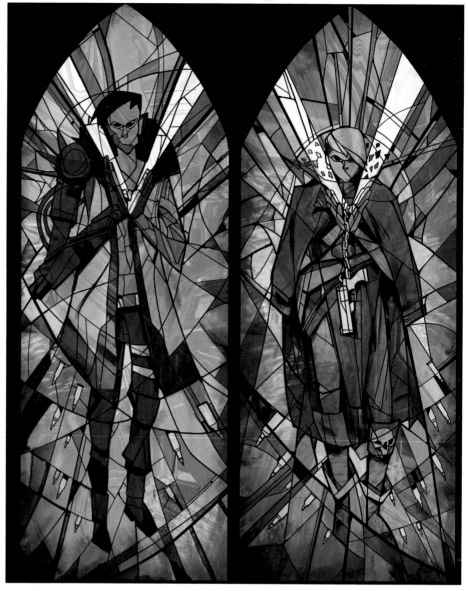

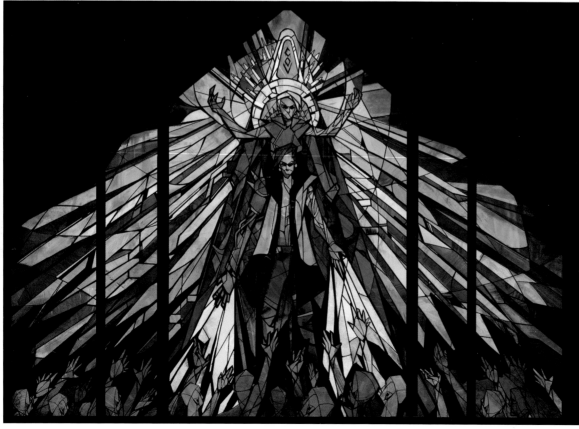

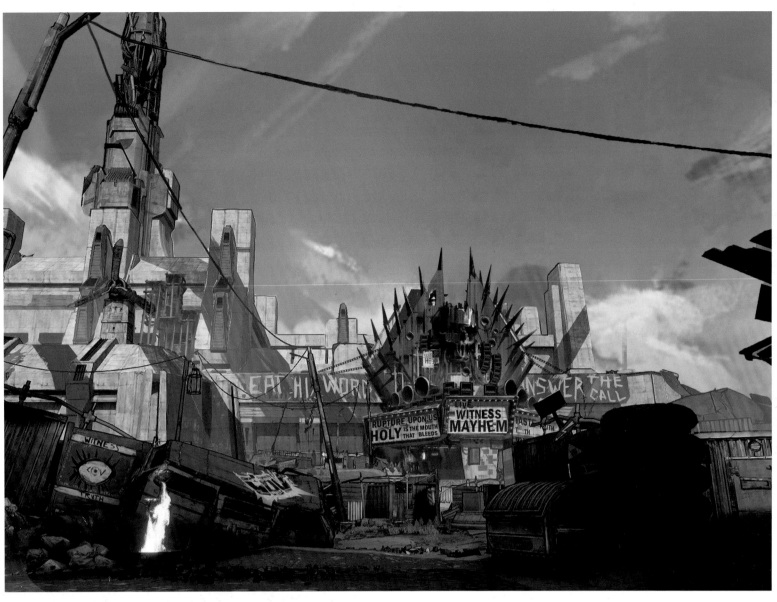

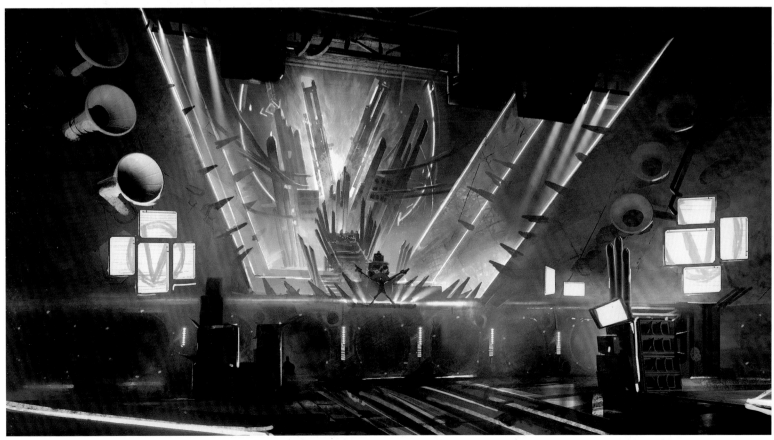

PROPS

HOLY BROADCAST

PIECE UPON US

MOUTH PIECE

HOLY ARE THE EYES THAT HEAR

FIND PURPOSE CLEANSE YOUR SKIN REBIRTH SPECIAL POWERS EAT MEAT

CHILDREN OF THE VAULT

GIVE YOUR FLESH TAKE YOUR GUNS

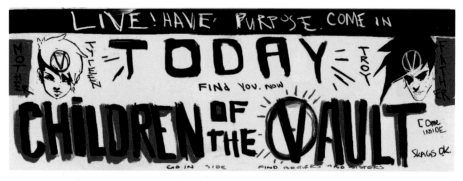

LIVE! HAVE PURPOSE. COME IN TODAY
MOTHER TROY FATHER
FIND YOU. NOW
CHILDREN OF THE VAULT
COME INSIDE SKAGS OK
GO IN SIDE FIND BROTHERS AND SISTERS

GIVE YOUR SKIN
CHILDREN OF THE VAULT CHILDREN OF THE VAULT
WEAR THE MARK

COME JOIN COME
BE TRIESTED BEHOLD the GLORY
CHILDREN OF THE VAULT

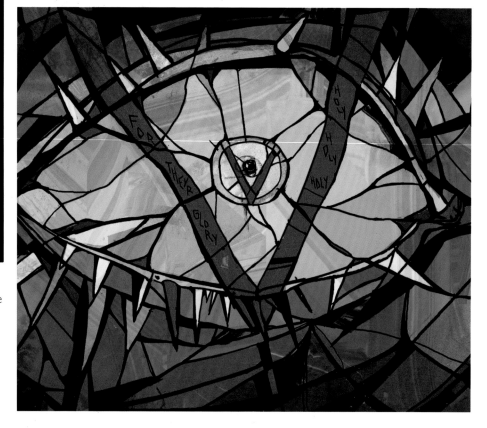

THIS PAGE: Handmade placards and signs stand in striking opposition to the messianic language and imagery the Children of the Vault use elsewhere on Pandora.

OPPOSITE TOP: The recruitment sign above the entrance to the Holy Broadcast Center.

OPPOSITE BOTTOM: A CoV recruitment sign of the kind depicted here appeared in the opening shot of *Borderlands 3*'s worldwide reveal, before giving way to the grand entrance of the Calypso Twins.

SIGNAGE

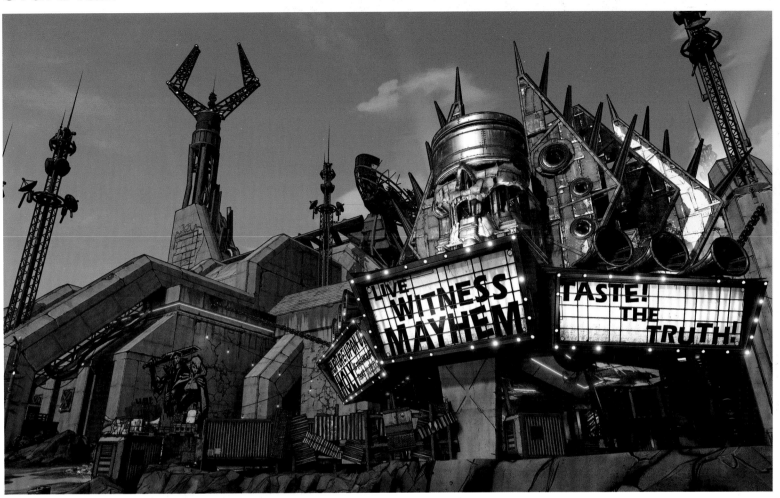

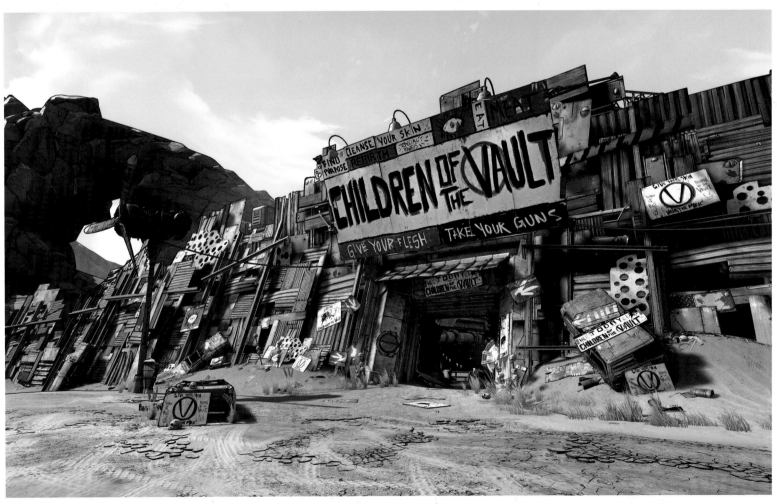

PROPS

RIGHT: It was only natural that Marcus, a born storyteller, would take an interest in the ultimate form of narrative entertainment—video games.

BELOW: Loot continues to be crammed into every nook and cranny of Pandora, from disused mailboxes to the enticing interior of a Dahl outhouse.

Top of cartridge visible when in use

Beefy cartridge with plenty of deco space

Blinking light makes cartridges visible in gam

Drop Items

Select/ Enter "A" on controller

Direction+ click to "Mark" items

Back/ Reject "B" on controller

DAHL LABS

INSERT CARTRIDGE

ELPIS

A tidally locked moon, Elpis has seen its share of mayhem in previous *Borderlands* titles, but here it is revealed to have an ancient purpose: It's the Vault Key to the largest Vault in existence, Pandora itself. The moon goes through some apocalyptic phases as the Calypso Twins' plans unfold. As for Elpis's established population . . . maybe they were all evacuated? They're fine. Probably.

RIGHT AND BOTTOM: Elpis, hanging low in the sky over Pandora. Its cracked, scarred surface is the result of past Dahl mining efforts as well as a more recent assault from Helios.

BELOW: Two color studies of Elpis acting as a "lens" for an Eridian machine, directing a beam of energy down toward the surface of Pandora.

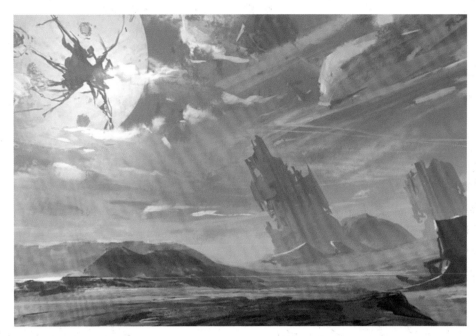

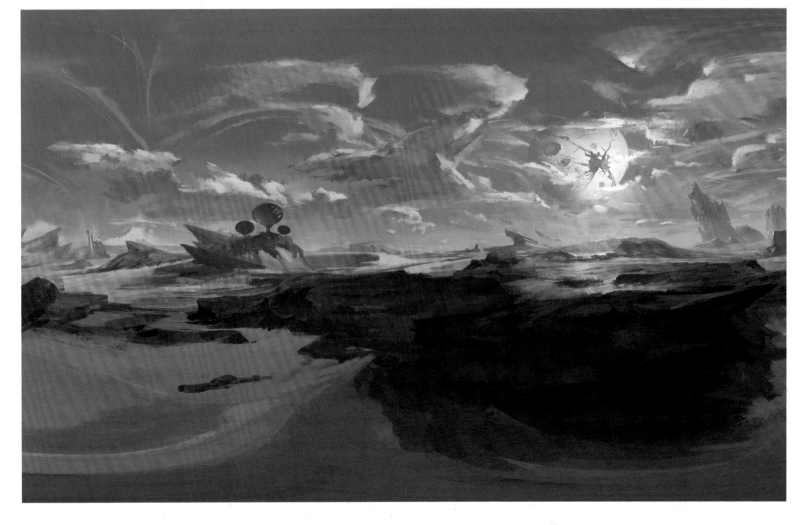

PROMETHEA
CITY

"Visiting new planets other than Pandora is definitely going to change the game," states Concept Artist Max Davenport. "We have our own guidelines when designing things for *Borderlands*, so new planets just give us a new subset of conditions to work with. It helps us offer more than we'd be constricted to if we kept things on Pandora proper, and it really just opens up the creative opportunities for us."

Promethea is the first new planet the Vault Hunters will visit during *Borderlands 3*, and they'd better be prepared for culture shock. Compared to the rocks and rugged terrain that have defined the arid surface of Pandora in previous *Borderlands* entries, the Promethean landscape is typified by its buildings: a vast concrete jungle of hard surfaces and gridded lines.

Having left Pandora behind, the creative team was presented with a completely blank rule book for not just imagining, but also actually constructing the finer points of these vastly different locations. Producer Anthony Nicholson explains: "Up to this point, the environment that you've played in is sand and rocks. That's completely different from when we first travel to Promethea. Now there's a skyline with skyscrapers, cars that aren't just shooting you, subway stations, and different things like that. So we needed to ask, How do we build that? How does it look different from Pandora? The roads obviously aren't just dirt roads, say, so how do they look?"

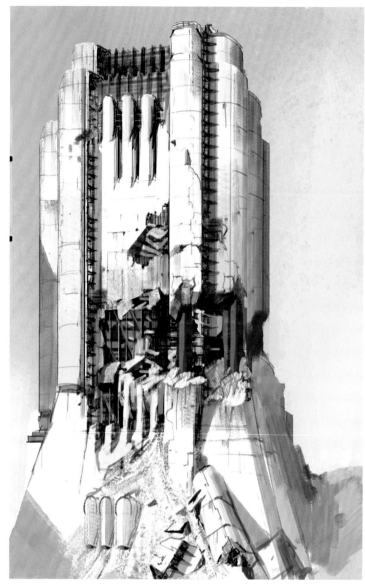

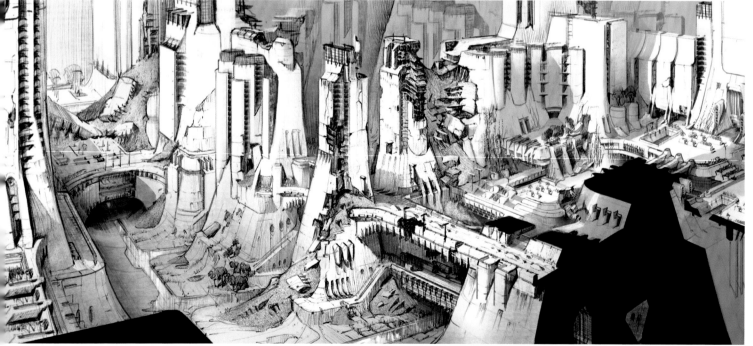

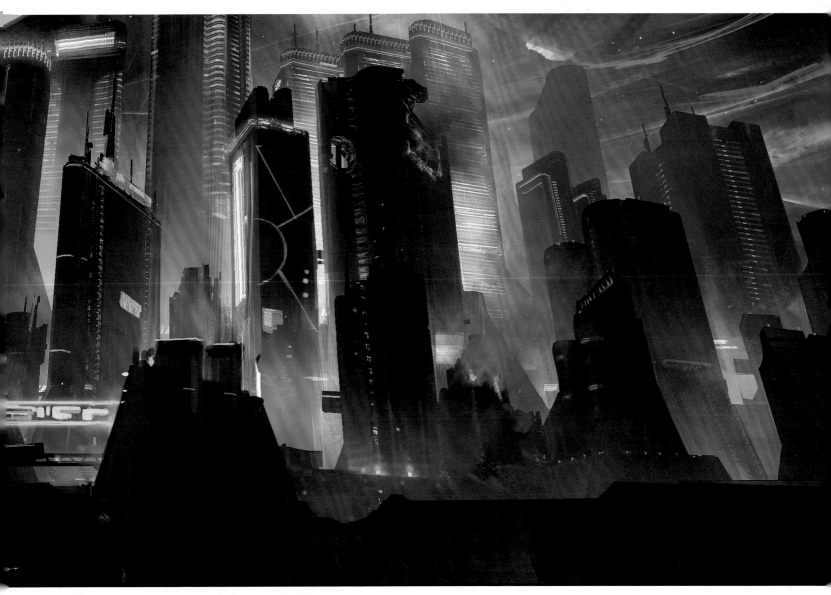

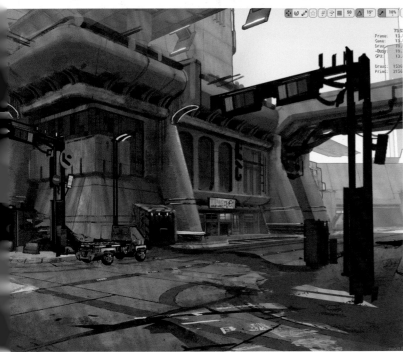

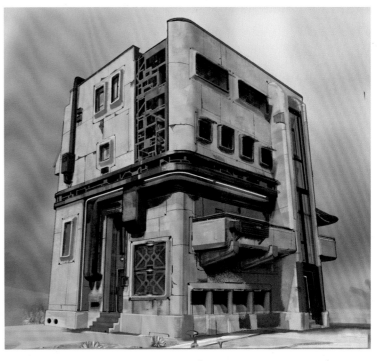

OPPOSITE BOTTOM: A three-quarters sketch of the Promethean city Meridian, showing the scale of the devastation inflicted by the conflict with Maliwan.

TOP: A Promethean cityscape offers a very different kind of environment to explore.

ABOVE: Despite the destruction, many of Meridian's buildings remain in better shape than the dilapidated dens of Pandora.

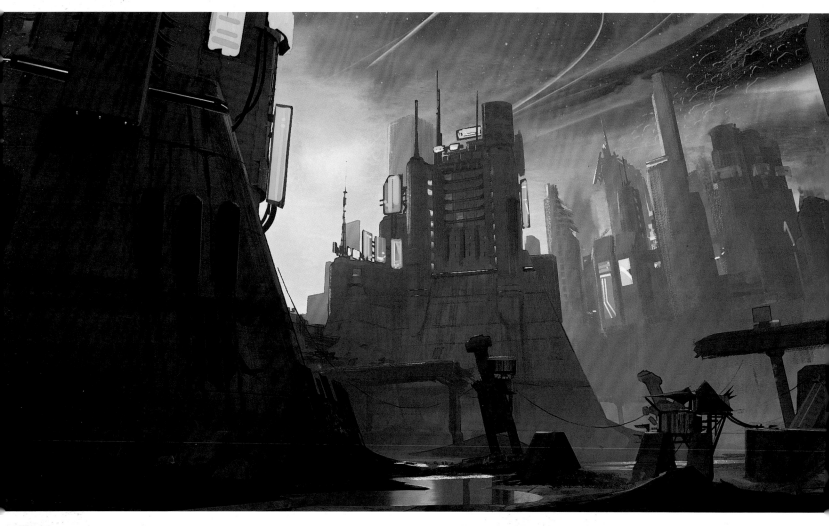

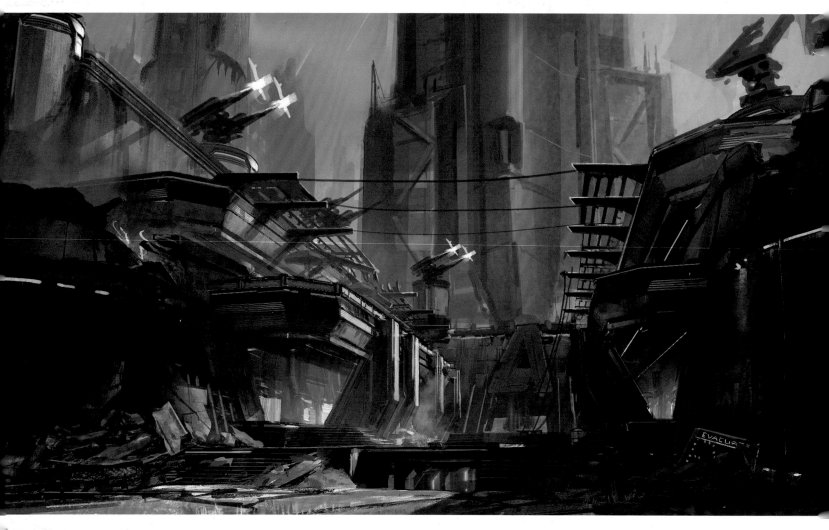

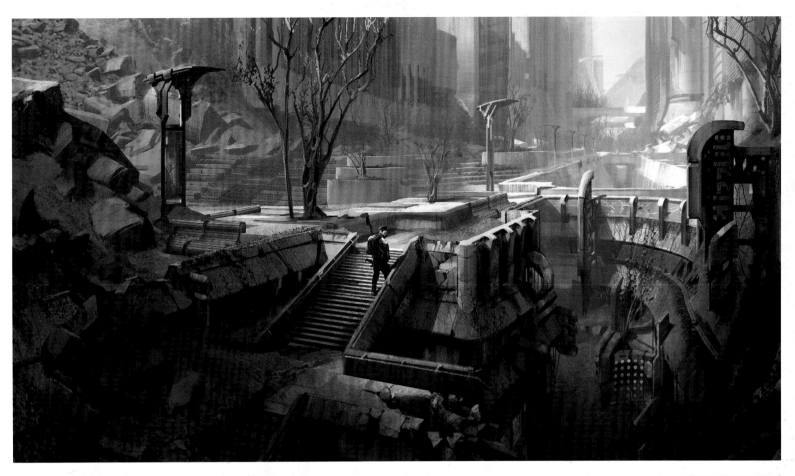

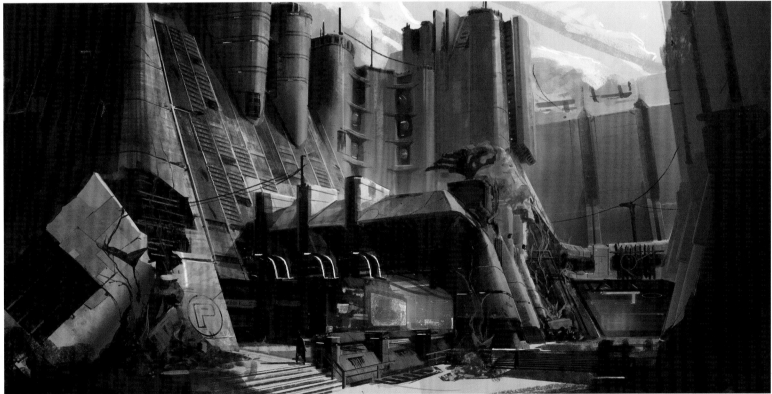

OPPOSITE TOP: In true *Borderlands* fashion, the first metropolitan area the Vault Hunters will visit isn't a glittering terrace bathed in neon or a landscaped corporate campus—it's a drainage ditch. This less-than-glamourous location now houses the civilians who have fled Maliwan's invasion.

OPPOSITE BOTTOM: The approach to Atlas HQ. Mounted turrets can be seen keeping enemy forces at bay.

THIS PAGE AND PAGES 94–95: Once-proud parks and plazas alike have been reduced to piles of rubble in recent days.

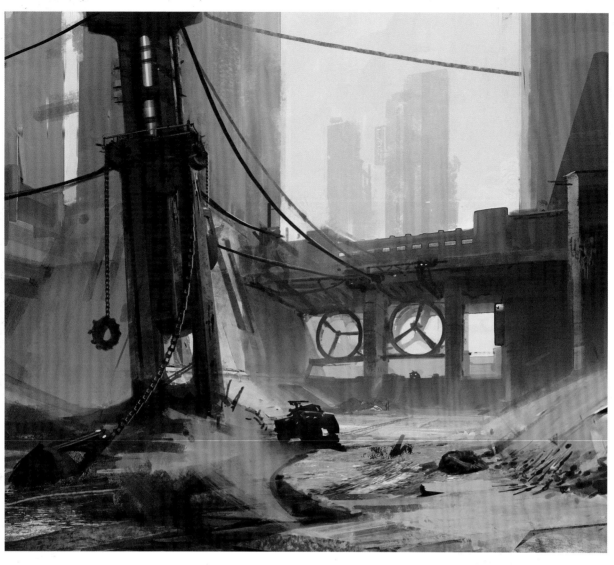

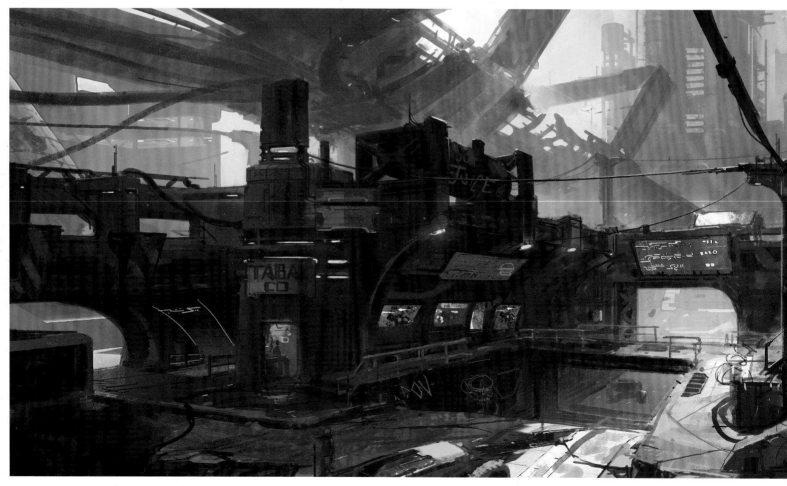

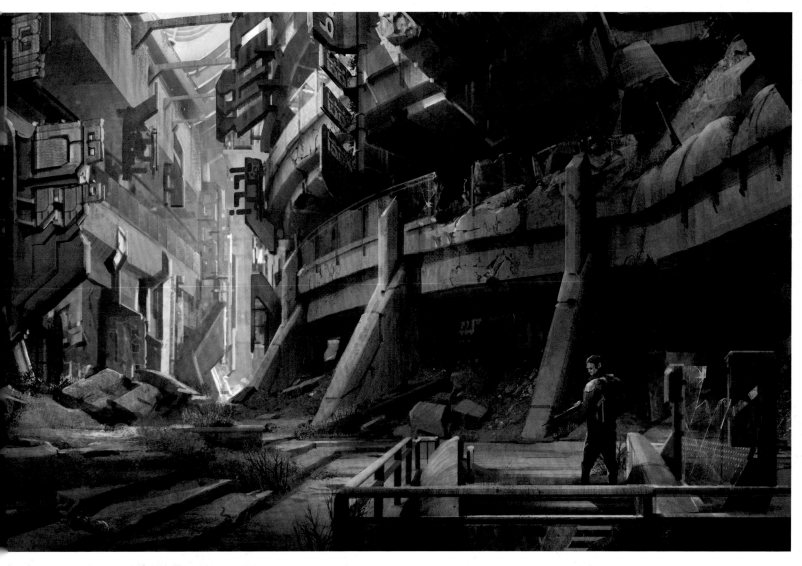

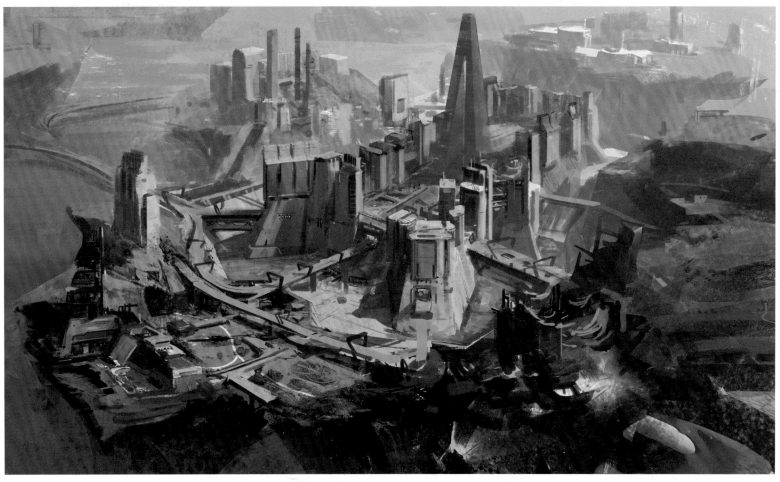

PROMETHEA
ATLAS HQ

Promethea is a planet caught in a crossfire, as Atlas and Maliwan—two huge manufacturers struggling for domination—trade blows across its surface and in high orbit. This feud will give players the opportunity to visit Atlas headquarters firsthand, offering a glimpse into the corporate power struggles behind much of the bloodshed in the *Borderlands* series.

BELOW: Huge Atlas gun turrets positioned around its headquarters help deter unwanted guests and discourage office supply theft.

OPPOSITE TOP: The main approach to the Atlas building leads visitors across a heavily guarded bridge.

OPPOSITE BOTTOM: Two concept images of the lavish interiors inside the headquarters building, the latter decked out with Atlas's signature color scheme.

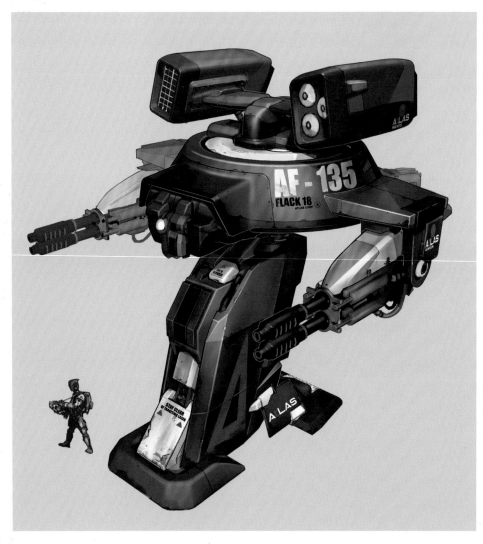

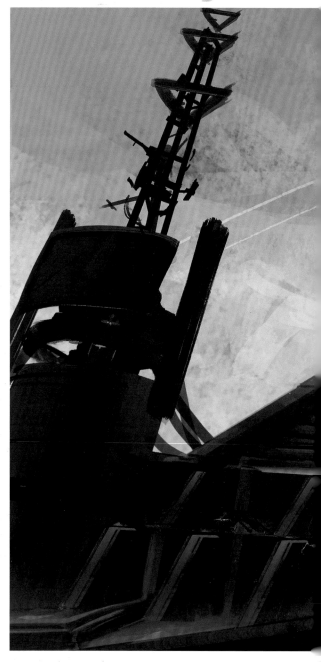

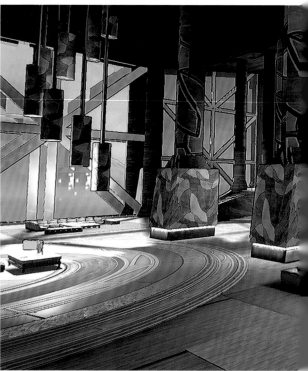

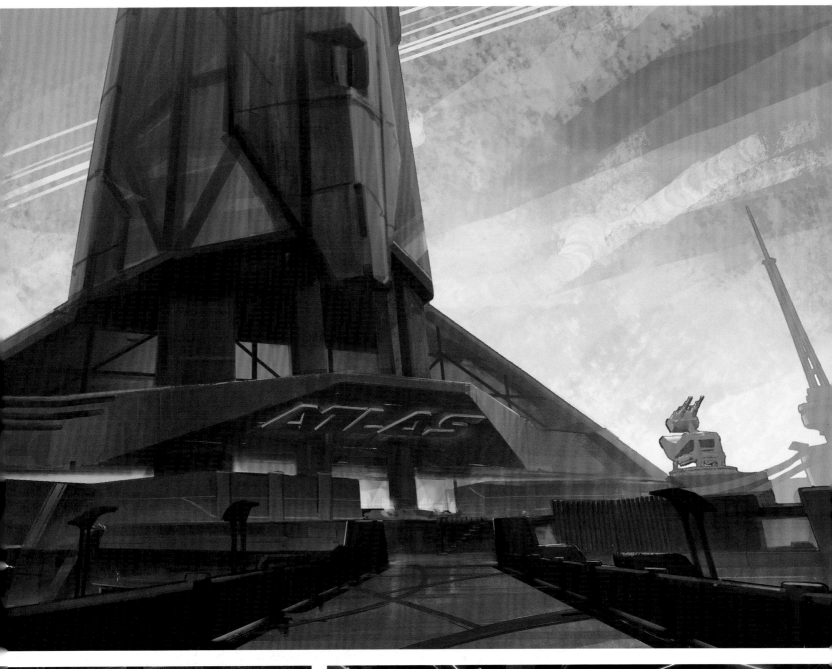

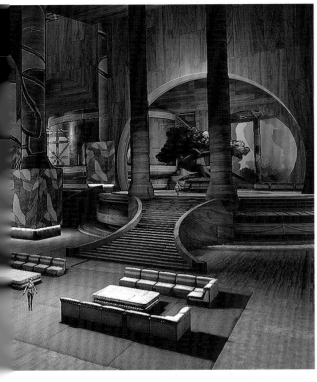

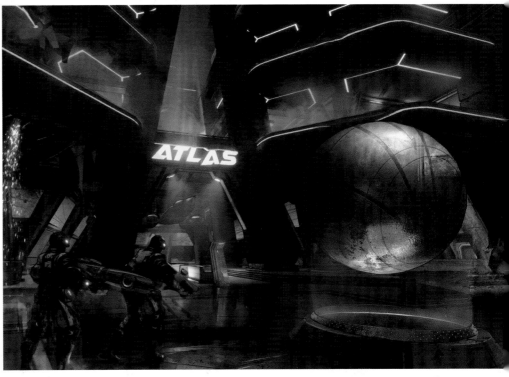

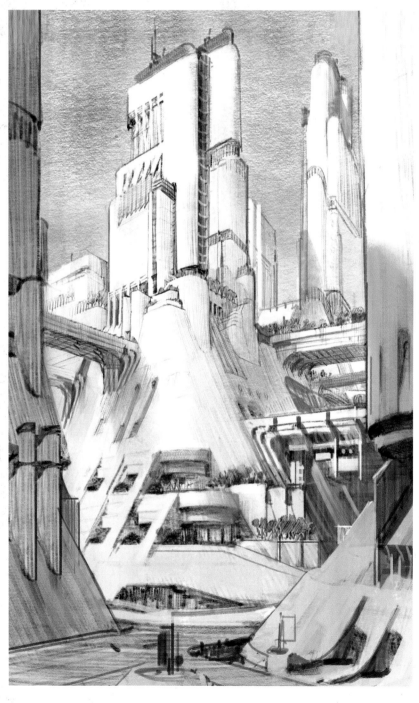

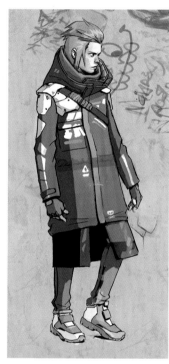

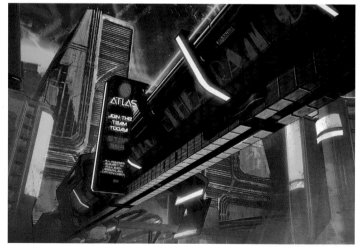

TOP, LEFT, AND ABOVE: The industrial areas of Promethea's metropolis serve as a stark contrast to its residential and business districts.

CENTER RIGHT: Ordinary Promethean civilians have been forced to flee their homes. A few, like Lorelei, have taken up arms to defend themselves.

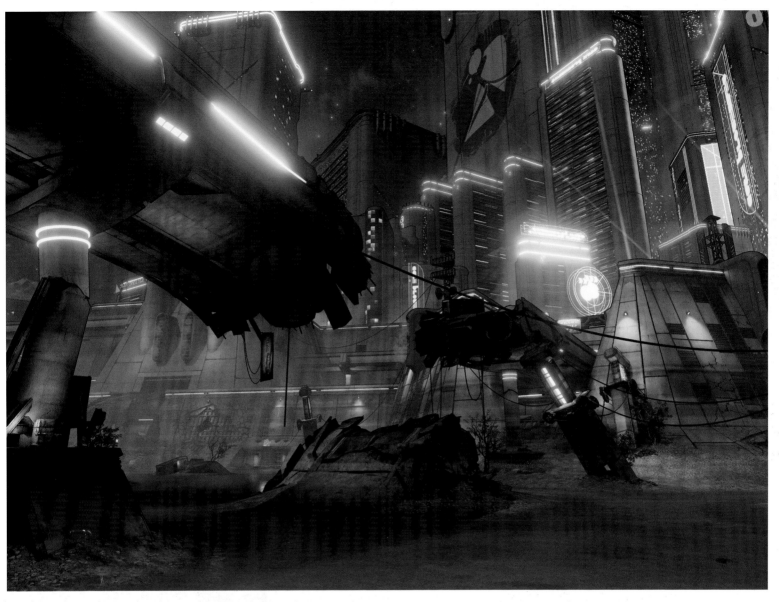

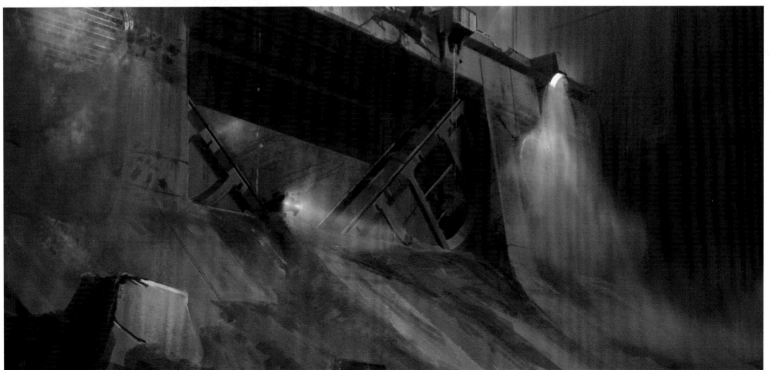

ABOVE: As shown in these two concept pieces, the war has torn apart entire freeways, sending concrete and cars alike down into the mud and slurry that coats Meridian's lowest levels.

PROMETHEA
VAULT

On their journey across Promethea, the Vault Hunters are dwarfed by buildings looming high overhead, liberate a captured command center, and fight their way through the underbelly of a city that's largely in ruins thanks to the Children of the Vault and their allies. An Eridian Vault lies somewhere below the sprawling city streets.

RIGHT: A sketch showing the layers of civilization that eventually lead down to the Vault entrance. Beneath Meridian, a network of subway tunnels sits atop rock and sediment, all of which has long disguised the Eridian ruins below.

BELOW: The Children of the Vault have taken advantage of the war between Atlas and Maliwan, and begun to make their presence known upon Promethea as they hunt for the Vault.

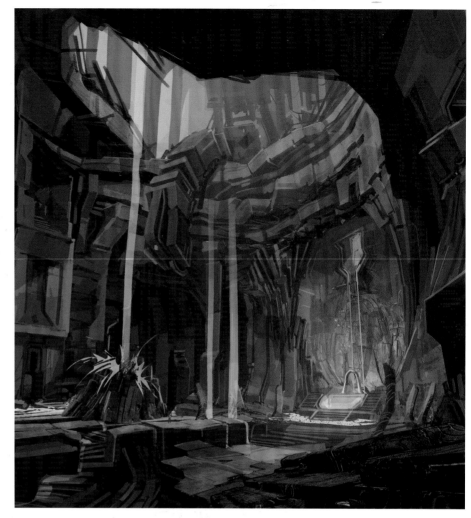

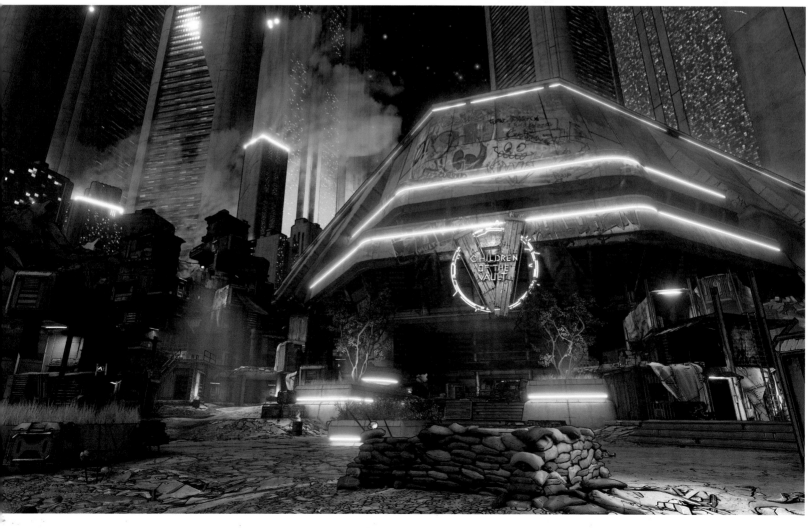

SIGNAGE

RIGHT: The populace of Promethea can still be persuaded to place bets on violent sporting events.

BELOW: Many of the signs around Promethea display a second script alongside more familiar words and phrases.

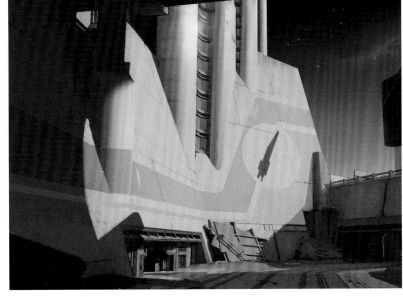

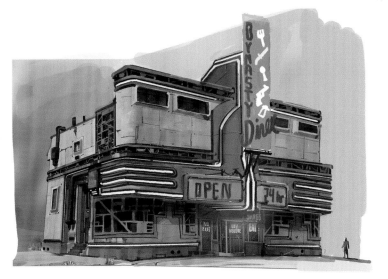

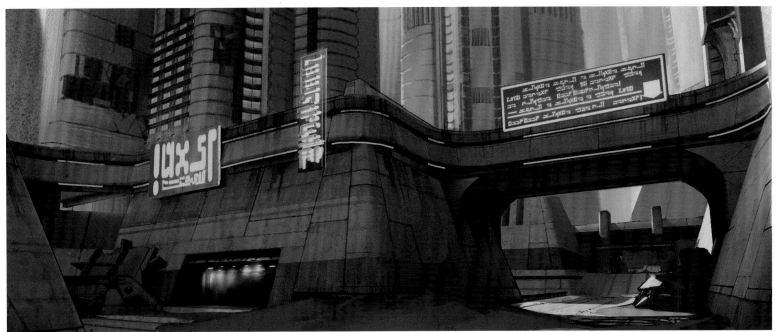

PROPS

BELOW: Maliwan-branded containers for storing weapons, ammo, and other loot that's just begging to be sifted through by passing adventurers.

BOTTOM: A mass-transit system runs beneath the Promethean streets and gets Meridian's inhabitants from place to place, though more traditional vehicles are still used to haul goods above ground.

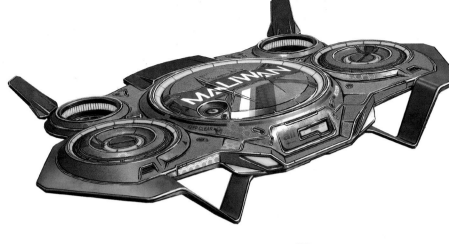

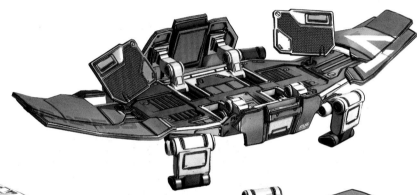

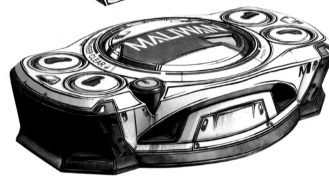

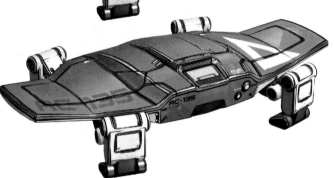

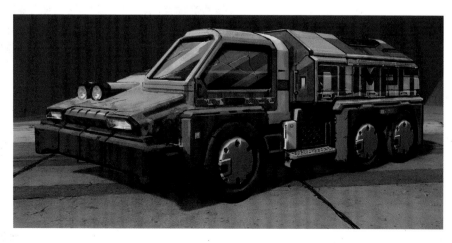

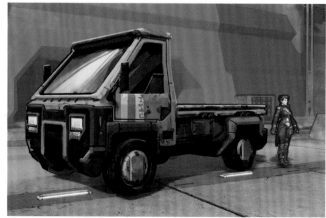

SKYBOX

LEFT: Promethea is ringed by an asteroid belt, the rocks of which were heavily mined by Atlas in the past.

BELOW: At night, the skies over Meridian are dazzling enough to make even the most hardened Vault Hunter stop and take a moment to drink in the scenery. Just one, though. There's people that still need shooting.

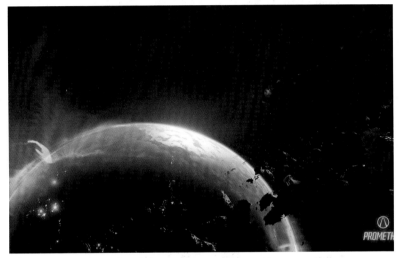

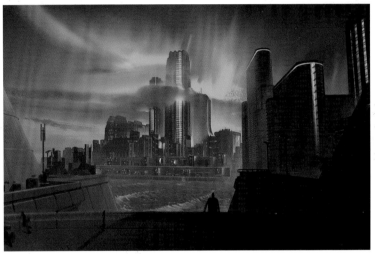

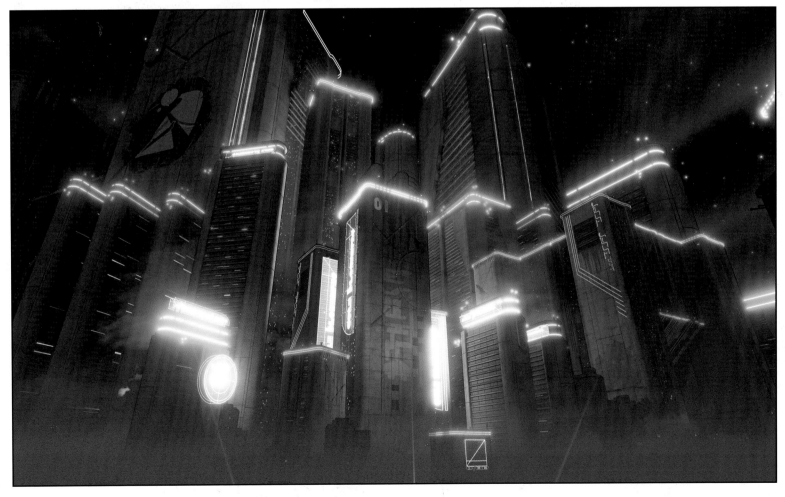

ORBITAL PLATFORM

RIGHT: A collection of signs and decals meant for Dahl's Skywell platforms.

BELOW: An interior corridor.

BOTTOM: Now that Maliwan has discovered the Skywell operation, a titanic mining laser has been repositioned to target Promethea itself.

OPPOSITE TOP: The asteroids that ring Promethea are rich in minerals, and many were first excavated by Dahl before being transformed into facilities intended for further mining efforts.

OPPOSITE BOTTOM: An entrance to the platform.

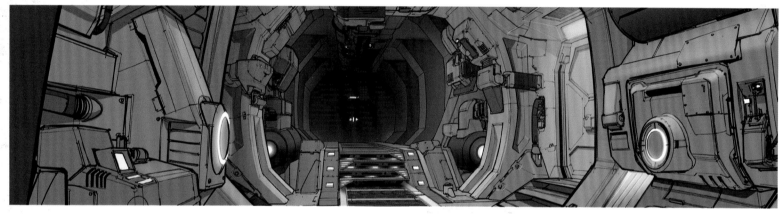

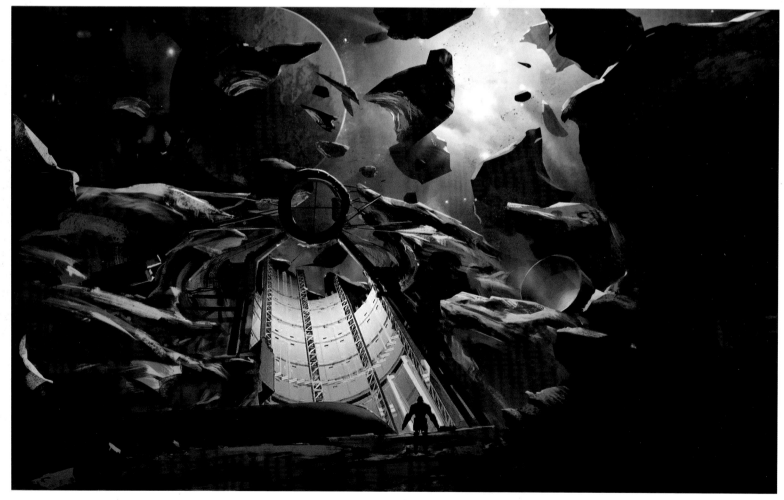

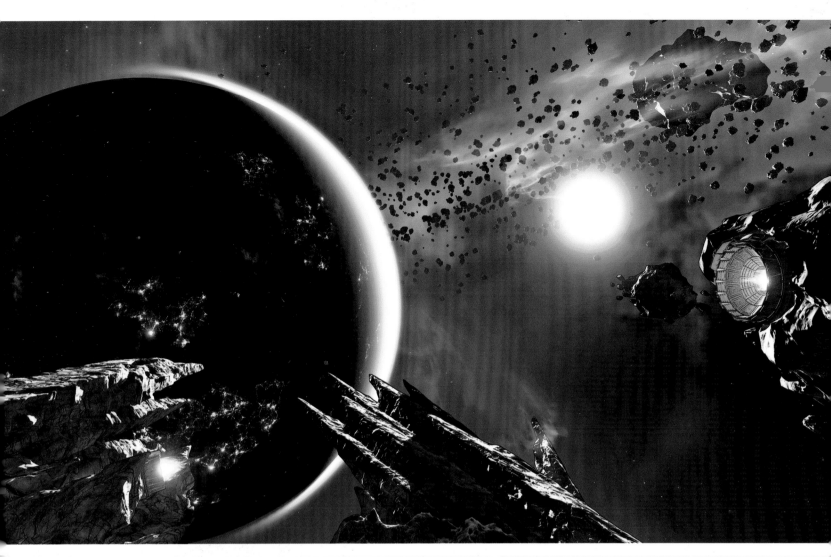

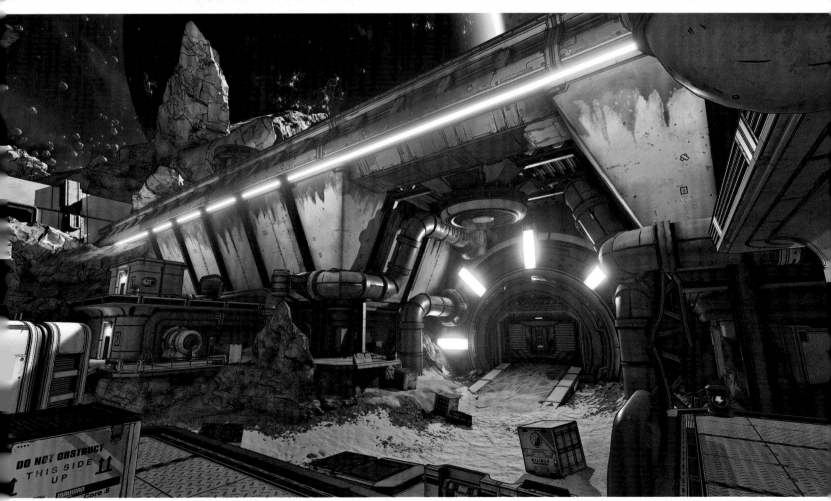

ATHENAS
MONASTERY

Athenas is the lifelong home of Maya, the Siren who once unwittingly helped a monastic sect known as the Order of the Impending Storm maintain total control over the planet, as tales of her powers were used to keep the population in check. Although Maya eventually realized the Order's deception and briefly fled to Pandora seeking answers about her Siren heritage, she has since returned and is now mentoring her young apprentice, Ava.

Despite the planet's bloody past, there's no denying the scenic tranquility of Athenas. High mountain peaks pierce the skyline and vibrant vegetation peppers the landscape, while temple gates and shrines, with their striking blue and yellow accents, reflect the palette of Maya herself. UI Designer Trisha DeSalvo recalls that each planet's bold use of vivid hues was something that the team had to carefully consider when constructing the game's user interface:

"It had a big impact on the UI team. We can't expect a certain color range or lighting to match to our UI screens—they have to work from desert yellows and oranges to lush watery blues and greens. It was a challenge finding a good balance with our elements, so that they can look good no matter where the player goes."

The Vault Hunters shouldn't expect a friendly welcome to Athenas, however peaceful the planet itself may seem. Maliwan forces have already seized control of the monastery, where part of the Promethean Vault Key has been located, turning a simple recovery mission into a vicious firefight. As these images show, other areas of the planet were also considered for inclusion; early sketches of a village and slum building designs suggest that perhaps life is not quite as serene and opulent for the locals as it is for the monks of the Order. A large and foreboding crypt built into the side of the mountain was also designed, and might perhaps have housed the Vault Key fragment deep within its gloomy interiors.

RIGHT: A selection of monochrome and color sketches exploring the different kinds of buildings that might be found on Athenas. Elements of East Asian architecture are evident in the high-tech barriers that resemble Japanese *torii* gates.

OPPOSITE: A collection of pieces exploring the mountainous terrain of Athenas and its structures.

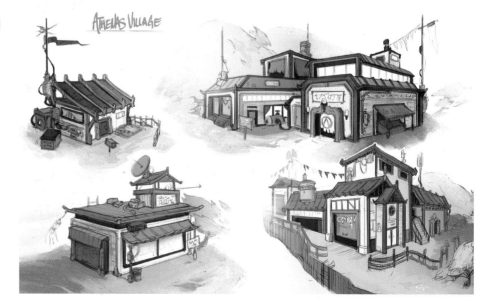

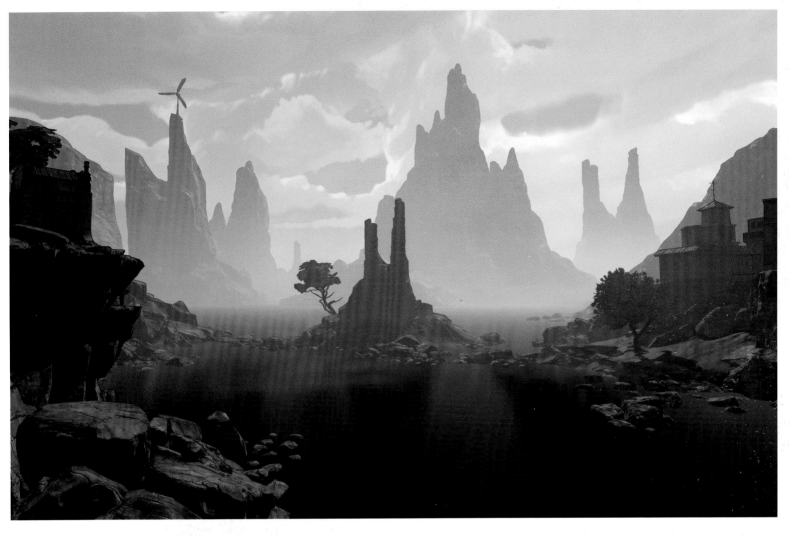

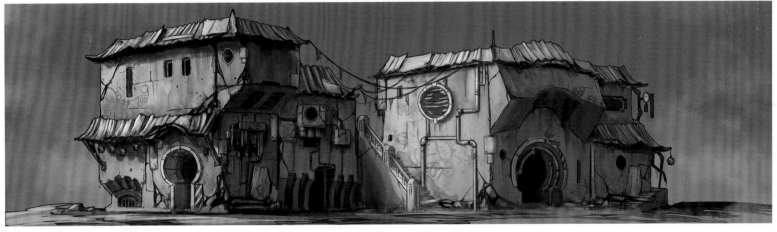

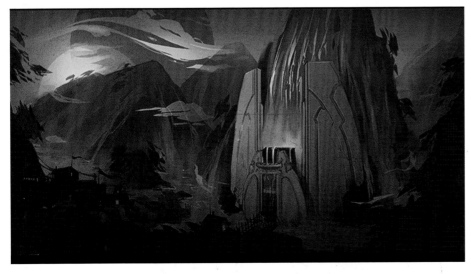

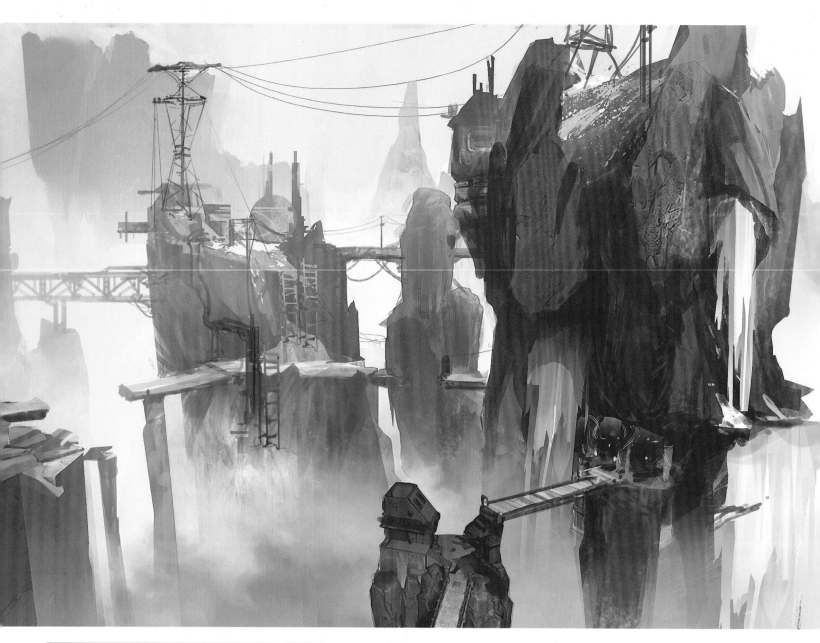

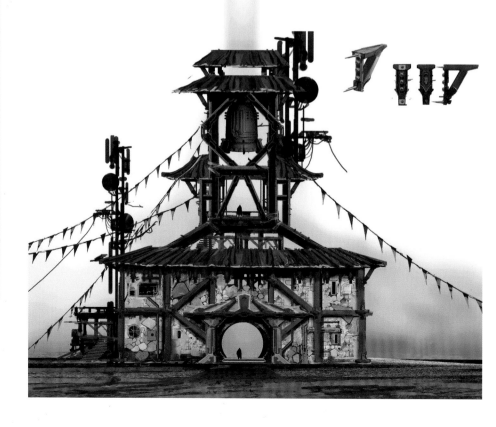

TOP: Walkways leading into the mountain caves.

RIGHT: An imposing monastery bell tower.

OPPOSITE: Additional paintings showing the beauty of Athenas.

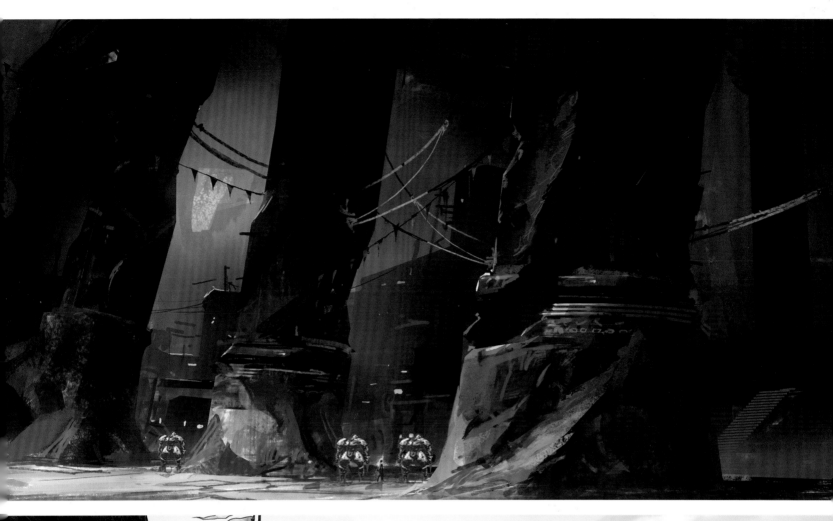

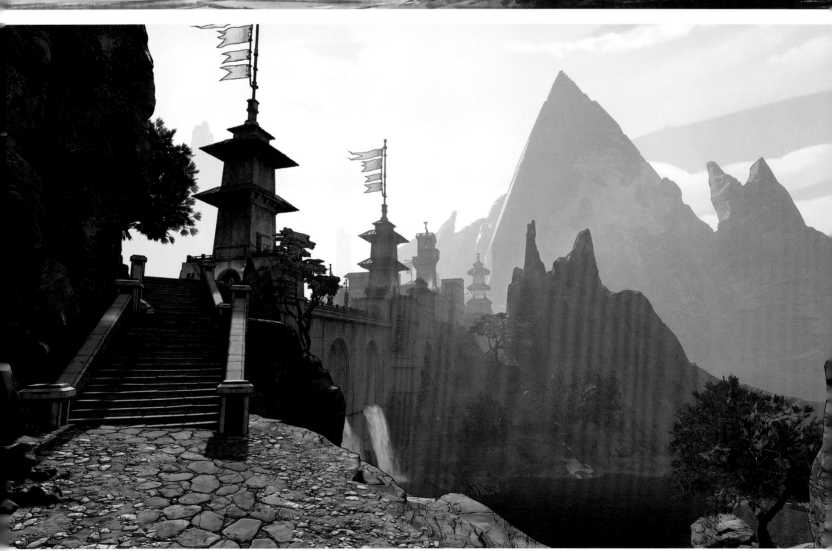

EDEN-6
WETLANDS

"We get to go to Eden-6," Producer Anthony Nicholson says enthusiastically, "which is basically the opposite of Pandora. It's lush, swampy rain forests. We get to do a lot of cool particles with different creatures hopping and flying around and screaming. All of this with mud and a canopy and different lighting techniques like God rays coming through, so that's really exciting."

"It's funny," adds Art Director Scott Kester. "I mean Eden-6 really is our fantasy world, but even as our big overgrown jungle, it's very lush in a gross, *Borderlands* way. It's more like a swamp and less like Endor [from *Star Wars*] or something. It's kind of like Dagobah, more in that vein. To me the thing that dominates is the wildlife and the organics. Even on Eden-6 there's a lot of wrecked and decrepit spaceships and spacecraft, but they've all been overcome with the organics, right? So it's highly vegetated, which is something we've also never done."

RIGHT: Black-and-white sketches showing ways that the swamp and its vegetation might snare and consume spaceships, buildings, and other structures over time, fusing together technology and organics.

OPPOSITE: Explorations of rock and tree shapes for the wetlands of Eden-6, all of which are meant to tower over the player and help build up the dense vegetative landscape.

BELOW AND PAGES 112–113: A selection of concept pieces exploring how buildings might be integrated into their surroundings. These, too, are steadily being consumed by the local plant life.

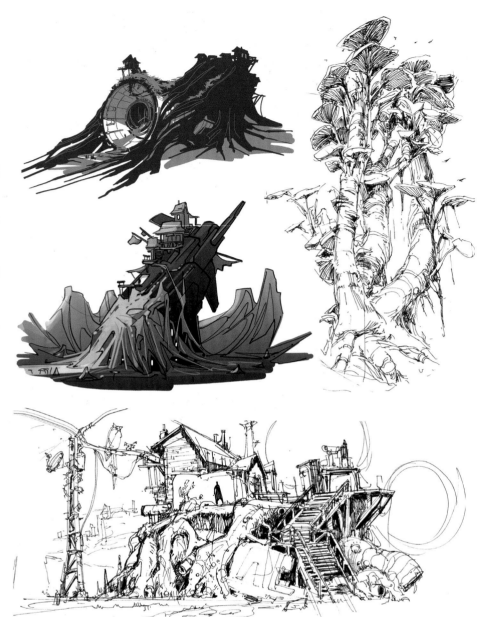

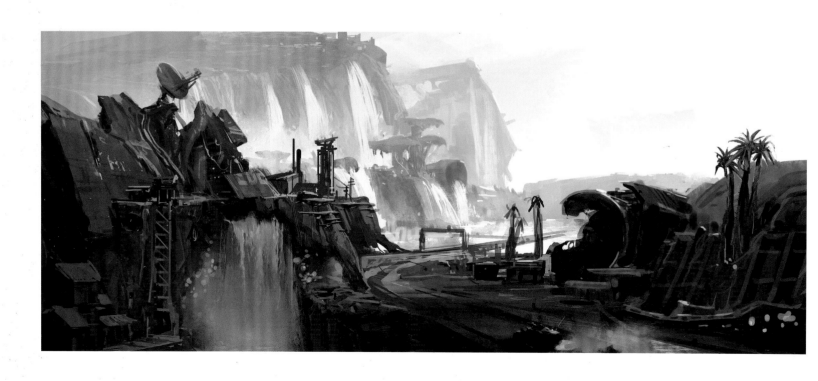

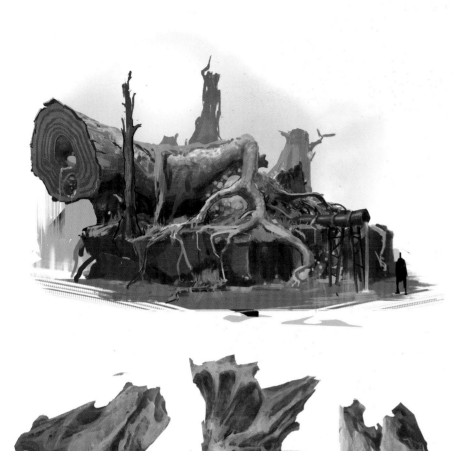

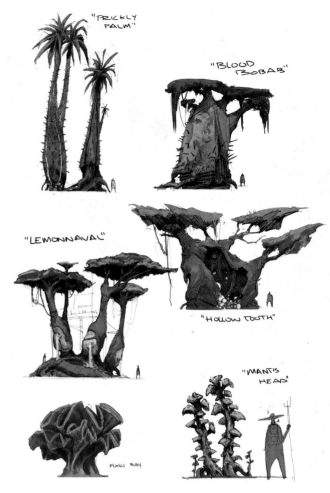

"PRICKLY PALM"

"BLOOD BOBAB"

"LEMONNAVAL"

"HOLLOW TOOTH"

"MANTIS HEAD"

FUNGI BUSH

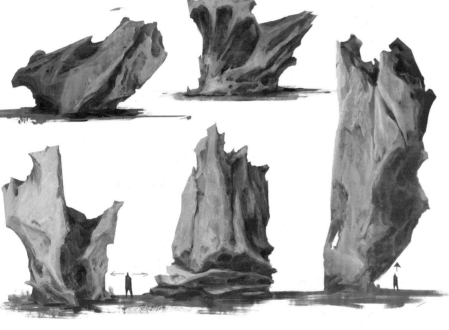

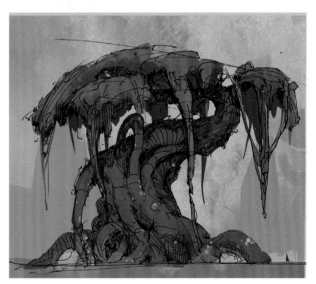

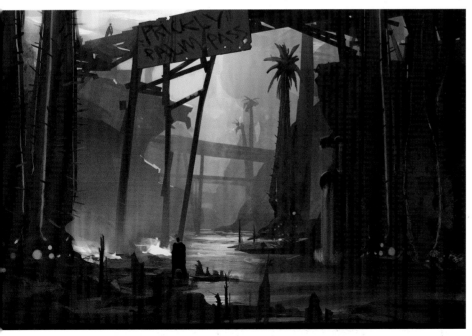

PRICKLY PALM PASS

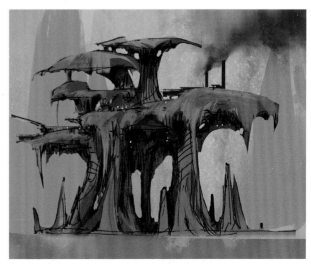

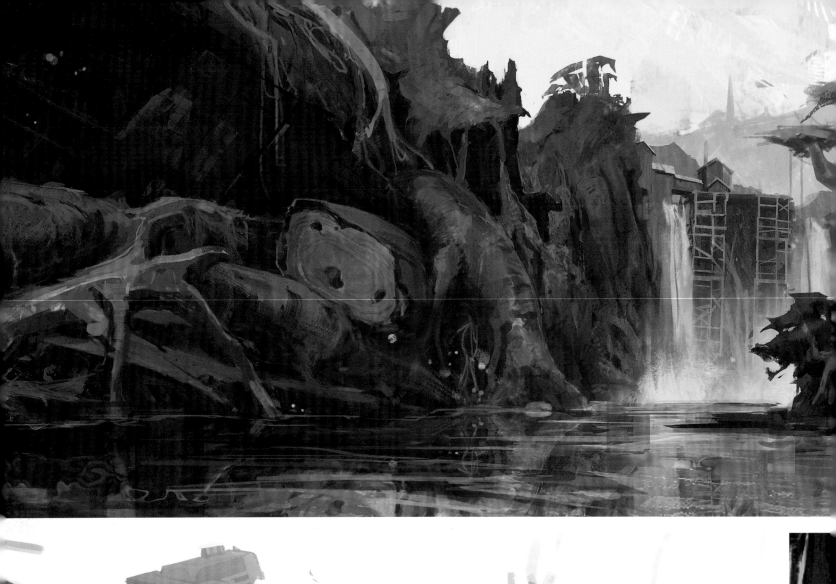
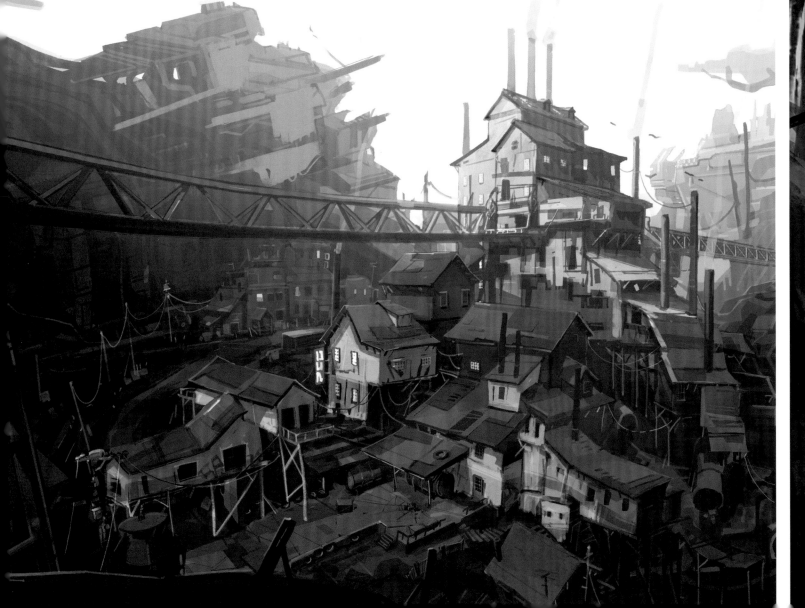

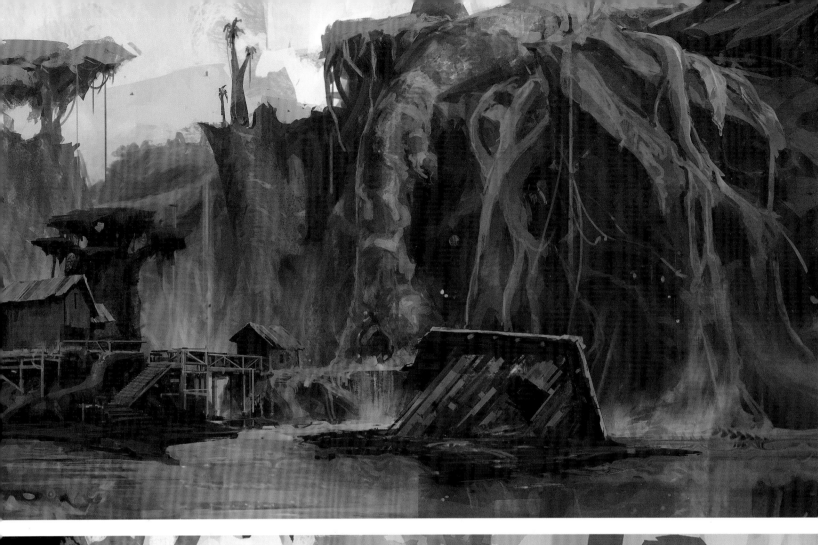
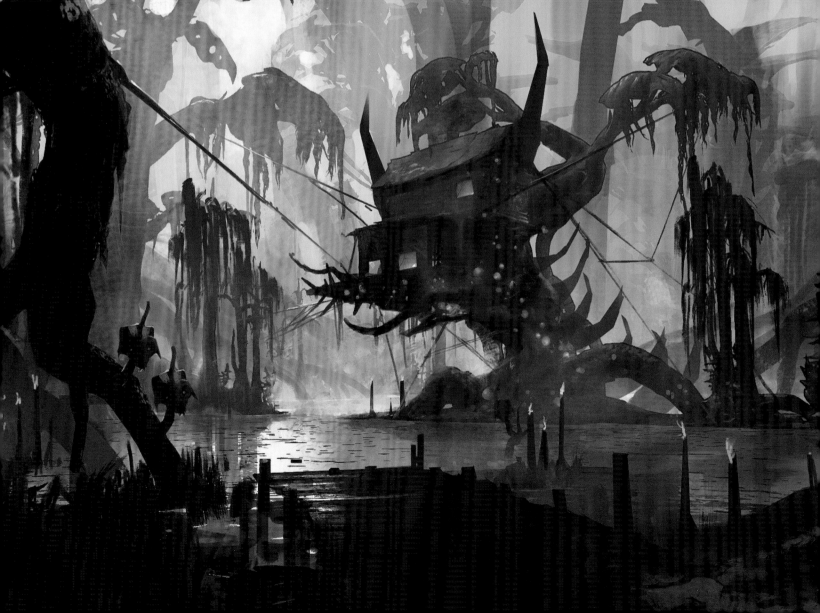

WETLANDS

RIGHT AND BOTTOM: Not even building interiors are safe from the pervasive plants of the moon's swamps and jungles. Whether it's the twisting corridors of an abandoned facility or the scuttled remains of Montgomery Jakobs's ship, the *Family Jewel*, creepers and vines will have found their way inside.

BELOW: The vintage aesthetic preferred by the Jakobs family is evident in many of the planet's major locations.

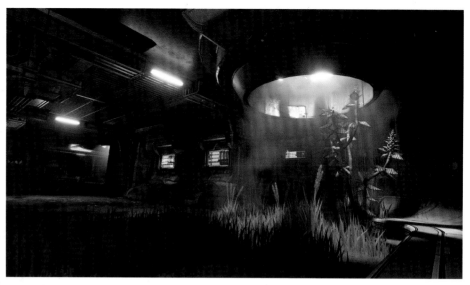

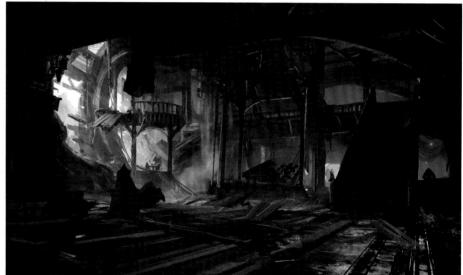

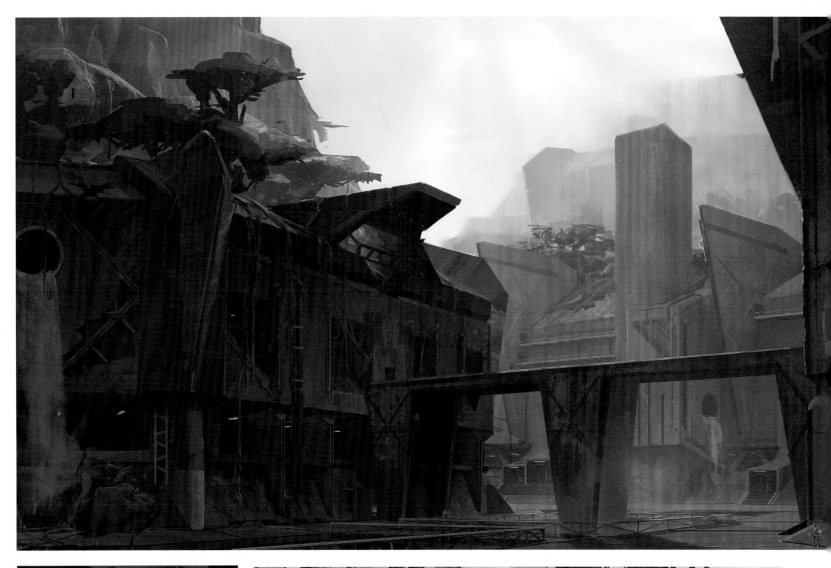

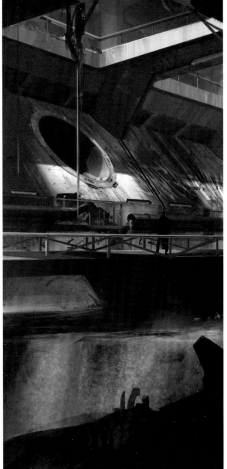

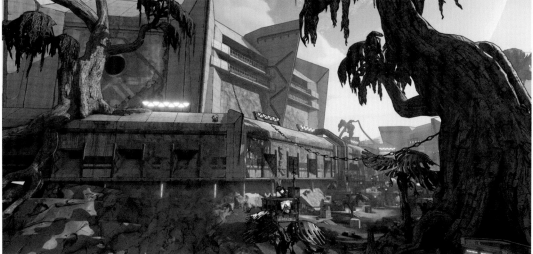

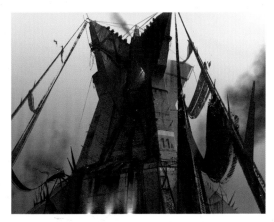

TOP: Not everywhere on Eden-6 is abandoned. The Scala Mirte prison—known to its unwilling residents as the Anvil—has long housed those whom the Jakobs family consider undesirable.

LEFT: By the time the Vault Hunters reach the Anvil, the inmates are running the asylum—all thanks to the Children of the Vault, who are using the prison to house mass numbers of their followers.

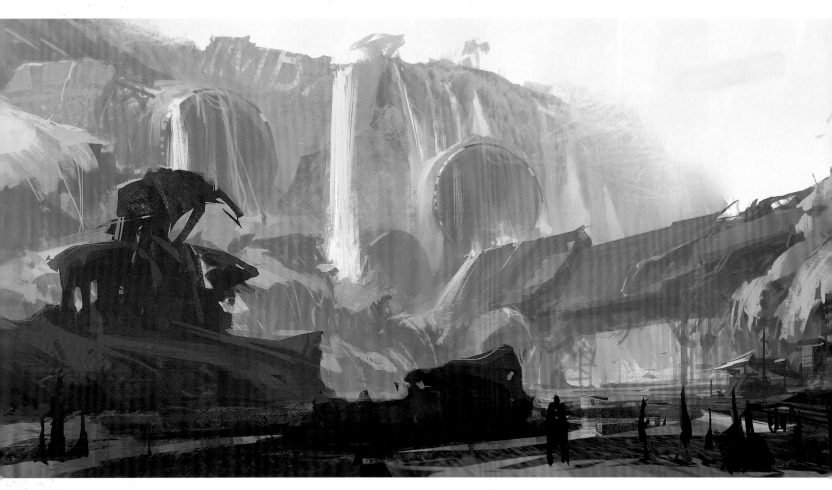

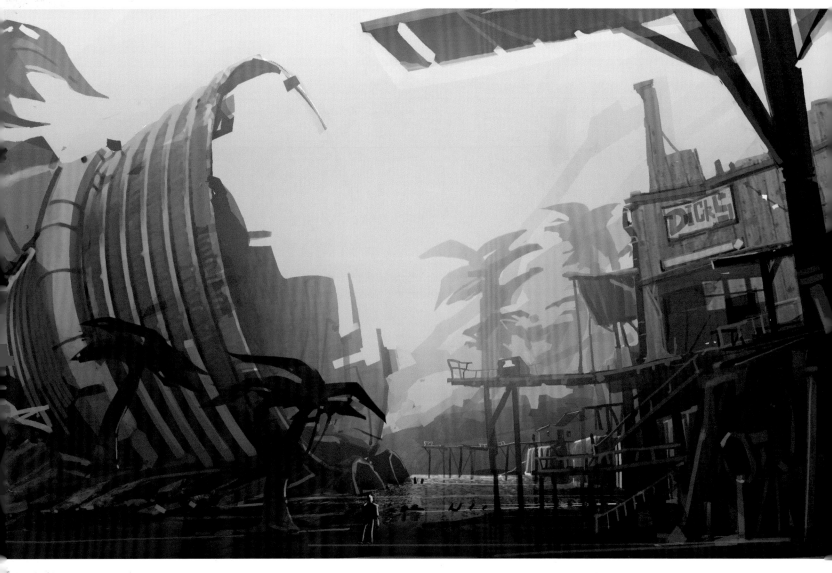

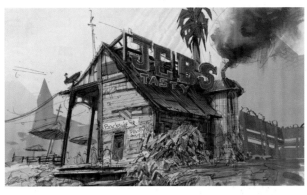

OPPOSITE TOP: The rusting wreckage of an enormous spaceship dwarfs the settlement that's been established in the valley below, creating huge waterfalls.

BELOW: As its name suggests, Eden-6 is just one of many moons orbiting the gas giant Eden. The Jakobs family has long used the resources of these satellites to establish a veritable galactic empire built around their signature weapons, but not everyone who inhabits the swamps of Eden-6 is a loyal employee.

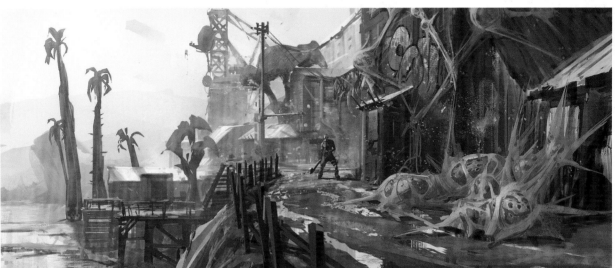

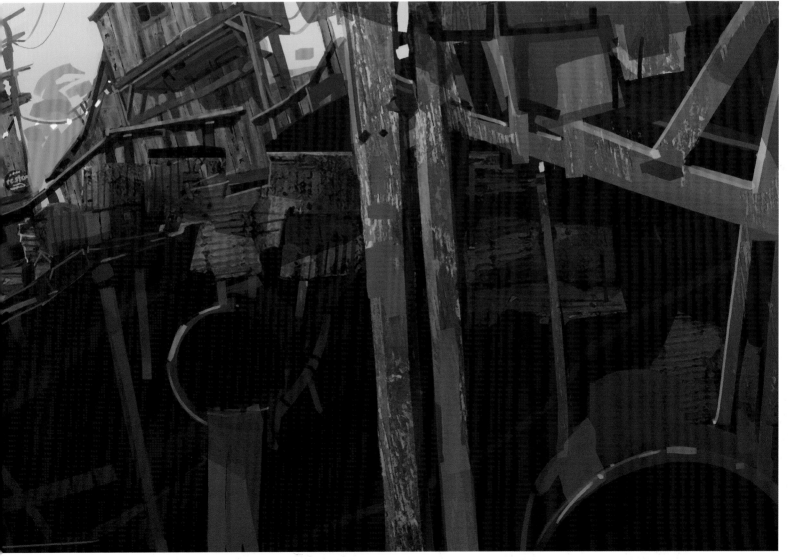

EDEN-6
JAKOBS ESTATE

Players will soon find they need to get up close and personal with the flora and fauna of Eden-6, as the moon is home to a number of important locations, including a Vault hidden somewhere beneath the moss and mulch. The Jakobs family have long resided here, using funds from their arms business to finance a grand mansion at the heart of an expansive estate, although this dilapidated building has since become the property and headquarters of Aurelia Hammerlock.

Elsewhere on Eden-6, inmates languish in a run-down prison complex guarded by those loyal to Aurelia, while Wainwright Jakobs has been forced into exile and now hides out in a nearby lodge. Bandits roam freely around Ambermire, seemingly given free rein under the Hammerlock regime to make a playground out of the lumber mills and oil rigs that jostle for position amongst Eden-6's densely packed vegetation and thick canopies.

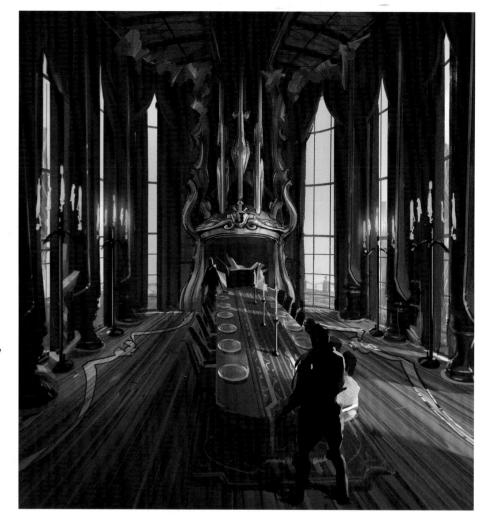

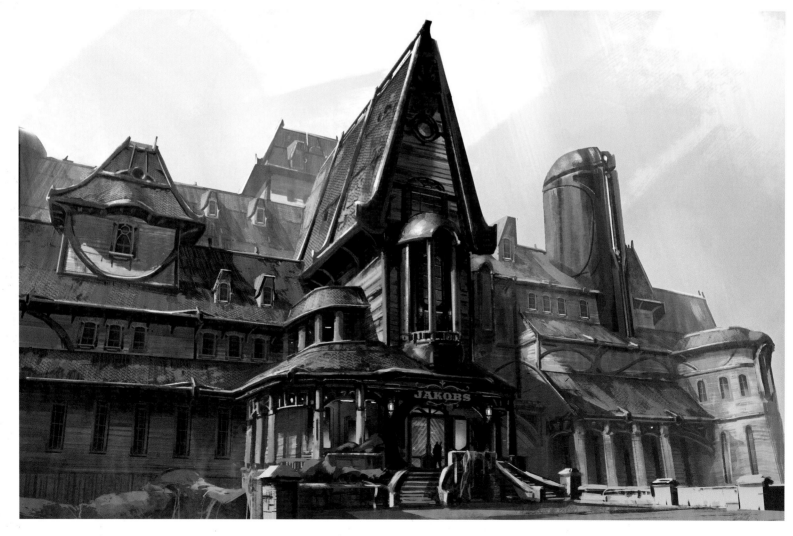

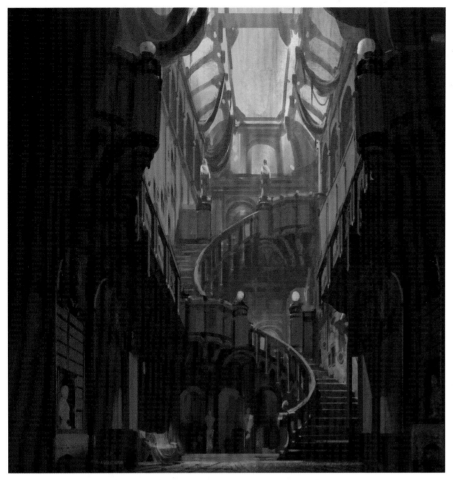

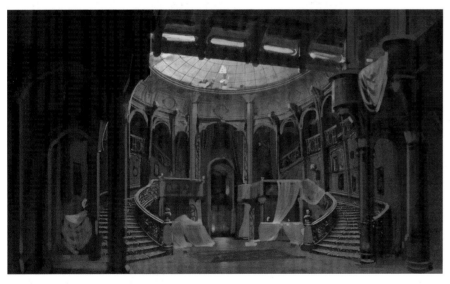

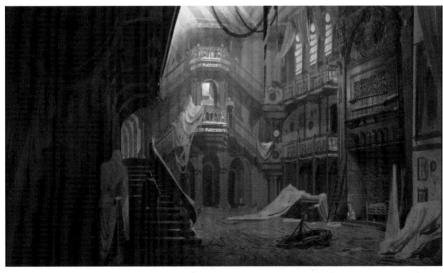

OPPOSITE TOP: A concept sketch of the dining room within the Jakobs estate, the site of a confrontation between Aurelia and the Vault Hunters.

OPPOSITE BOTTOM: An idea for the exterior of the mansion. At one point, a crashed spaceship was integrated into the design.

ABOVE: Rugs and other fine details for the interior of the Jakobs estate.

LEFT: Ideas for the mansion's main hall and its layout, with several different types of staircases lit by a high, vaulted ceiling.

EDEN-6
VAULT

Every family has its secrets, but few can claim to have an alien treasure trove hidden at the bottom of their garden. The Vault of the Graveward, an Eridian stronghold similar to those found on Pandora and Promethea, is tucked away on the expansive grounds of the Jakobs estate and explains much of the Calypso Twins' interest in the moon and its occupants.

Nowhere on Eden-6 is exactly welcoming, but the mists surrounding the Vault are particularly eerie. The gnarled roots of ancient trees have snared massive boulders and carried them aloft, creating the illusion of floating islands in the distant, gloomy expanse.

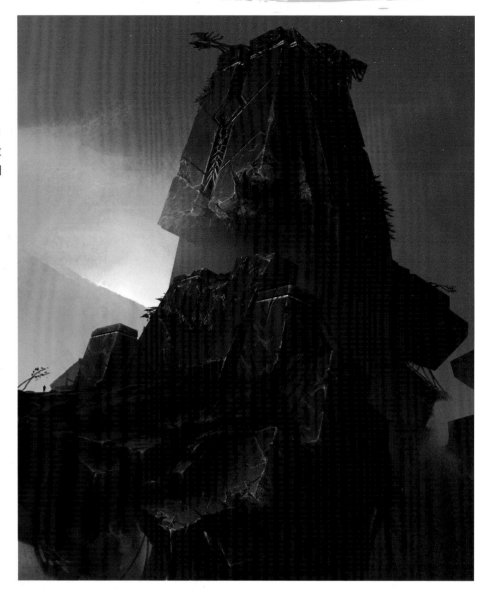

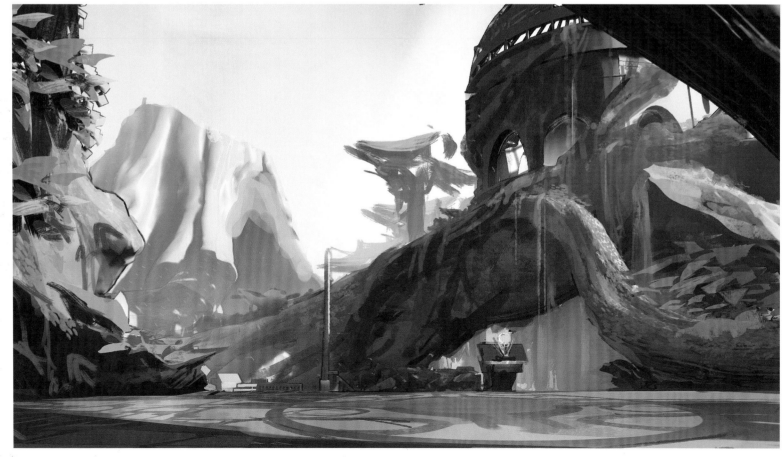

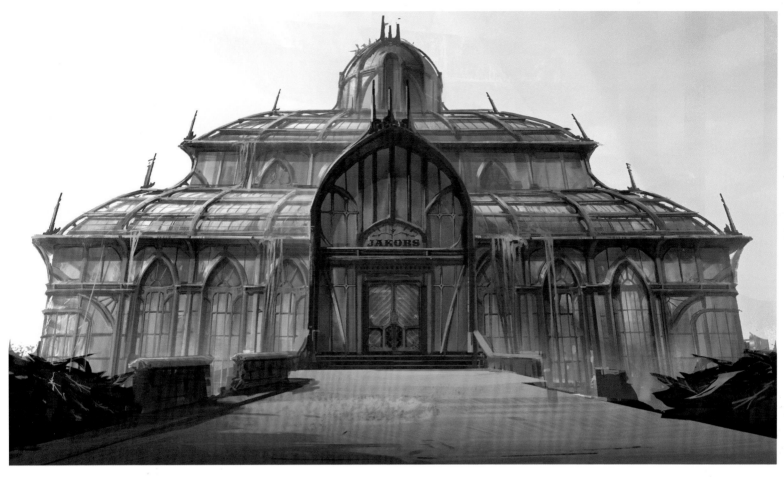

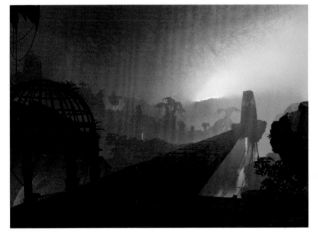

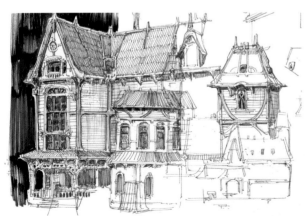

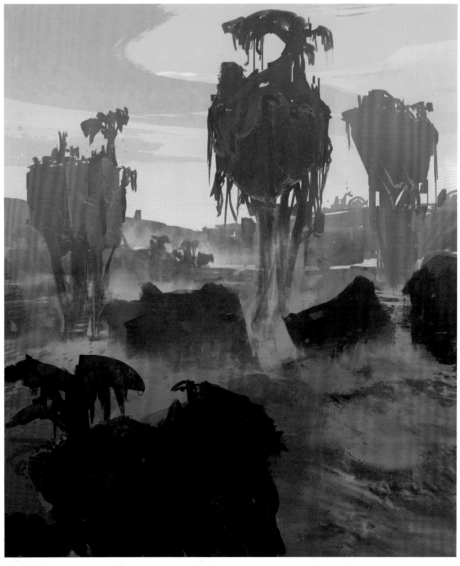

TOP AND ABOVE: Artwork of the atrium's exterior. Though little plant life remains inside, the entrance to the vault still lies somewhere within its grungy glass panes.

OPPOSITE AND RIGHT: Mood pieces of the area surrounding the atrium, which is considerably more barren—but no less dangerous—than the swamp below.

PROPS AND SIGNAGE

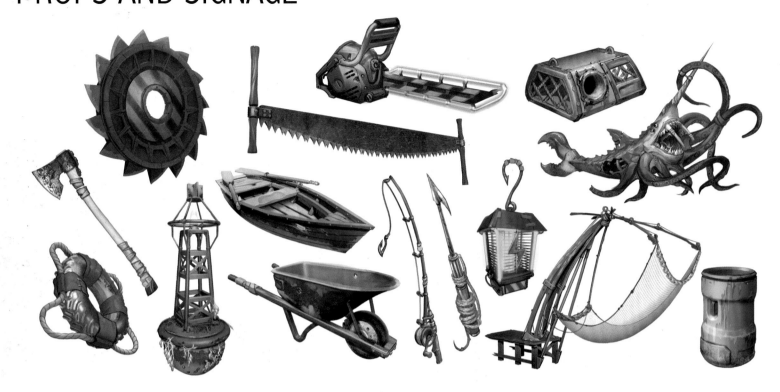

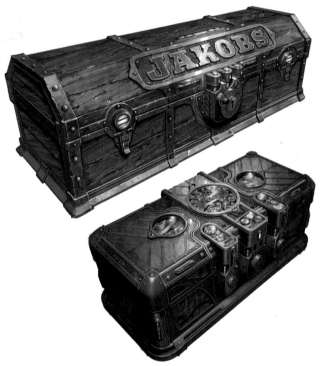

ADOPT-A-ROAD!

ADOPTED BY:

Reiss's Cheeses

KEEP EDEN-6 CHARMING

PURE

Only Good Things

Thorny Goodness Only. PURE

Good Groomer GROUP

POLLY GROG CLUB

ANVIL PRISON

"HANG" A RIGHT

WARDEN SEES YOU

WARDEN WATCHES

THIS COULD BE

THIS COULD BE

YOU KEEP OUT

SKY

NEKROTAFEYO

Visiting Nekrotafeyo is much like walking into a veritable Aladdin's cave for any Vault Hunter, for this is the fabled homeworld of the Eridians, whose technology normally proves to be as valuable as it is dangerous. The depravity and strangeness of the landscape is evident everywhere, and in many ways, the planet can be thought of as holding a twisted mirror up to Pandora itself. This is a deliberate artistic decision that Art Director Scott Kester compares to *The Legend of Zelda: Twilight Princess*: "Nekrotafeyo is what

I call 'Weird Pandora.' This is when I get to put my *Zelda* hat on and say it's like the Twilight Realm in a way. Pandora's like desert terrain, right? But you flip it into a weird version of that. And you take the Pandoran rocks, which we lovingly refer to as potato rocks, but then you twist them and kind of flip them inside out and you see the skeleton inside them. And then you trade the architecture of all this Dahl monolithic stuff for these weird Eridian temples. Everything's dark and weird as opposed to bright, arid, and sunny."

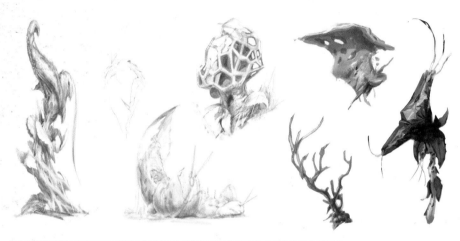

LEFT: A selection of early studies for plant life that served as the basis for future exploration. The coral-like "inverted" plant and the veinlike tendrils were particularly well received.

BELOW: Shape tests for rock formations and much larger plants; note the human silhouettes used for scale comparison.

OPPOSITE AND PAGES 126–127: Concept sketches that work to integrate both the plant and rock formations into a cohesive landscape.

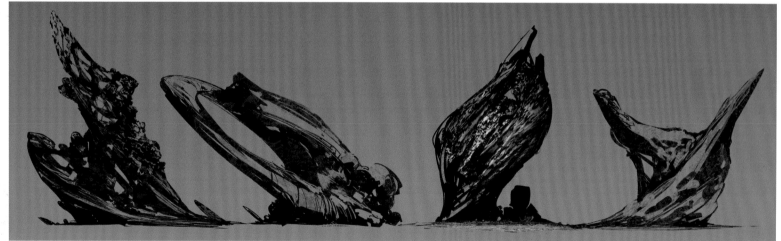

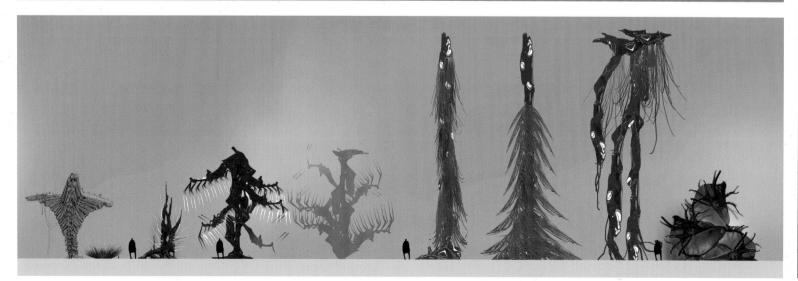

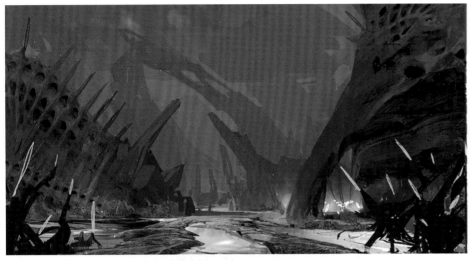

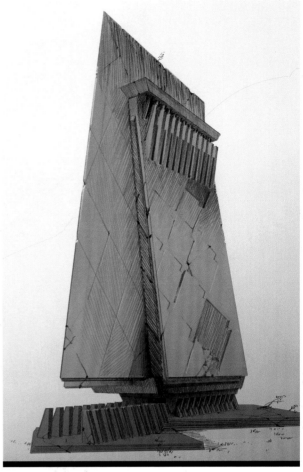

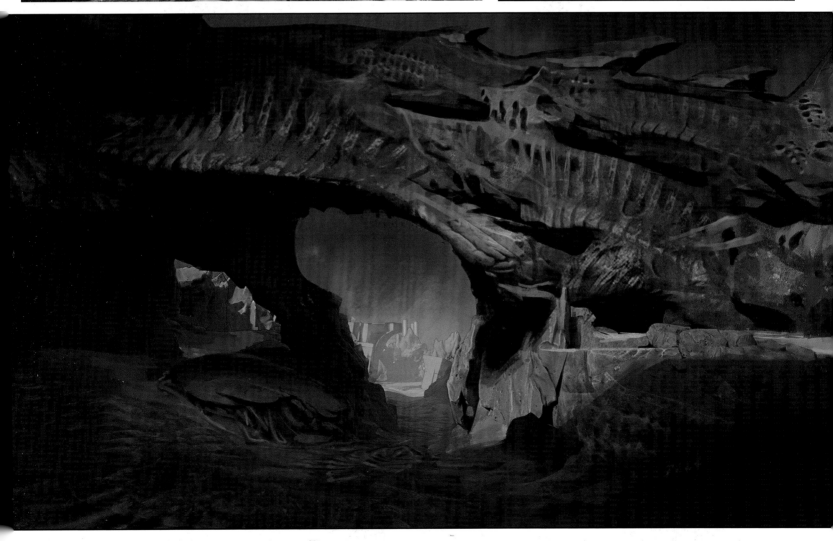

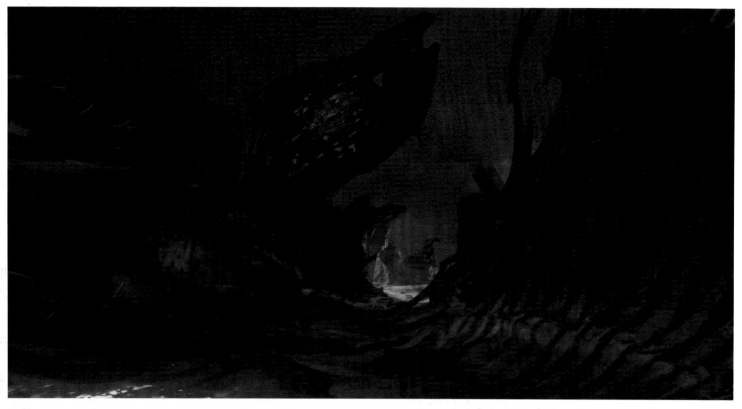

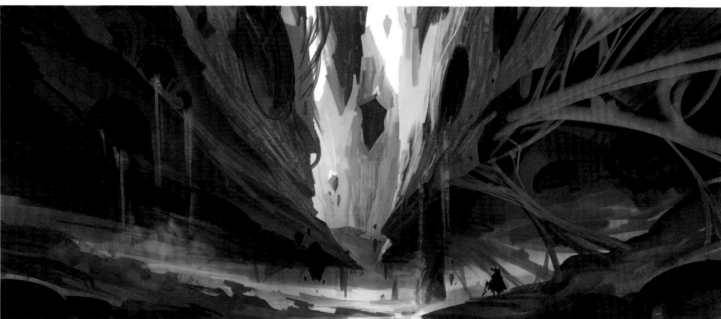

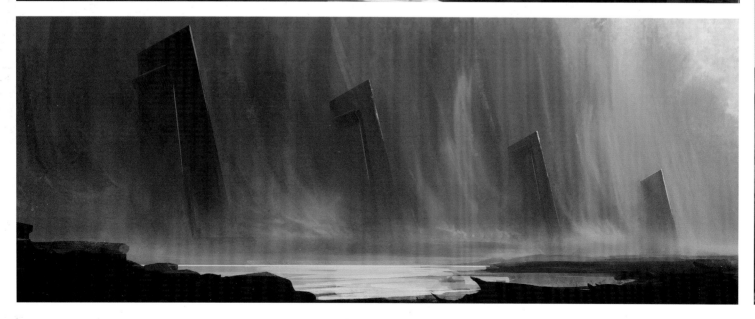

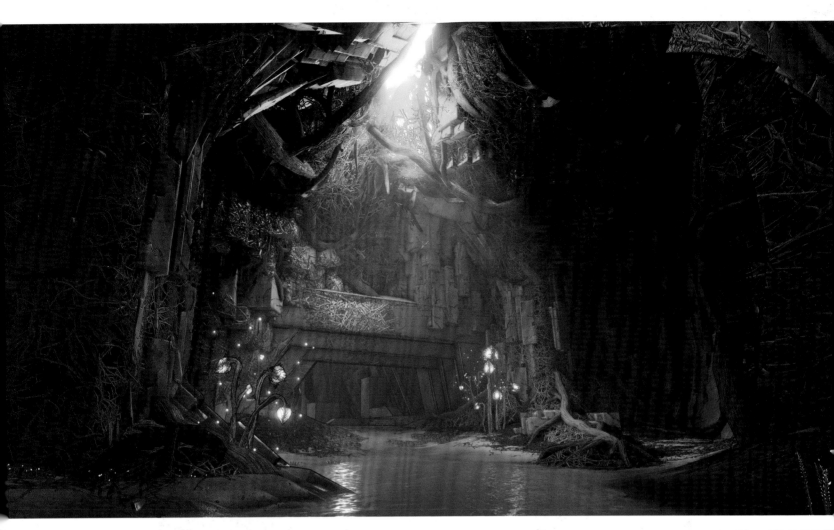

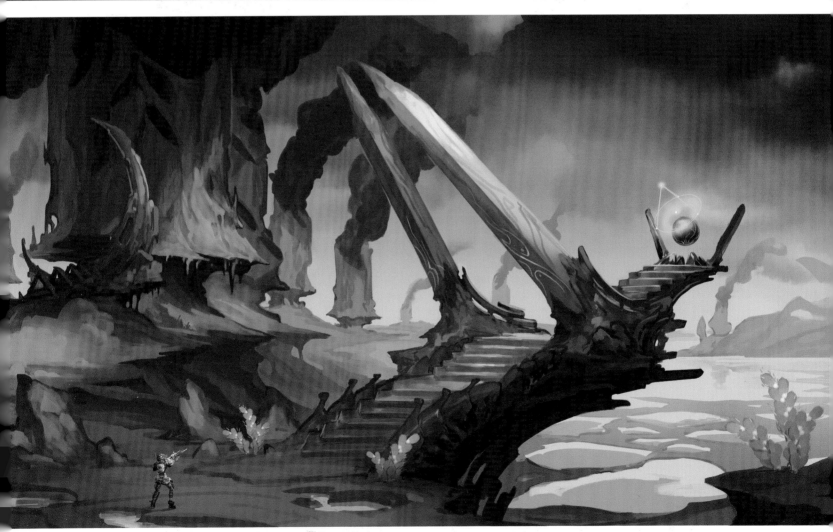

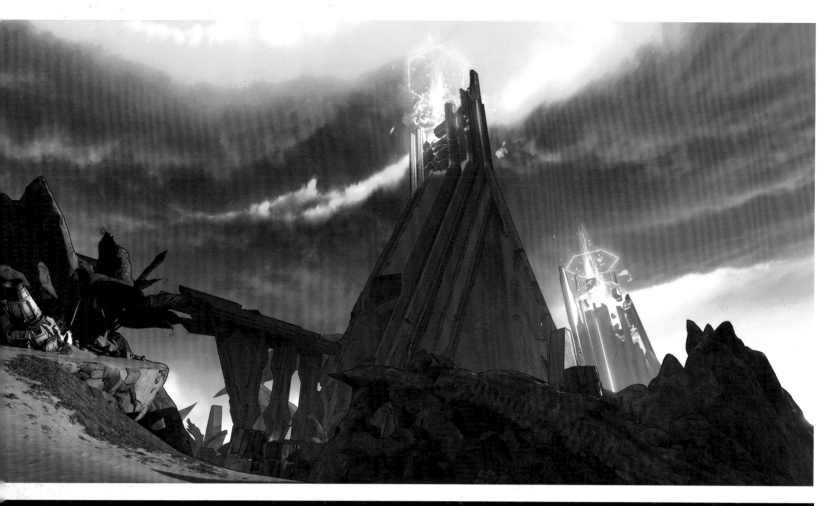

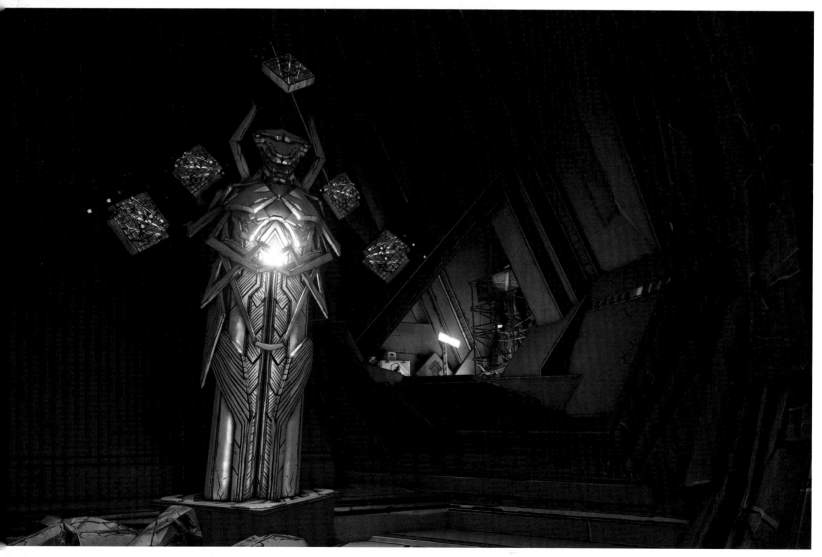

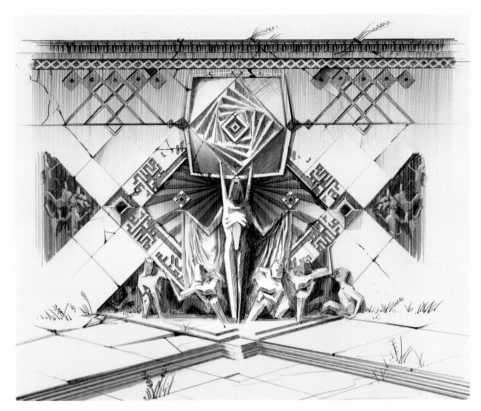

OPPOSITE: Inside and out, Eridian architecture stands in sharp relief to the twisted natural landscape. Walls incline at sharp angles, staircases zigzag this way and that, and strange humanoid carvings effortlessly defy gravity as they light the path ahead.

BELOW: Intricate geometric designs and use of depth add complexity to the walls, pillars, and towers of Nekrotafeyo, with their fine detailing embellished by regal reds and golds.

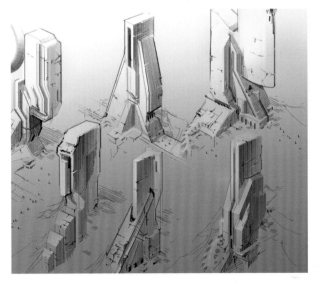

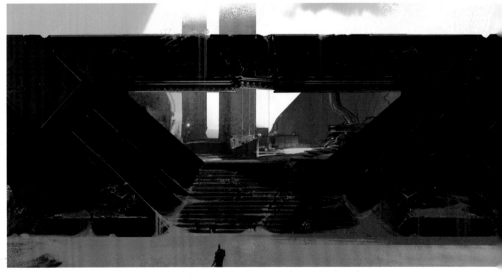

NEKROTAFEYO
VAULT

While Nekrotafeyo is far from lifeless, covered as it is in thorny vegetation, scraggly vines, and strange mushroom-like growths, intelligent creatures appear to be few and far between. Although a Hyperion stronghold was at one point considered for inclusion on the surface, the planet's two most significant geographic features are both Eridian in origin.

The first, Nekrotafeyo's own Vault, was opened long ago by Typhon DeLeon and is now guarded by Guardians. The second is known only as the Pyre of Stars, and the Eridian secret buried at its heart is the ultimate goal of Troy and Tyreen Calypso . . .

RIGHT: Art design for the Pyre of Stars presented the team with a daunting task. For the first time, Eridian technology would be front and center in the environment rather than simply visible, as in previous *Borderlands* games.

BELOW: The Pyre of Stars is the heart of an ancient machine that spans light-years and harnesses the power of multiple Vaults for a single purpose: to keep the Destroyer in its chains.

OPPOSITE: For obvious reasons, the interior of this Vault was dubbed the "Neon Crypt" during the game's production.

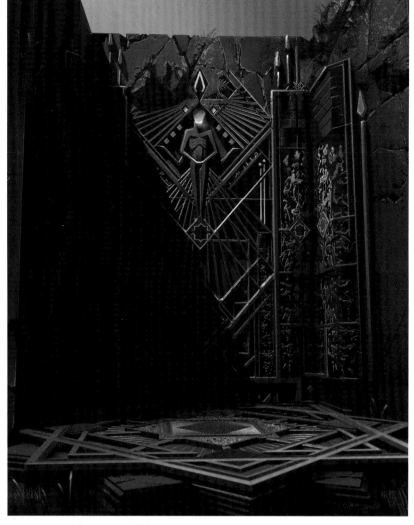

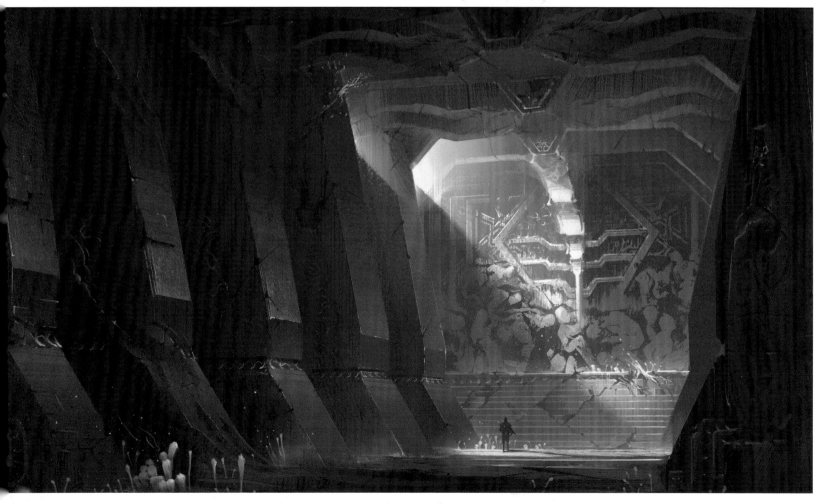

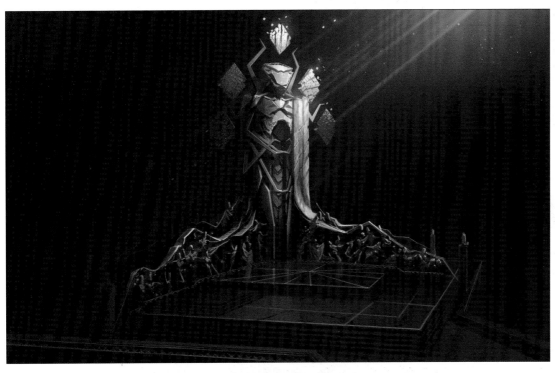

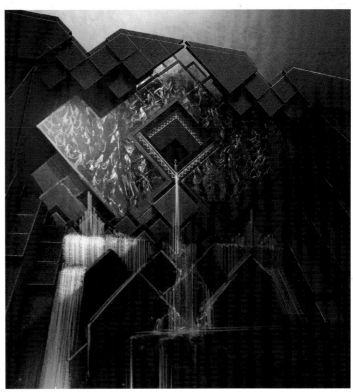
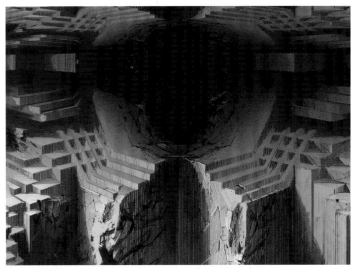

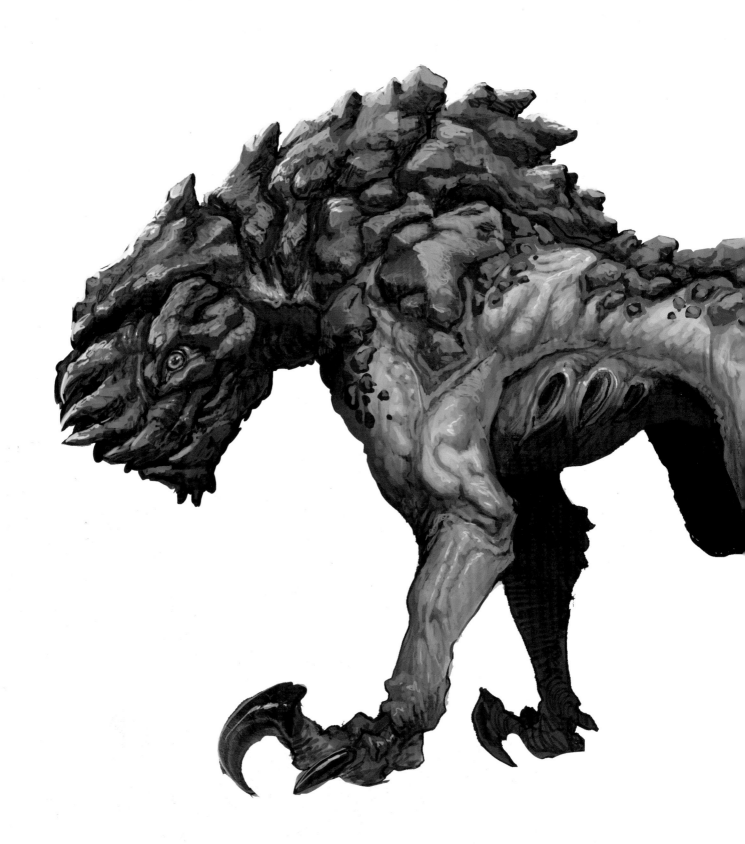

3

CREATURES AND ENEMIES

Weapons are big business in the world of *Borderlands*, and it's an understandable economy given the vast assortment of hostile life-forms eager to tear chunks out of the nearest unwary Vault Hunter. Whether it's a pack of the canine, bone-armored skags that scavenge the wastes of Pandora or an intimidating squad of troopers stomping forward in mechanized power armor, there's always something or someone ready and willing to cast players back to the nearest New-U machine. Just like their humanoid counterparts, all the creatures of *Borderlands 3* needed to be taken back to the drawing board this time around.

For the first time, players will encounter female bandit enemies as they play, a change that the team knew needed to be handled carefully. Previous experiments with different bandit types had shown that when too many differences between individual enemies were introduced, adding variant body types and voices into the mix, players began thinking of them as people and felt worse about killing them—and there was concern that deliberately highlighting their genders would do the same. Eventually, the art team settled on a design where the female "fanatic" bandits would be kept anonymous, with their faces obscured by masks, just like their male equivalents.

Elsewhere, similar care was being taken when considering the finer details of creature anatomy, as Concept Artist Amanda Christensen explains: "So we have these creatures—they're kind of like little spider monkeys—called Jabbers,

that throw poop at you. I'm working on the elemental version, and so I had to leave a note to make sure their poop is an emissive that corresponds to their appropriate element, because when they poop it's now fire poop or corrosive or something. And this is the kind of attention to detail that we have to have."

"There is a lot of documentation," adds VFX Lead Nick Wilson. "I have written an insane amount that would probably seem pretty esoteric to a lot of other people, like Spiderants and stuff. We'd go and have a critique and everyone's like, 'This is feeling pretty good,' getting ready to walk out of the room. And I'm like, it bleeds the wrong color. They don't realize the Spiderants have always bled light blue. So like that was one thing I went through: Here's every creature in the entire *Borderlands* universe that we have any hope of bringing back, with the correct blood color."

With a story that encompasses multiple alien worlds and numerous ecosystems, there were plenty of opportunities to invent new types of enemies, like a towering creature known as the Rampager and the hovering menace of the Maliwan Overspheres that patrol the orbital platform high above Promethea. This chapter examines the genesis of the most distinctive and memorable critters that the Vault Hunters will encounter on their journey, as well as the various human factions vying for domination out among the stars.

OPPOSITE: A skag.

133

NEKROBUGS

RIGHT: Nekrobugs (unsurprisingly) inhabit Nekrotafeyo, and their physical forms are a twisted hybrid of flora and fauna.

BELOW: The nekrobug acts as a gestalt life-form—the flying Korax form can combine with the ground-based Manta variation to create the vicious, bipedal Mantakore.

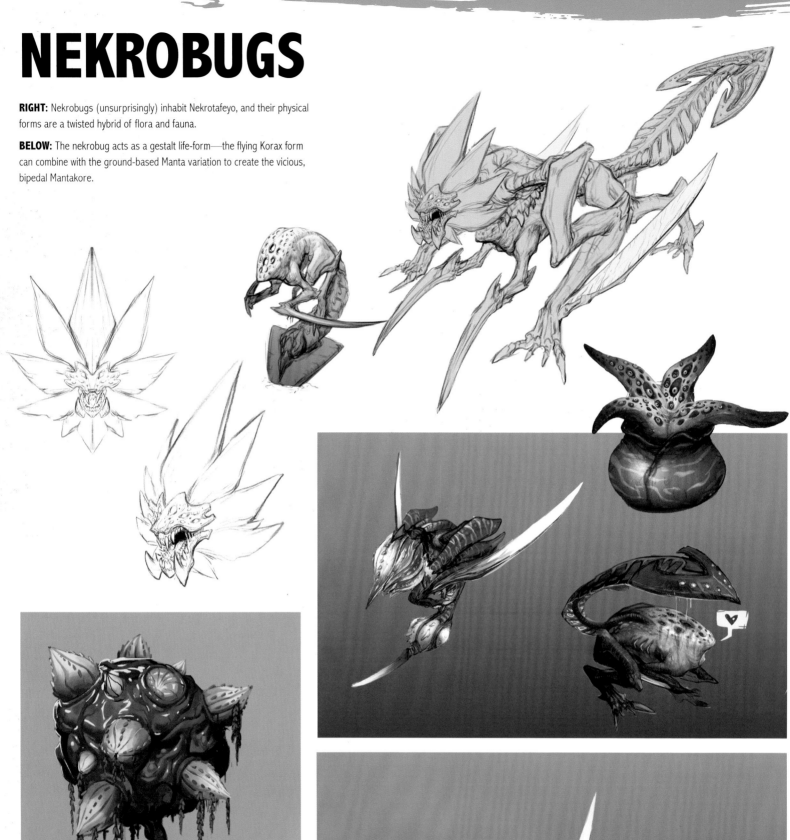

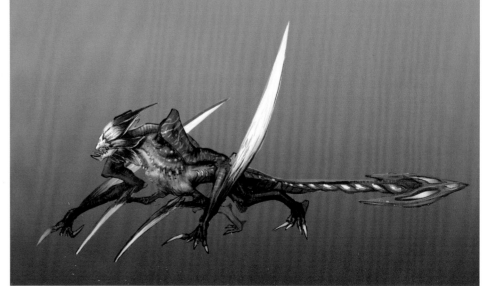

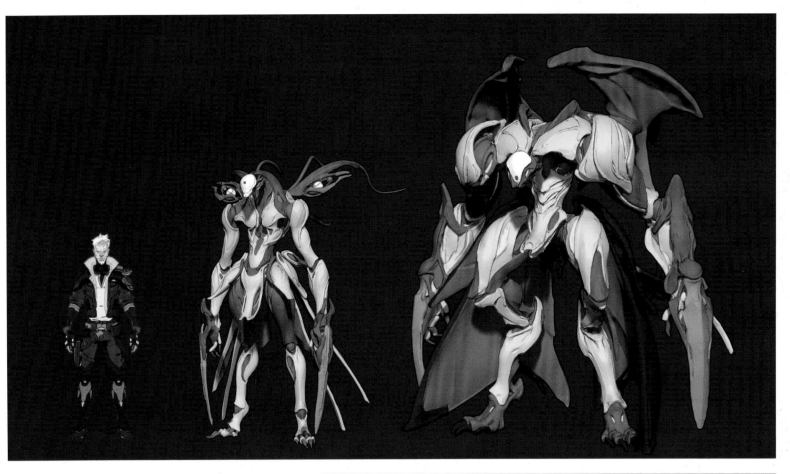

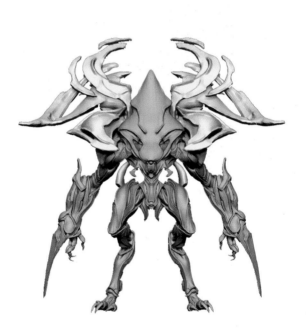

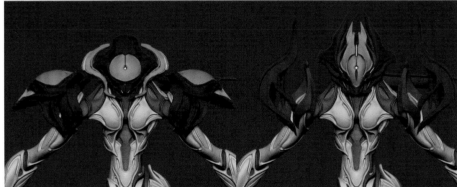

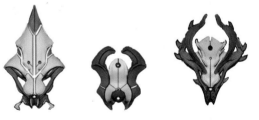

GUARDIANS

TOP: An Eridian Guardian, reimagined for *Borderlands 3*. The Badass variant shown alongside it is larger and bulkier, with better-developed wings, though the range of its bladed arms is roughly the same.

CENTER RIGHT: A selection of Guardian head shapes.

BOTTOM RIGHT: Untextured Guardian models. Their oddly jointed limbs help to give them a unique silhouette compared to other enemies.

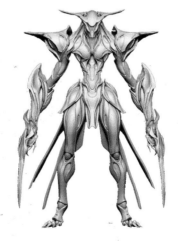
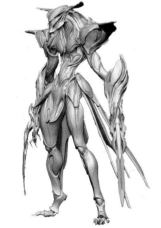
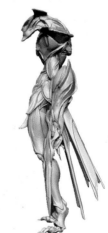

JABBER

RIGHT: Very early Jabber concepts that range from small, cute marsupials to larger, more ferocious beasts.

BELOW: The spiked clubs, baseball caps, and scarves shown here were conceived as upgrades for FL4K's pet Jabber.

BOTTOM: Larger, more muscular Jabber were also explored for the creature's variant classes.

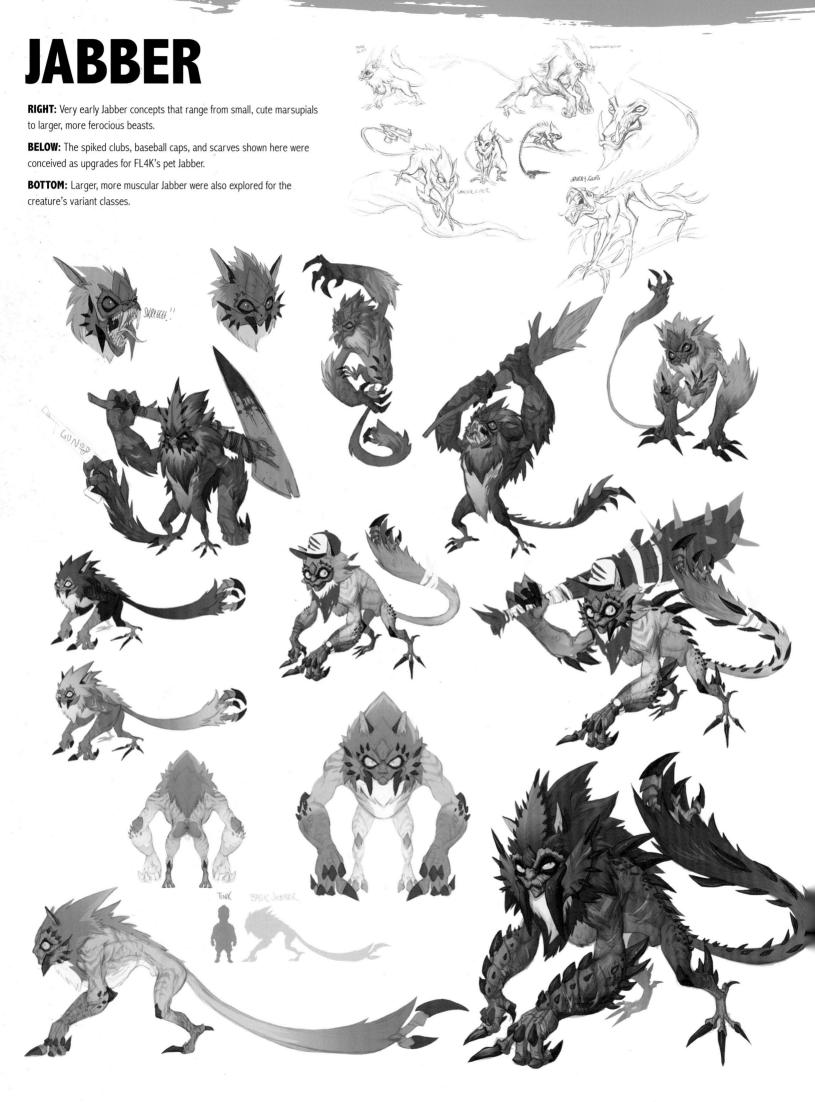

SAURIANS

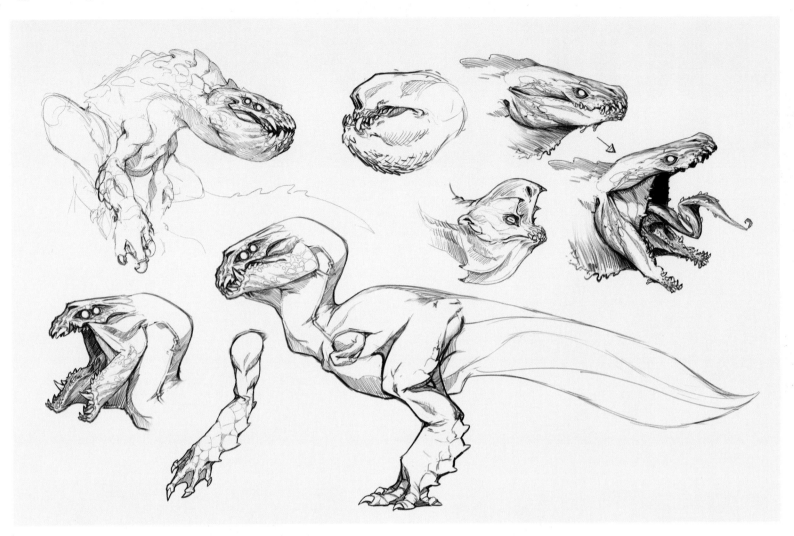

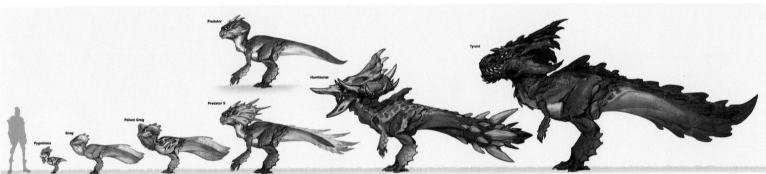

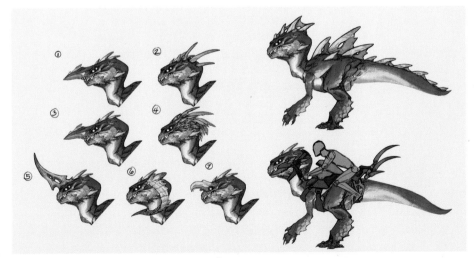

ABOVE: A uniquely *Borderlands* take on dinosaurs, Saurians run the gamut of prehistoric predators. The *Compsognathus*-sized Pygmimus are the smallest, and the Saurian size range swells rapidly to the raptor-like Predator variants and, finally, the looming Tyrant.

LEFT: A collection of attachment parts for a Predator, including a saddle.

BOT JOB

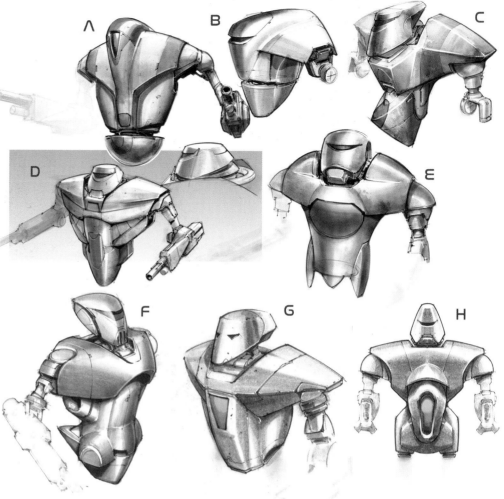

A

B

C

D

E

F

G

H

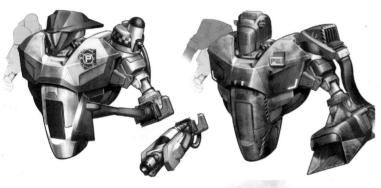

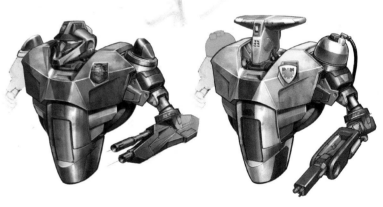

INCINERATOR VENTING

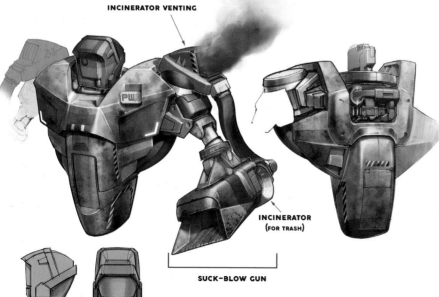

INCINERATOR
(FOR TRASH)

SUCK-BLOW GUN

SERVICE BOTS

TOP: Holloway Robotics' robust catalog of all-purpose service bots has filled the gap in the robotic assistance market left by the abrupt murder of the CL4P-TP line at the hands of Handsome Jack.

ABOVE: Sporting a number of different designs and color schemes, service bots perform numerous functions and can be found on almost every planet, civilized or not.

RATCHES

RIGHT: Part rat and part roach, Ratches begin their lives as eggs in nests. These eggs grow and mutate rapidly, as shown in these early sketches.

BELOW: Early versions of the Ratch took heavy inspiration from the shape of a cockroach, albeit with a long tail and rodent head.

BOTTOM: Later revisions dialed back the insectoid attributes to show more of the Ratch's quadrupedal body. Eridium-enhanced variants were also designed.

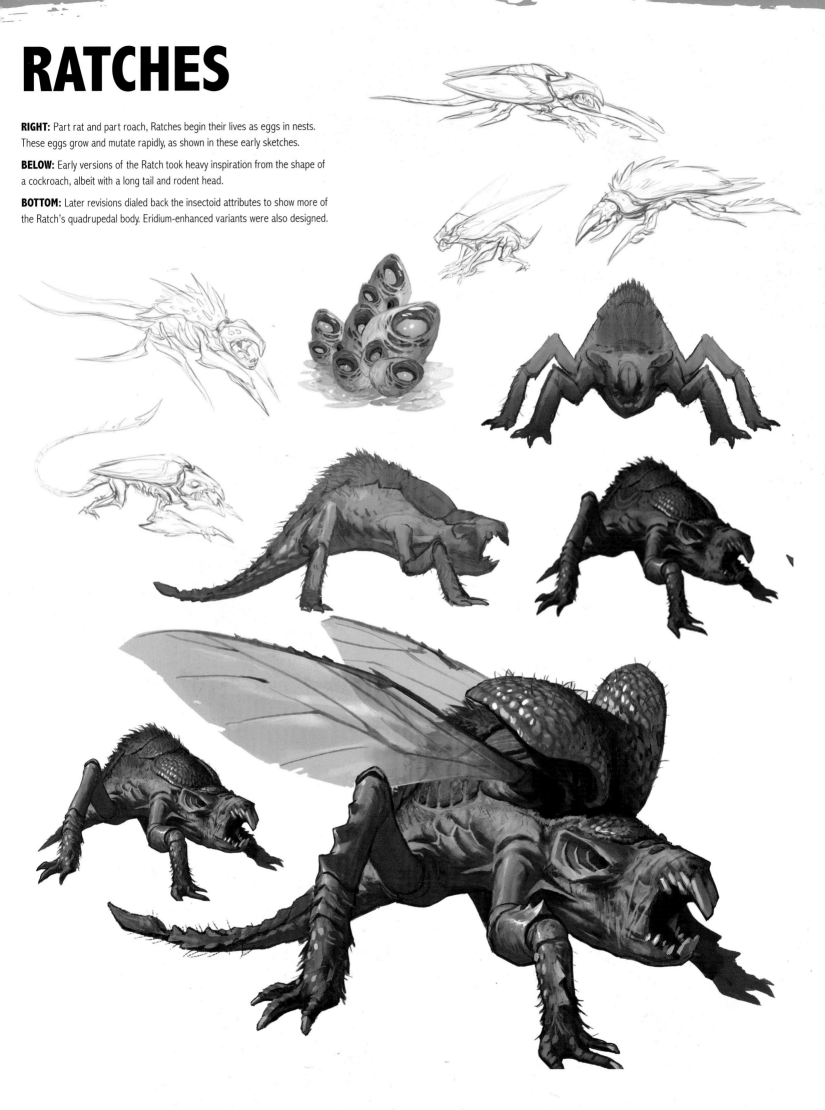

RAKK

TOP: Rakk are flying predators native to Pandora. As a Rakk has no limbs other than its wings, it uses its long, spiked tail both to attack and to adhere to the landscape to rest.

ABOVE: A sketch of a Rakk nest.

LEFT: Possible attachments for the base Rakk enemy. The first example adds head fins, a second set of wings, and a large, club-like tail. The second adds two fins, a twin tail prong, and a number of spikes to the head.

SKAG

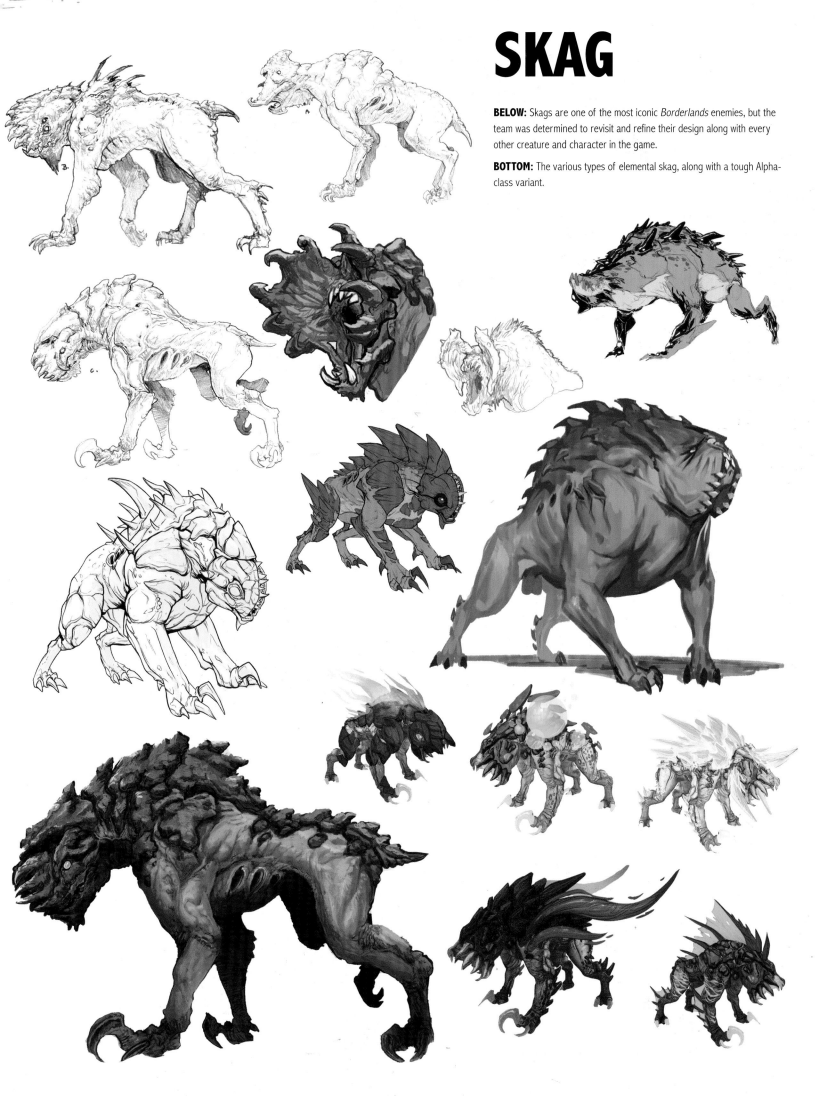

BELOW: Skags are one of the most iconic *Borderlands* enemies, but the team was determined to revisit and refine their design along with every other creature and character in the game.

BOTTOM: The various types of elemental skag, along with a tough Alpha-class variant.

SPIDERANTS

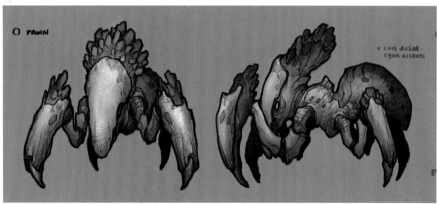

O PAWN

+ cool desat - cyan accents

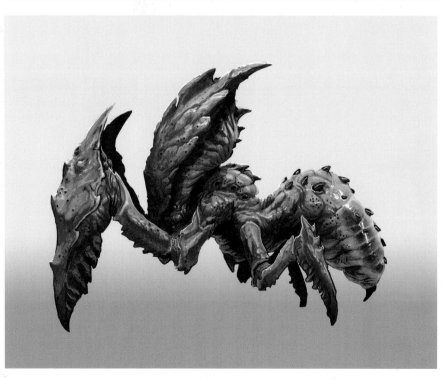

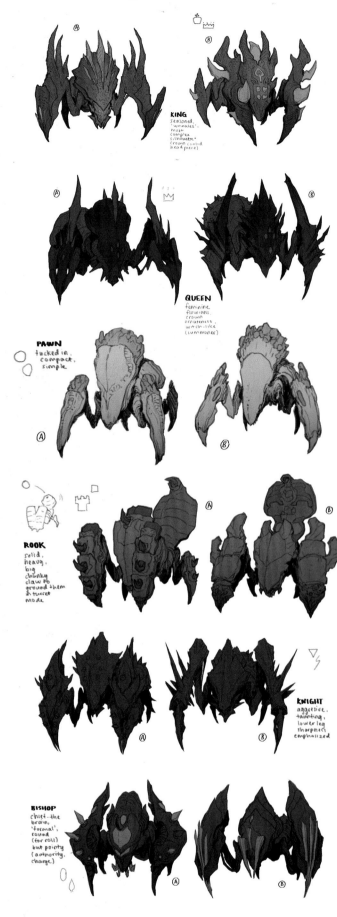

KING
seasoned, 'wrinkles', most complex silhouette, crown (solid headpiece)

QUEEN
feminine, flowiness, crown, ornateness, witch-like (summoner)

PAWN
tucked in, compact, simple

ROOK
solid, heavy, big chunky claw to ground them in turret mode

KNIGHT
aggressive, taunting, lower leg sharpness emphasized

BISHOP
chief, the brain, 'formal', round (for roll) but pointy (authority, charge)

ABOVE: Spiderants operate with a strict hierarchy that is evident in their bodies; the unassuming pawn is the simplest in form while the king and queen Spiderants are the most intricately detailed.

LEFT: While Spiderants have heavily armored heads and claws, their bodies and abdomens remain largely exposed, making the creatures vulnerable to attacks from the side.

VARKIDS

BELOW: Varkids are insectoid enemies with the uncanny ability to trigger the next stage in their life cycle during a fight. Whenever they reemerge from their cocoons, their new form will be stronger and harder to kill. The winged varkid shown here can attack from the air by spitting corrosive acid.

BOTTOM: Varkids start out smaller than humans but quickly grow to tower over them.

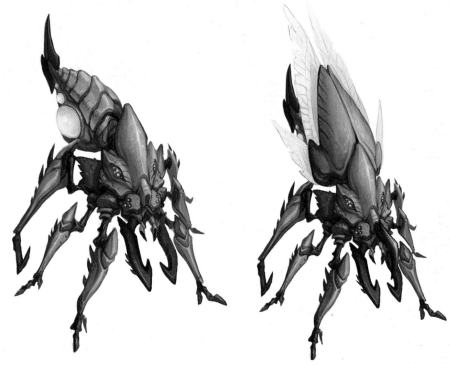

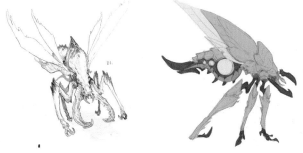

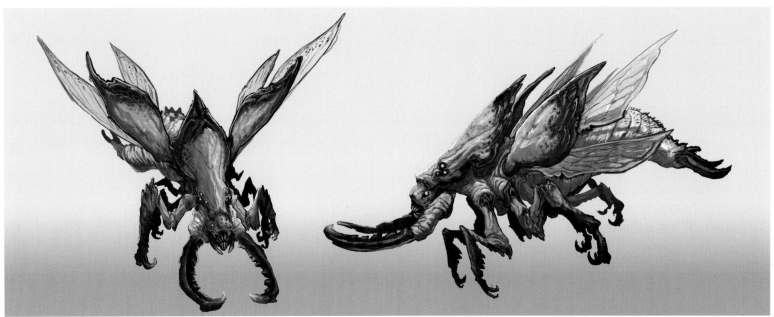

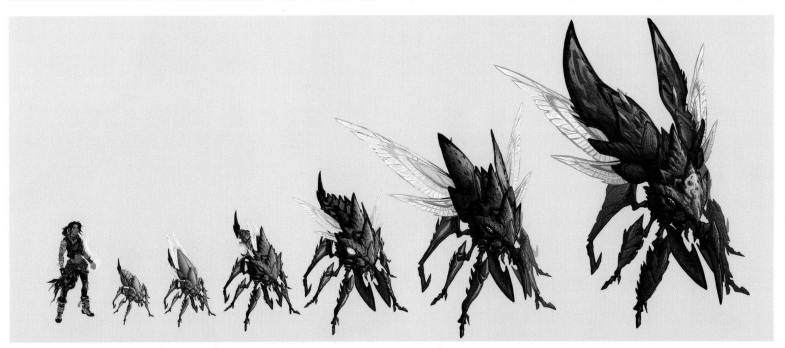

HUMANIOD ENEMIES
MALIWAN ARMY

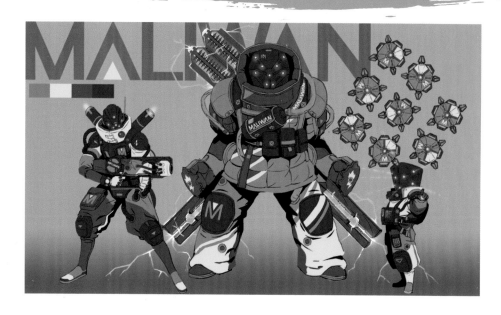

Maliwan exclusively manufactures elemental weapons, and the troops the corporation deploys will proudly show off its latest and greatest arsenal—anything designed to shock, burn, or dissolve unwitting Vault Hunters. Their forces are first encountered on Promethea, where they're clashing with the Atlas Corporation, and the distinctive green-and-orange color scheme of their baggy uniforms makes them easily recognizable even during a frenzied firefight.

Seeking to "acquire" its assets by any means necessary, Katagawa Jr. leads the assault against Atlas—a move he views as just another form of business transaction—and he has many different kinds of soldiers at his disposal. Even regular Maliwan Troopers pose a serious threat, as they're known to attack with batons and disk-like boomerangs, both of which have been infused with elemental energy.

They may not be the most nimble of fighters, but the lumbering Heavies can cause serious problems if they get into range, unleashing elemental attacks of all kinds, fueled by the tanks on their backs. The armored mech-suits that round out Maliwan's operations are large and strong enough to wield enormous particle cannons, elemental energy blades, or shields capable of absorbing incoming fire, all of which spells very bad news for Atlas and its allies.

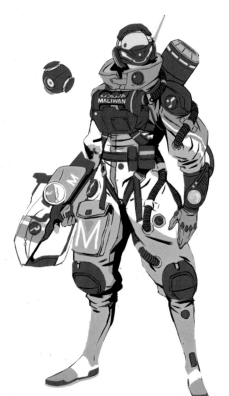

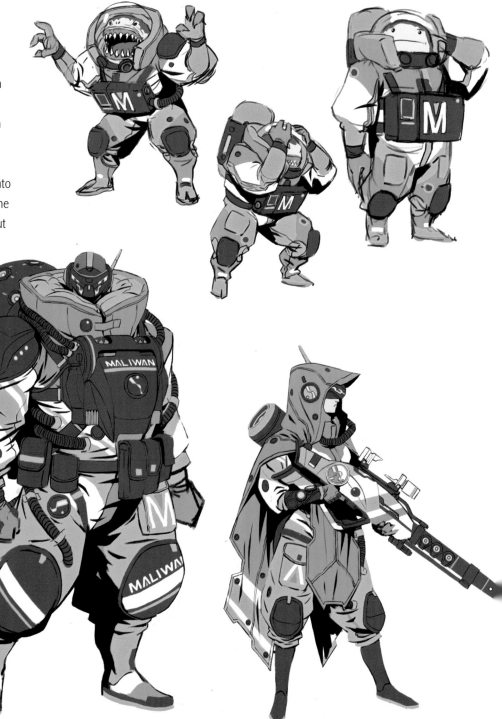

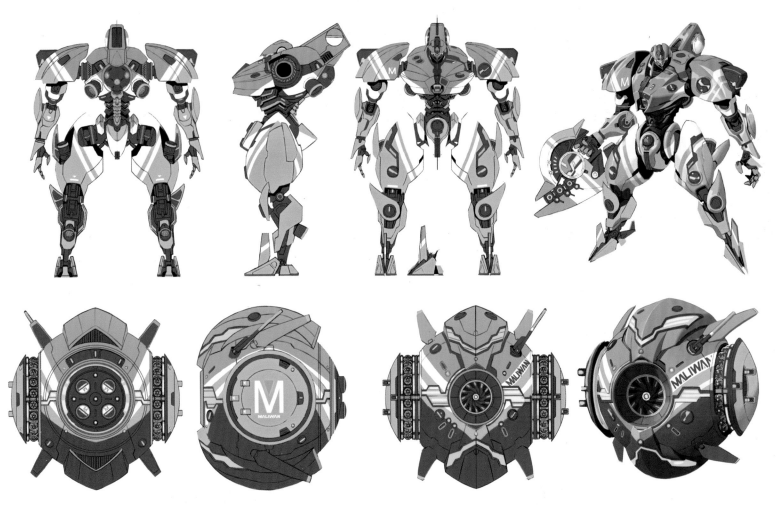

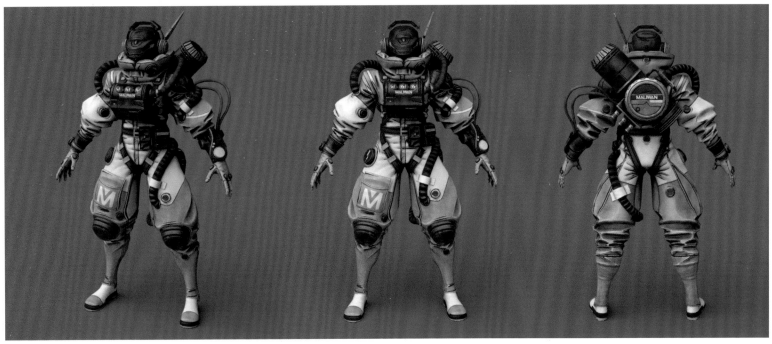

OPPOSITE TOP: A gray and neon-green color palette was considered early on for Maliwan Elites.

TOP: The Maliwan Mech and Oversphere (also known as a Death Sphere) seen from various angles.

ABOVE: Renders of the Maliwan Flash Trooper's final design. Variants include a quad-cylindered backpack and a second antennae mounted to the helmet.

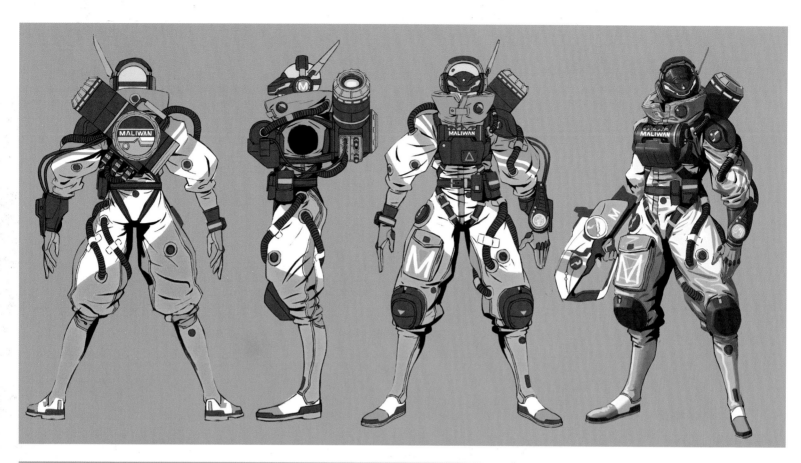

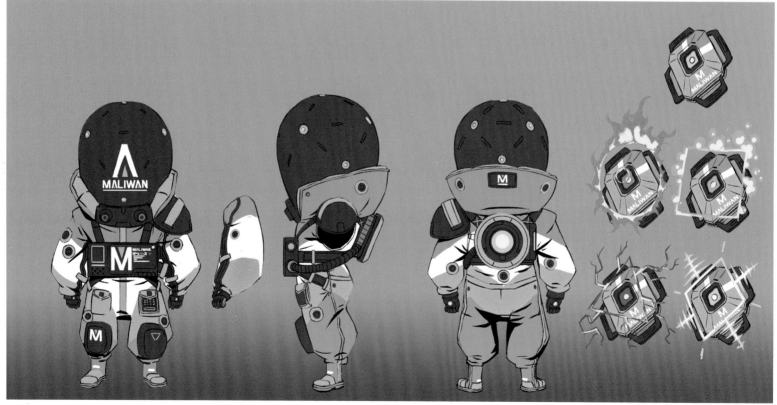

MALIWAN

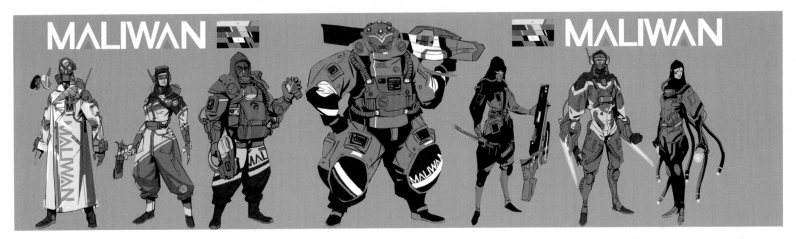

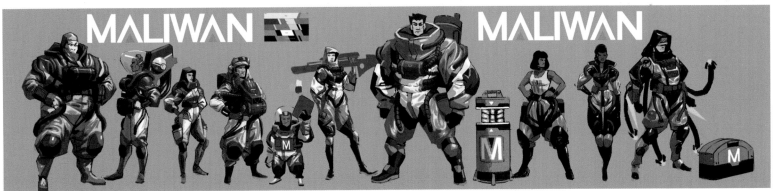

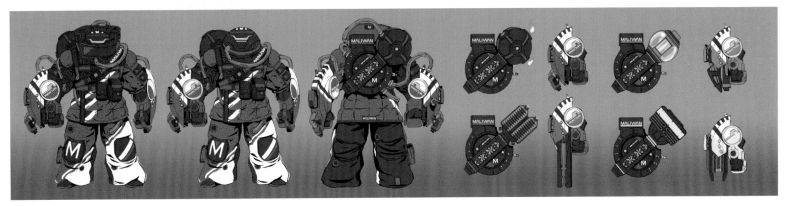

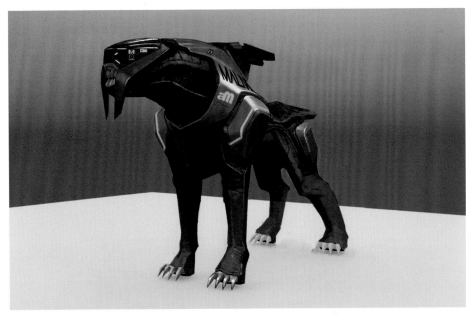

OPPOSITE TOP: The standard Maliwan soldier. Unlike Flash Troopers, they lack headset antennae and are covered only in standard webbing and pouches. Their backpack is also devoid of attachments.

OPPOSITE BOTTOM: Angles of the Maliwan NOG and their drones, which they use both offensively and defensively.

ABOVE: The Maliwan Heavy Trooper and the different types of elemental weapons they carry.

LEFT: An early model of the Frontrunner enemy with canine features, to be deployed alongside Maliwan soldiers. Fast and nimble, the drone would be equipped with both elemental lasers and energy shields.

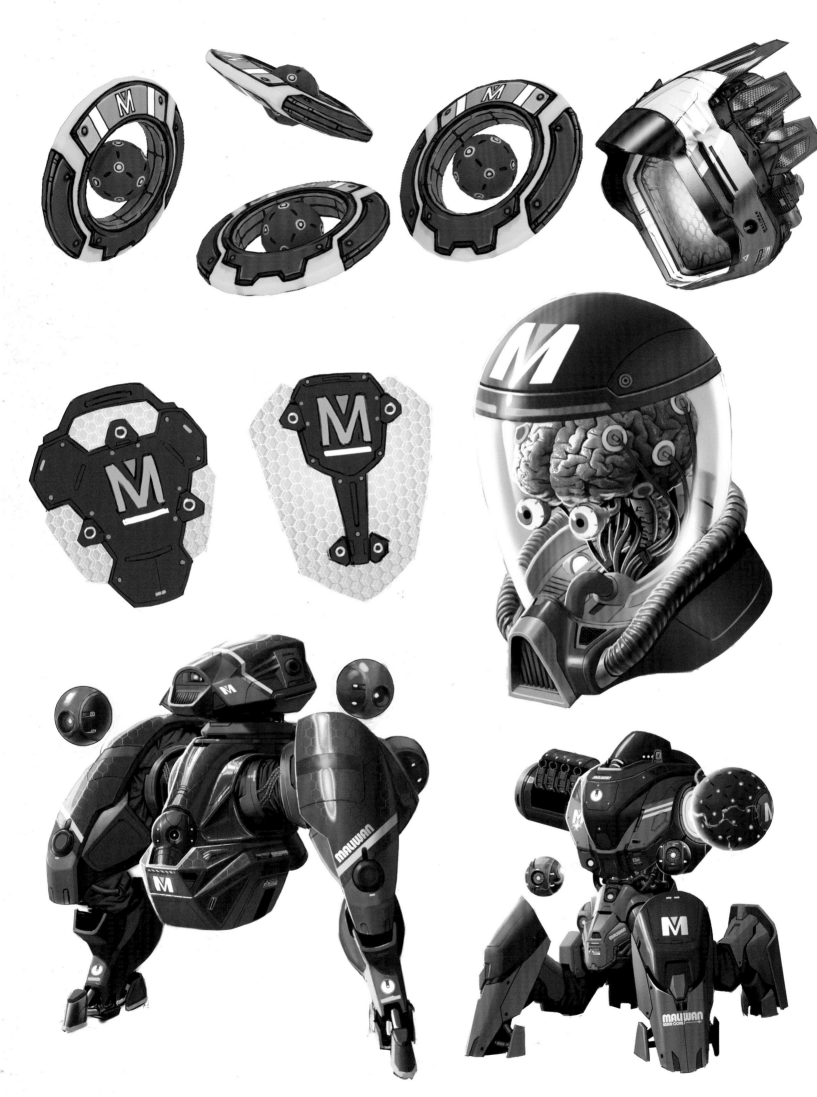

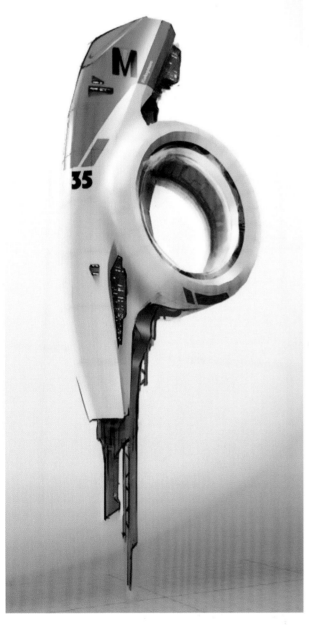

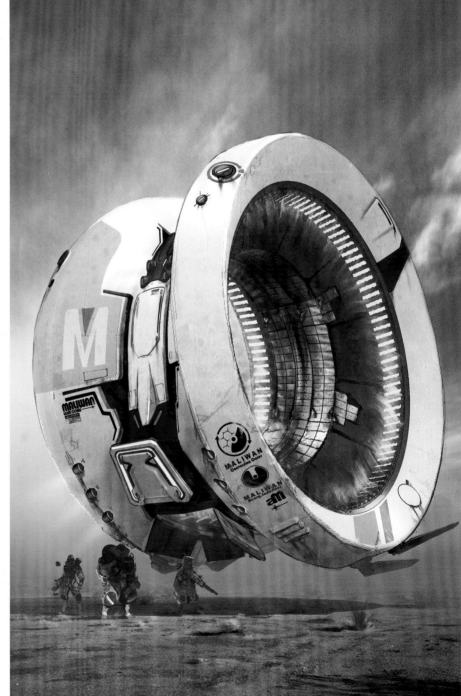

OPPOSITE: A collection of designs for Maliwan weapons, shields, and drones, along with a rather exotic life-support helmet.

THIS PAGE: When it comes to bringing down Atlas and seizing control of Promethea, Maliwan doesn't consider any measures to be too extreme.

CHILDREN OF THE VAULT

As their name implies, the Children of the Vault—otherwise known as the CoV—treat the Eridian repositories with a fanatical reverence because of the powers they can bestow on their would-be gods. As an eclectic gang of misfits and malcontents, members of their cult are absolutely devoted to Troy and Tyreen Calypso, and will happily head out into the galaxy to slaughter and savage in their name. Their unwavering loyalty to the twins and to one another provides an example of the different forms a family can take, an idea that *Borderlands 3* explores throughout its story.

With their punkish, disaffected style, CoV soldiers are visually distinct from bandits and from the corporate soldiers who wield power elsewhere in the cosmos: Leather jackets, ragged trousers, and lengths of metal chain are just a few of their defining features. Even so, they're more than willing to make use of advanced technology to achieve their goals, not to mention ally themselves with titans of industry like Maliwan. Like Troy, some elite CoV troops have gone so far as to cybernetically enhance their bodies, turning themselves into even more efficient killing machines.

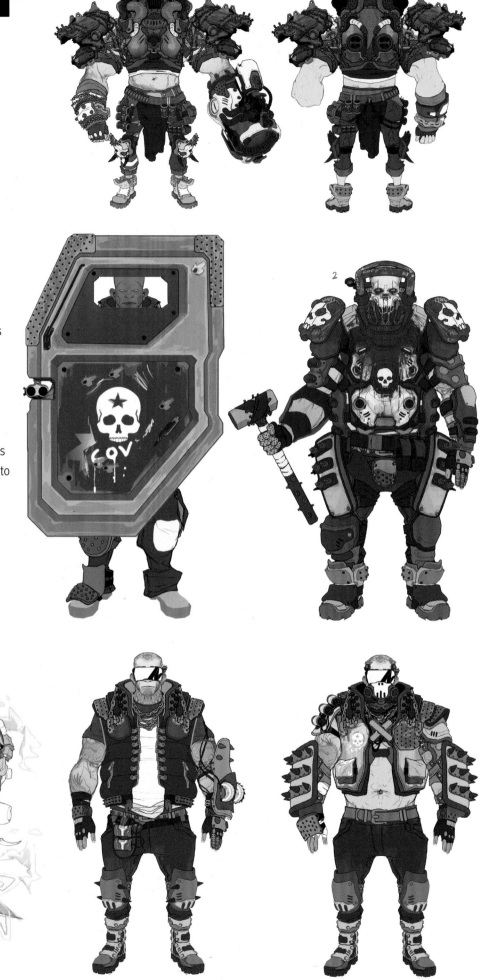

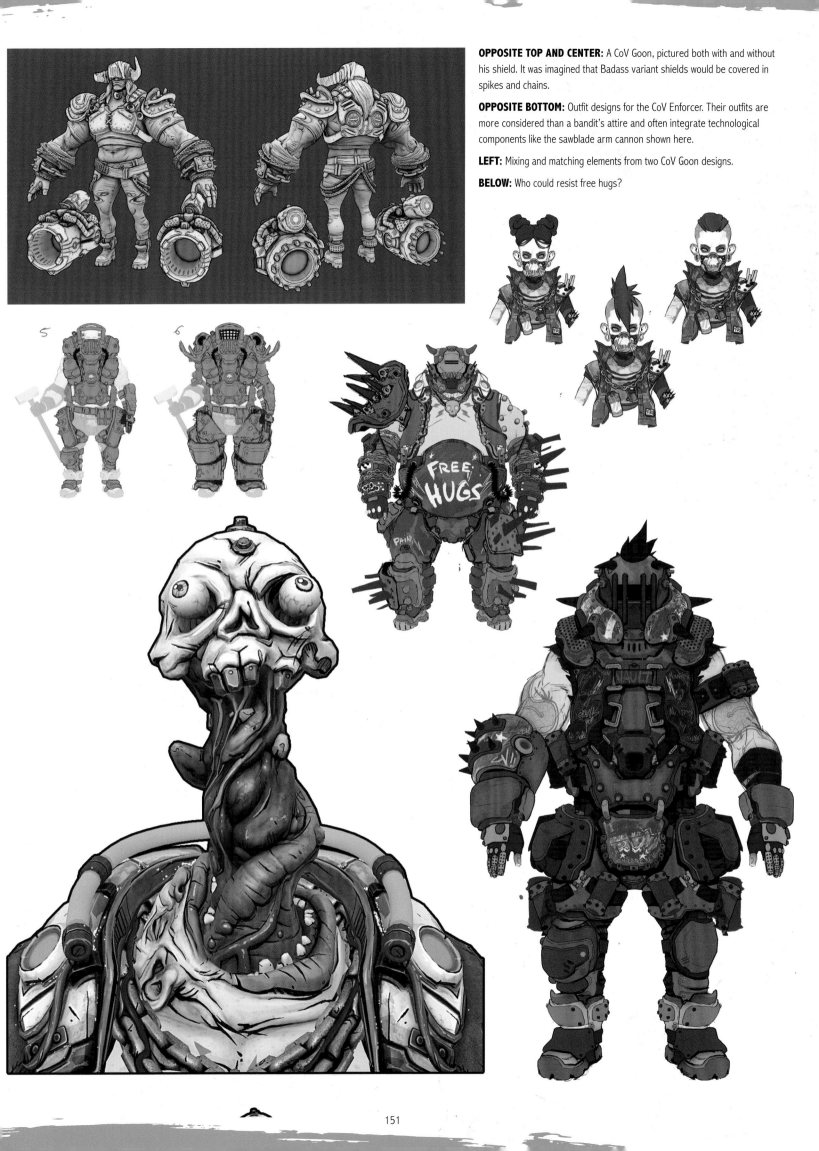

OPPOSITE TOP AND CENTER: A CoV Goon, pictured both with and without his shield. It was imagined that Badass variant shields would be covered in spikes and chains.

OPPOSITE BOTTOM: Outfit designs for the CoV Enforcer. Their outfits are more considered than a bandit's attire and often integrate technological components like the sawblade arm cannon shown here.

LEFT: Mixing and matching elements from two CoV Goon designs.

BELOW: Who could resist free hugs?

BANDITS

RIGHT: Any bandit who signs up to join the Children of the Vault becomes more threatening in both appearance and weapons access.

BOTTOM: The visor-wearing Bandit Goon uses various hand tools to attack.

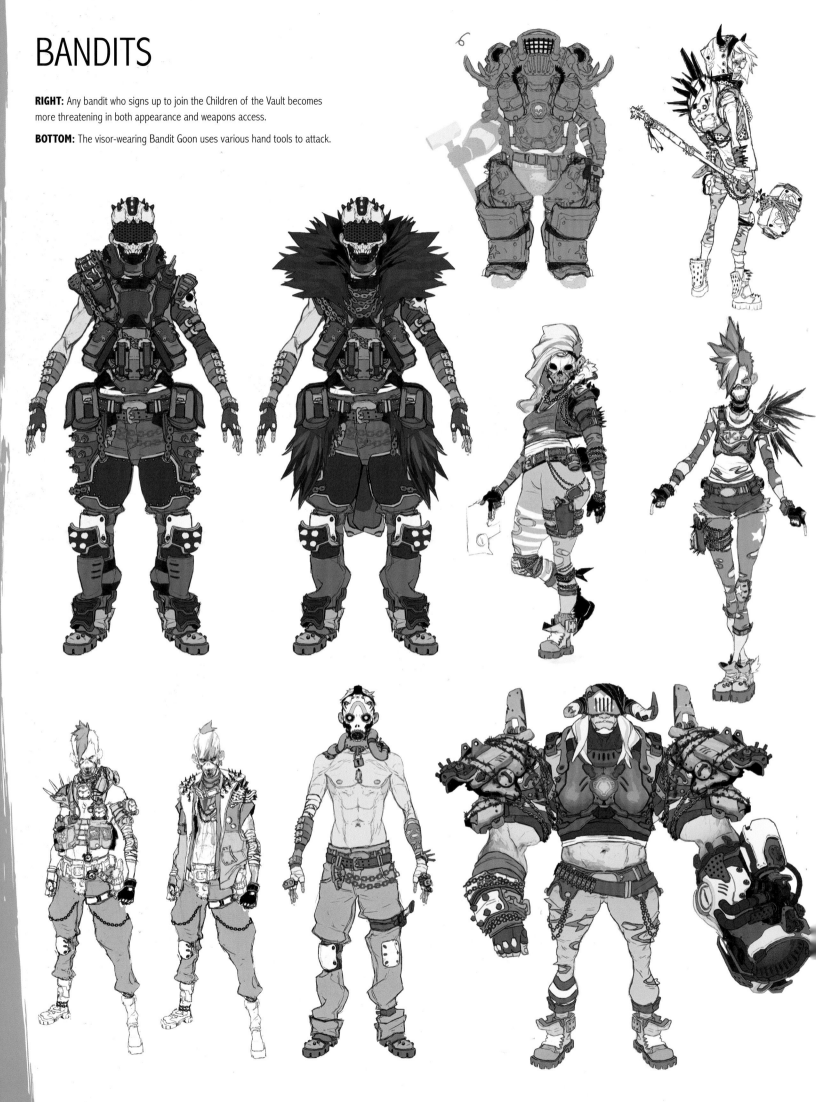

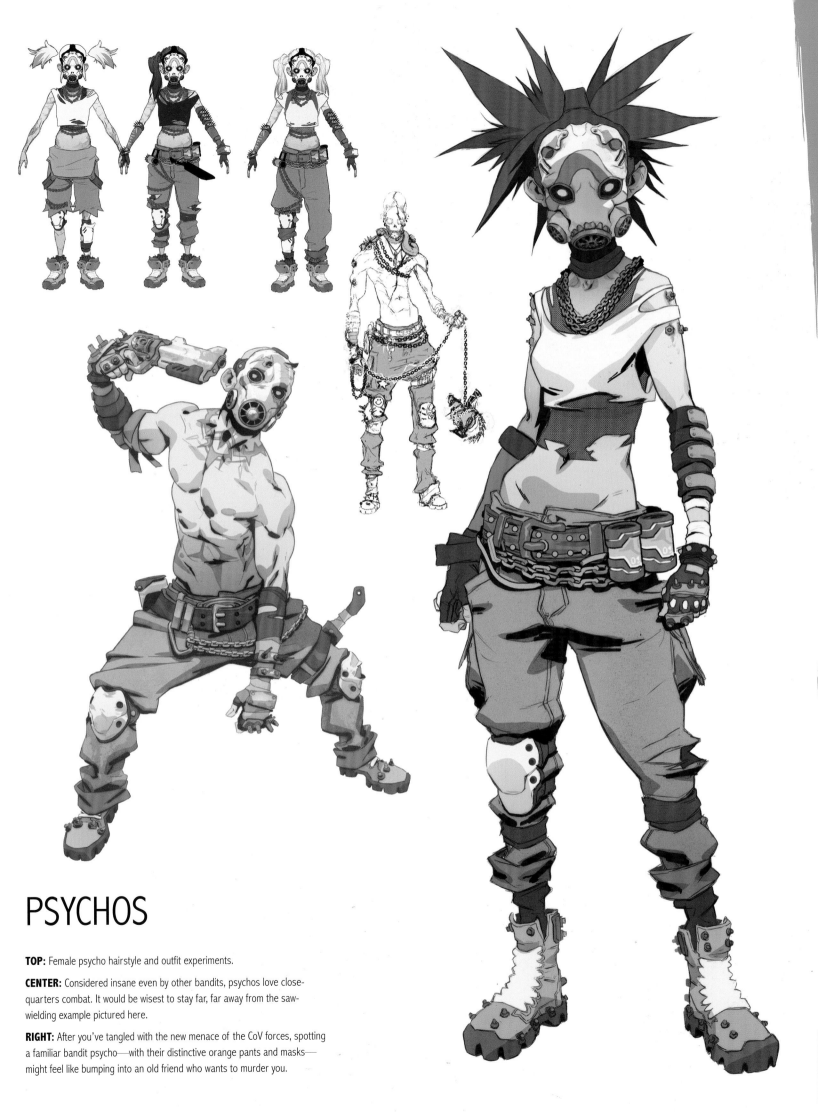

PSYCHOS

TOP: Female psycho hairstyle and outfit experiments.

CENTER: Considered insane even by other bandits, psychos love close-quarters combat. It would be wisest to stay far, far away from the saw-wielding example pictured here.

RIGHT: After you've tangled with the new menace of the CoV forces, spotting a familiar bandit psycho—with their distinctive orange pants and masks—might feel like bumping into an old friend who wants to murder you.

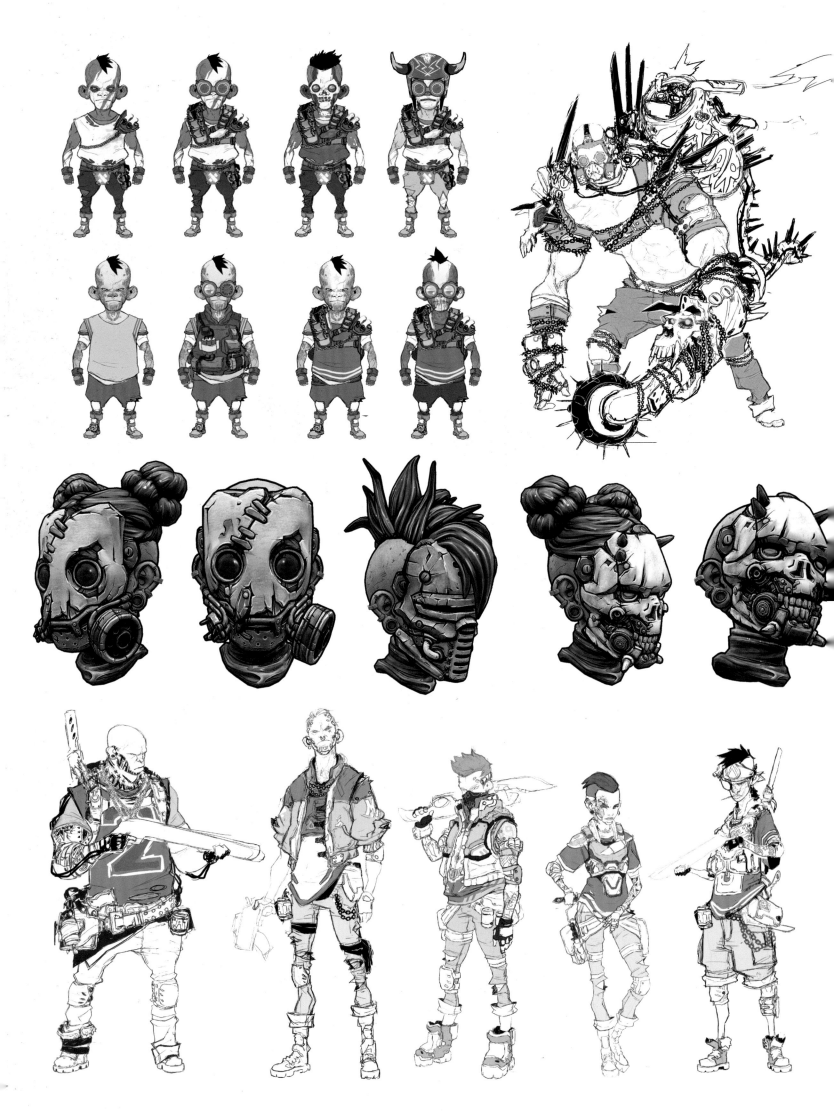

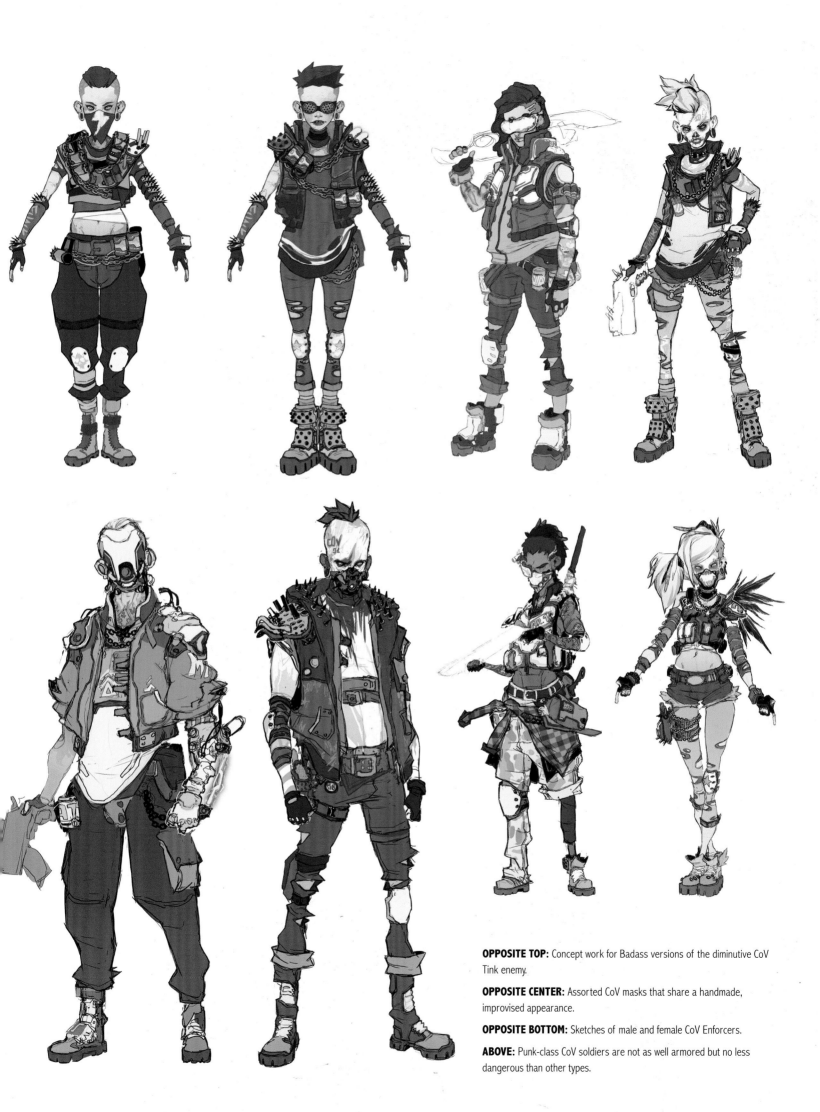

OPPOSITE TOP: Concept work for Badass versions of the diminutive CoV Tink enemy.

OPPOSITE CENTER: Assorted CoV masks that share a handmade, improvised appearance.

OPPOSITE BOTTOM: Sketches of male and female CoV Enforcers.

ABOVE: Punk-class CoV soldiers are not as well armored but no less dangerous than other types.

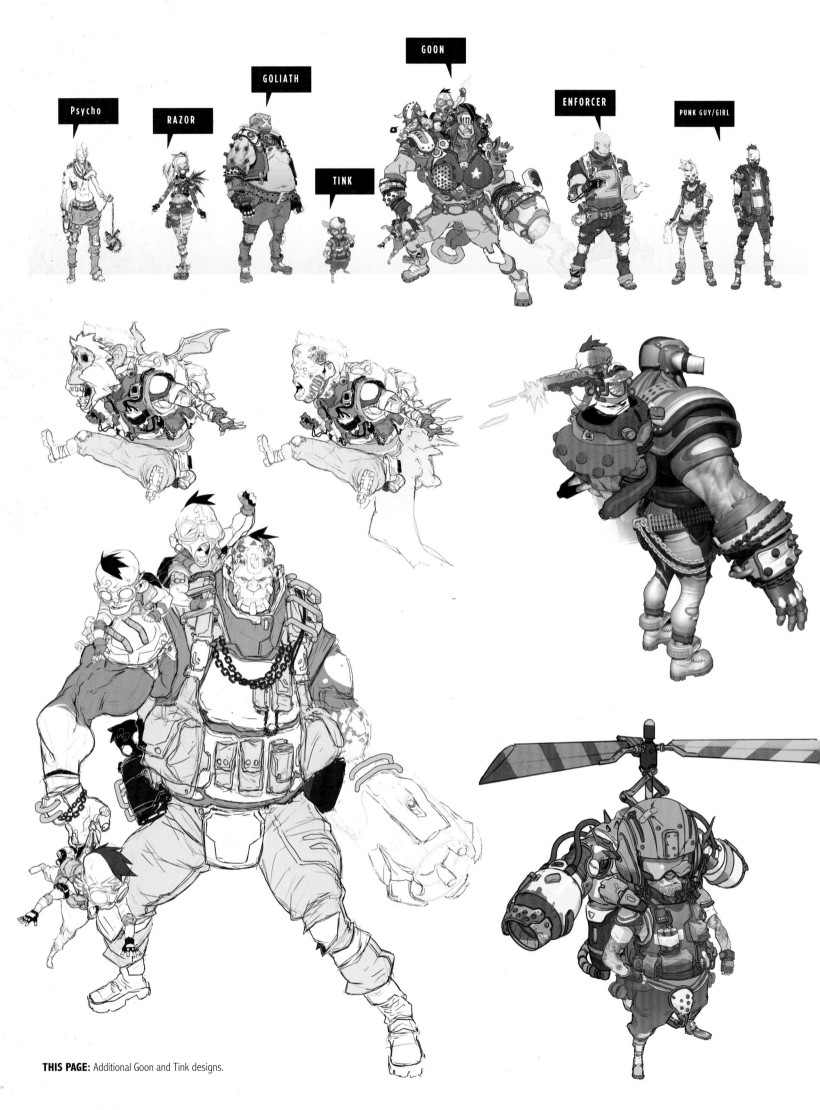

THIS PAGE: Additional Goon and Tink designs.

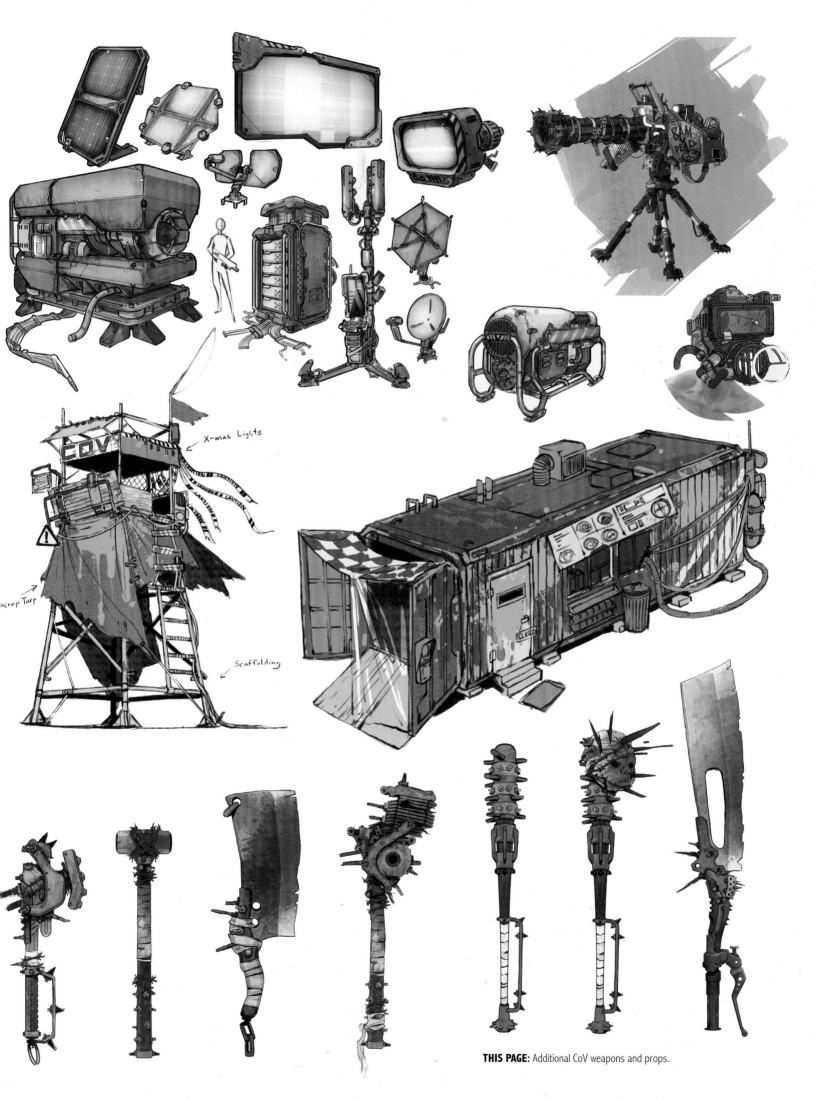

X-mas Lights

Scrap Tarp

Scaffolding

THIS PAGE: Additional CoV weapons and props.

VAULT MONSTERS

As their name implies, Vault Hunters are drawn to the promise of ancient and powerful technology hidden deep underground by the Eridians who created it. While it's true that many Vaults contain unique relics that offer insights into a (mostly) absent and (very) powerful alien race, they're also packed with dangerous creatures designed to act as security measures protecting the contents within.

Chief among these are Vault Monsters: vicious, gigantic creatures with powerful offensive attacks. Despite the obvious danger that they pose, several aspiring tyrants have deliberately sought out Vault Monsters, hoping to harness their incredible destructive power for themselves.

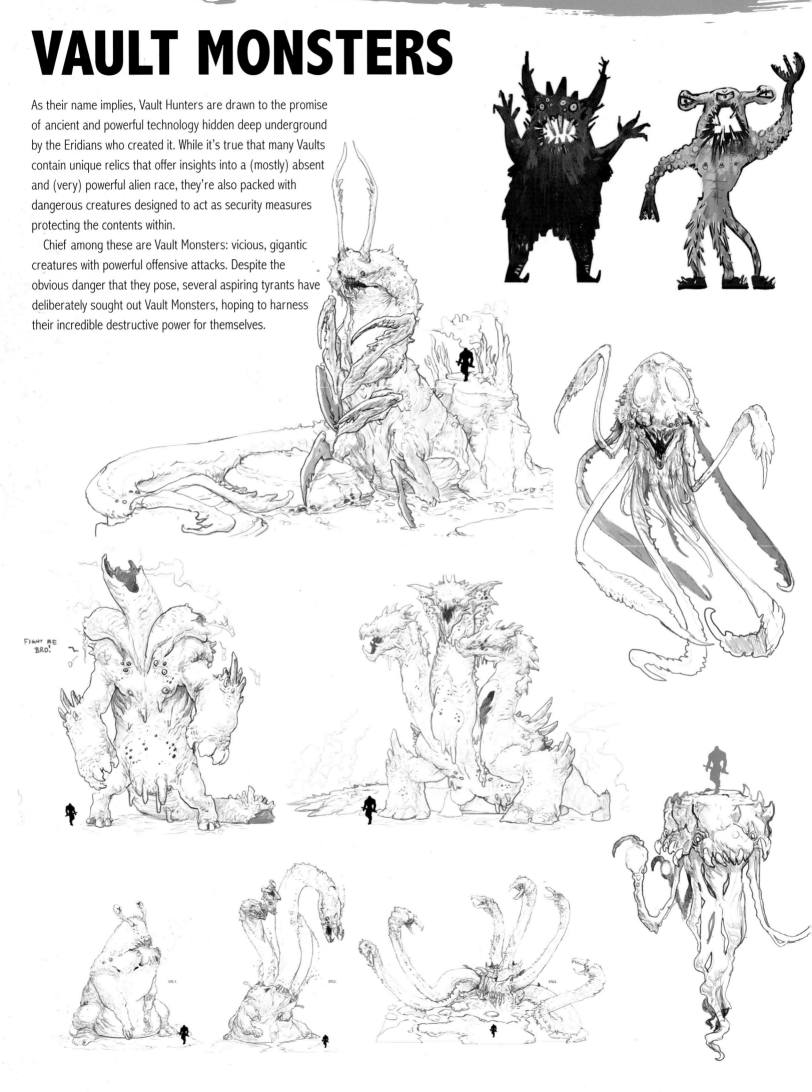

FIGHT ME BRO!

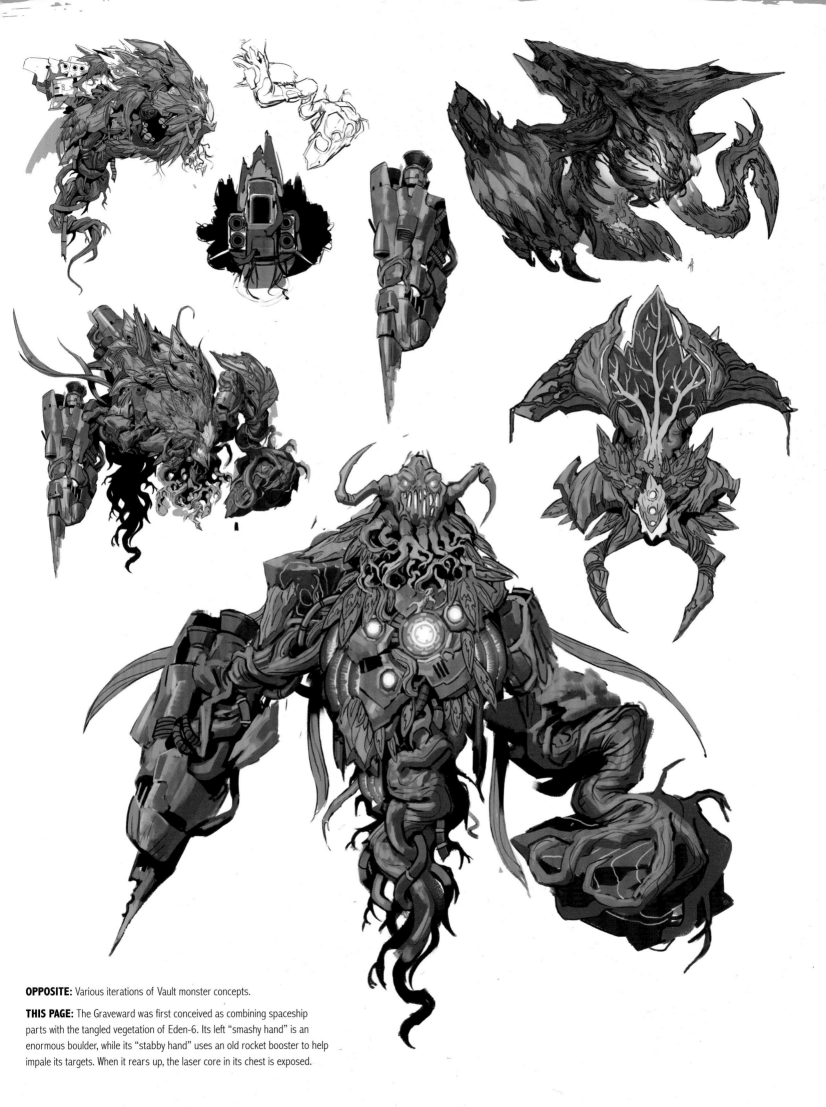

OPPOSITE: Various iterations of Vault monster concepts.

THIS PAGE: The Graveward was first conceived as combining spaceship parts with the tangled vegetation of Eden-6. Its left "smashy hand" is an enormous boulder, while its "stabby hand" uses an old rocket booster to help impale its targets. When it rears up, the laser core in its chest is exposed.

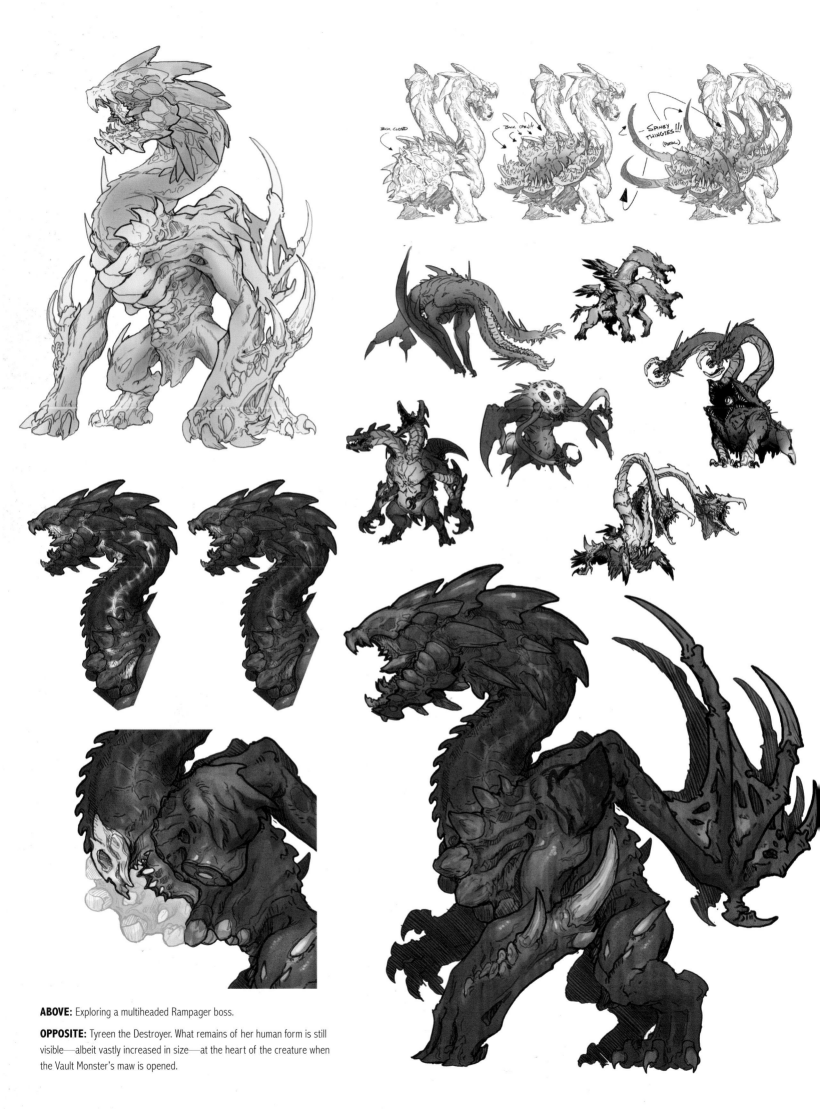

ABOVE: Exploring a multiheaded Rampager boss.

OPPOSITE: Tyreen the Destroyer. What remains of her human form is still visible—albeit vastly increased in size—at the heart of the creature when the Vault Monster's maw is opened.

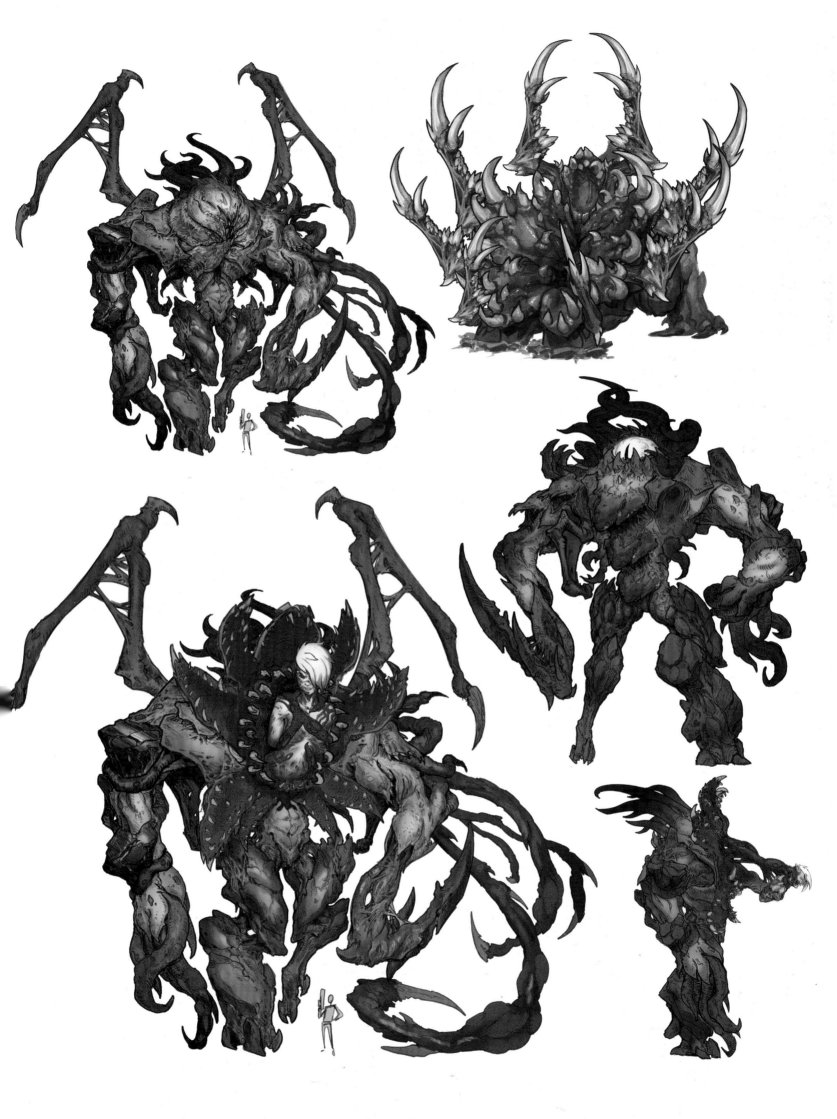

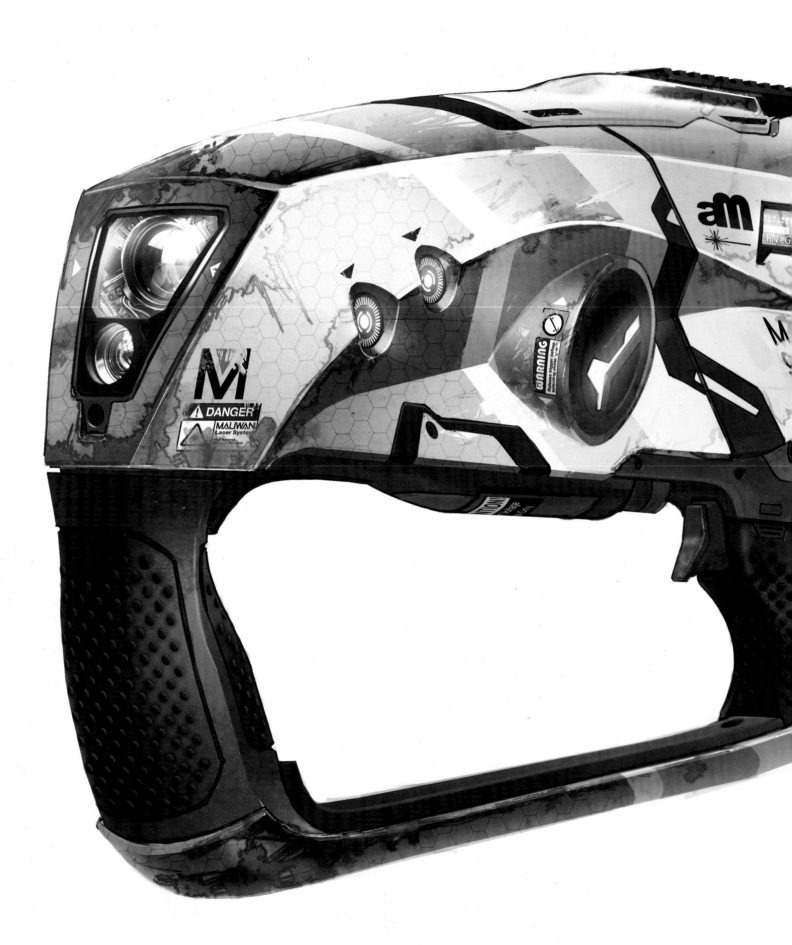

4
WEAPONS

Think *Borderlands*, and you think guns. Whether it's snatching an acid-spewing shotgun or claiming a new sniper rifle with explosive rounds, new and more powerful weapons are a Vault Hunter's ultimate reward as they blast their way through bandit camps and topple huge bosses in search of the loot that waits in the chambers beyond. When stat values are taken into consideration, the first *Borderlands* had over sixteen million unique weapons—a staggeringly high number until you learn that *Borderlands 3* contains over one *billion*. This chapter explores the many manufacturers that give the galaxies their guns, and the unique aesthetics and functions of each, along with grenades, shields, and other gadgets.

Previously, guns had been developed by members of the team who showed a particular affinity for weapon design, or who came up with visually appealing sketches that could then be developed into 3D models. This approach sometimes meant additional work and fixes near the end of the project, so that parts designed by two different artists could be combined into one "gestalt" weapon when fit together correctly. This time, a dedicated weapons team was created to focus on firearms.

With nearly fifteen hundred weapon parts to consider, one big change for *Borderlands 3* was grouping guns into "families" based on the philosophy of the corporation supplying them. Lead Weapons Artist Jimmy Barnett explains why: "When we were figuring out our end goal, our mantra this whole time was manufacturer identity. We really wanted to make sure that when you picked up a gun you knew what it was no matter [the] configuration: a Dahl, Jakobs, whatever.

"In the past, we would just mix all the parts together, and then you'd get a skin of the manufacturer. The problem with *Borderlands 2* was, as soon as you black-and-white that weapon, I would challenge people in this building to tell me which gun they're holding without having to look at a card or something. From the very beginning, I wanted manufacturer identity, so that informed what we needed to do with the system."

These family groupings, along with an upgraded game engine, allow for weapons that are not only visually distinctive but more intricately designed, with higher material definition and more surface detailing. Animation is also a vital part of making the guns feel alive, and many weapons have components that move or transform in surprising ways.

"Part of doing the individual gestalts was that we got unique skeletons for every single weapon, and unique rigs that allowed us to get some really crazy animations going," says Lead Concept Artist Kevin Duc. "They've all got supercool reloads. And on top of visuals, we have [Lead Senior Sound Designer] Brian Fieser. He decided to build basically the audio equivalent of [the system we use to make the guns]. So now every gun sounds at least slightly different, but if you get one weapon that's totally different visually [from another, they're] going to sound pretty different, you know? It's awesome. Dude went nuts."

THIS PAGE: A close-up of a Maliwan SMG.

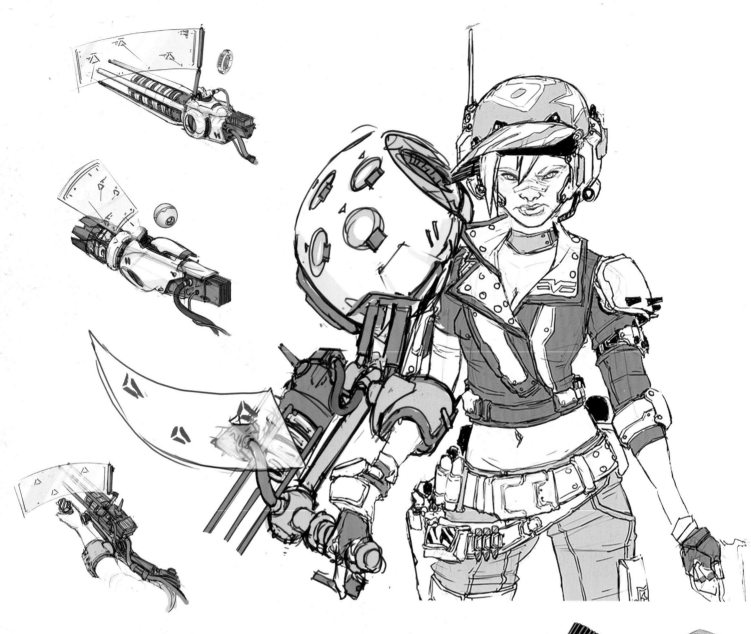

ATLAS

Atlas is back with a bang in *Borderlands 3*, having been largely out of the picture since the defeat of General Knoxx. It takes practice to use its weaponry efficiently, for the unique selling point of an Atlas is the tracer darts that can be planted on an enemy. Once the gun has found its target, it transforms, opening up to deliver a sizable payload upon whatever or whomever has been marked.

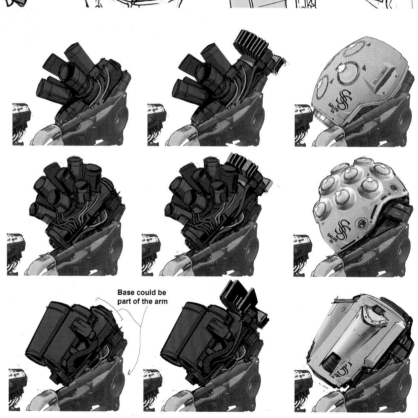

Base could be part of the arm

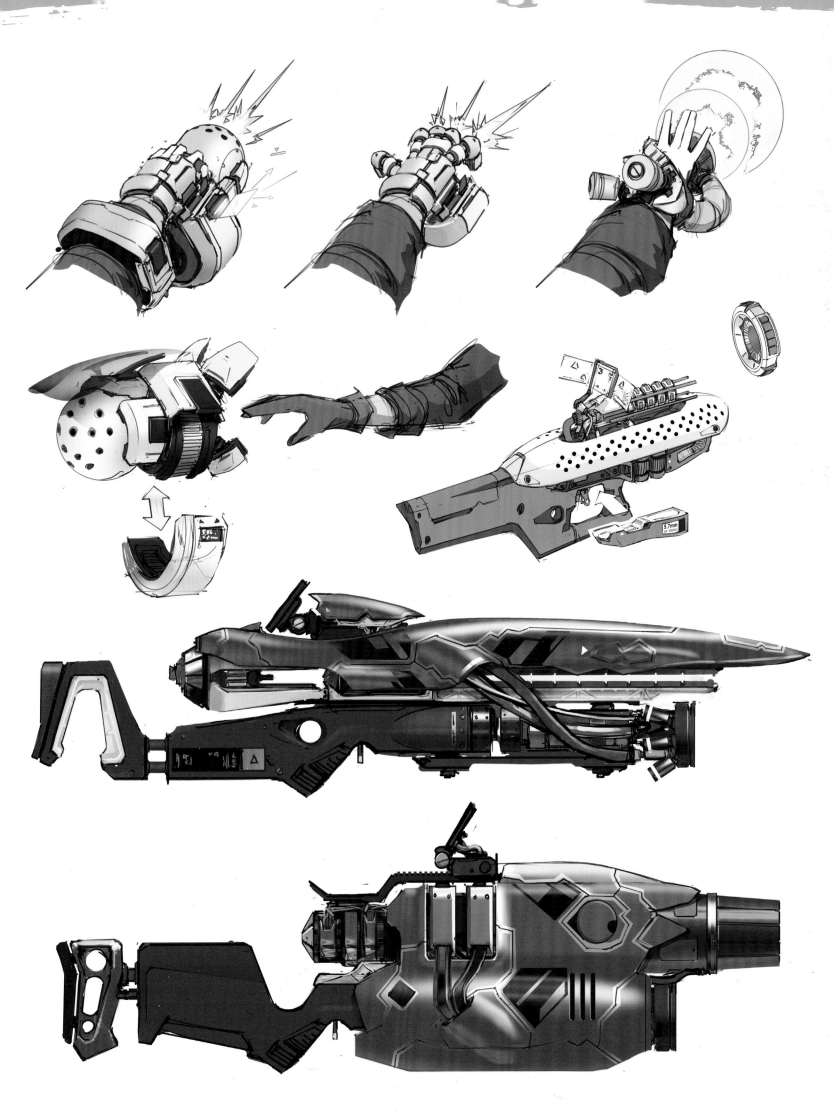

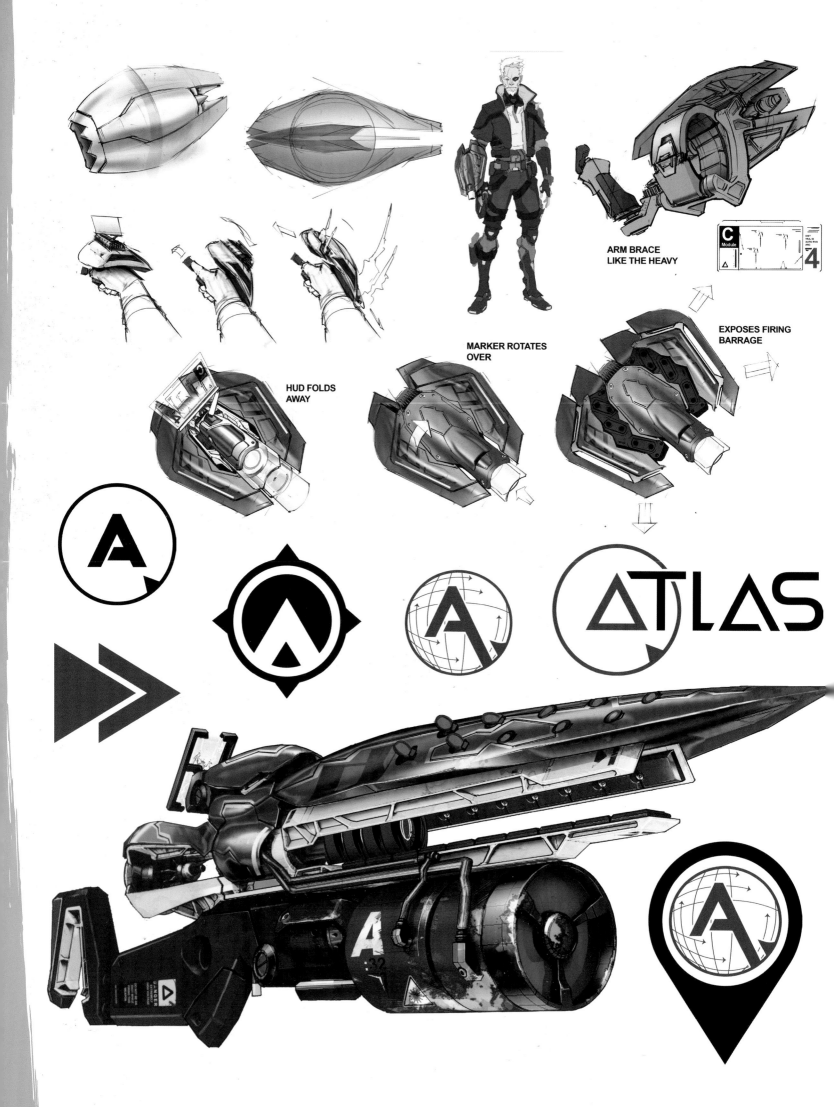

ARM BRACE
LIKE THE HEAVY

MARKER ROTATES
OVER

EXPOSES FIRING
BARRAGE

HUD FOLDS
AWAY

ATLAS

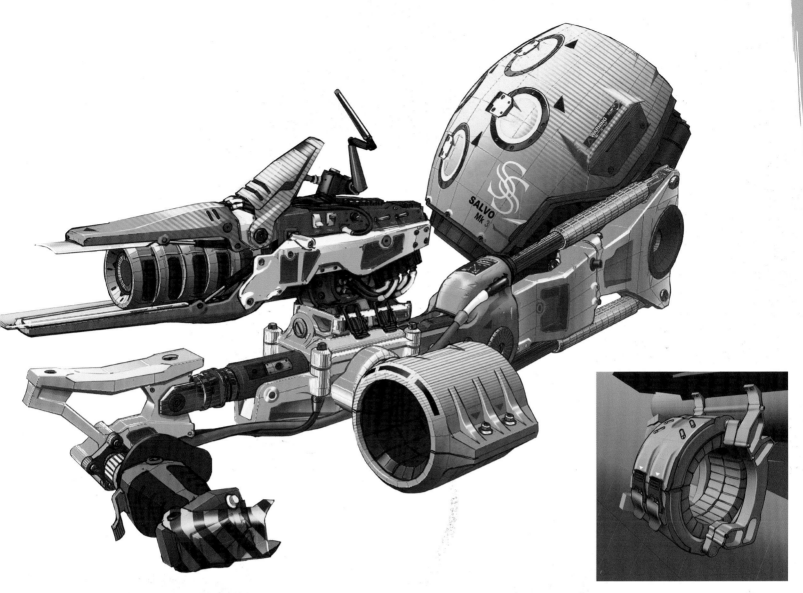

SALVO
Mk 3

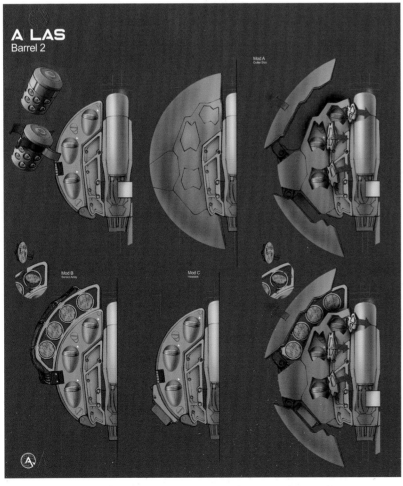

A LAS
Barrel 2

Mod A
Outer Skin

Mod B
Sensor Array

Mod C
Hardpoint

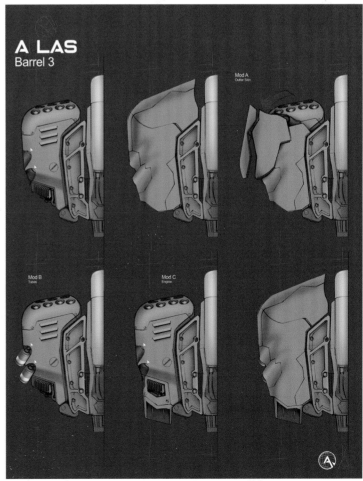

A LAS
Barrel 3

Mod A
Outer Skin

Mod B
Tubes

Mod C
Engines

DAHL

Dahl's legacy is evident all across Pandora, including its weapons, which prioritize smooth and stable performance when the sights are used to aim. Styled after twenty-first-century military armaments, Dahl family weapons have several different firing modes ranging from single-shot to burst fire and fully automatic, and their optics reconfigure automatically to best suit the situation.

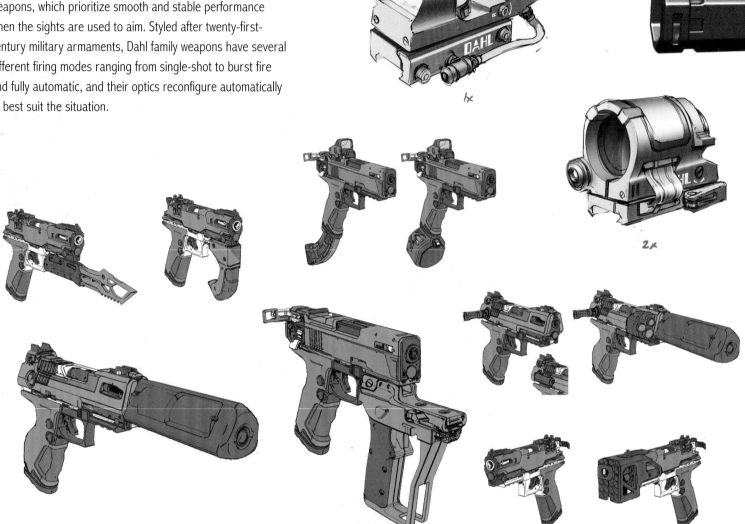

1x

2x

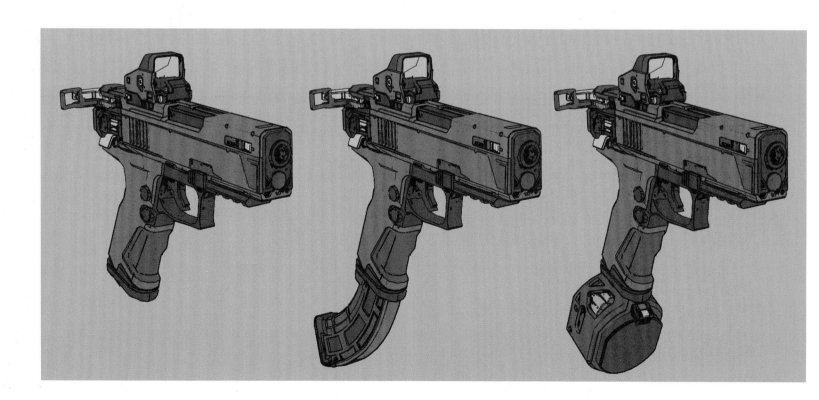

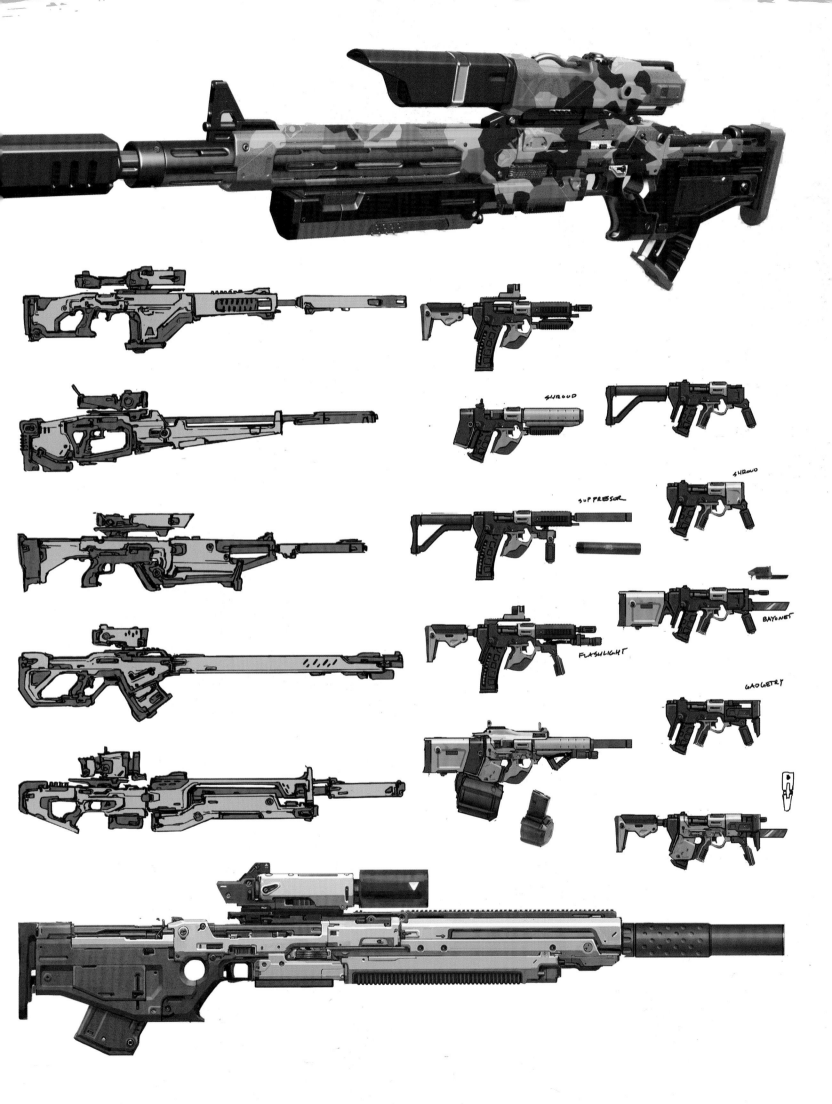

SHROUD

SHROUD

SUPRESSOR

BAYONET

FLASHLIGHT

GADGETRY

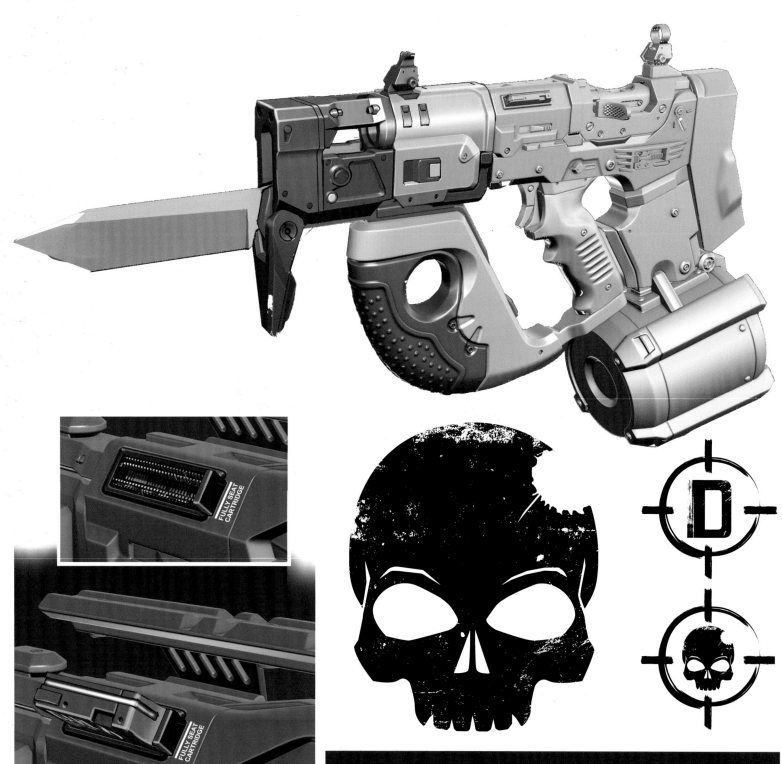

DAHL

FACTORY SEALED
7.62 AP
123.5857.1

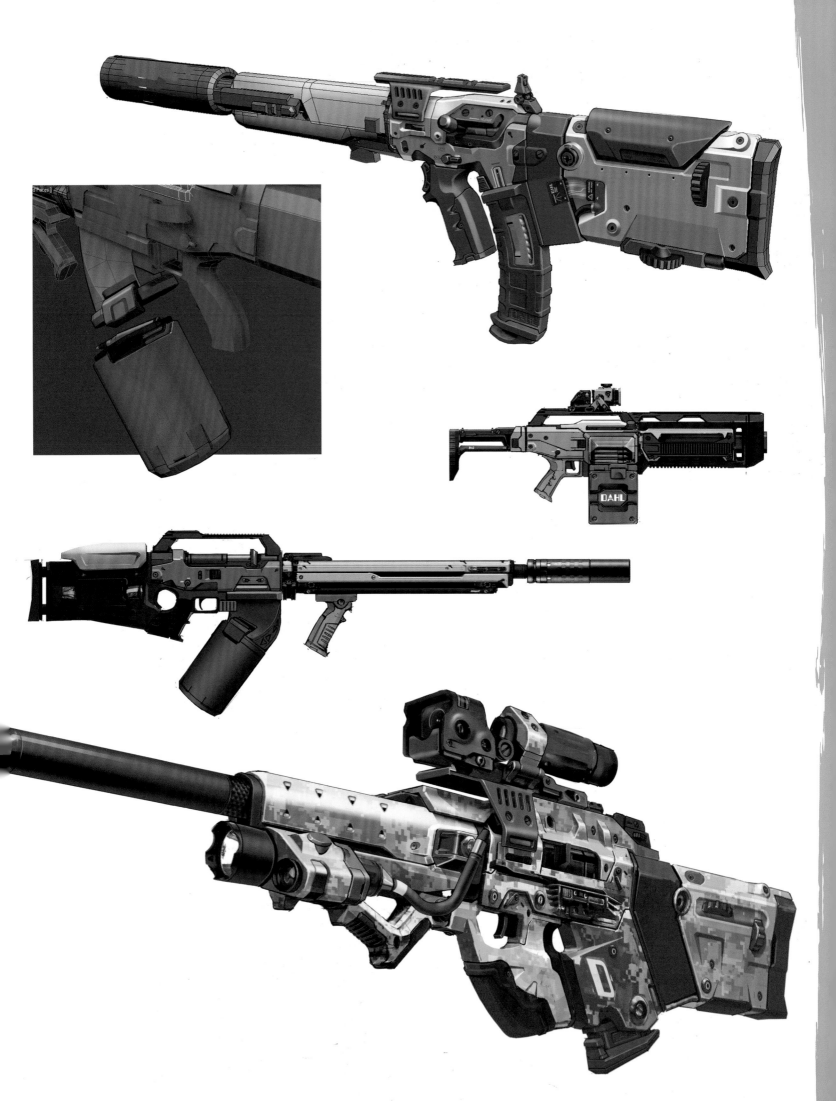

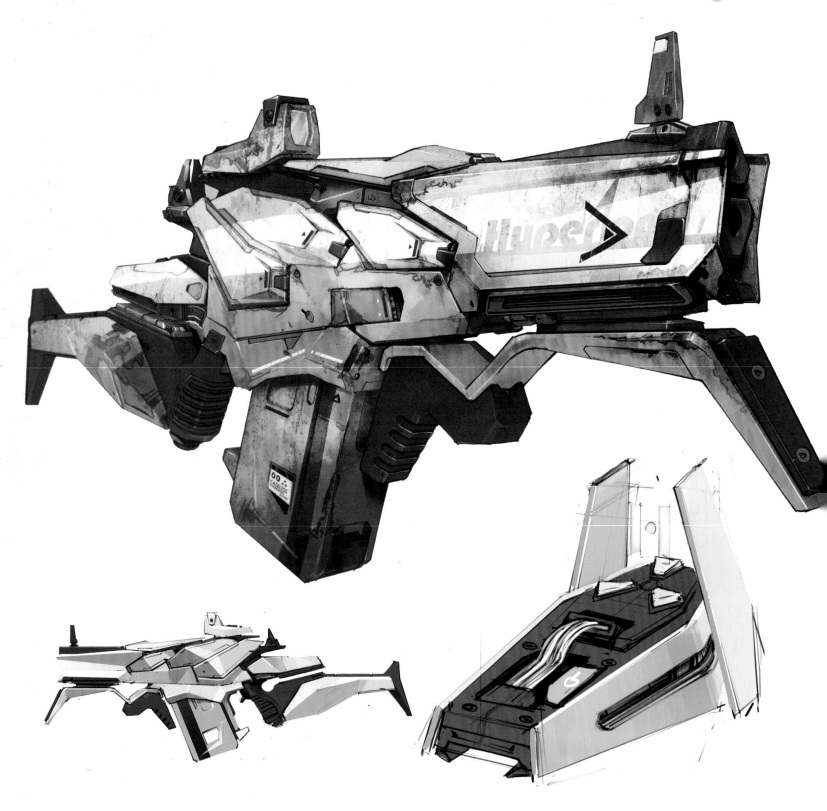

HYPERION

Weighty and angular, Hyperion weapons are notable for being able to generate an energy shield, similar to the turrets deployed by Roland in the first *Borderlands*. At their most basic level, these shields will block incoming fire. At higher levels, they will trap enemy projectiles before spraying them back in the direction they came from, or converting them into ammunition for the gun's own magazine.

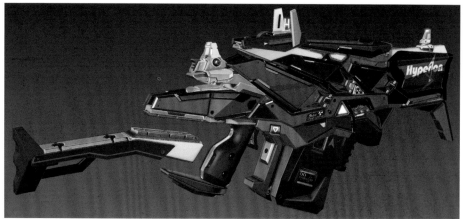

Shield Generators

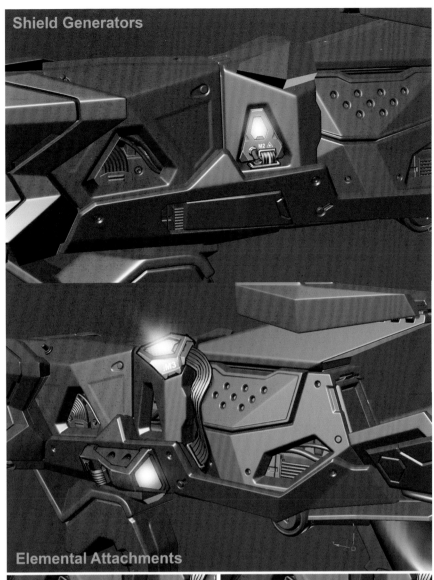

Elemental Attachments

ON OFF

5.7 mm ▶
CASELESS AP
HYPERION INC.
65-957

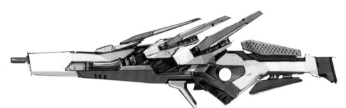
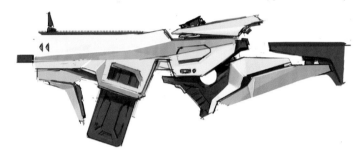
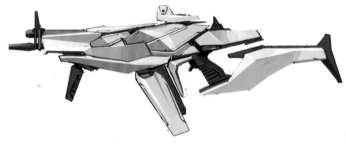

Hyper on
Shield FX Pre-vis

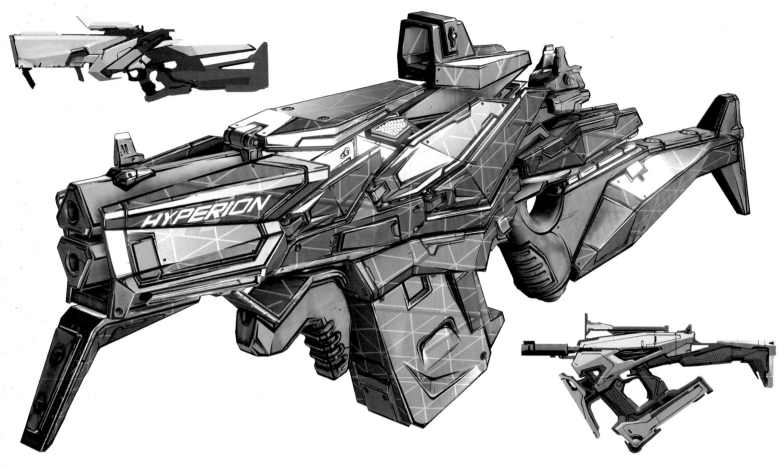

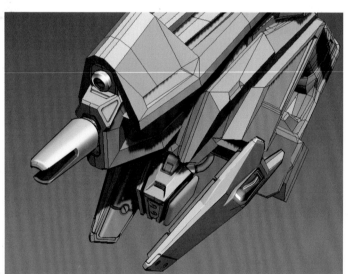

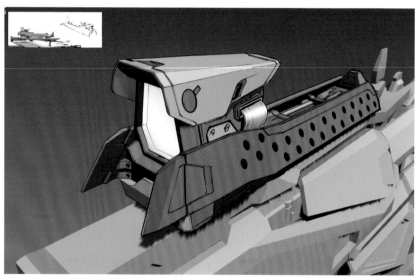

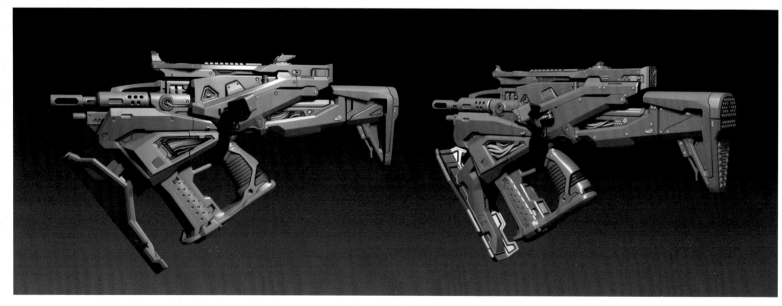

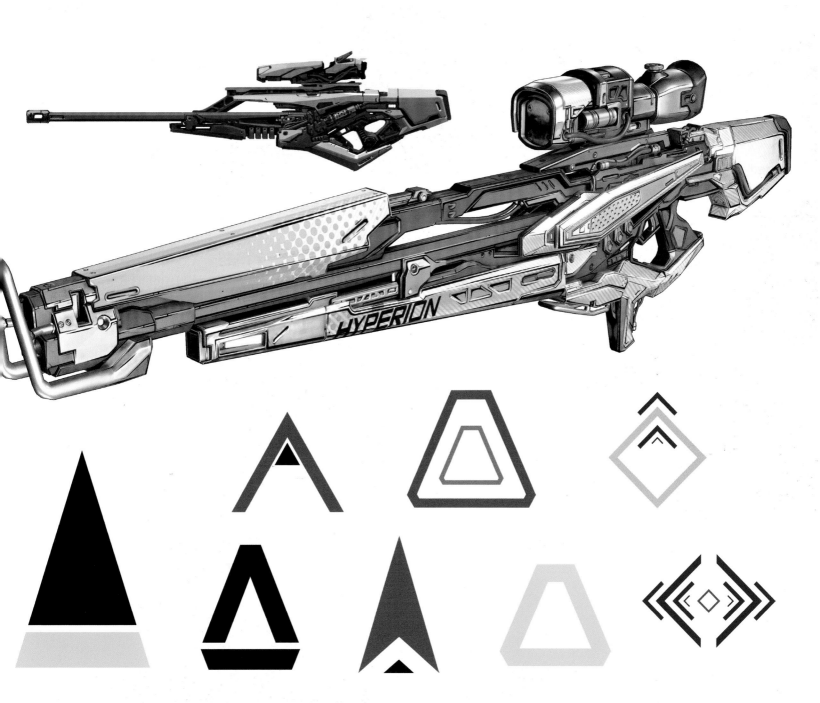

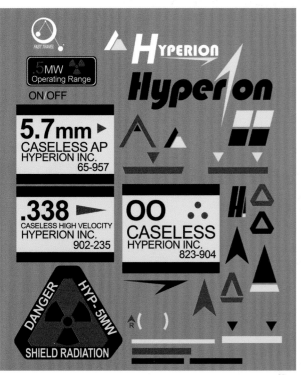

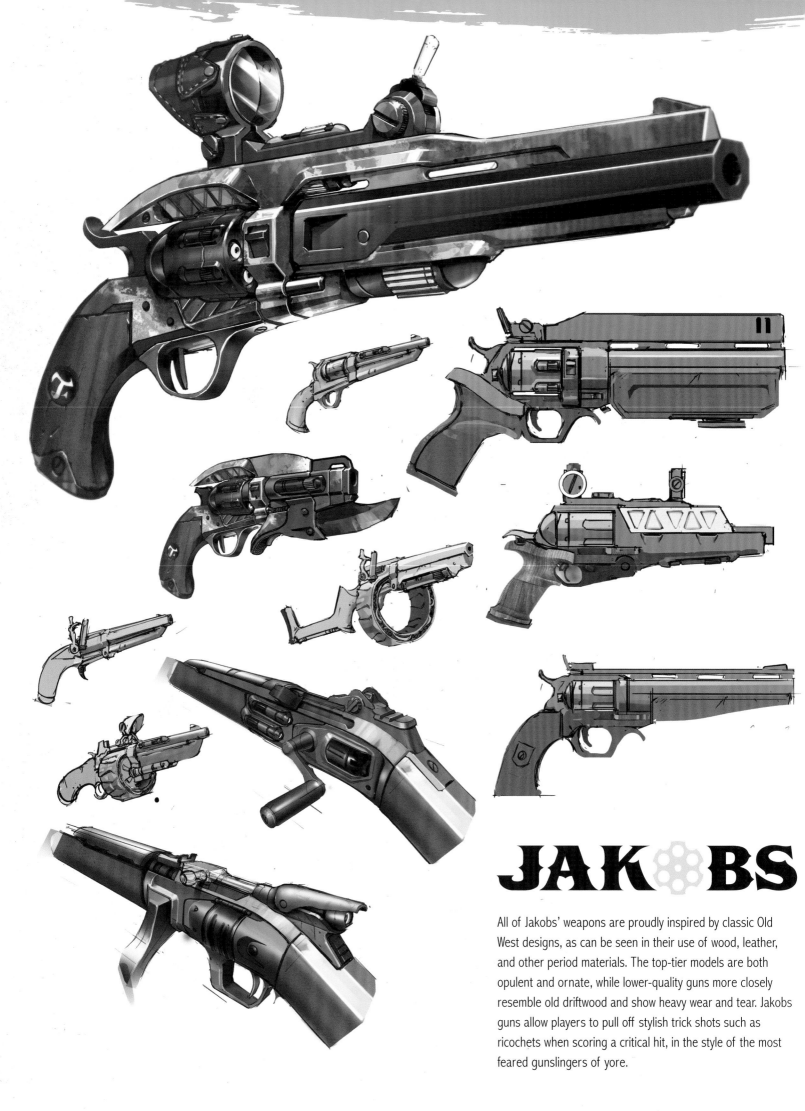

JAK⬡BS

All of Jakobs' weapons are proudly inspired by classic Old West designs, as can be seen in their use of wood, leather, and other period materials. The top-tier models are both opulent and ornate, while lower-quality guns more closely resemble old driftwood and show heavy wear and tear. Jakobs guns allow players to pull off stylish trick shots such as ricochets when scoring a critical hit, in the style of the most feared gunslingers of yore.

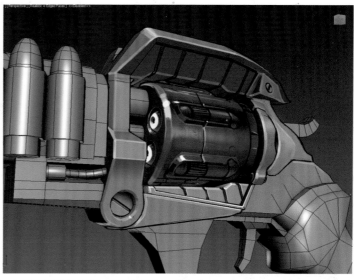
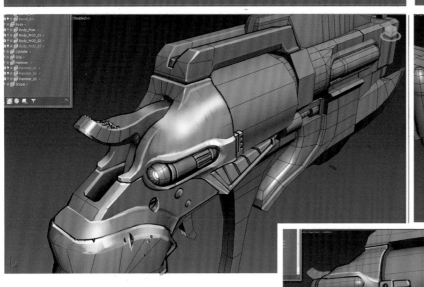
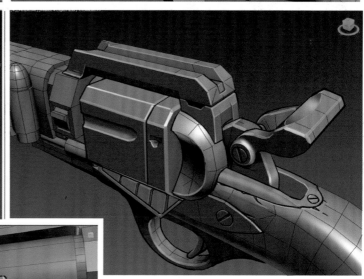
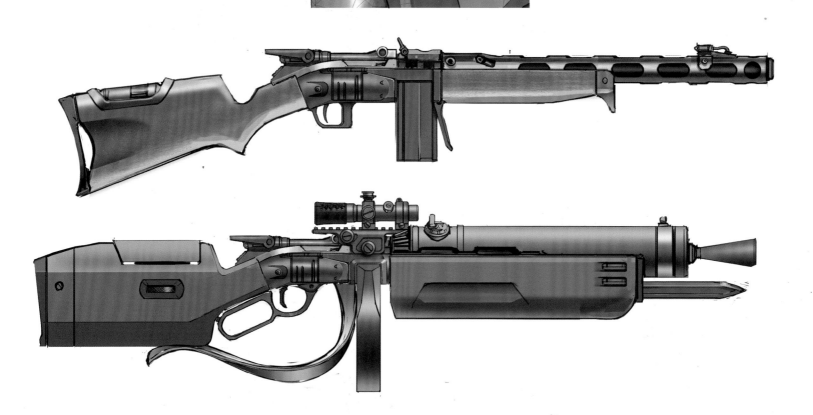

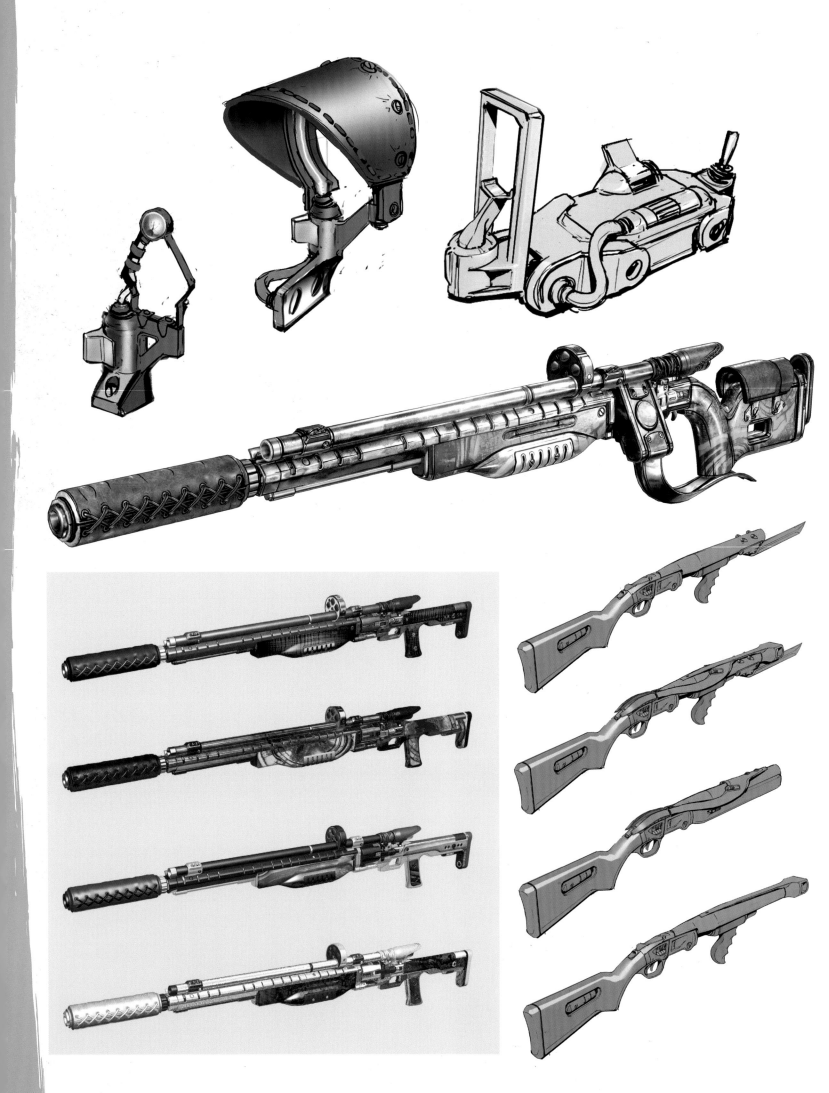

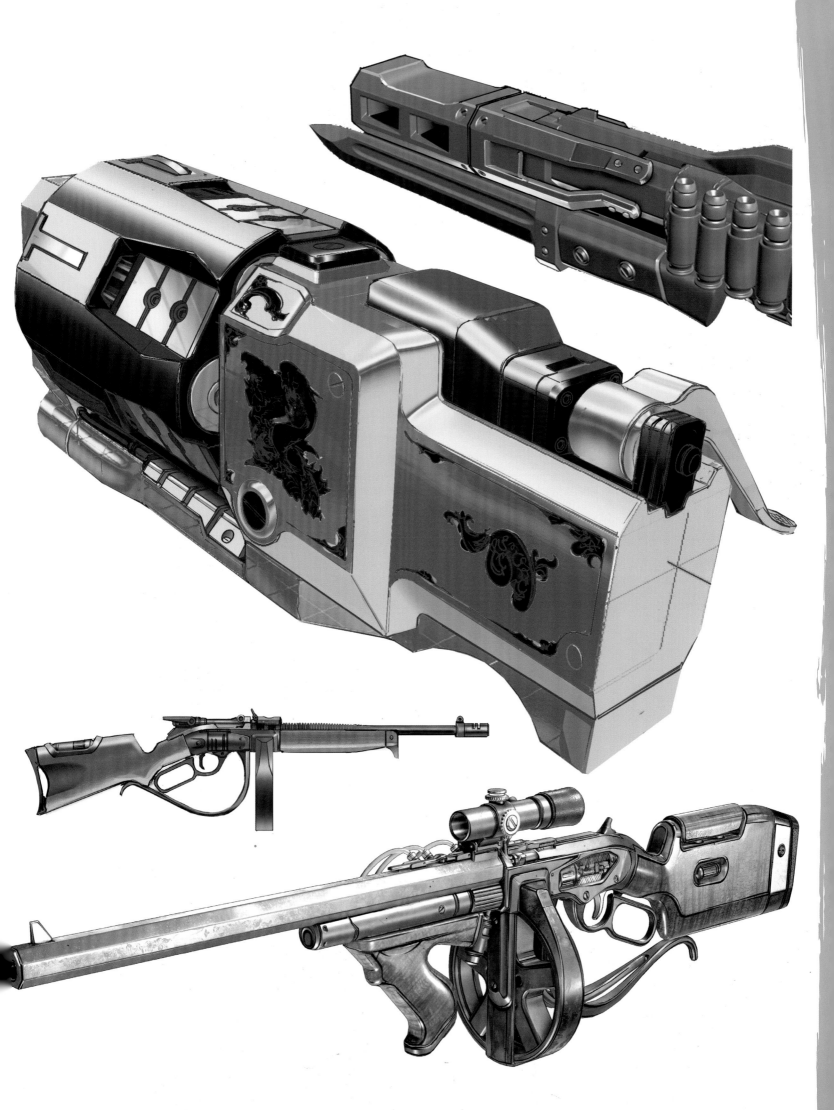

MALIWAN

Vault Hunters who think they're familiar with Maliwan firearms will be in for a shock (and a burn, and a freeze) when facing off against the corporation's troopers on Promethea. These chemically infused guns have been upgraded and now contain two cores, allowing for many different combinations of elemental attack from a single weapon. Of course, players can turn the tables by grabbing some Maliwan stock of their own . . .

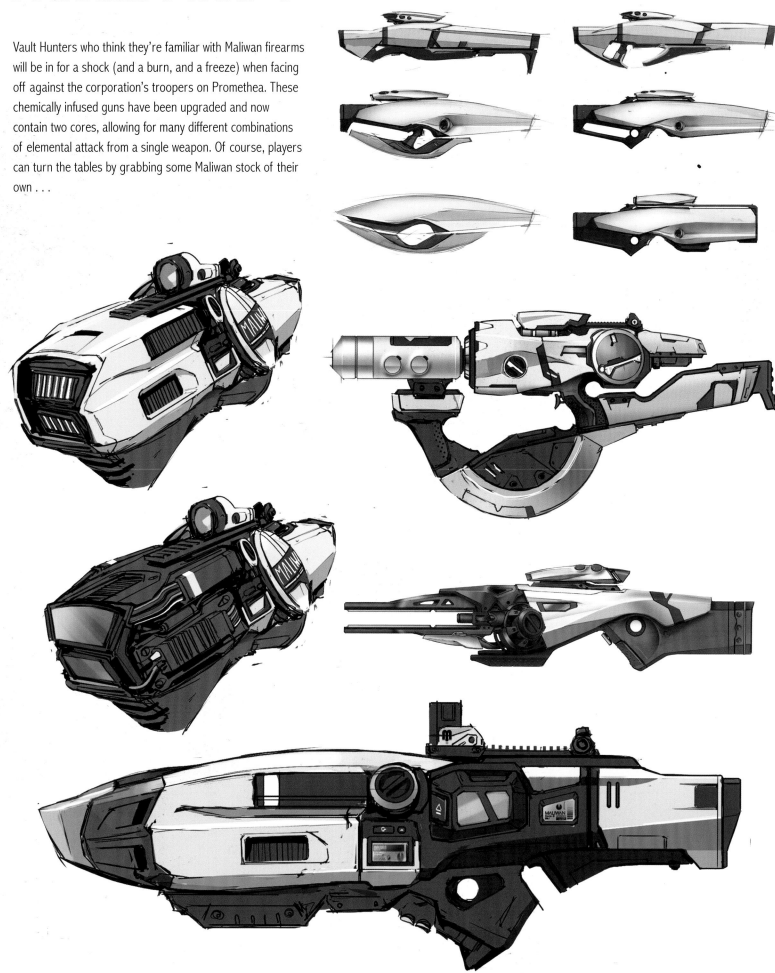

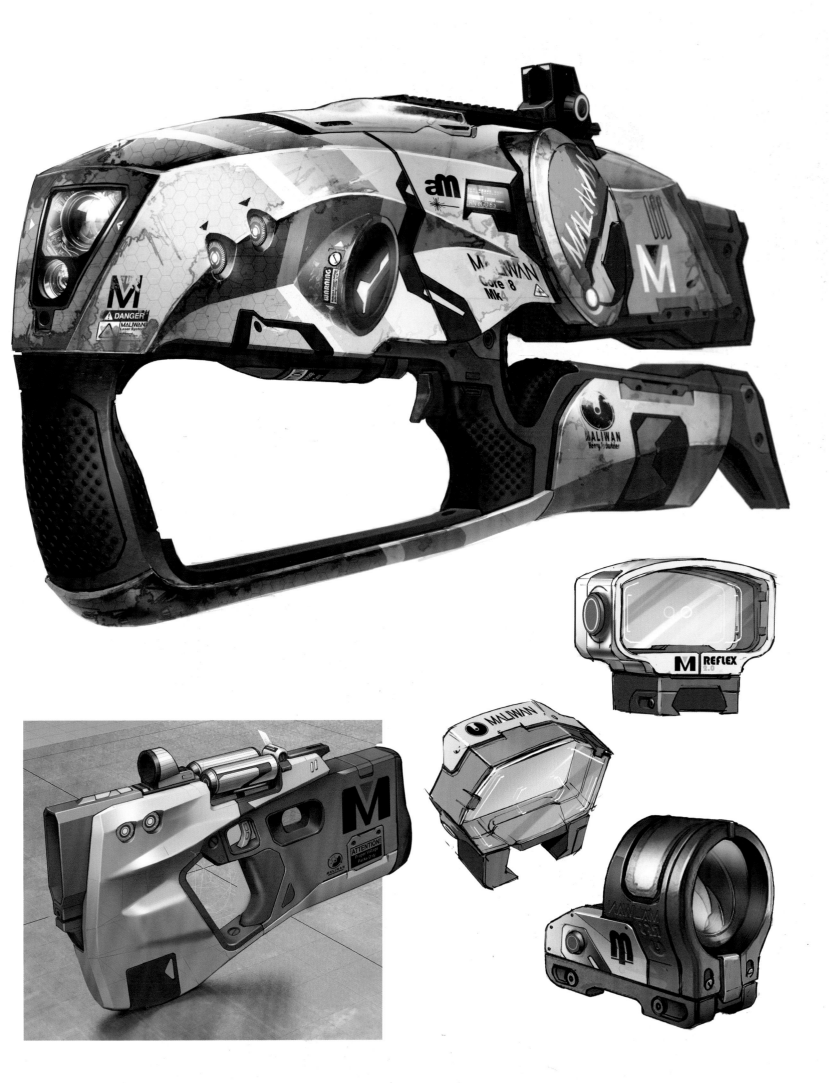

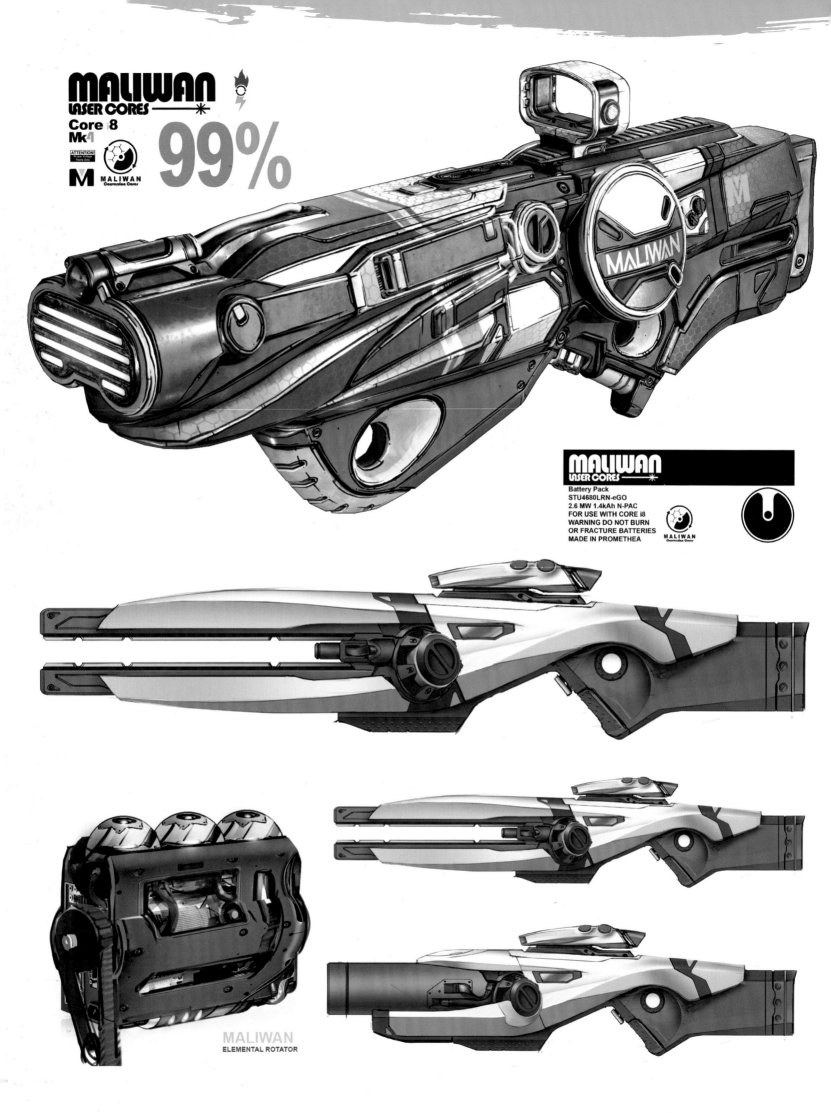

MALIWAN
LASER CORES ✳

Core 8
Mk4

ATTENTION!
Proper Voltage
Packs Only

M MALIWAN
Conversion Cores

99%

MALIWAN
LASER CORES ✳

Battery Pack
STU4680LRN-eGO
2.6 MW 1.4kAh N-PAC
FOR USE WITH CORE i8
WARNING DO NOT BURN
OR FRACTURE BATTERIES
MADE IN PROMETHEA

MALIWAN
Conversion Cores

MALIWAN
ELEMENTAL ROTATOR

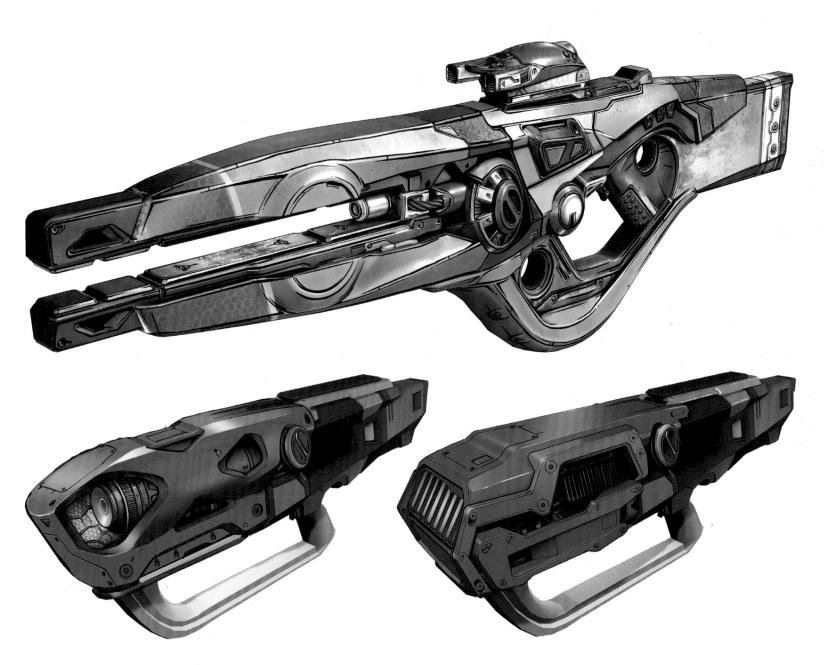

SCREEN DISPLAY:

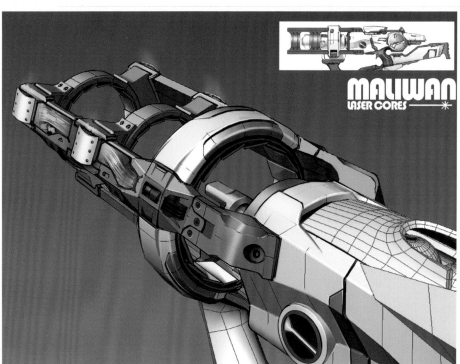

MALIWAN
LASER CORES

TEDIORE

Inspired by the cheap plastic look of a low-grade cell phone, Tediore weapons are designed to be the very definition of disposable; once their ammunition starts to run low, rather than reloading, you simply toss them away. In *Borderlands 3*, a number of things can happen once a Tediore has been thrown down: Certain mods will make the guns ping dangerously around the room, while other variants will unfurl little legs and scuttle after nearby enemies.

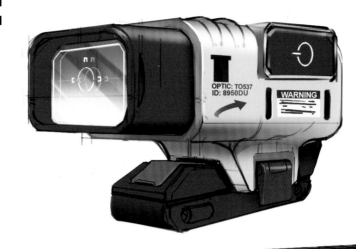

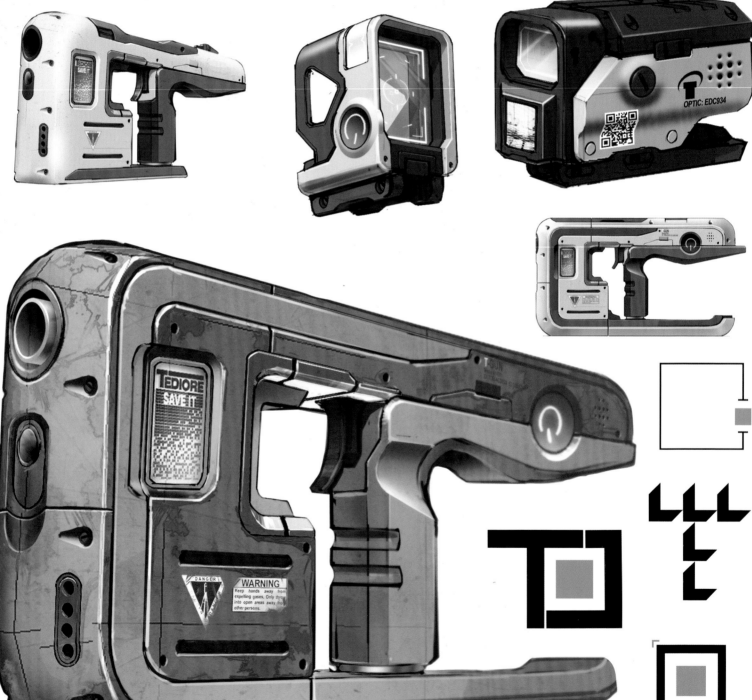

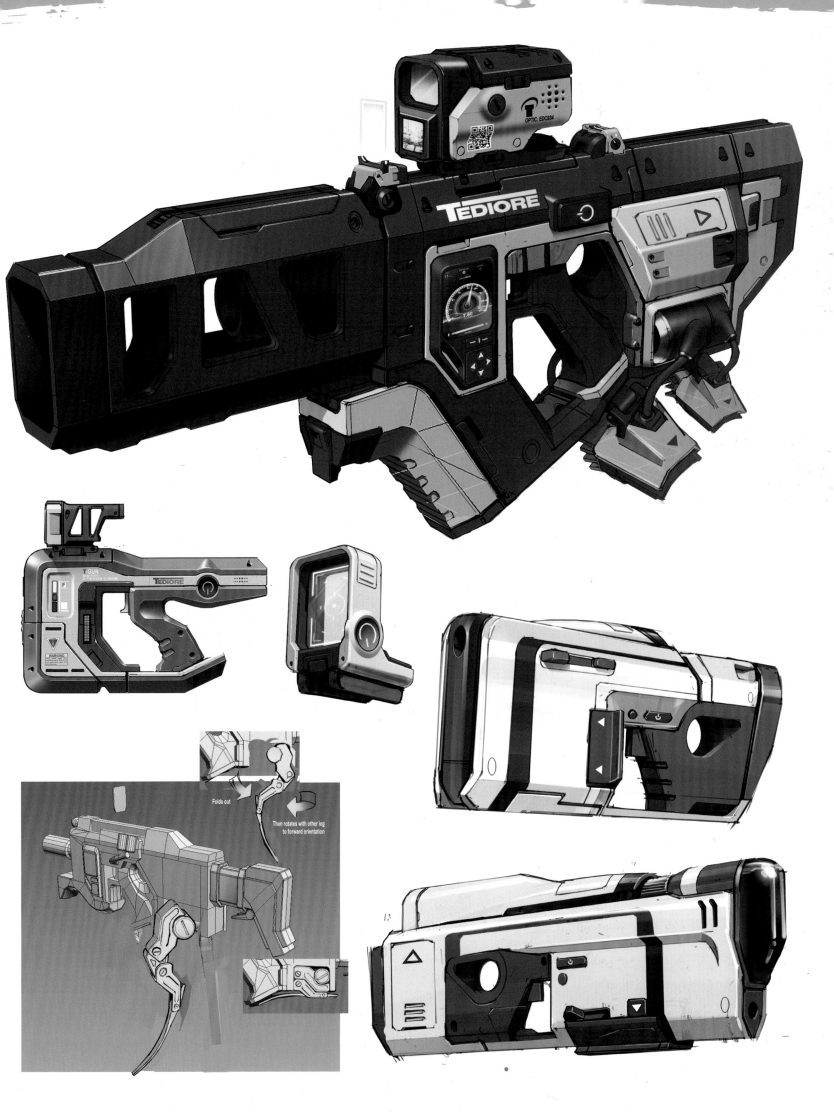

TEDIORE

OPTIC: EDC334

T-GUN

TEDIORE

Folds out

Then rotates with other leg to forward orientation

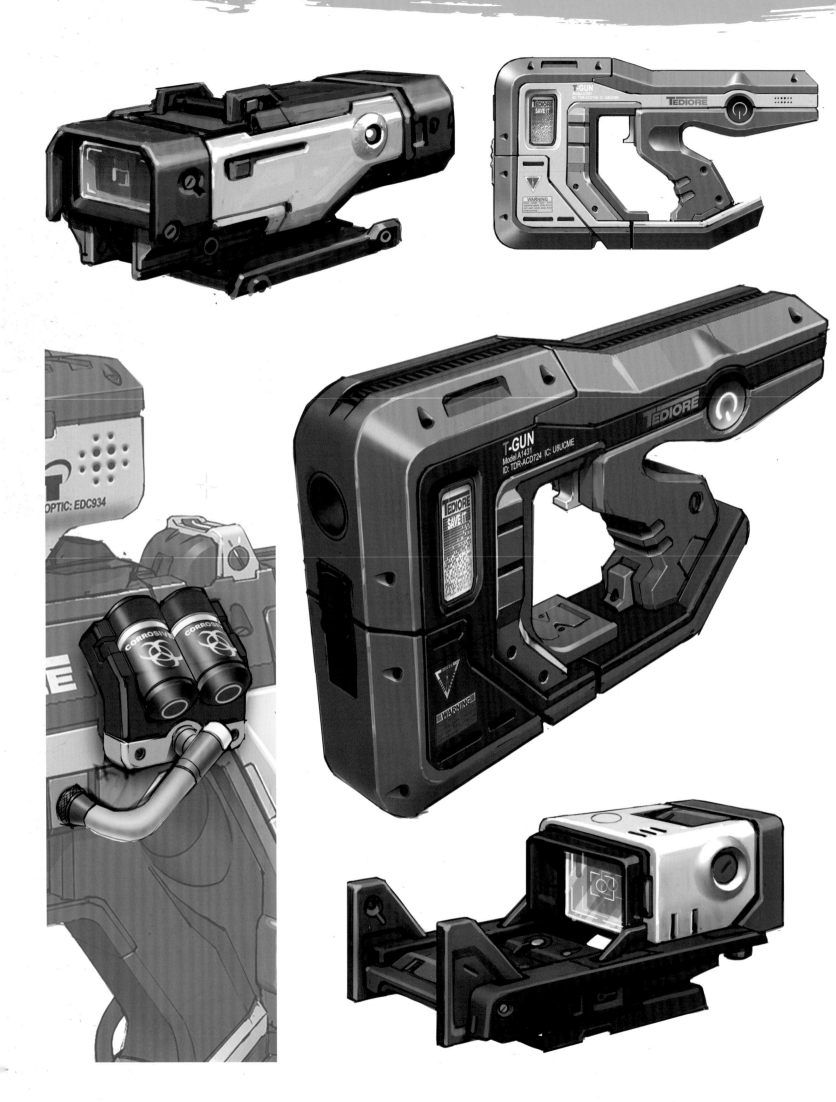

OPTIC: EDC934

CORROSIVE

T-GUN
Model A1431 IC: U8UCME
ID: TDR-ACD724 IC: U8UCME

TEDIORE
SAVE IT

TEDIORE

WARNING

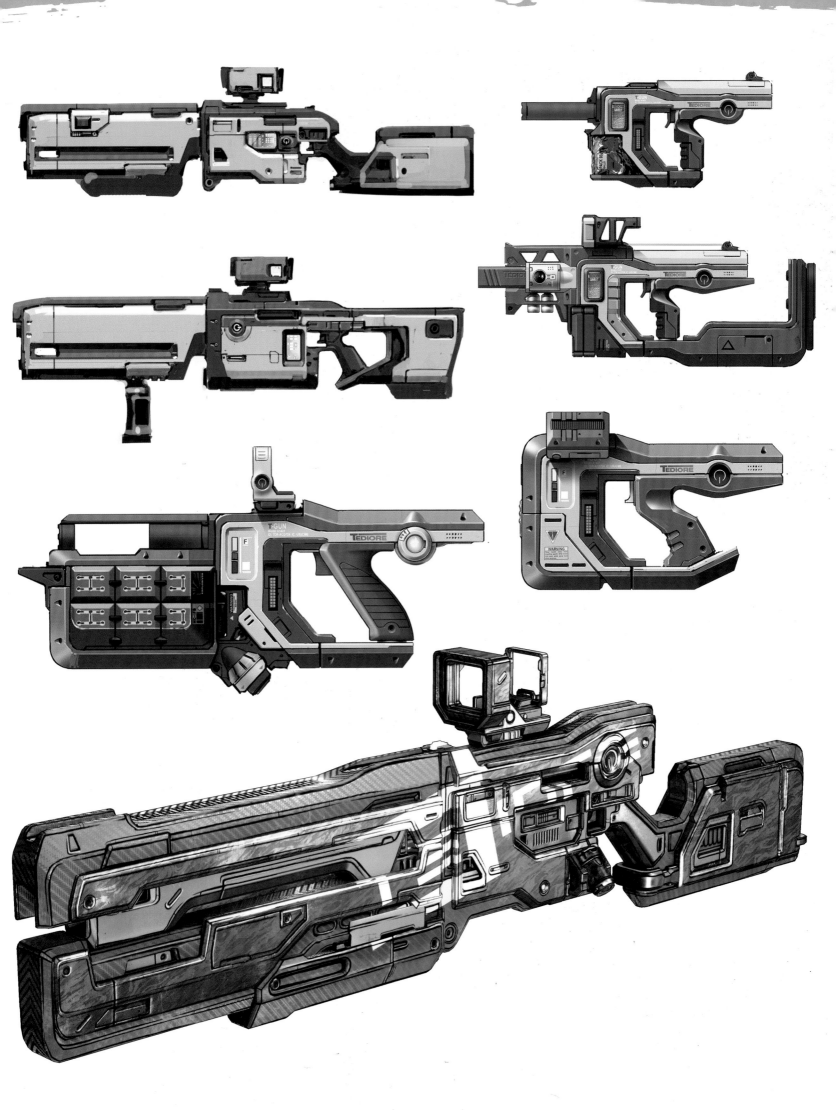

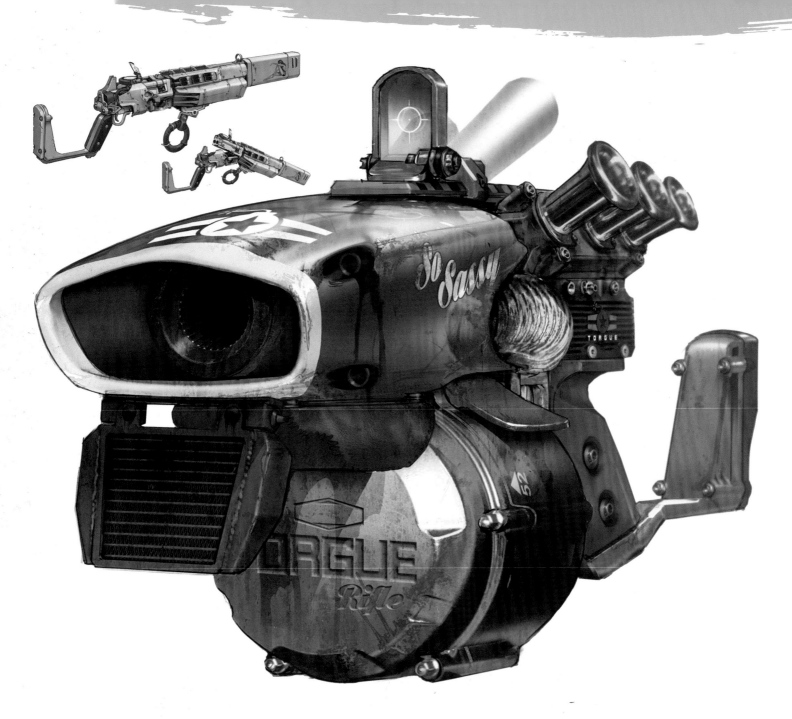

TORGUE

Torgue specializes in bringing back the boom. Its heavy equipment spurns snazzy color schemes, opting for a no-frills industrial style that takes design cues from the automotive and aerospace industries. Most notably, Torgue weapons use explosive rounds by default, creating the kind of macho mayhem their clients have come to expect. As a secondary function, the shells they fire can stick to enemies and cling passively until the weapon is reloaded—at which point all the shells explode simultaneously to cause additional damage.

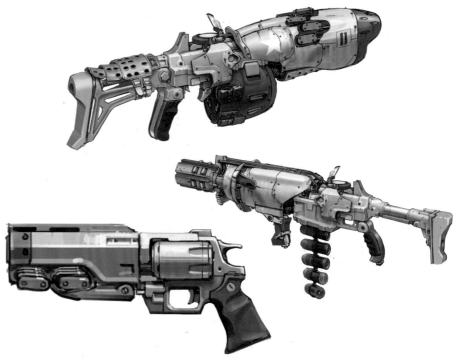

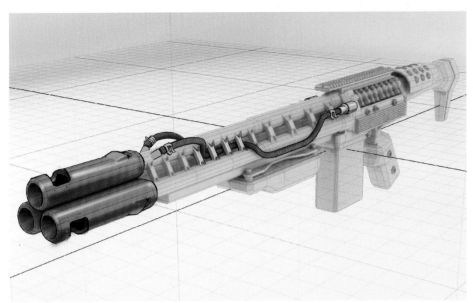

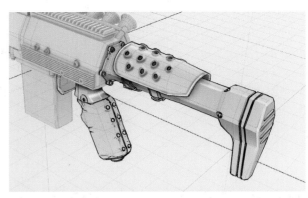

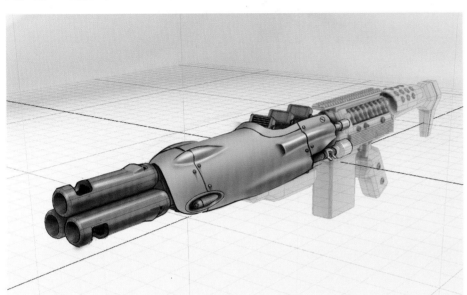

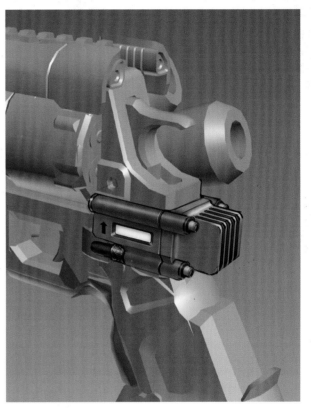

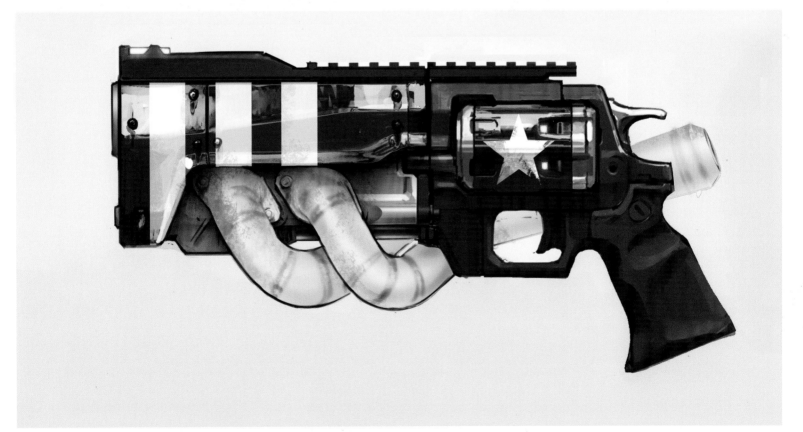

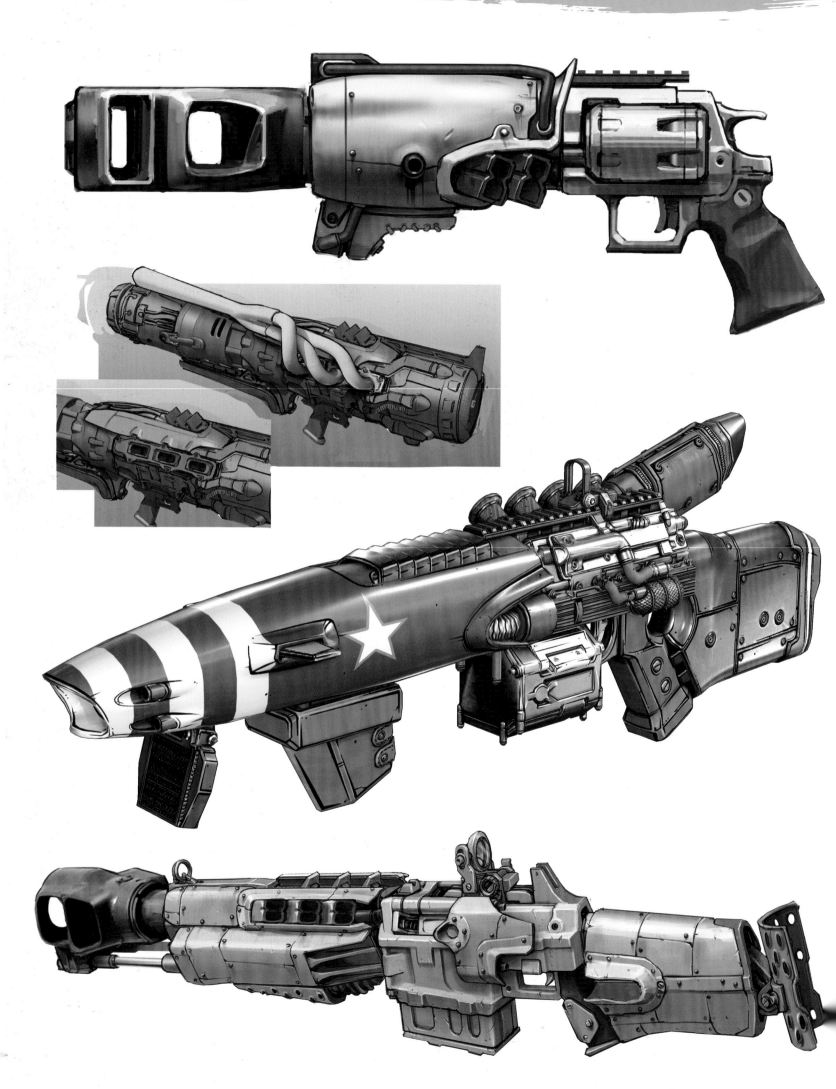

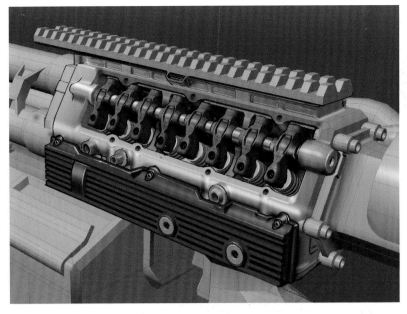
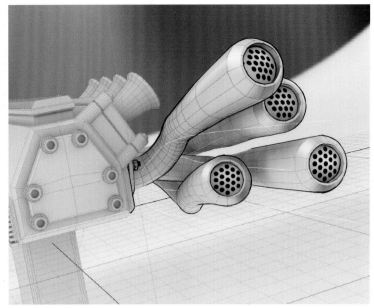
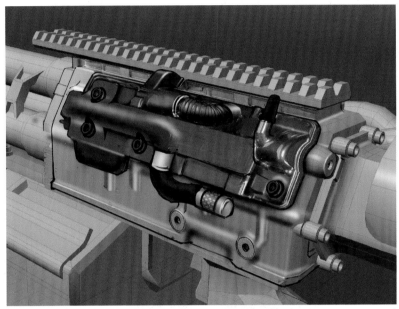
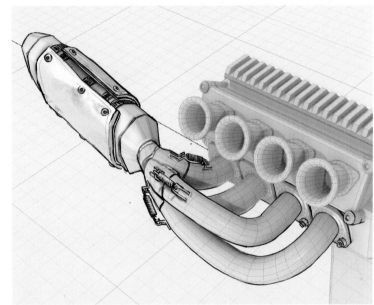
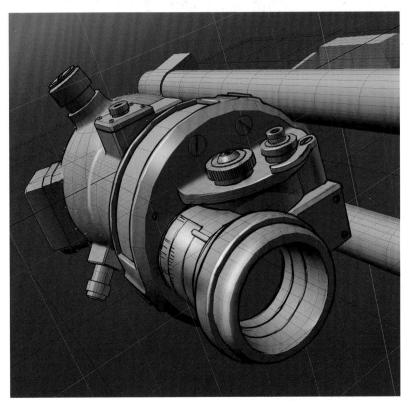
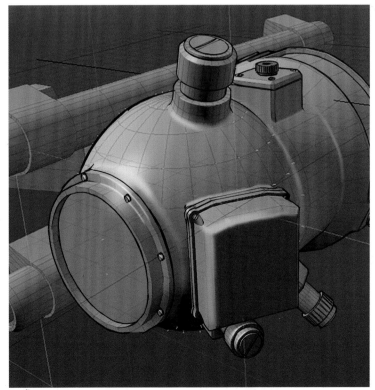

VLADOF

Guns produced by Vladof tend to have a very high rate of fire, at the cost of accuracy. In *Borderlands 3*, a Vladof weapon has a secondary function: Flipping its barrel upside down exposes the ancillary under-barrel and allows the wielder to briefly switch to a different kind of attack, or even to steady their aim with a rocket stabilizer, offering some unique forms of assault.

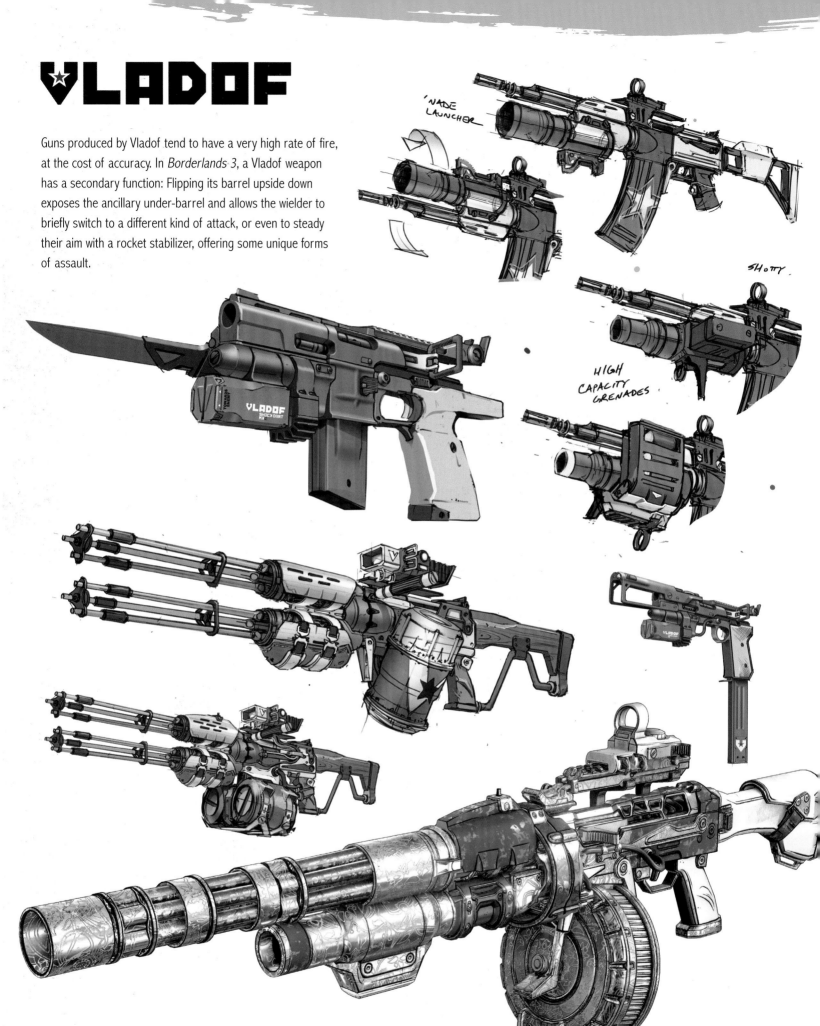

'NADE LAUNCHER

SHOTTY

HIGH CAPACITY GRENADES

VLADOF SHOCK DART MX

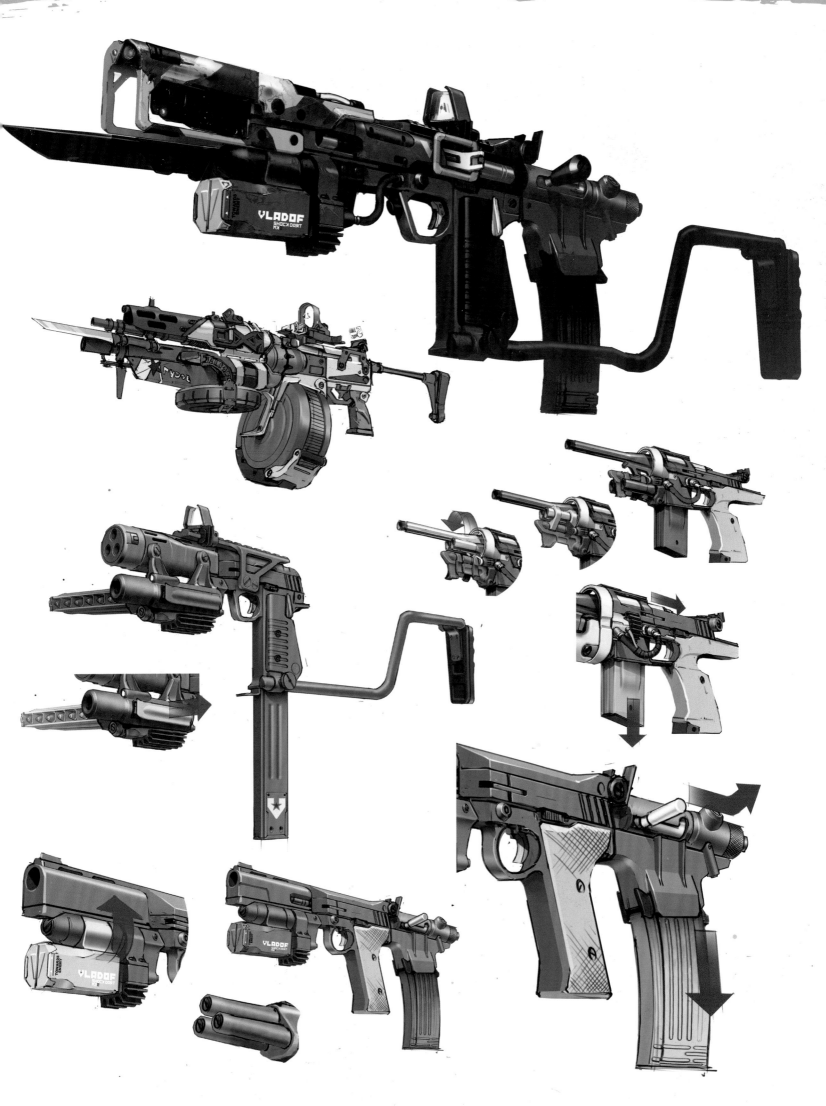

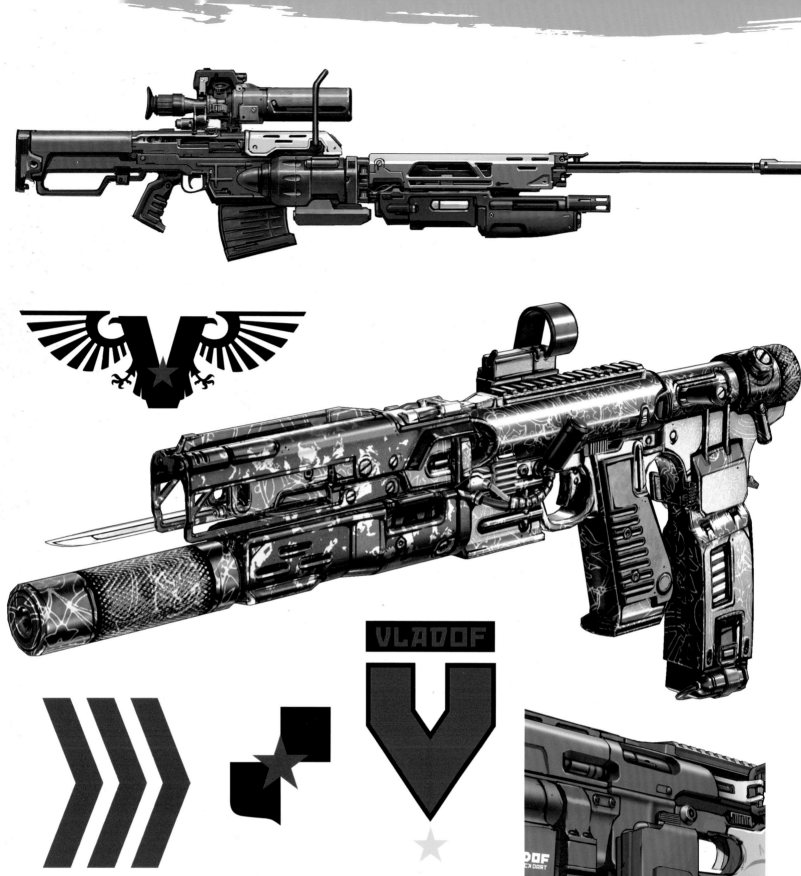

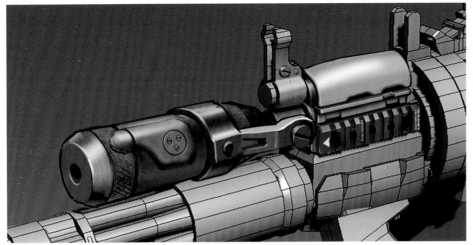

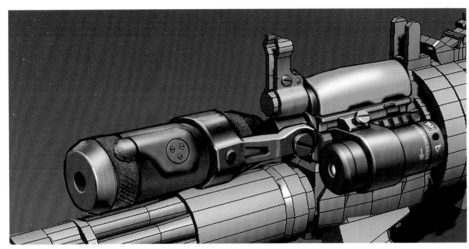

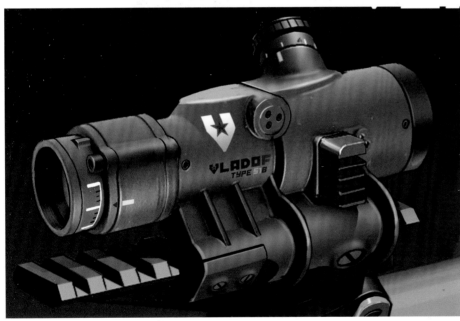

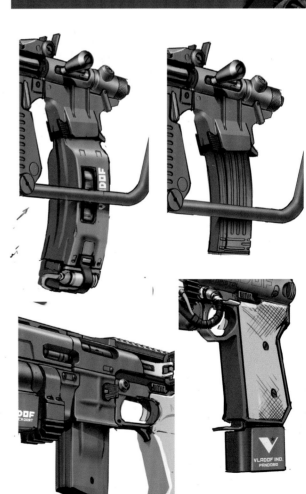

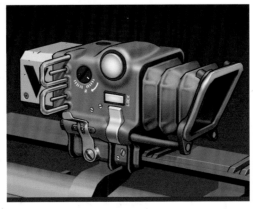

CHILDREN OF THE VAULT

Much like the Bandit manufacturer of *Borderlands 2*, the Children of the Vault have found ways to create their own weapons decorated with their signature spikes and chains. CoV weaponry is distinct in that it features a literal "bullet forge" attached to the weapon, ensuring that the magazines will never run dry. It does make the guns rather prone to overheating, though, and if that happens they'll need to cool off before they can be fired again.

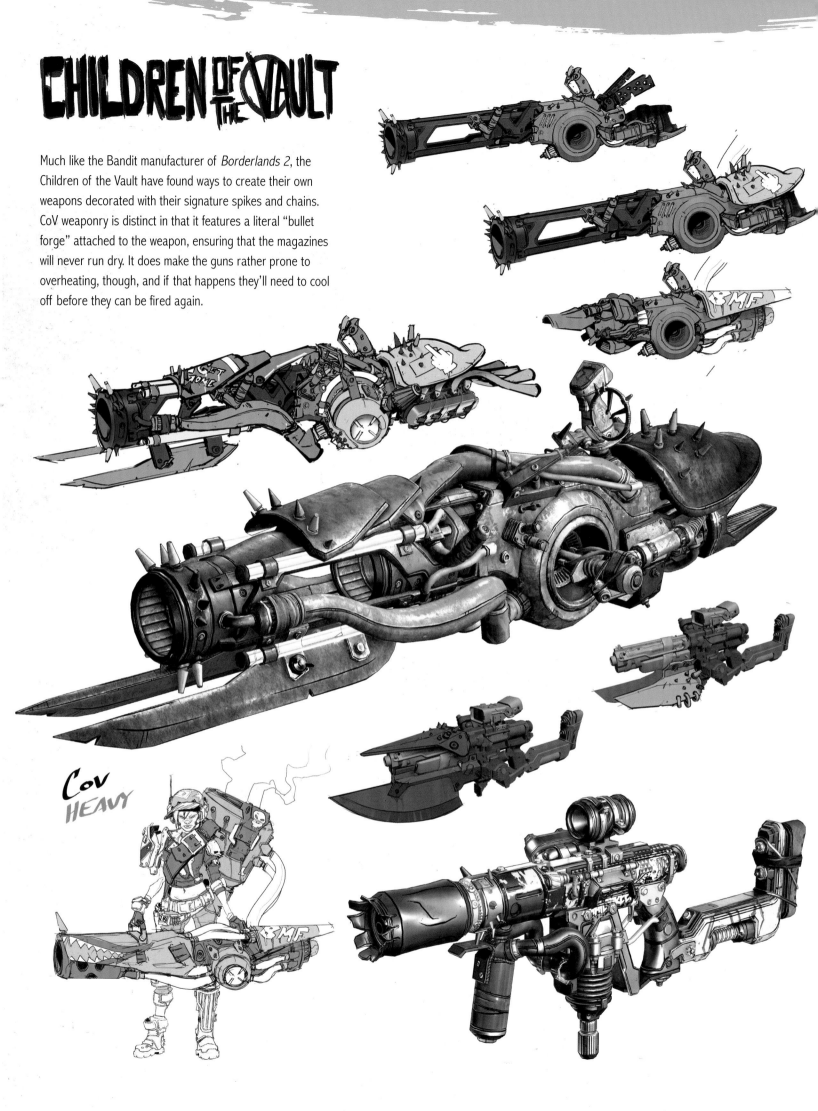

Cov HEAVY

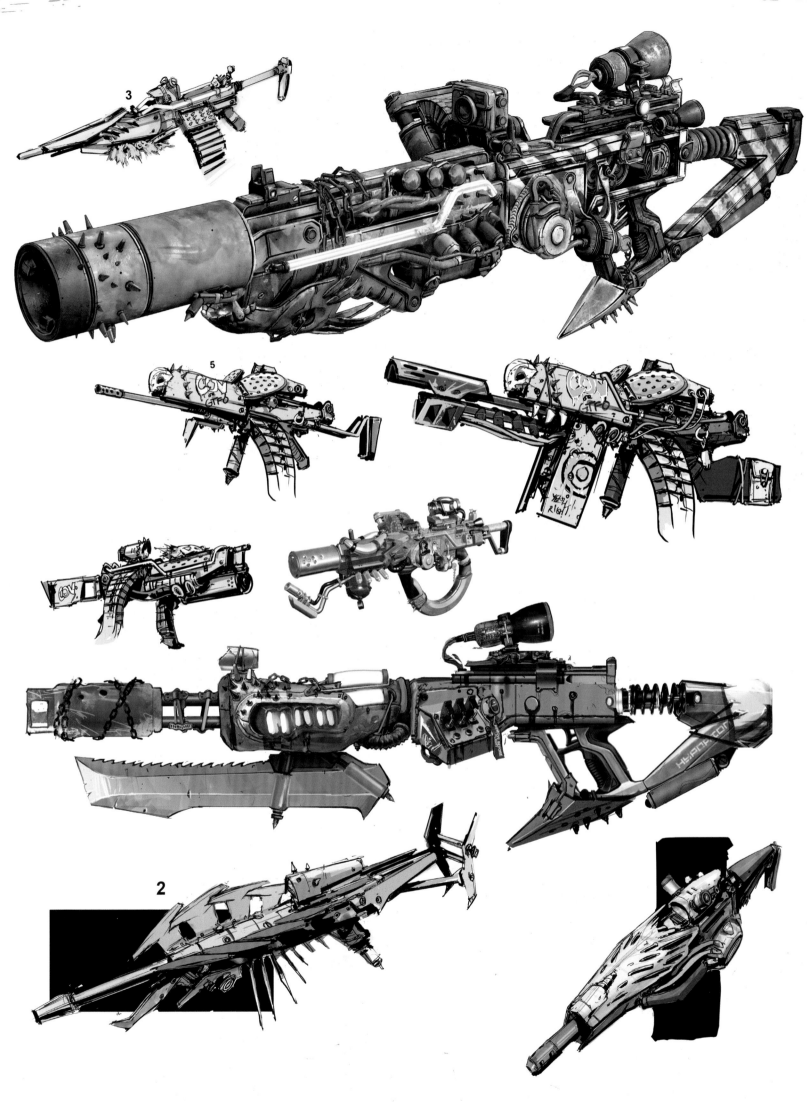

ALIEN

Not so much a corporate identity as a perversion of existing brands, these images explore the idea of familiar guns that have been fused with the strange, alien Eridian technology found on planets like Nekrotafeyo, the homeworld of Eridians, in order to create powerful—if bizarre—new weapons. The Eridian influences on E-Tech guns can be seen intertwined with organic tendrils that have subsumed the original design.

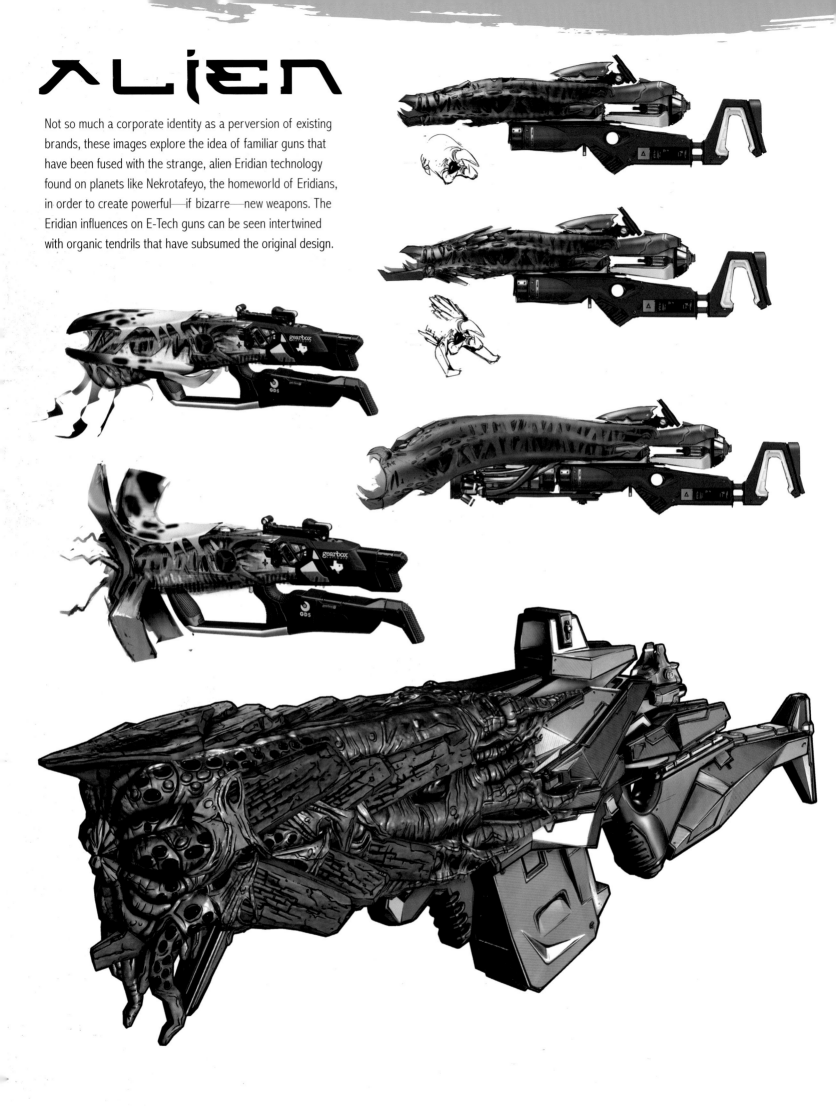

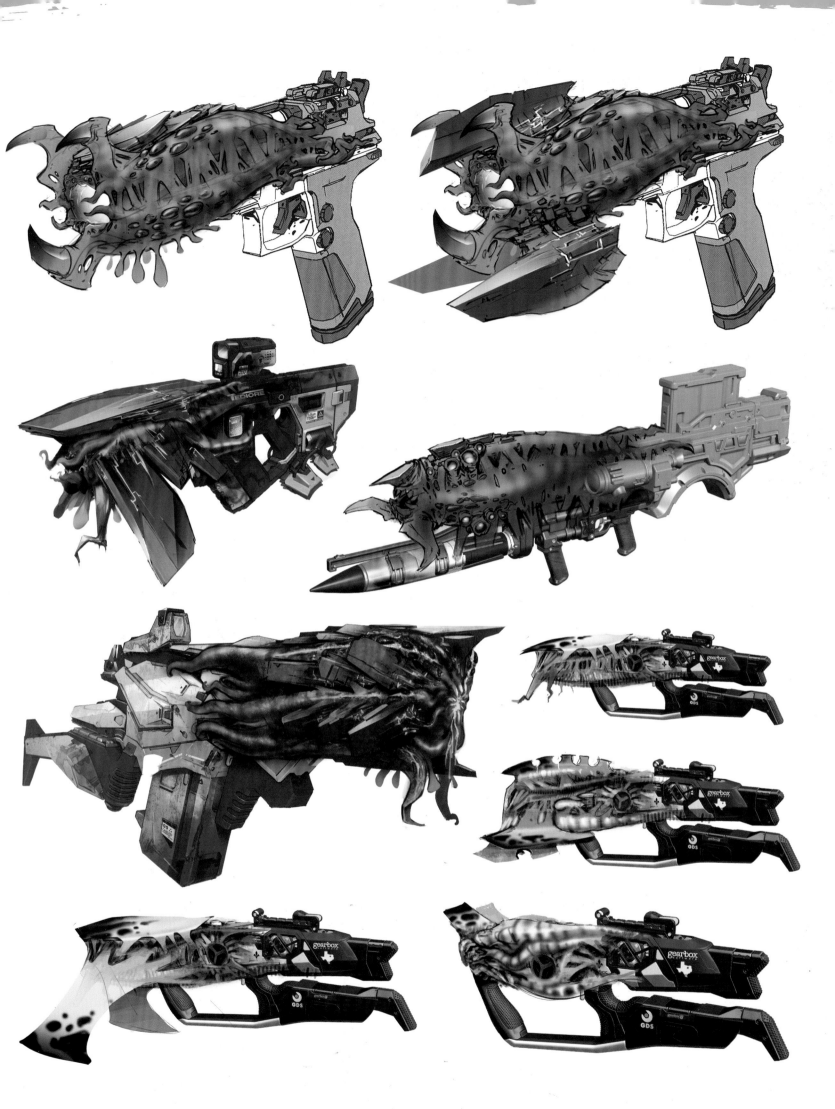

CLASS MODS

Class mods, sometimes referred to as COMs, provide upgrades to the abilities of a particular Vault Hunter—or sometimes an entire team. Like weapons and other items, class mods aren't just numbers in a menu; they're in-world objects that can be found in lootable locations or purchased from the right kind of vending machine.

As such, class mods take the form of new and shiny objects worn or carried by the Vault Hunter they were designed for—Amara's scroll, FL4K's toy animal, Moze's flask, and Zane's goggles. There are many different mods to find, and they offer lots of different color combinations.

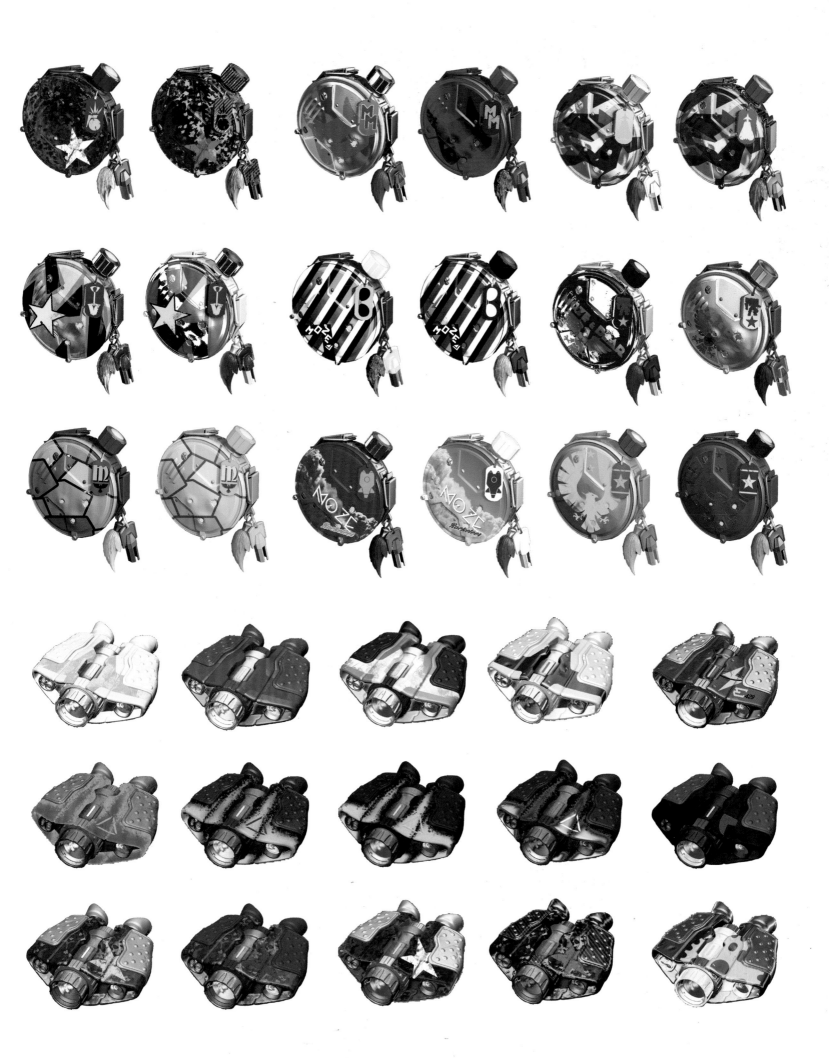

GRENADES

Most of the corporations manufacture other types of munitions for special circumstances, and grenades are one of the more common examples. Some are traditional explosives, while others are imbued with elemental energies instead. Other equally deadly alternatives available include transfusion grenades, homing variants, and types designed to leave lingering effects.

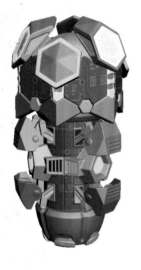
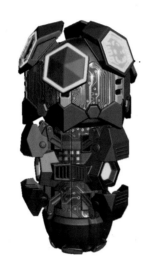
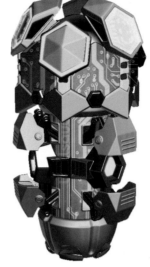

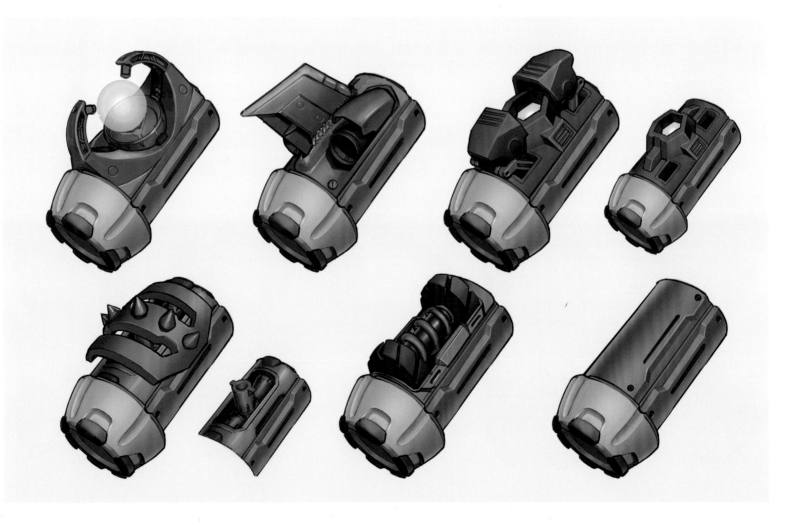

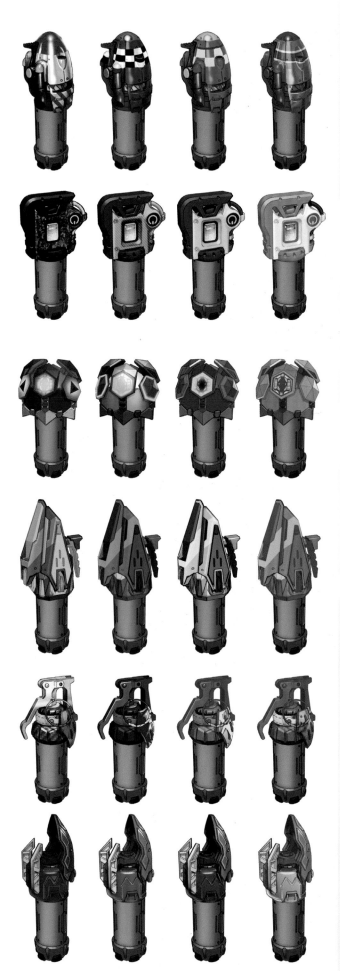

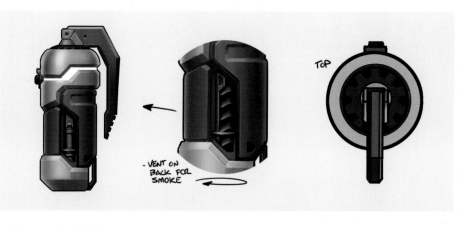

TOP

- VENT ON BACK FOR SMOKE

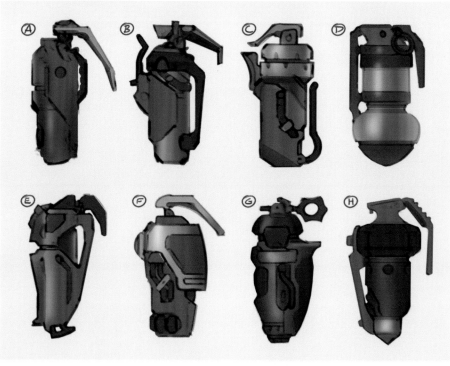

Ⓐ Ⓑ Ⓒ Ⓓ
Ⓔ Ⓕ Ⓖ Ⓗ

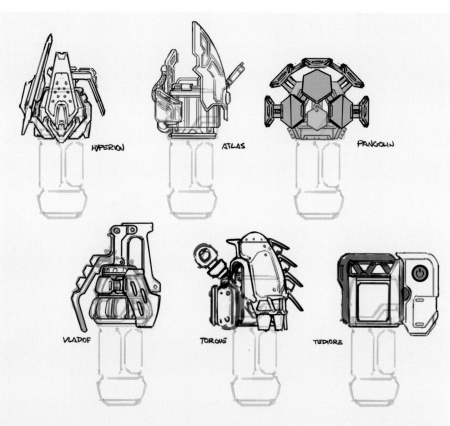

HYPERION
ATLAS
PANGOLIN

VLADOF
TORGUE
TEDIORE

SHIELDS

Each of the various corporations has a slightly different way of designing shields. Some are designed to act as physical barriers and block up-close attacks; others are better suited to reducing or even reflecting damage from gunfire.

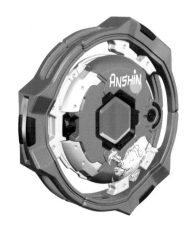

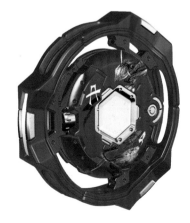

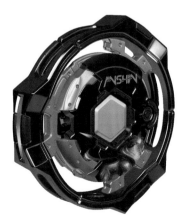

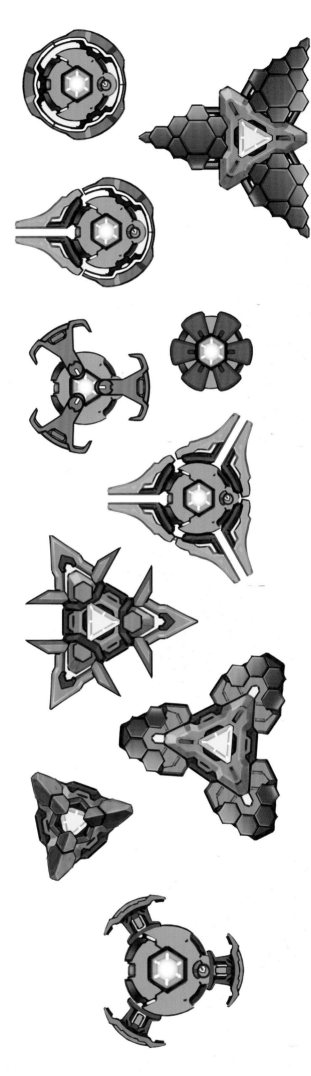

LEGENDARY WEAPONS

Legendary weapons— highly sought, one-of-a-kind creations with their own appealing look and special abilities—are the pick of any loot pile and a great way for Vault Hunters to commemorate quests. For *Borderlands 3*, the Gearbox community team slyly consulted fans to compile a list of the best-loved designs and made sure to include them alongside new designs that take legendary guns in crazy new directions.

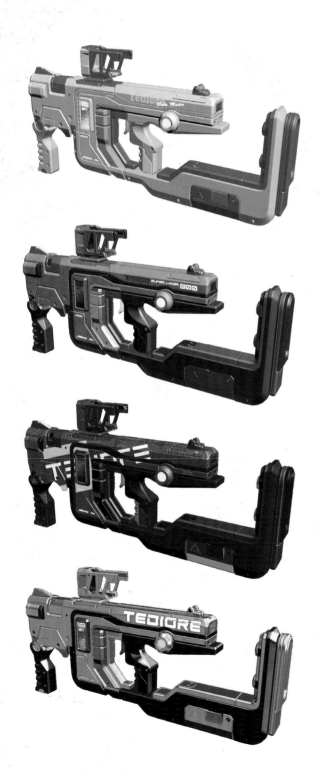

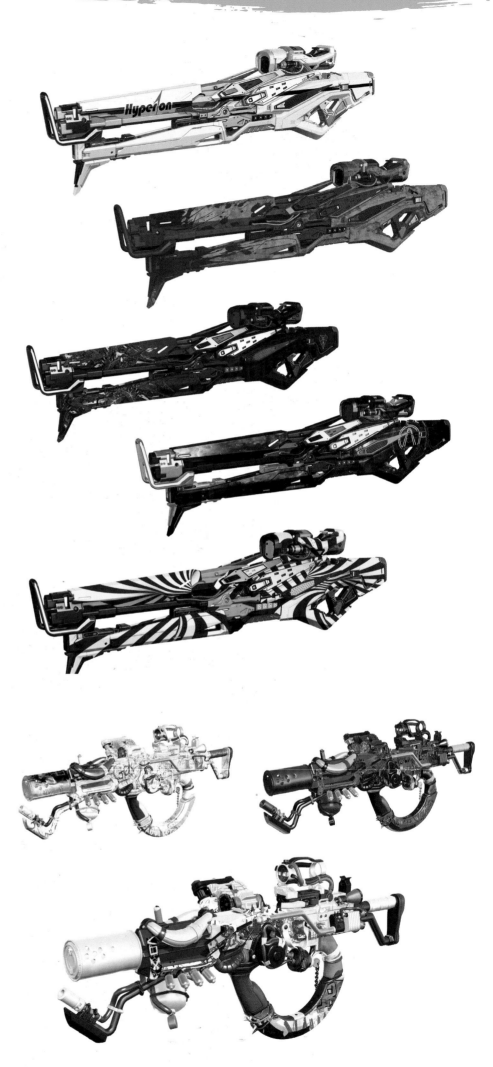

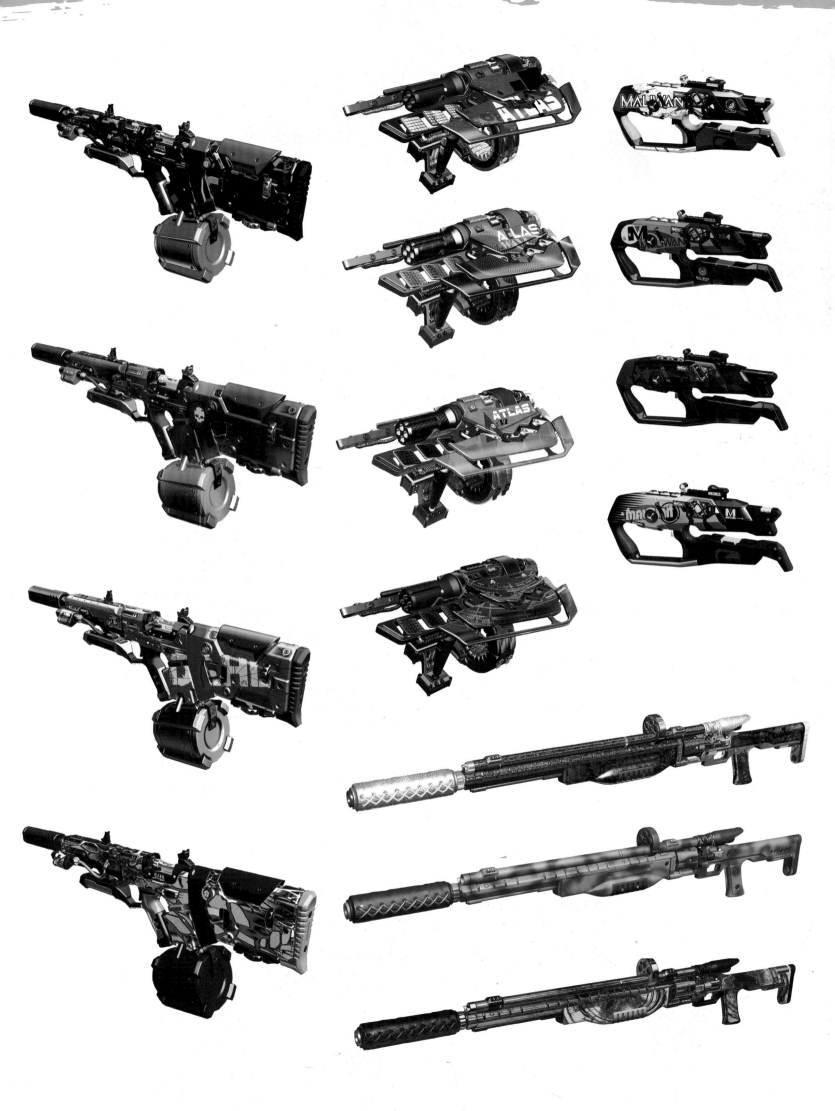

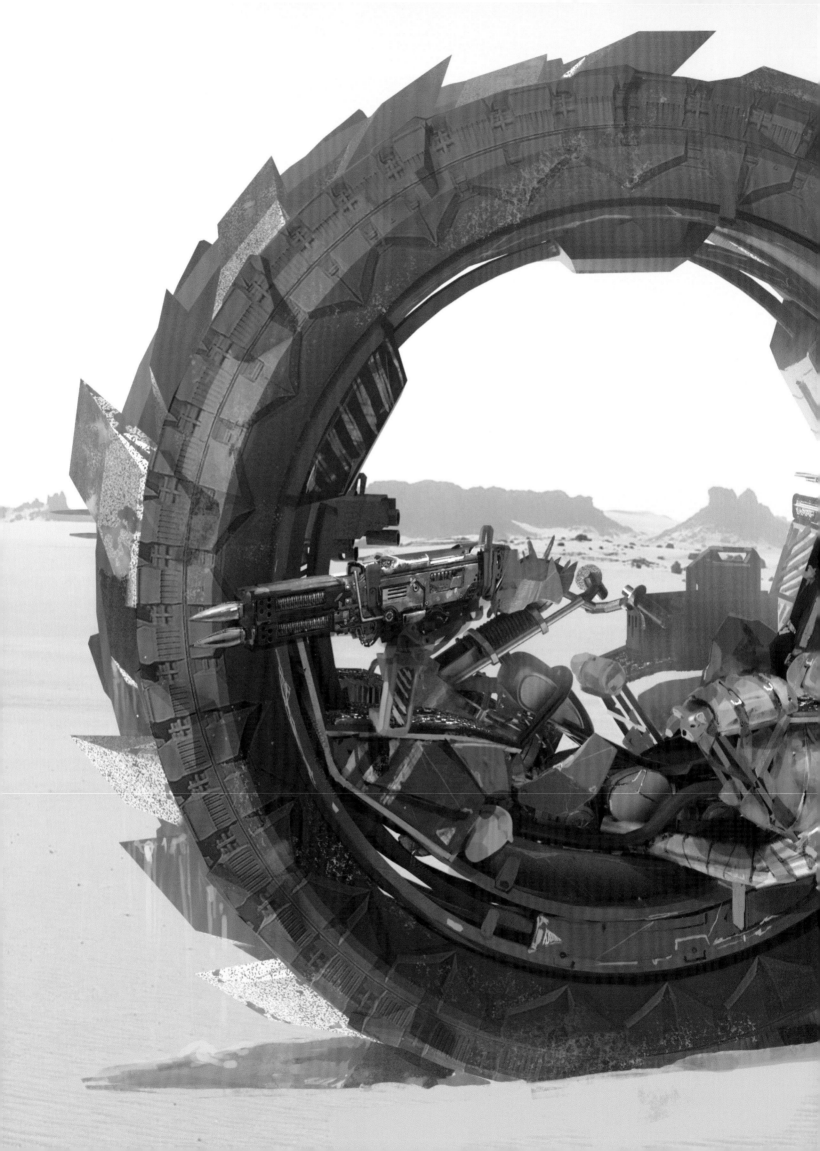

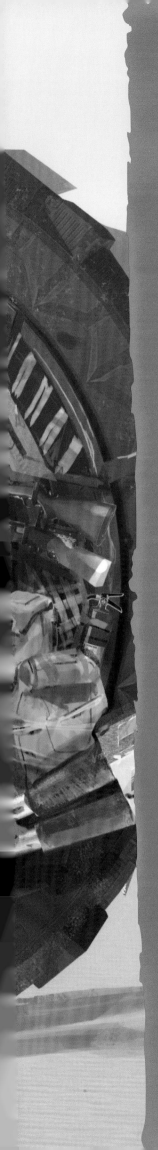

5
VEHICLES

"The vehicle work that the GSQ guys have been doing has definitely pushed all the mechanics far beyond anything we've had in the past few games," Technical Design Animator Michael Sewell begins, referring to colleagues at Gearbox Studio Quebec who also contributed to *Borderlands 3*. "We've got a variety of vehicles, like three different types now. The smoothness with which you can get in and out, the control scheme variety, it all feels super-solid. Everything is coalescing and coming together." Aware that driving and racing games have come a long way in the decade since the first *Borderlands*, the team was determined to make sure that their vehicle handling and physics stack up with what players have come to expect when they get behind the wheel.

Players will get the chance to reacquaint themselves with the vehicles of *Borderlands* shortly after their arrival thanks to Ellie, who seems to share her brother Scooter's knack for maintaining the network of terminals that make transportation possible. As ever, Catch-A-Ride stations are used to instantly construct vehicles using digistructing technology, meaning that the Vault Hunters will be able to customize the vehicle's appearance and, crucially, given the dangers ahead, what type of weapons are mounted to its frame.

To capture original audio samples for the Vault Hunters' rides, members of the team were encouraged to volunteer their own cars and motorbikes to the cause, which would then be transported to the top of Gearbox's HQ so that their engine sounds could be recorded in isolation. Although vehicles have provided only a small part of *Borderlands'* gameplay before now, and have mostly been used as ways to cross the expansive wastes of Pandora, the narrative team made a conscious effort to work them into the story this time around, allowing for the return of old favorites like the Bandit Technical introduced in *Borderlands 2*.

The selection of images in this chapter offers an insight into the thought process that underlies the construction and customization of vehicles. Much like the game's weapons, cars and trucks need to be highly modular so that many variants can be created from a single kit of parts and still leave space for a wide range of turrets, speed boosters, and other optional accessories, including sawblades, rocket launchers, and more.

OPPOSITE: The Cyclone.

OUTRUNNER

A staple of the *Borderlands* series, the Outrunner buggy is a good all-arounder: a fairly speedy vehicle that can handle rough terrain and comes with your choice of either a large mounted machine gun or a rocket launcher.

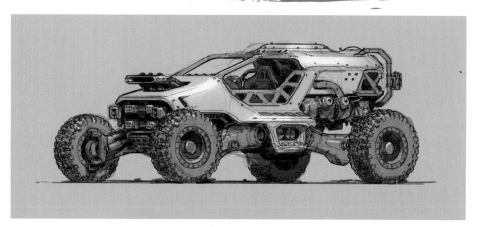

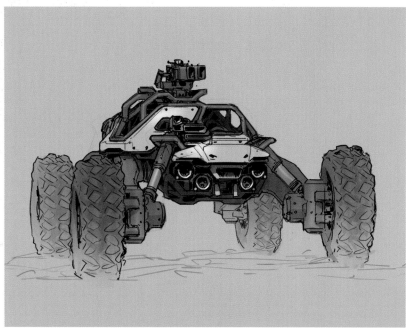

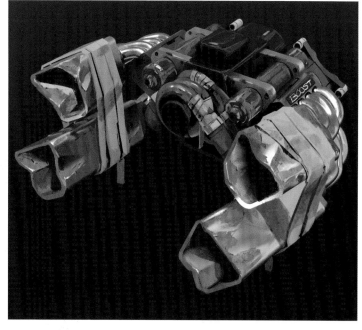

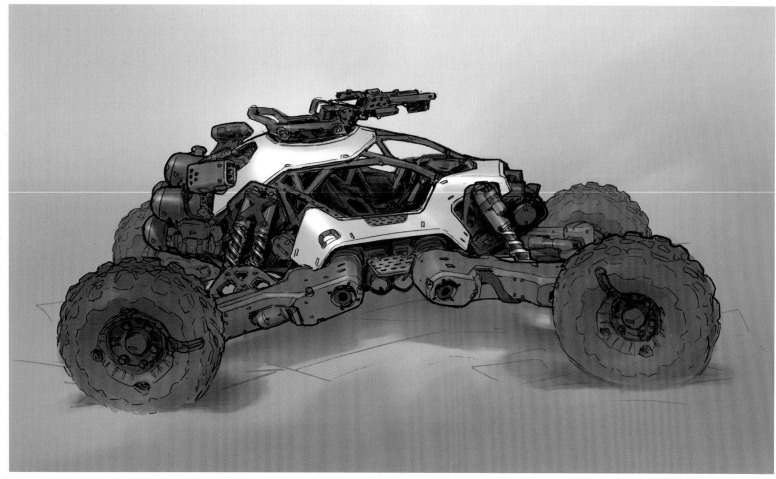

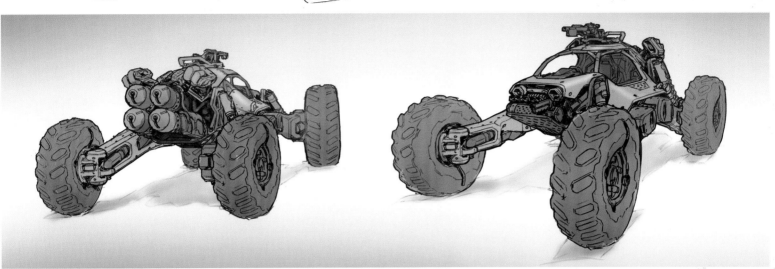

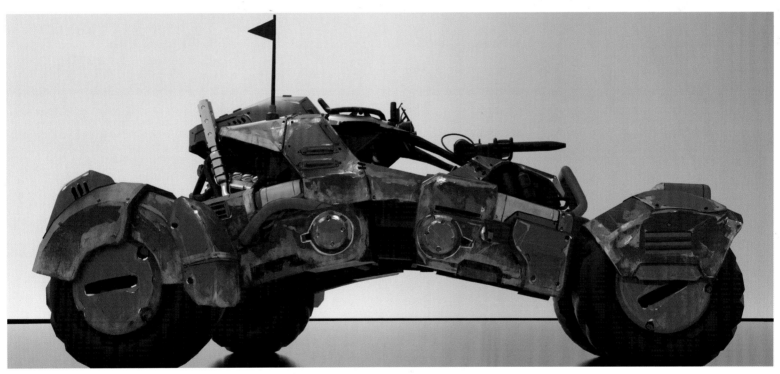

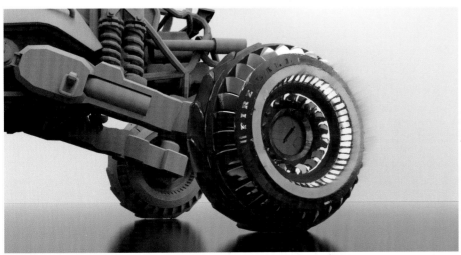

OPPOSITE: Vehicles are more customizable than ever before, giving players the chance to tweak armor and materials as well as weapon load outs and paint jobs.

THIS PAGE: The dedicated gunner's seat allows a second Vault Hunter to concentrate on dealing out destruction during the journey.

TECHNICAL

The Technical—also known as the Bandit Technical—is the preferred ride of Pandora's ne'er-do-wells. Whoever's in the driver's seat can operate the front-mounted machine gun while a passenger gets to play with either a sawblade launcher or a catapult that launches explosive, digistructed barrels.

BELOW: All four Vault Hunters can squeeze into the Technical at once, but only the one riding atop the flatbed can make use of their regular weaponry.

OPPOSITE: The Technical's formidable armor and weighty modification options come at the cost of maneuverability, though it's much more durable than other vehicles.

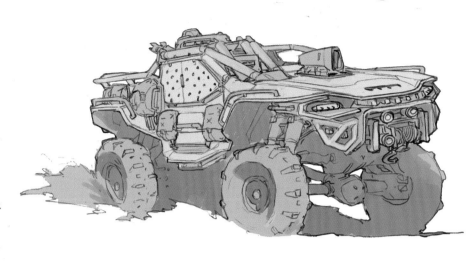

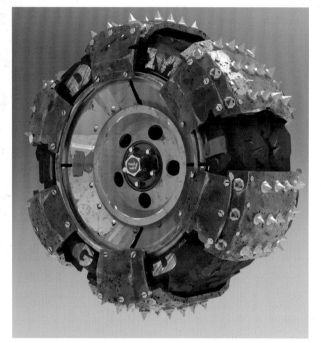

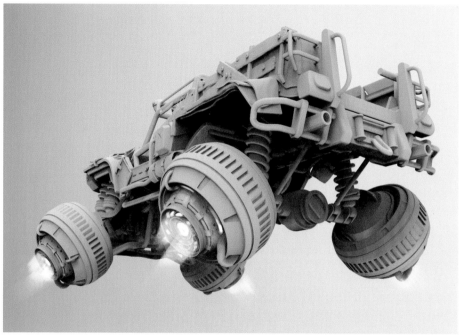

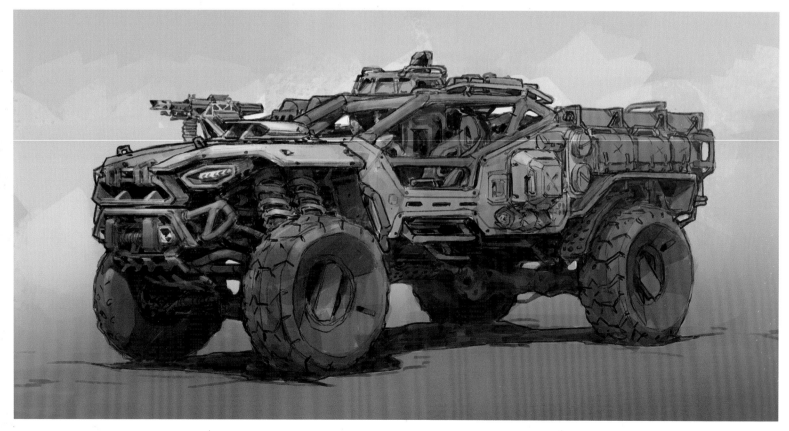

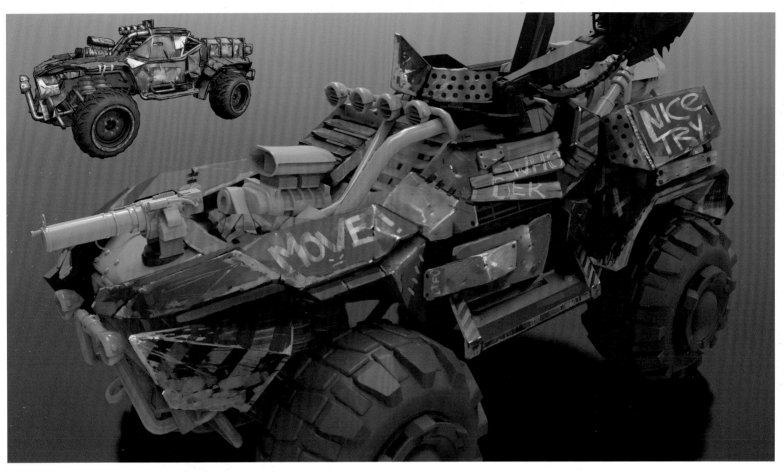

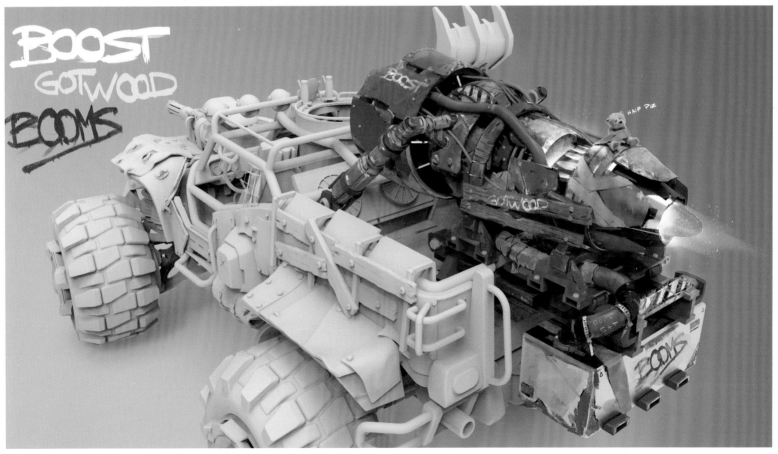

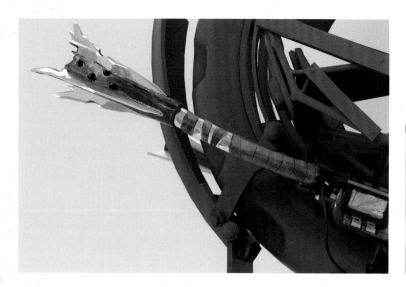

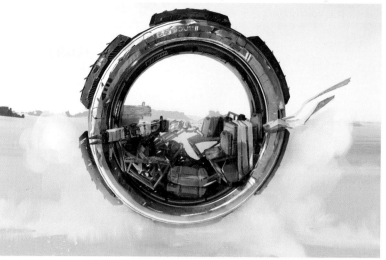

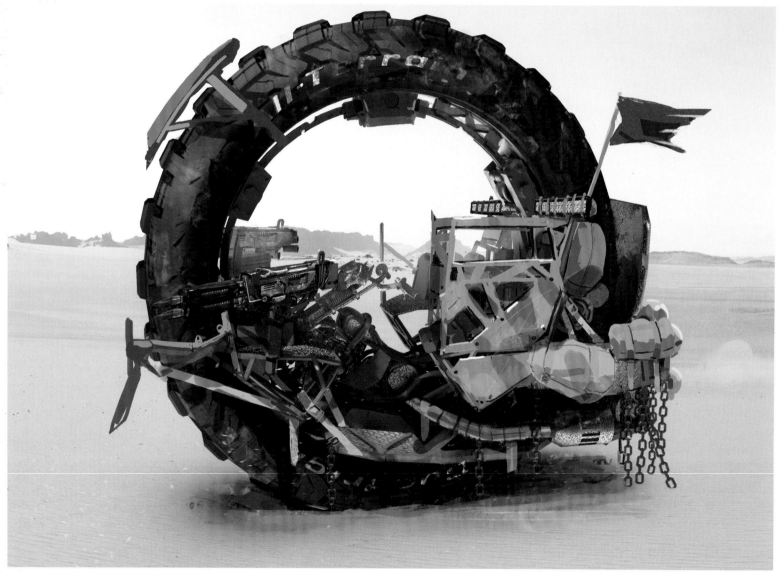

CYCLONE

So stylish! This trendy transportation is a ring-shaped monocycle. The outer wheel spins rapidly when in motion but, luckily for the drivers of Promethea, the inner parts don't. The Cyclone is speedier and more agile than the Outrunner but offers little protection from incoming fire.

ABOVE: The twin guns of the Cyclone aren't just for show, but they're a lot weaker than weapons mounted to the Catch-A-Ride's alternatives.

OPPOSITE: The Cyclone's customization options allow the outer wheel to be switched out with alternative designs like the Fire Starter and Cryo Booster—concepts shown here.

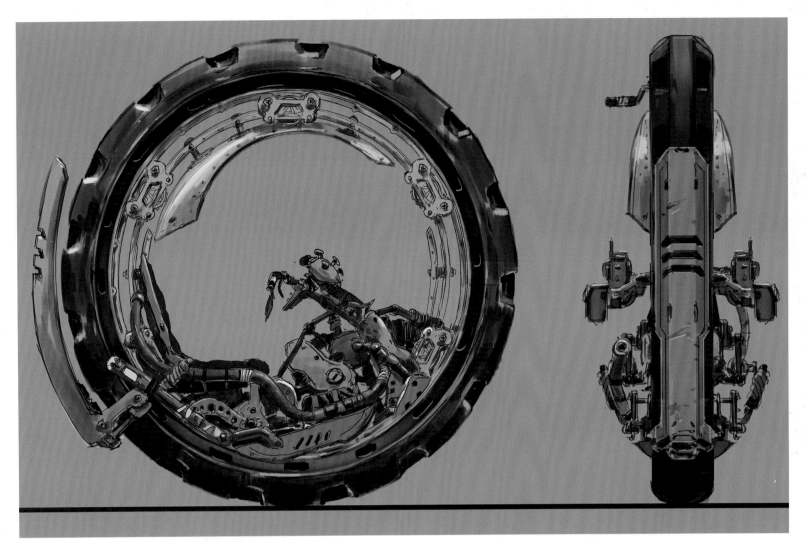

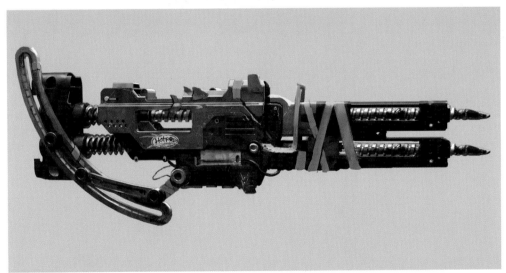

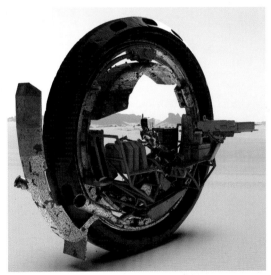

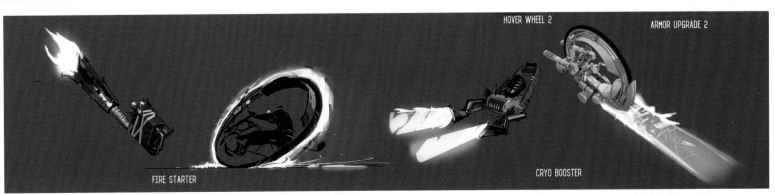

HOVER WHEEL 2

ARMOR UPGRADE 2

FIRE STARTER

CRYO BOOSTER

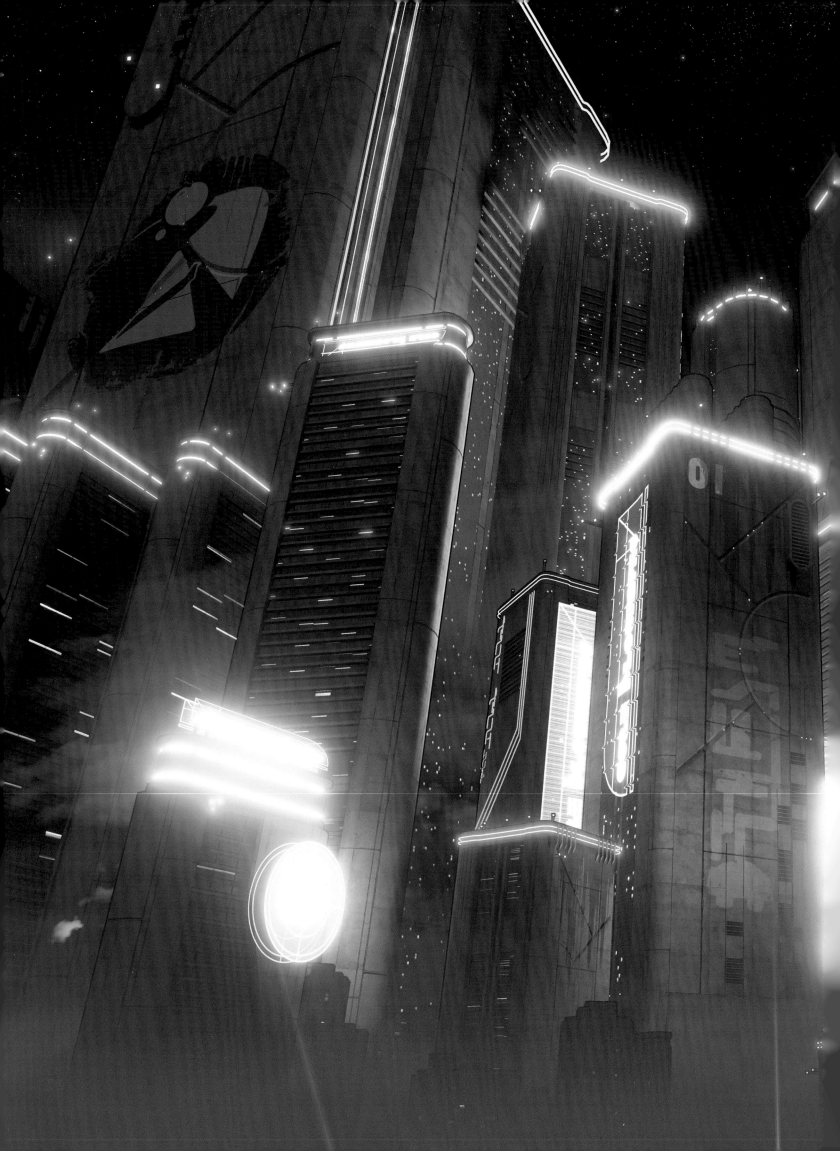

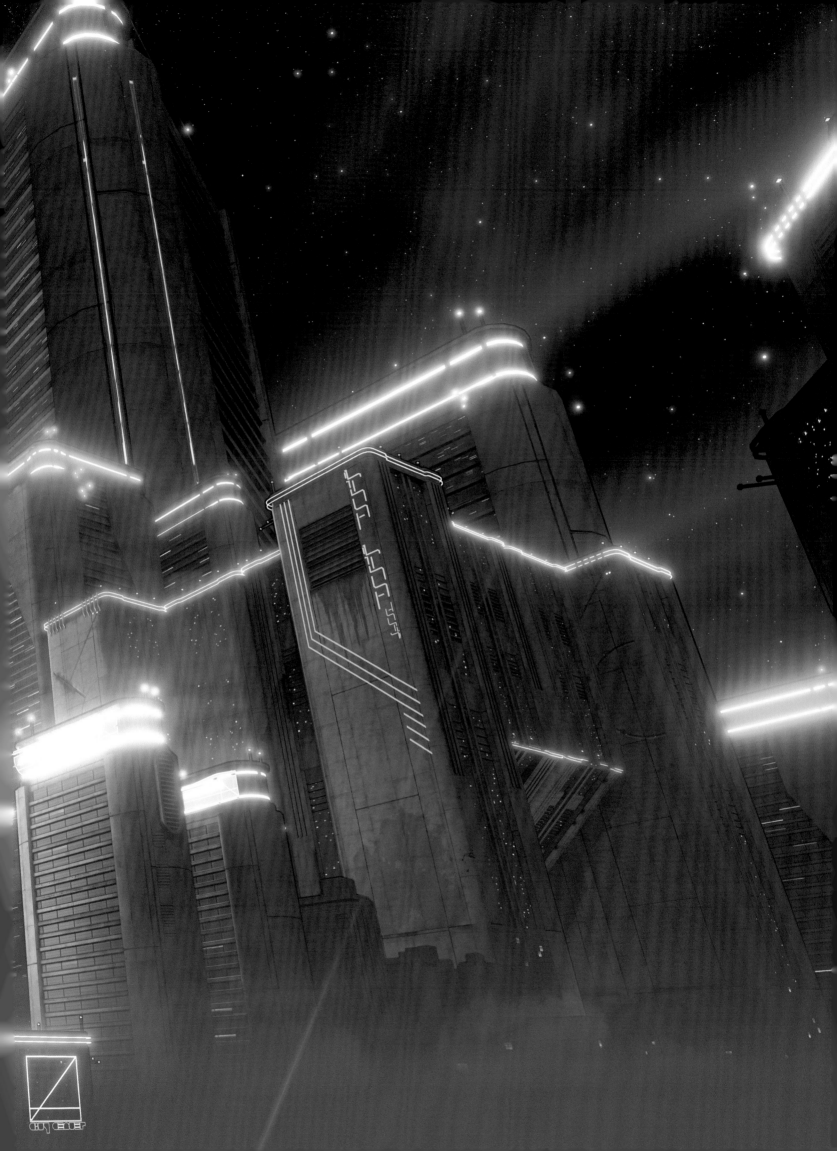

CREDITS

PRESIDENT

GEARBOX

RANDY PITCHFORD

BOOK TEAM

GEARBOX

ERICA STEAD

MEREDITH HERSHEY

SEAN HARAN

2K

ASHLEY LANDRY

RYAN TALJONICK

GABE ABARCAR

PAT ALVARADO

EXTERNAL PARTNERS

CHRIS FAYLOR

ART PRODUCER

GEARBOX

KAYLA BELMORE

ART DIRECTORS

GEARBOX

SCOTT KESTER

BRIAN COZZENS

GEARBOX STUDIO QUÉBEC

FRÉDÉRICK RAMBAUD

JONATHAN RANCOURT

ANIMATION

GEARBOX

KENT ALFRED

JAMES ASH-HOUCHEN

NICHOLAS BENKE

CHAZ COLVIN

IAN DAVIS

HILL GALVIN

DIA HADLEY

JIMMIE JACKSON

KYLE KING

RYAN METCALF

JORDAN MOORE

TU NGUYEN

JOSHUA OLSON

JEFF RAPESS

JERETT REARICK

MICHAEL SEWELL

JOSHUA TOWNS

GEARBOX STUDIO QUÉBEC

YANICK BÉLANGER

MIKE BISSON

MARC-ANDRE BOURDAGES

SÉBASTIEN BOURGOING

STÉPHANE DUCHESNE

CYRIL GARDENT

MARC-ALEXANDRE JOBIN

MAXIME LAJEUNESSE

CHRISTINE MARTINEAU

JONATHAN OUELLET

EXTERNAL PARTNERS

TYLER ANTHONY

STEVEN BODNAR

RAYMOND CHASE

ADAM CLARK

JUSTIN KUPKA

PETE PAQUETTE

ANIMATION DEPARTMENT

ROMAN ANDROSCHUK

LARISA KUCHERENKO

ANNA PAVLOVSKAYA

ALEX PENKOV

ANDREW SKAKUN

CRUSH ISLAND ANIMATION STUDIOS, INC.

COREY BELINA

GHOSTPUNCH GAMES

DEVON BROWNE

LIQUID DEVELOPMENT

RUSS BERNICE

JASON BASKETT

MANISH BHANDARI

JASON NEWKIRK

THOMAS RIHN

LAURA SMITH

ALLYSON WILLSEY

MINDWALK

LI HONGYU

HUANG JIAPENG

LI XINPENG

CHANG YINGJIE

FENG YONGXIAO

HE ZHIQIANG

LAKSHYA

ROHIT CHAUHAN

ANKIT KUMAR SINGH

SANJAY LOKHARE

JAINENDRA MAHORE

MANISH MALIK

MAYANK RAJPOOT

VARUN SHARMA

SHUBHAM SHARMA

VARUN SONI

SINDHU TYAGI

KARAN VERMA

SURYA

CHARACTER ART

GEARBOX

BEN GETTLEMAN

JAMES GILLIGAN

DAMIAN KIM

MATT LINK

ADAM MAY

KEVIN PENROD

TOMMY WESTERMAN

JAKE WILLIAMS

GEARBOX STUDIO QUÉBEC

ALEXIS BELLEY DUFAULT

OLIVIER GAGNÉ HOULE

HENRICK PELLETIER

STEPHANE RABATTU

HUGUES THIBODEAU

EXTERNAL PARTNERS

JJ BIGLEY

BRETT BRILEY

ADRIEN DEBOS

RACHEL QUITEVIS

MIKE SHULTZ

BRYAN WYNIA

CGBOT

GFACTORY

KEOS MASONS

OMNOM! WORKSHOP

CONCEPT ART

GEARBOX

ROBERT CHEW

AMANDA CHRISTENSEN

MAX DAVENPORT

KEVIN DUC

LUCAS HELMINTOLLER

ADAM YBARRA

GEARBOX STUDIO QUÉBEC

JENS CLAESSENS

DAVID FORTIN

DIMITRI NERON

TYLER RYAN

GET SET GAMES INC.

BROCK GROSSMAN

EXTERNAL PARTNERS

SERGI BROSA

JACOB EARL

DANNY GARDNER

HICHAM HABCHI

CARLYN LIM

ELIJA MCNEAL

STEPHEN OAKLEY

DANIEL SOLOVEV

HUA SONG

ATOMHAWK

VOLTA

TECHNICAL ART

GEARBOX

TEVEN STROBEL

TERRY BETTS

CAROLINE GRUBER

CONTENT ART

GEARBOX

TRIS BAYBAYAN

JUN CHOI

JACOB CHRISTOPHER

NINA DAVIS

JONATHAN FAWCETT

TAYLOR GALLAGHER

EVAN GILL

ASIA HAWKINS

DANIEL KINNEAR

TAYLOR MCCART

MACE MULLEADY

JASON NEAL

CHRIS NEELEY

ANDY NELSON

CHRIS PEACOCK

HUNG PHAM

PAUL PRESLEY

ROBERT SANTIAGO

KAI WEBB

GEARBOX STUDIO QUÉBEC

ETIENNE BOISSEAU

PHILIPPE FAUCHER

RAPHAËL JEAN

ROMAIN LAMBERT

ALEXANDRE MARBAIX

EXTERNAL PARTNERS

TRACY M HUNT

MANISH JANGID

RICHIE MASON

WES PARKER

WATSON WU

JANIMATION

LIQUID DEVELOPMENT

MINDWALK

LAKSHYA

LEVEL ART

GEARBOX

DAVID AVERY

MIKE DAVIS

CRAIG HARRISON

JONATHAN HERNANDEZ

NATE OVERMAN

BRAD SIERZEGA

GEARBOX STUDIO QUÉBEC

KARINE BÉDARD

JULES GAGNON

STÉPHANIE MALENFANT

GLEN MARTIN

ISABELLE MICHAUD

DOMINIC PAQUET

LOUIS ROULEAU

DANIEL VOYER-LESSARD

VIRTUOS GAMES

DANG NGUYEN VIEN KHANH

LEVEL DESIGN

GEARBOX

TREVOR BAGGETT

MORGAN DAVIS

ZACH FORD

STEPHAN HALDAMAN

MATTHEW HIGGINS

MATTHEW LEFEVERE

VANESSA LITTLE

ALYSSA LUTZ

COREY MCKEMY

SHANE PALUSKI

JASON SHIELDS

GRAEME TIMMINS

KYLE UMBENHOWER

GEARBOX STUDIO QUÉBEC

DAVID BLONDEAU

SÉBASTIEN CHAUDET

FRANCIS COUTURE

JONATHAN DELL'AQUILA

JONATHAN DROLET

JONATHAN LACHANCE

NICOLAS LADOUCEUR

MAXIME LANDRY

FRANÇOIS LAPERRIÈRE

MARIO NOTARO

FREDERIC OUELLET

GABRIEL RICHARD

GABRIEL ROBITAILLE

EXTERNAL PARTNERS

JOE SWINBANK, TEPHRA LLC

MARKETING ART

GEARBOX

SEAN AHERN

NICOLE DOROSH

KELLY ROMEO

MIKE ROTH

LIGHTING TEAM

GEARBOX

JEAN PIERRE ARIAS

PIET BRAUN

STEPHEN COLE

ANNGELICA PARENT

CARL SHEDD

GEARBOX STUDIO QUÉBEC

LOUIS-PHILIPPE LEBEL

NARRATIVE TEAM

GEARBOX

RANDY VARNELL

SAM WINKLER

DANNY HOMAN

CONNOR CLEARY

DANTE SILVA

APRIL JOHNSON

ERIK DOESCHER

JOEL MCDONALD

MICHAEL COSNER

QUALITY ASSURANCE

GEARBOX

COLTON KURTH

STEPHEN CHRISTOPHER

TECHNICAL ART

GEARBOX

TERRY BETTS

CAROLINE GRUBER

BRIAN MCNETT

RYAN METCALF

RYAN SMITH

STEVEN STROBEL

CAITLYN TROUT

GEARBOX STUDIO QUÉBEC

DANY BOUDREAULT

JEROME VIENS BRIE

BENJAMIN HUGUENIN

MATHIEU LEBLANC

VISUAL EFFECTS

GEARBOX

JOSEPH JOYAL

SEUNG KIM

ASHLEY LYONS

GABRIEL SIMON

SAMANTHA SPRAY

KATERINA VOZIYANOVA

NICHOLAS WILSON

GEARBOX STUDIO QUÉBEC

CHRISTIAN DUBÉ-LEBEL

VINCENT FISET

LUC-ANDRÉ MURRAY

YAN SHU

WEAPONS TEAM

GEARBOX

JAMES BARNETT

TRAVIS EVERETT

GRANT KAO

JETT SARRETT

GHOSTPUNCH GAMES

ARTEM SHIRYAEV (FRIDOCK)

EXTERNAL PARTNERS

BEN LEARY

RENO "LONEWOLF" LEVI

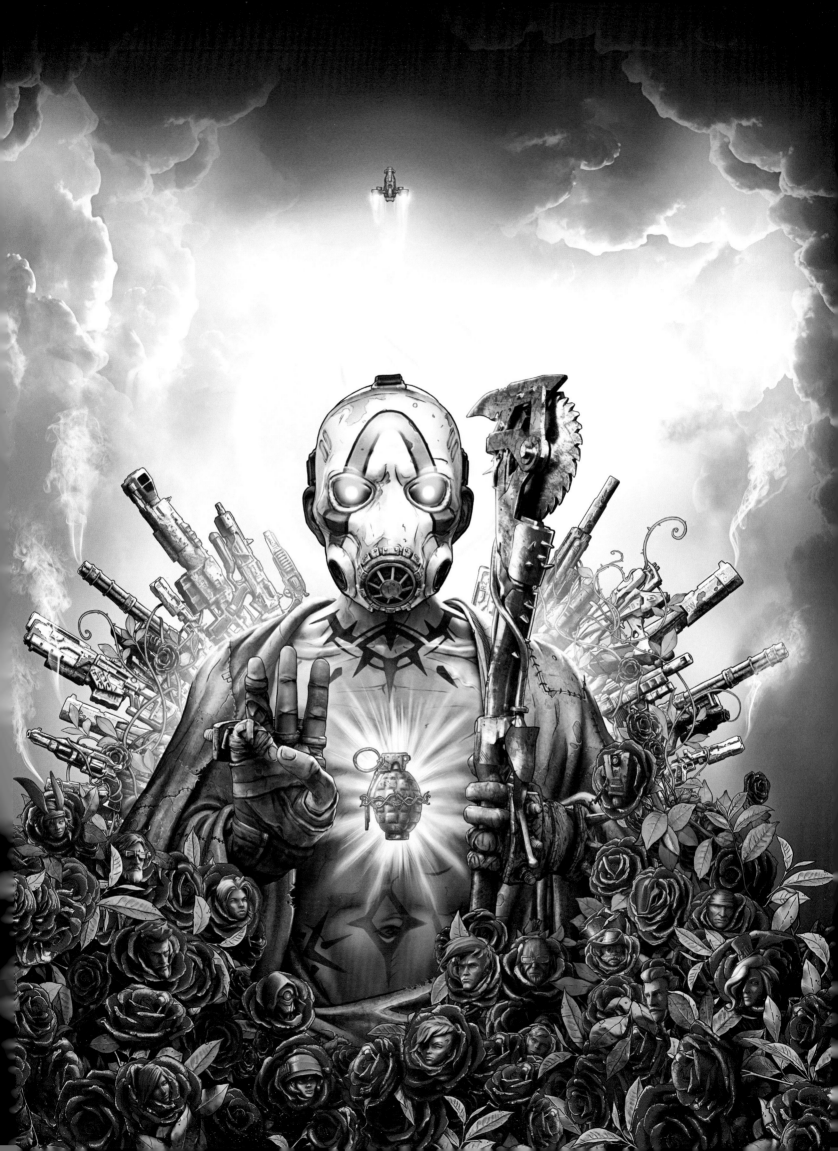

INSIGHT EDITIONS

PO Box 3088
San Rafael, CA 94912
www.insighteditions.com

Find us on Facebook: www.facebook.com/InsightEditions
Follow us on Twitter: @insighteditions

Published by Insight Editions, San Rafael, California, in 2019.

Library of Congress Cataloging-in-Publication Data available.

ISBN: 978-1-68383-571-4

Publisher: Raoul Goff
President: Kate Jerome
Associate Publisher: Vanessa Lopez
Creative Director: Chrissy Kwasnik
Designer: Brooke McCullum
Senior Editor: Amanda Ng
Editorial Assistant: Jeric Llanes
Managing Editor: Lauren LePera
Senior Production Editor: Elaine Ou
Senior Production Manager: Greg Steffen

ROOTS of PEACE REPLANTED PAPER

Insight Editions, in association with Roots of Peace, will plant two trees for each tree used in the manufacturing of this book. Roots of Peace is an internationally renowned humanitarian organization dedicated to eradicating land mines worldwide and converting war-torn lands into productive farms and wildlife habitats. Roots of Peace will plant two million fruit and nut trees in Afghanistan and provide farmers there with the skills and support necessary for sustainable land use.

Manufactured in Italy by Insight Editions

10 9 8 7 6 5 4 3 2

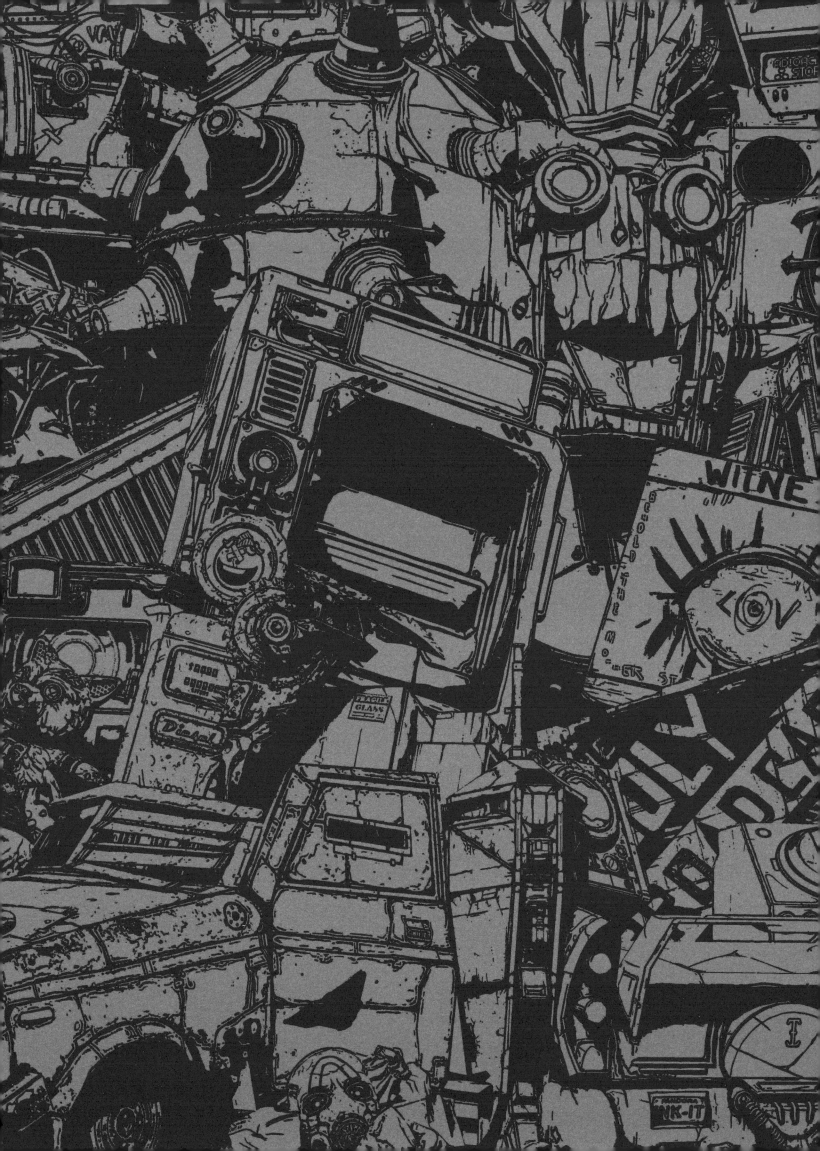